ART AND AESTHETICS
IN PRIMITIVE SOCIETIES

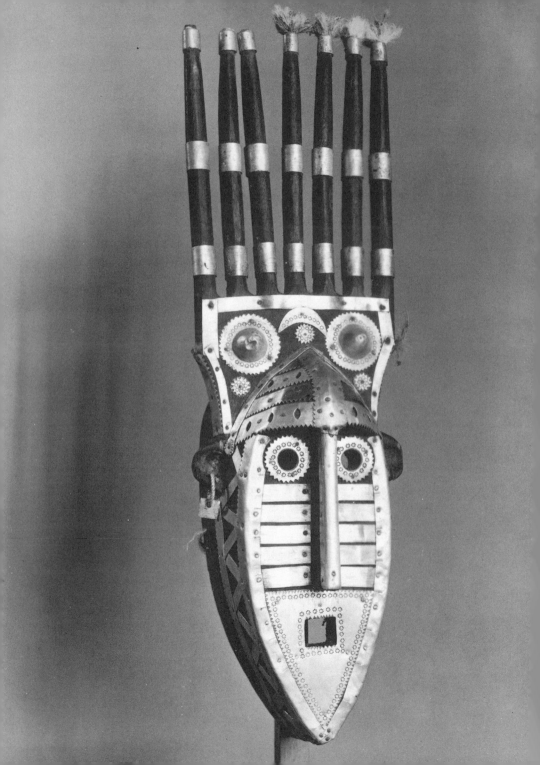

ART
AND
AESTHETICS
IN
PRIMITIVE
SOCIETIES

A critical anthology
edited by
Carol F. Jopling

New York 1971
E. P. DUTTON & CO., INC.

Published simultaneously in Canada by
Clarke, Irwin & Company Limited, Toronto and Vancouver

Library of Congress Catalog Card Number: 73–87202

SBN 0–525–05783–8 (CLOTH)
SBN 0–525–47257–6 (DUTTON PAPERBACK)

FIRST EDITION

Grateful acknowledgment is made to the following for permission to quote
from copyright material:

WARNER MUENSTERBERGER: *Some Elements of Artistic Creativity Among
Primitive Peoples.* Reprinted from *Beiträge zur Gesellungs und Völker-
wissenschaft* by permission of Gebr. Mann Verlag, G.M.B.H., Berlin.

ANTHONY F. C. WALLACE: *A Possible Technique for Recognizing Psychological
Characteristics of the Ancient Maya from an Analysis of Their Art.* Re-
printed from *The American Imago,* Vol. 7 (November, 1950), pp. 239–58,
by permission of the author and editor.

DAVID B. STOUT: *Aesthetics in "Primitive Societies."* Reprinted from *Men and
Cultures, Selected Papers of the Fifth International Congress of Anthro-
pological and Ethnological Sciences, Philadelphia, September 1–9, 1956,*
by permission of The University of Pennsylvania Press.

PAUL S. WINGERT: *Anatomical Interpretations in African Masks.* Reprinted
from *Man,* Vol. 54, No. 100 (May, 1954), pp. 69–71, by permission of the
author and editor.

EDMUND R. LEACH: *A Trobriand Medusa?* Reprinted from *Man,* Vol. 54, No.
158 (July, 1954), pp. 103–05, by permission of the author and editor.

HAROLD K. SCHNEIDER: *The Interpretation of Pakot Visual Art.* Reprinted from
Man, Vol. 56, No. 108 (August, 1956), pp. 103–06, by permission of the
author and editor.

HERBERT BARRY, III: *Relationships Between Child Training and the Pictorial
Arts.* Reprinted from the *Journal of Abnormal and Social Psychology,*
Vol. 54, No. 3 (May, 1957), pp. 380–83, by permission of the author and
editor.

GEORGE MILLS: *Art: An Introduction to Qualitative Anthropology.* Reprinted

from the *Journal of Aesthetics and Art Criticism,* Vol. XVI, No. 1 (September, 1957), pp. 1–17, by permission of the author and editor.

RONALD M. BERNDT: *Some Methodological Considerations in the Study of Australian Aboriginal Art.* Reprinted from *Oceania,* Vol. 29, No. 1 (September, 1958), pp. 26–43, by permission of the author and the editor, Emeritus Professor A. P. Elkin.

ROY SIEBER: *The Aesthetic of Traditional African Art.* Reprinted from *Seven Metals of Africa* by Froelich Rainey by permission of the author.

MARGARET MEAD: *Work, Leisure, and Creativity.* Reprinted from *Daedalus* (Winter, 1960: *The Visual Arts Today*), pp. 13–23, by permission of *Daedalus,* Journal of the American Academy of Arts and Sciences, Boston, Massachusetts.

HERSCHEL B. CHIPP: *Formal and Symbolic Factors in the Art Styles of Primitive Cultures.* Reprinted from *The Journal of Aesthetics and Art Criticism,* Vol. XIX, No. 2 (Winter, 1960), pp. 150–66, by permission of the author and editor.

JOHN L. FISCHER: *Art Styles as Cultural Cognitive Maps.* Reprinted from *American Anthropologist,* Vol. 63, No. 1 (February, 1961), pp. 79–93, by permission of the author and the American Anthropological Association.

GEORGE DEVEREUX: *Art and Mythology: A General Theory.* Reprinted from *Studying Personality Cross-Culturally,* ed. Bert Kaplan, copyright © 1961 by Harper & Row, Publishers, Incorporated, by permission of the publishers.

CLAUDE LÉVI-STRAUSS: Excerpt from the chapter "The Science of the Concrete" in *The Savage Mind.* Reprinted from *The Savage Mind,* copyright © 1966 by George Weidenfeld & Nicolson Ltd., by permission of The University of Chicago Press, Chicago, and George Weidenfeld & Nicolson Ltd., London.

VYTAUTAS KAVOLIS: *The Value-Orientations Theory of Artistic Style.* Reprinted from *Anthropological Quarterly,* Vol. 38, No. 1 (January, 1965), pp. 1–19, by permission of the author and editor.

IRVIN L. CHILD and LEON SIROTO: *BaKwele and American Aesthetic Evaluations Compared.* Reprinted from *Ethnology,* Vol. 4, No. 4 (October, 1965), pp. 349–60, by permission of the authors and editor.

ANTHONY FORGE: *Art and Environment in the Sepik.* Reprinted from *Proceedings of the Royal Anthropological Institute of Great Britain and Ireland,* 1965, pp. 23–31, by permission of the author and editor.

DANIEL J. CROWLEY: *An African Aesthetic.* Reprinted from *The Journal of Aesthetics and Art Criticism,* Vol. XXIV, No. 4 (Summer, 1966), pp. 519–24, by permission of the author and editor.

MICHAEL C. ROBBINS: *Material Culture and Cognition.* Reprinted from *American Anthropologist,* Vol. 68, No. 3 (June, 1966), pp. 745–48, by permission of the author and the American Anthropological Association.

NANCY D. MUNN: *Visual Categories: An Approach to the Study of Representational Systems.* Reprinted from *American Anthropologist,* Vol. 68, No. 4

Acknowledgments

In addition to the authors who have so willingly permitted their articles to be published in this book, I am indebted to many kind and generous people who have encouraged and helped me during its compilation. I am grateful to all of them. I would particularly like to express my appreciation to Allan Chapman and his staff and Elizabeth Little of The Museum of Primitive Art in New York for their invaluable assistance, and to Margaret Currier of The Peabody Museum and Harvard University.

Contents

x　　Contents

Illustrations

Introduction

In 1935 the first important exhibit of African art in the United States was held at the Museum of Modern Art in New York. In 1946 *An Outline Guide to the Art of the South Pacific* by Paul S. Wingert was published, and in 1957 the Museum of Primitive Art was established by Nelson A. Rockefeller. Although primitive art had been a subject of study for some time, these landmarks reflect an increasing interest. In the years since, there has been an accelerated development of theory pertaining to primitive art. The chronological arrangement of the theoretical ideas collected in this anthology shows to some degree what this development has been.

The focus of this book is on aesthetic ideas and the creative process in primitive societies. Although many of the publications related to primitive art are beautiful and a pleasure to look at, they often do some injustice by oversimplification. Identifications of objects and explanations of their ritual use and meaning do not make clear the importance of art in a tribal society. This anthology includes representative and meaningful writings that are concerned with these problems.

Until quite recently it was believed that the peoples of tribal societies had no aesthetic ideas, that art was only a manifestation of religious and magical beliefs. Field studies have shown, however, that neither of these assumptions is true; rather, there is such variation in aesthetic views among preliterate peoples that very few general statements can be made. Some peoples have aesthetic ideas close or parallel to Western aesthetics; others cannot or do not express any opinions, or, at least, any that a field worker is able to interpret; and still others have a completely different but well articulated set of standards. Roy Sieber's discussion of African

aesthetics defines the problem clearly. Although many different points of view are expressed in this book, they can be grouped into five broad categories. Psychological, cognitive, and methodological approaches are represented, as well as those concerned with the creativity of the artist and the total process of art in a given society.

Methodological studies like D. B. Stout's provide a useful introduction to primitive aesthetics and summarize many of the problems related to its study. Although the differences between anthropologists and non-anthropologists working in the field are no longer so great, and a start has been made on the research he advocates, his other observations remain valid.

Ronald M. Berndt and George Mills also offer general ideas and observations that are helpful introductions. Berndt's discussion of the various theories bearing on his own work is especially informative. His analysis of the art and social organization of three Australian societies illustrates clearly the difficulties both of relating art style to culture context and the need for knowledge of the specific situation. Mills attempts a general theory of the art process, drawing on aesthetic theory. His contrast of the qualitative and cognitive modes of experience may be profitably examined in relation to the articles by Claude Lévi-Strauss and George Devereux for other points of view and could also be compared to Herschel B. Chipp's paper.

Nearly ten years later, Vytautas Kavolis tried developing a theory of the linkage of values and art styles, using among his sources, the writings included here by Mills, Chipp, J. L. Fischer, Herbert Barry, and Anthony Wallace. He believes that if value orientations and art styles are linked subconsciously, and if this psychological congruence does exist (he documents the possibility with many examples), then it is a useful tool for investigating "intracultural linkages which hold total cultural systems together." Although his conclusions are admittedly speculative, he provides a welcome synthesis of a great deal of information related to specific social data from many different cultures, both historical and preliterate.

Psychological studies are closely allied to this group of writings in a number of ways. Devereux's definition of art in society from a psychological point of view, or as he says, in terms of

communications theory, can be used as a guide to an understanding of art related to culture and personality. To mention only two ideas from his broad discussion: he gives reasons for the distortion of the human figure, a visual characteristic of primitive art that is difficult for the novice to understand, or rather, too easy for him to misinterpret. Cross-cultural conceptual artistic communication is also complex, because it, too, is easy to misunderstand. Aesthetic plausibility, according to Devereux, is what makes an art object acceptable or fitting in one society and not in another.

When Wallace made his study of the Maya it seemed to offer much promise. However, subsequent research has shown the unreliability of this kind of cross-cultural psychological comparison. Since a way of relating art style to personality has not been discovered, the search continues. Such a linkage, as Dr. Wallace says, "should be of considerable value in providing archaeologists and historians with insights into personalities of long-dead populations."

Warner Muensterberger's psychoanalytic analysis of primitive art offers some original observations about the societal limitations of the artist, the effect of fear on creativity, and a hypothesis about the origin of sculpture.

More recent psychological studies have been related to cognitive research. Barry's brief paper relating severity of socialization and complexity of design has been both a stimulus and a source for others, including Michael Robbins and Fischer. It would be useful to know what works of art were used as a basis for his test. In most societies certain forms and patterns of art are sex-linked. That is, the women in most tribal societies traditionally create pottery, basketry, and sometimes textiles. Repetitive design is characteristic of women's art. Women are often prohibited from creating representational or figurative designs. Therefore a theoretical distortion may exist if Barry's conclusions are based partly on women's art and partly on men's. It is quite possible Dr. Barry allowed for this in his test, and the results would not be changed.

Fischer extends Barry's ideas to examine the connections between social structure and art style, specifically social stratification and form of marriage. His observations on historical diffusion, social conditions as determinants of creativity, and the adoption by societies of some stylistic features and the exclusion of others on

the basis of congeniality, offer stimulating avenues for further research.

Turning an apparently negative result into a positive theory makes the brief report by Robbins more interesting than if his original hypothesis had proved correct. His use of Berlyne's cognitive theories adds another dimension to the research stemming from Barry's.

Cognitive studies, the analysis of the aesthetics of primitive peoples, and the art process in specific societies are topics of continuing investigative interest. Directly or indirectly, Lévi-Strauss has been a major influence on symbol theory and cognitive research. Although the excerpt included from *La Pensée Sauvage* includes some specific observations on art and the creative process in primitive societies, it represents only a fraction of Lévi-Strauss's theory that has influenced research on art.

Nancy Munn uses Lévi-Strauss to support her analysis of the interaction of art symbols and totemic systems. She believes that her structural analysis could be used in cross-cultural comparisons. Her well-defined presentation provides a model for similar studies.

Anthony Forge's comparative analysis relates the art of the Iatmul and the Abelam to the social structure. Two points: 1) that the differences between the two styles are not so much caused by different concepts, but by different environments resulting in divergent economies; and 2) that "disparate objects may serve very similar symbolic functions . . ."—could be of particular consequence to archaeological research as well as to theories of primitive art. Archaeological reconstruction of entire societies often uses style as the basis for assuming similarity or difference in culture.

The writings of Wingert and Edmund Leach relate to the present interest in symbol theory and aesthetics. Leach's article stimulated a lively correspondence in *Man* that resulted in the presentation of additional material and a number of arguments for and against his hypothesis. Whatever one's conclusions, the controversy is an excellent example of the difficulties in interpreting symbols with a limited knowledge of the culture, as Berndt mentions in his article.

Wingert describes the formal characteristics of African masks, showing how the visual influences in the maskmaker's environment affect the patterns and structural qualities of his art. This emphasis on sensitivity of artists to their visual surroundings makes an important and useful point.

Chipp compares the art of the Maori and of the Plains Indians in a stylistic analysis relating art and its meaning. Like Wingert, Chipp understands the need to include the creative process in an interpretation of a society's art.

One of the first attempts to examine the aesthetic ideas of a culture from within that society is Harold Schneider's sympathetic description of the Pakot and their ideas of beauty. The essay offers points that could be tested in other societies. It would be interesting to know something about the personalities of his informants; for example, are only a few of the Pakot able to express the evaluations cited by Schneider, or are all of them equally articulate?

Another important essay is Irvin Child's and Leon Siroto's cross-cultural study of aesthetics using photographs of BaKwele masks. The surprising concurrence in aesthetic judgment between Yale students and BaKwele carvers tends to reinforce ideas of universal aesthetic standards and recommends their method for use in future research.

James W. Fernandez leads up to his question "To what extent does social structure reflect aesthetic principles?" with an interesting, precise analysis of the occurrence of the concept of duality and opposition in art objects and village pattern, and in religious beliefs and social structure. Although this article is based on a field study, a student might well try a similar approach using ethnological source material.

Robert F. Thompson, in his study of Yoruba aesthetics, has been able to focus on the art object and the evaluation of it by its creators or viewers, without permitting it to become separated from its cultural context. His explanations of Yoruba aesthetic criteria and their application to specific objects conveys as clear a picture of the significance of art to its society as we could hope to find.

Daniel J. Crowley and William H. Davenport describe the art process among the Chokwe and Solomon Islanders respectively.

They give special attention to the artist, his role in his society, the creative process, and the evaluative criteria. Crowley points out the variations of art within the society according to its use, kind, significance, and creator. Davenport discusses the disparate abilities of the artists studied and the relative importance of aesthetics and religious belief.

Hopefully, this anthology of twenty-four articles and their accompanying illustrations will stimulate further research, particularly in the field, where first-hand opportunities for investigation must inevitably decrease.

Carol F. Jopling

ART AND AESTHETICS
IN PRIMITIVE SOCIETIES

Some Elements of Artistic Creativity Among Primitive Peoples*

WARNER MUENSTERBERGER

This article is an analysis of the psychological factors in primitive society related to art and ceremony, to the origins of sculpture, and the restrictions of artistic expression. The observation is made that fear, particularly of the dead, may be a major source of the primitive's creativity activity.

Dr. Warner Muensterberger is an Associate Professor in the Department of Psychiatry of the State University of New York, Downstate Medical Center. His research fields include psychosociological research in personality, social structure, and culture; and motivation and human interaction. He is the author of "The Creative Process; Its Relation to Object Loss and Fetishism," *Psychoanalytic Study of Society* (1960–1967) and coeditor of *Psychoanalysis and Culture* (1965).

For years, even after the "discovery" of primitive art, every figure was called an idol, or, in sophisticated circles, with just a little justification, a fetish. Every mask was described as a dancing mask. In the course of time, anthropologists have been able to establish some sort of order and precedence for sculpture, while painting and poetry remain, on the whole, unclassified.

On the basis of more recent research, we have come to the conclusion that primitive creativity is not exclusively stimulated by religious ideas, although it cannot be denied that the religious element has had a strong influence on all artistic creation. Nevertheless, it is apparent that it was often simply a delight in ornamentation, such as we also feel, which led to the decoration of articles of daily use, to drawings, and to molded and carved objects. A number of groups of natives with definite artistic talent, such as many New Guinea tribes and islanders of Indonesia and Oceania,

* Reprinted from *Beiträge zur Gesellungs und Völkerwissenschaft,* Berlin, Mann, 1950, pp. 313–17.

in Northwest America and in West Africa, do not limit themselves to the creation of objects, dedicated solely to "religious" purposes.

But what we find is that the creative expression of a tribe does assume a kind of institutional character, perhaps because of the deep connection between art and ceremony.

We find everywhere traces of ceremonial institutions which are, for psychological reasons, of greater importance than in Western society. We must understand that what to us are often seemingly casual, spontaneous expressions, are to primitive man imbued with a thoroughly ceremonial attitude. It is evident in almost every area, in customs of welcome, in the relationship of the generations and sexes, in eating manners, games, and trade. We would certainly have more understanding for many peculiarities of primitive art if we had a deeper insight into the ceremonial laws of the respective ethnic units.

There are, for instance, the famous scar ornamentations of the Maori of New Zealand, of the Bena Lulua and the BaTeke in the Belgian Congo, of the Baoulé on the Ivory Coast, who repeat those marks in their sculpture. The scarifications have a ceremonial meaning and are not, as some might presume, just playful embellishments. They are significant for the Maori, in that they are a mark and proof of personal achievement and rank, and as such, an individual distinction. These marks, we find repeated in the sculptural representations. We also know that many African figures and masks represent individuals, friends, and acquaintances who are still living, as well as dead ancestors. However, more intensive research is needed to furnish us with a clearer picture of the thought processes and interindividual relationships of these peoples.

Speaking about elements of artistic creativity among primitive peoples, we observe first the inclination to personify things and ideas. Ghosts, gods, and demonic or mythological creatures generally assume the appearance of humans or animals and only rarely do we find really hybrid figures. Man reflects his own ideas, conflicts, and desires in his thinking about the world, and artistic expression forms a medium for the solution of unconscious conflicts.

In his book *Primitive Kunst und Psychoanalyse* Eckart von

Sydow made an attempt to explain the sculptural art of primitive people through the pole worship, where the pole is a symbol of the phallus. Frobenius had also developed a similar theory. I find a germ of truth in their idea, but to base the explanation of the origin of sculpture on a few facts which have been observed in fertility rites and ancestor cults is not quite sufficient.

It seems to me, that the foundation of primitive sculpture can be seen in the skull cult and worship and fear of the dead, which is almost universal, and that can still be observed among many primitive peoples. To give only a few examples from various tribes: the Pahouin (Pangwe) in West Africa, the natives of New Britain, the Solomon Islands, New Zealand, and some of the areas of New Guinea, observe the custom of preserving the skulls of the dead. The painted skulls of the Sepik region of New Guinea have become rather well known. Approximately one year after the funeral, the skulls are exhumed and are freed of all remnants of flesh. The lower jaw is then fastened to the upper one and the face is modeled to the point above the forehead with a mixture of clay and resin in an extraordinarily realistic manner. Then it is painted, generally with the same pattern with which the deceased painted himself on festive occasions. The eye sockets are laid out with Cypraea shells, so that the diagonal opening gives the impression of an eyelid with lashes. Finally, the skull is decorated with human hair and sometimes with feathers. A rather similar method is used in the Solomon Islands. Here, the skull is artistically decorated with mother-of-pearl inlay. On the New Hebrides we find an intermediate form of the free standing figure. A skull is covered with a layer of clay, in a fairly rough way. It is placed on a wooden stick which is dressed up with tree bark, clay, resin, and other materials to give it the appearance of a human body. This figure is ornamented and painted in a specific manner to indicate the identity, rank, and position of the deceased. These representations are placed in front of or inside the men's houses, and there are worshiped.

Another transitional form of sculpture can be found in the coastal region of West (Dutch) New Guinea. Here skull shrines are built which are called *korwar* (or *korowar*). They are containers, carved in imitation of a human figure. The head of this

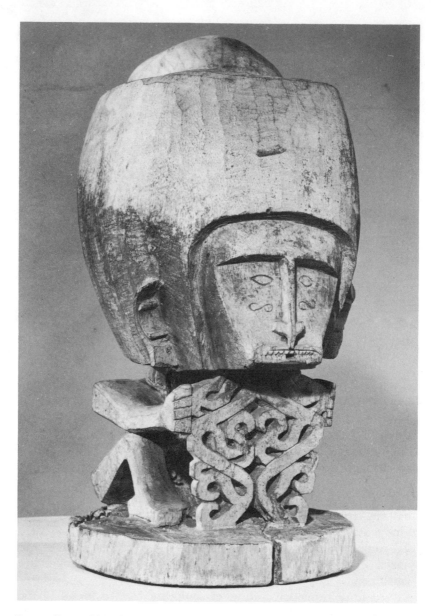

Korwar figure. Biak, Geelvink Bay, Western New Guinea. Type of funeral sculpture permitting consultation with an ancestor. Rijksmuseum voor Volkenkunde, Leiden.

figure, which generally does not possess a skull top or face, is used as receptacle for the ancestral skull. In this way, the valuable relic is preserved. The head of the sculpture is life-sized, while other parts of the body are greatly reduced, so that a comparatively large head sits on the tiny body, which is generally represented in a squatting position. We do not know of the existence of skull shrines of this type anywhere else. However, figures which possess the characteristic peculiarities of the *korwar* do exist. They seem, at first sight, to be carved somewhat roughly and have a disproportionally large head, a more or less square face with a horizontal chin, and a prognathic jaw. They are in a squatting position which is a reminiscent of the burial and the fetal position.[1]

In this transitional form of sculpture, primitive man apparently dared to make a double experiment: he preserved the ancestral skull and imitated a natural figure. The skull and ancestor worship, give a new basis to the hypothesis that a close connection exists between primitive sculpture and the faith in the power of the dead. But this procedure reveals at the same time the ambivalence toward the dead—since they use his skull, the ancestor is, so to speak, in the hands of his descendants.

But we have to guard carefully against the generalization that this is *the* function of all primitive sculpture. Other factors also operate. Fertility and pregnancy figures, defense and deity statues, amulets, representations of medicine men, are connected with the religious-magical world or, psychoanalytically speaking, with projective means. A very pleasantly familiar custom is observed in the island of Nias, Indonesia, which has become famous for its high megalithic culture. If a daughter gets married and leaves the parental home, a statuette of her is made and placed in the house. Such custom is certainly not based on religious thoughts but reminds us rather of our custom, of hanging up photographs or paintings of friends and relatives whom we love or admire. People like to keep alive the memory of those who are absent.

The exhibitionistic tendency is another important factor in the production of primitive art. Possession of figures, amulets, and masks is enjoyed and the native feels proud of his objects as part

[1] Cf. W. Muensterberger, "Over Primitieve Kunst en over den Korwar-Stijl in Indonesië en Oceanië," *Cultureel Indië*, Vol. VII (1945), p. 63 ff.

of his property. Much has been said about the annual exhibition of the *malanggans* of Northern New Ireland. These figures presumably represent dead persons. At the exhibition, it is the owner of objects that are particularly beautiful, who gains prestige.

Not all primitive people possess masks or sculptured objects and many tribes display no graphic talent at all. From a sociopsychological viewpoint, it is curious, yet important, that cattle breeders who are organized on a patriarchal basis, know hardly anything of sculpture. They are generally forced to travel with their herds through large regions in search for pasture land. This sort of life, with little permanence or restfulness, is hardly conducive to modeling patiently large figures with simple tools. Neither would it be wise to add extra possessions to the burden that must be carried on the excursions.

It cannot be a coincidence that we find in those African regions where sculpture and rich handicraft exist, a state or tribal organization with a matriarchal structure, or one in which the woman has at least a strong position. Again, we observe an inner connection between sculptural art, social structure, economic conditions, and psychological conditions. We find in Africa, a definite region from the West Coast to the central area, where a matrilinear or, at times, a bilateral society functions, but never the exclusively patrilinear. Here, there are families who have been artisans for many generations. Artists prefer to take their own sons and the sons of their sisters (but not their brothers' sons) as apprentices to carry on the traditional technique and style. Apprentices receive orders to copy certain pieces as precisely as possible. But sculpturing as a profession is rare. The "artist" is generally also a farmer or hunter and has to make his living from these occupations. For example, in some parts of Oceania, persons who are adept at building houses, are also expected to be good sculptors. The customer describes his order as exactly as possible, but he leaves the execution of it to the "professional" man. Among certain tribes in West Africa, each family has its own specialty—potters, weavers, blacksmiths, woodworkers. Sculpturing is considered an absolutely masculine profession, while pottery making is usually left to the women. When clay is used for making figures, it is again the man who assumes the artistic work, which fact is interesting from an

anthropological and psychological point of view. He forms figures, pipes, bowls, etc. Women are sometimes avoided or even rejected, while the artist is at work. The Ashanti women risked capital punishment, in former times, if they tried to approach the sculptor while he was working. Elsewhere, masks and figures were created in seclusion, again strictly isolated from all contact with women. The explanation of, what, to the Westerner, seem to be curious rules, differs, but they generally deal with religious and social laws, which certainly can only be considered as rationalizations for a deep conflict with regard to the woman[2] as well as to the artistic activity.

Another important aspect of primitive art is the striking similarity in style within a certain area. Since anxiety seems to be one of the important elements of artistic creativity among primitives, we believe that it limits the artist in his opportunities for self-expression. Not technical, but rather psychological and social conditions, interfere with his individual work. And we have reason to believe that the social pressures and demands influence even his artistic imagination.[3] The primitive artist, creating entirely according to his own impression and intention, is strongly restrained. Apart from the social restraints, does the primitive artist entertain many new ideas and thoughts? Is it possible for him to create an entirely new style? Can he find other themes than those which have been known for generations?

It is difficult to answer these questions, because our knowledge about the artists' personality and individuality is extremely limited. By the time modern research started, the artists were no longer uninfluenced by Western culture.

Since we are not able to discover the origin and development of primitive art through the artists themselves, we have to depend upon our knowledge of the reactions and emotions of the human being to find the universal motifs for the artistic drive.

The unconscious aggressions against, and the fear of, the dead, which have already been mentioned, demand a certain conservatism in the entire philosophy of life. People who worship,

2 Among the Ma-Ngbetu we find women-sculptors as well. Cf. Frans Olbrechts, *Plastiek van Kongo* (Antwerpen, 1946), p. 125.

3 Olbrechts, *op. cit.*, pp. 97 ff.

venerate, or fear the dead—which is basically the same thing—try to live according to the wishes of the deceased and to remain true to their beliefs. This is also apparent in the life and rituals of many civilized peoples. The reticence and fear of the primitive may be considered a major source of his creative activity. He is making a compromise with the dead toward whom he has ambivalent feelings. It is this bipolarity of feelings that we consider a prelude to what, on a sublimated level, can be called "art." The mask or the figure, which is used or worshiped, is a paternal representation, which is in the possession of the living generation; which can be used in a dance so that the dancer is identified with the dead, or, so that the son is identified with the father. Or the figure can be used like the nail fetish of the lower Congo region—so that the dead (or demon) can be tortured. As such the "artistic" object gives the maker as well as the worshiper a socially accepted chance to solve his inner conflicts of love and hate; it enables him to ward off hostility and anxiety.

We are approaching an understanding of primitive creativity through psychoanalytic insight, and our knowledge of the natives' beliefs and customs, mythology and traditions. The artistic creation is largely an expression of the conglomerate of forces in which the particular character of a population projects itself. Chesterton's definition of art as "the signature of man" puts it succinctly. The strangely fascinating heathen images of Rurutu or Bougainville or the Ba-Songe are perhaps typical and expressive works of art of the respective peoples in just the same way, as the Greek spirit, or even the Greek ideal of beauty speaks to us through the Venus of Milo or the Pollux of Pythagoras.

A Possible Technique for Recognizing Psychological Characteristics of the Ancient Maya from an Analysis of Their Art*

ANTHONY F. C. WALLACE

Using psychological projective techniques, the Rorschach technique, the Thematic Apperception Test, etc., Dr. Wallace analyzes here the personality of the Maya by an examination of some of their codices. His analysis was later compared to descriptions of the Maya found in Landa and others. The agreement of the psychological and historical data was convincing and ". . . this implies that the deductive criteria used in the art analysis have, in this case at least, cross-cultural applicability."

Dr. Wallace is Chairman of the Department of Anthropology at the University of Pennsylvania and is also Research Associate of the East Pennsylvania Psychiatric Institute. He has served in an advisory capacity on the board of many institutes, among them the Social Science Research Council and the National Research Council. His specialities include culture and personality, North East American Indians, and religion. Three important publications are *Culture and Personality* (1961); *Religion: An Anthropological View* (1966); and *Death and Rebirth of the Seneca* (1970).

INTRODUCTION

This paper has a twofold objective. First of all, it suggests a possible method for handling the art products of a society as psychological data in order to make statements about the personality structure characteristic of individuals in that society. Secondly, it presents, as a test case, certain statements about the personality of the precontact Maya, derived from an analysis of the three codices. These statements are then compared with remarks by Bishop Landa, and also with recent Rorschach findings, in order to check on the validity of the "art-analysis" diagnosis.

* Reprinted from *The American Imago*, Vol. 7 (November, 1950), pp. 239–58. This paper was read in abbreviated form before the session on "Personality and Culture" at the XXIX International Congress of Americanists, New York City, September 6, 1949.

HISTORY OF THE RESEARCH

I became interested in this problem directly as the result of taking a course in 1948 under Dr. Linton Satterthwaite of the University Museum, University of Pennsylvania, in "Indian Backgrounds of Latin American History." Under the guidance of Dr. A. I. Hallowell of the Department of Anthropology, University of Pennsylvania, I had already been introduced to the general field of personality and culture, and more specifically to the Rorschach technique. During the summer of 1948 I had spent three weeks studying Rorschach and other projective techniques with Dr. Bruno Klopfer under the auspices of the Rorschach Institute, Inc. When under Dr. Satterthwaite's tutelage I became aware of the extent and nature of some of the art products of aboriginal Middle America, it occurred to me that it might be possible to derive some insight into the personality of these people by applying to their art the same diagnostic criteria which a number of clinical psychologists in America and Europe are applying systematically to the art products of both normal and disturbed people in our own society.

The initial statement of Maya personality which I drew up was submitted as a term paper to Dr. Satterthwaite in January, 1949. This statement was essentially a "blind" diagnosis: i.e., when I made it, I had practically no knowledge of those Maya source materials which were psychologically revealing. I had deliberately avoided reading Landa and the other colonial commentators; I had not read the recent studies of the folk cultures of Yucatan, by Redfield and others; and I had not read the articles by Billig, Gillin, and Davidson on Maya Rorschachs which were published in the *Journal of Personality* in 1947 and 1948. I have retained my original statement, "blind" as it is, in this paper, verbatim, since if the proposed method is to be of any use, it must be possible to apply it independently of any guiding information from other sources. Otherwise, it would be only too easy to read into the art whatever preconceptions the student had acquired elsewhere.

Dr. Satterthwaite read the original paper and made several

useful comments which will be taken up later. After he had seen the paper, I read Landa, Redfield, Stephens, and the Maya Rorschach paper, which was called to my attention by Dr. Hallowell in March, 1949.

Thus, the present paper consists of the presentation of the "blind" diagnosis, together with a discussion of its methodology and rationale, and a comparison of this diagnosis with descriptions of Maya personality from other, subsequently studied, sources.

RATIONALE

The basic assumption underlying this approach is that all kinds of human behavior are determined, among other factors, by the personality of the agent. All behavior is expressive of—is a "projection"[1] of—the agent's personality; the technical problem is to isolate behavioral categories which can be directly correlated with psychological categories. Once it has been empirically established that all, or almost all, persons who behave in a given way in a given situation are characterized by a given personality trait, the procedure becomes deductive. By recognizing that an individual belongs in a certain behavioral class, one also recognizes that he belongs in a certain psychological class.

This is essentially the logic of the "projective techniques" which are now given such a prominent role in clinical psychology. These techniques, which include the Rorschach ink blot test, the Thematic Apperception Test, the Szondi Test, and various tests based on an analysis of drawings or paintings, began as a series of more or less intuitive propositions about the correlation between certain personality traits and behavioral traits. Many of these propositions have subsequently proved to be clinically valid; their further validation by statistically organized observations has occupied much time and space on the part of psychologists. Clinical

1 "Projection," as the word is used here and by workers with projective techniques, does not have altogether the same meaning as the same word used by psychoanalysts. Projection in the psychological test sense is automatic, inevitable, and involves the total personality; in the analytical sense, as one of the mechanisms of defense, it refers only to selected areas of the personality. I am not using the word in the analyst's sense.

experience inclines many of those who have worked with projective techniques to feel that diagnosis from projective data is at least as promising a basis for designing therapy as any other psychodiagnostic technique which has as yet been devised.

The nature of the behavior which is regarded as "projective" in any test varies, of course, with the technique. Usually, the categories chosen for observation are "trivial" in a conventional sense: color preferences, quickness of response to a stimulus, preference for seeing animals or human beings during fantasy, and so on. One of the reasons for selecting areas of behavior which are "unimportant" is that, by so doing, the investigator avoids those which are consciously standardized according to cultural prescriptions. It is not that the investigator is bored by cultural patterns, but because people who display the same culturally standardized behavior may have very different personalities.

There are several considerations that prevent our jumping eagerly to apply to ancient Maya art the same criteria which have proved to be useful in analyzing the art products of twentieth-century Western Europeans and Americans. Are *our* systems of interpretation cross-culturally valid? Is it legitimate to infer the personality characteristics of a whole society from the productions of a few individuals? And to what extent are the chosen criteria affected, in Maya, by their culturally standardized function?

The question of the cross-cultural validity of systems of interpretation found useful in Western society was an early preoccupation of anthropologically inclined Rorschach and TAT workers. Dubois and Oberholzer's Alorese experiment, and the experience of Rorschach students working with American Indian materials, have indicated that, for Rorschach at least, cross-cultural interpretations, even by persons unacquainted with the culture, are valid. The Alorese data also included analyses of dreams and drawings. These, too, yielded meaningful results when evaluated by standard "Western" criteria. It would seem, therefore, worthwhile going ahead on the operating assumption that "Western" criteria will prove to be valid with Maya materials too. The hypotheses derived from the projective techniques can later be checked against independent evidence, such as descriptions of the Maya by early European observers like Landa. And agreement among two or

more projective techniques of interpretation would tend to increase confidence in both.

The legitimacy of inferring the psychological character of a whole society from the artistic behavior of a few male representatives would be very dubious if the art in question were spontaneous, private, and secular. In the case of the Maya, however, art was not spontaneous, private, and secular; it was largely a function of the ceremonial and magical activities of the priesthood. The major Maya arts—painting and drawing, sculpture, and architecture—were public activities even if they were planned and executed by individuals. As such, they were highly stylized rather than idiosyncratic; and the styles were consistent enough, outside of minor variations, to be regarded as diagnostic traits of Maya culture. Thus, in any style there are fundamental similarities among the three surviving codices, there are fundamental similarities in the sculpture of the various cities, and in the architecture. If we confine our observations to these common elements, we shall avoid confusing idiosyncrasies of particular Maya artists with the tendencies of Maya art in general.

In a statistical sense, furthermore, we are justified in assuming that *very probably* the particular artists we are dealing with were subjected to the primary institutions typical of the society, and that hence their basic personalities were, again *very probably*, representative of the society as a whole. This unprovable assumption is even more likely to be true in Maya than in Western society, because Maya art was not considered to be so much the expression of a free and unique soul struggling for self-expression as the mechanical arrangement of conventional forms in functional (calendro-magical) relationships. Artists, in Maya society, would have to be conventional people.

But why were the "conventional forms" which are evident in Maya art just these particular conventional forms and no other? We can partly answer this by saying that a conventional art style must contain elements which are aesthetically (i.e., psychologically) congenial to the large majority of the people supporting art production over continuing generations. The nature of what is aesthetically congenial is determined by the basic personality structure of the people. An art form is congenial if it reproduces

the same sort of art which the viewer himself would try to produce if a brush (or a chisel or whatever the instrument might be) were put into his hands. In other words, no matter what the utility of the object may be, people like to look at art forms in which they can recognize the projection of their own personalities, in which there is implicit the same world of meanings to which they are accustomed.

If all this is true, then an analysis of Maya art according to the criteria used in projective techniques should reveal personality characteristics, certainly of the artists themselves, almost certainly of the class involved in ceremonial and calendro-magical affairs, and probably enough of the whole society.

Another type of pertinent objection to this sort of analysis, which I have heard several times from Dr. Satterthwaite and others, is that the Maya codices were essentially utilitarian documents—astrological handbooks containing elaborate astronomical and arithmetical calculations—and hence cannot properly be regarded as equivalents of such documents as Rorschach protocols, TAT stories, and random drawings. Certainly the student cannot totally ignore the social function of the codices. But I think it is a mistake to assert that the codices were intended *either* as astrological manuals *or* as expressive art. Obviously they are both. Those aspects of the codices which are determined by their astrological function—e.g., the particular sequences of numbers, the particular day signs, the particular deities represented—are probably irrelevant to the particular sort of analysis I wish to make. On the other hand, those descriptive categories which I have chosen—e.g., the general avoidance of sharp in favor of rounded corners, the arbitrary use of color in a non-naturalistic way, the preference for profile over full-face representation of human beings—do not appear to be determined by the necessities of preparing an astrologer's handbook or of making arithmetical calculations.

I confess to abysmal ignorance of Maya calendrical arithmetic, cosmogony, and ritual lore. I have nothing whatever to add about the use to which these books were put; I am confining my observations to those aspects of Maya drawing, in the codices, which appear to be determined by factors other than the purposes for which the books were consciously made.

Hieroglyphic text of a divinatory almanac supplemented by an illustration of Ixchel, moon goddess and wife of the sun— the patroness of childbirth, sexual relations, disease, the earth and its crops, water, and the art of weaving. Plate 17 from the *Codex Dresdensis Maya.*

SPECIFIC METHODOLOGY

In order to make inferences about Maya character, it is necessary first to describe the sample of their art in psychologically relevant terms. There is, unfortunately, no standard list of descriptive categories to be used automatically in the projective analysis of art products. Each worker in this field has a more or less individual system of description and interpretation because each worker uses slightly different kinds of data. Schmidl-Waehner handles spontaneously produced drawings and paintings; Machover asks the subject to "draw a person"; and so on. In the face of this welter of methodologies, it seems advisable to take an eclectic approach: to select any descriptive categories (with their interpretive meanings) that are applicable to the sample chosen for analysis.

The choice of the sample thus may be made more or less arbitrarily before the descriptive categories are selected. There is initially available a wide variety of materials: the three codices, sculpture, architecture, wall paintings, ceramics, mosaics, textiles, lapidary work, metalwork, featherwork. For practical reasons I have chosen the three codices as most suitable for primary study. They are generally available to scholars; they are a sort of drawing-and-painting which is similar to already studied art forms; and they were probably made not many generations before the historic period and hence inferences drawn from them can be checked against approximately contemporary documentary accounts.

It would be tedious to list all the possible descriptive categories, with their meanings, to be gleaned from the literature. For those unfamiliar with the general nature of the technique, however, the few following examples may be useful. In the interpretation of Rorschach responses, it has been found that persons who use the color in the inkblots freely to form concepts, in general, tend to be persons who enjoy emotional relationships with other people: they are "extratensive." The precise way in which the color is used indicates how the person normally behaves in these emotional relationships: crudely and impulsively, or smoothly, or either, depending on the occasion. In the Bender Gestalt Test it is considered that the drawing of pointed shapes is an indication of

aggression; blunted, rounded figures suggest an absence or inhibition of aggression. Schmidl-Waehner found that a preference for small form-elements was shown by persons who were constricted, inhibited, and anxious. According to Machover, a preference for drawing human heads in profile is correlated with general evasiveness in character, a "spectator's view of life." The apparently arbitrary meanings of these categories are difficult to rationalize because the mechanisms involved are largely unconscious; but their validity seems to be pretty well established by clinical experience.

My initial procedure in making the blind diagnosis was, having a general familiarity with the categories employed by Rorschach, Machover, Elkisch, and Schmidl-Waehner, to peruse the codices (using both colored and photographic reproductions) and to jot down certain features which seemed common to all or almost all and which had been used by one or more of the authors as interpretive criteria. I then matched these descriptive categories with the interpretive categories. This gave a disjointed list of personality traits. These personality traits were then studied and reorganized into a somewhat more structuralized personality portrait, the aim being to see the traits in a dynamic relationship to one another rather than as a loose handful of labels. The sketch of Maya personality which follows is this "structuralized personality portrait."[2]

About six months later, I returned to the paper, and, having in the meantime read some of the early sources and also Redfield, Gillin, and others of more recent date, I abstracted two more personality sketches of the Maya: one from Landa's data, and extremely fragmentary; and another from Gillin *et al.*'s Rorschach report.

MAYA PERSONALITY: A "BLIND" DIAGNOSIS[3]

The typical Maya male of the period of the three codices appears to have been a somewhat introverted person who sought

[2] In the appendix will be found the descriptive categories used, together with the matched interpretive categories and the source.

[3] The numbers refer to items in the appendix which give the source for the statement.

the clarification of his problems in ideation rather than in social interaction (1, 3, 4, 5, 7, 18, 20); he had, however, little real insight into the sources of his anxieties (2, 23); he was blandly egocentric (1, 3, 6). This does not mean, however, that he was a solitary boor; on the contrary, he was distinctly sociable, but in a superficial way—he was a type who would like being "alone in a crowd." He made a sincere effort to appear outgoing and friendly (8, 11), and he was able to support a mechanical and ritualized social facade (6, 10, 11, 12), but he felt little need for relating himself to others emotionally (5, 20). Consequently, his social relations were polite and formal.

The Maya was an ambitious, creative individual with considerable initiative (1, 13, 14, 15, 16). In view of his introversiveness and the slightness of superego (conscience) development (19), these ambitions were essentially egocentric rather than attached to the fortunes of church or state, city or tribe.

At heart the Maya conceived other people as hostile to himself (17, 18). This anticipation of the hostility of others was probably the outgrowth of unsatisfactory relationships with the mother (20, 21). The almost fetishistic emphasis on the breasts as the criterion of female sexuality suggests a fixation of libido at an oral level (22). This undoubtedly had profound implications for economic, social, and religious institutions.

In response to this stereotype of the social world as inherently frustrating, the Maya nourished his own aggressive impulses. He felt hostile toward people (23, 24). This aggression, however, he normally suppressed rather rigidly, presenting to the world a preoccupied, restrained, almost constricted social facade (9, 10, 17, 25, 26). If and when the social facade broke down, however, there were no defenses in depth against the underlying aggressive tendencies; behavior, then, was likely to become disorganized and irrationally destructive (2, 11, 19, 23, 24). One thing which no doubt helped to bleed off some of this aggression was the lack of inhibitions about the exercise of phallic aggression in sexual relations (27).

The egocentricity of historic Maya character (if, as is likely, it was old and well established) may have had something to do with the brittleness of Maya society. The unexplained breakup of the

Old Empire, and the instability of the New Empire, may have been grounded in the incapacity of the Maya themselves really to "get together" in any but a formal, conventional way.

VALIDATION: THE RORSCHACHS OF MODERN MAYA INDIANS

The following description of the personality structure of the modern Maya Indian male based on a series of thirty-six Rorschachs taken by William Davidson, a graduate student at Duke University, who worked with Gillin in San Luis Jilotepeque, a township with a total population of some 7,500 persons (of whom about 5,000 are "Indians") in eastern Guatemala. The sample is small, but it is the only one available. The records were interpreted by Otto Billig of the Duke School of Medicine. Davidson actually took sixty-seven Rorschachs, but thirty-one of these were of "Ladinos," who seem to have a culture much less "Indian" than that of the considerably acculturated "Indians" themselves. It is worth mentioning that these "Indians" apparently do not consider themselves to be the descendants, racial or cultural, of the imperial Maya, and that they are considered by the ethnologists as being "heavily acculturated" and much less Maya than many other Guatemalan Indians.

Billig's extended statement of Maya personality is too technical and too long to quote in full; therefore, I will present an abbreviated digest, arranged in an order to facilitate comparison with the art-analysis diagnosis:

The typical Maya male in San Luis Jilotepeque is basically neither introverted nor extroverted, but his social behavior probably would be considered introverted by United States white standards; he is "shy." He has no real insight into the forces within his own personality and hence is apt to be blandly egocentric, dominated by his own drives, which he is incapable of evaluating. "Instead of living with each other, the members of this community will live next to each other."

The San Luis Jilotepeque male is definitely not ambitious and creative. In his social relationships, he is not very responsive to stimulation. He tends toward a dependence upon careful control of his behavior in a formal sense rather than upon a mature balancing of values; he appears to be dominated by stereotypes of social

patterns rather than able to depend on his own ability to meet and organize his social relationships anew with each social contact. He solves his problems in terms of "all inclusive generalities and rationalizations." Often this implies a constricted kind of personality which is like a machine, impervious to emotional contact either with himself or others. There is no turbulent release of tension in uncontrolled aggression.

There are a number of points on which, owing to the differences in the data for analysis, comparison is impossible. Essentially, there are only two points of disagreement. I interpreted the Maya male on the codices as ambitious and creative; Billig saw him as almost the opposite. I saw possibilities of disorganized aggression when the stereotypes were useless and the rather secure controls broke down; Billig regards that as unlikely. In other respects, the two approaches come to very similar conclusions.

The significance of the disagreements is problematical. Either or both of our interpretations may be in error; and, of course, we are dealing with two populations, separated by at least five hundred years in time and by only partly defined differences in culture. These differences certainly include, however, the considerable difference between the great ceremonial civilization of the imperial Maya, and the simpler ceremonies of the local Catholic parish. It probably also includes the difference between a markedly class-stratified society in the old days and a relatively undifferentiated social system now (within the "Indian" segment of Guatemalan culture, that is).

I am inclined to feel that the politically dominant magicoreligious class in Old Empire times probably was a good deal more creative and ambitious than the bulk of the peasant population, either then or now. This suggests that in this respect at least, the codices give data primarily on the ruling class and its associates. It does not seem likely that the impressive Maya ceremonial centers could have been conceived and planned by persons who were unambitious and uncreative to the degree apparent in the Rorschachs. But if the bulk of the population were, both then and now, relatively unambitious and uncreative, in comparison to the dominant class, then the remarkable brittleness of Maya political and ceremonial culture might be owing in part at least to the fact

that any disturbance of equilibrium of the ruling families could not be readily repaired by families rising from the ranks. When the leading family lives were smashed in their function as community leaders, the frosting on the cake of custom was shattered. This inability of Maya society to renew its more complex manifestations readily after shock thus may be owing both to the atomistic social attitudes of the general population and to the uncreativeness of the peasant portions of it.

The disagreement over the potentialities for aggression I really do not know how to evaluate. It may be that the difference is only a semantic one, since Billig and myself may have slightly different aggression-perception thresholds. I feel, however, that Landa's data suggest that orgies of aggression were characteristic of the Maya on certain occasions, as for example at public sacrifices, or in drunken brawls, and that this tends to corroborate my statement; but this formalized kind of aggression may not be what Billig is referring to.

VALIDATION: LANDA'S DESCRIPTION OF POST-CONQUEST MAYA

It is always easy to impeach the testimony of missionaries on the grounds of cultural bias. My own experience with missionary accounts from the Eastern Woodlands culture area in North America, however, has been that while caution is necessary, missionaries are often more impartial than political or military observers. I am deliberately giving Landa the benefit of the doubt in the following abstract.

Landa saw the Maya as a superficially equable, polite people who delighted in presenting an agreeable and plastic social facade. Oaths and imprecations were carefully avoided. He remarked, however, the significant fact that when they were drunk—which was a frequent occurrence—they were violently aggressive, and that young warriors were notably arrogant.

Interpersonal relations were not characterized by great stability of affect. Relations between men and women were notably unstable; sexual infidelity and divorce were common.

Cultural patterns indicated a preoccupation with oral and phallic rather than anal rituals. Ceremonial cannibalism, for in-

stance, was practiced; and the sexual organs of victims were mutilated before they were killed. In one case, a woman's breasts were mutilated. All ceremonies involved fasting and abstinence. Preferred zones for self-mutilation were ears, tongue, and penis.

Illness, death, and misfortune were considered to be owing to sin; and, therefore, confession was resorted to in crises as a therapeutic measure. This suggests that guilt feelings were important determinants of behavior and implies the existence of superego comparable, in kind if not in content, to the conscience stressed by psychoanalysts in our own society.

While Landa's data are extremely fragmentary, they suggest a basically similar pattern to the ones we have already found: the stress on the stereotyped social facade, the shallowness of emotional relationships to other people, the preoccupation with oral and phallic rituals. Unexpected here is the importance of confession and the sense of guilt (if it was a sense of guilt and not simply expediency which motivated confession).

CONCLUSION

So far as my sketch of Maya characteristics is concerned, I do not wish to give the impression that I think I have solved the problem. These statements are not intended to instruct experts in the Maya area in their own specialty. I am not competent to state their specific relevance to problems of present research, or to say how reasonable or unreasonable is the personality picture that I have drawn. The fact that Maya themselves were chosen for the test case is a historical accident; and I want to be the first one to observe that my knowledge of the Middle American field is extremely limited.

In regard to the second objective of this paper, the presentation and validation of a method of using art products as material for psychological generalization, I have sketched the history, rationale, and specific methodology, that I used in making a "blind" diagnosis of late Second Empire Maya personality. I then presented this diagnosis and compared it with evidence from contemporary Rorschach protocols and from post-Conquest observations by Bishop Landa. Although there were several discrepancies

(which might theoretically be expected, since the data came from at least three separate periods and communities), there was observed a fundamental agreement in outline (which could also be theoretically expected, since group personality characteristics being based on intimate patterns of family life are highly resistant to change). Owing to the variability of the techniques employed, many statements could not be checked at all. Nevertheless, I feel that the method does appear to be valid; and this implies that the deductive criteria used in the art analysis have, in this case at least, cross-cultural applicability.

Nevertheless, one case of this kind cannot prove a point. All that can really be said is that the method deserves to be investigated and refined further. If, upon future research, it does prove to be useful, it should be of considerable value in providing archaeologists and historians with insights into personalities of long-dead populations.

Appendix

The following table lists the categories which I used to describe the art of the codices; the interpretive categories suggested by several psychologists; and the sources. With a more refined system of analysis, the list could be extended. Naturally, it is not intended to compose a "description" of Maya art in the ordinary sense. Furthermore, it will be noted that the interpretive column is merely a list of isolated traits of character. The organization of this list into a personality portrait depends upon a feeling for the fit of the elements in a general theory of personality dynamics.

Descriptive	Interpretive	Source
1. Tendency to avoid sharp corners and to emphasize rounded corners.	Introversive, creative, restrained, preoccupied with self.	Schmidl-Waehner, 1946.
2. Lack of perspective.	(a) Little insight. (b) Little introspective activity.	Machover, 1949. Klopfer and Kelley, 1946.
3. Tendency to enlarge human heads.	High value on intellectual achievement; egocentric.	Machover, 1949.

Descriptive	Interpretive	Source
4. Tendency to keep human arms close to body.	Mild introversion.	Machover, 1949.
5. Lack of background.	Little need for relating self to objects	Machover, 1949.
6. Relative nudity of human figures together with extreme ornamentation.	Egocentric but with good social facade.	Machover, 1949.
7. Generally compressed design.	Introversive, obsessive, compulsive.	Elkisch, 1945.
8. Ready use of color (at least fifteen colors throughout the spectrum are used throughout the codices).	Ability to enter into social contacts.	Klopfer and Kelley, 1949.
9. Tendency to outline form-elements carefully in black.	(a) Repression of aggression. (b) Anxiety over aggression problems (use of black), depression.	Machover, 1949. Naumburg, 1947.
10. Avoidance of blending colors.	Careful control of emotional responsiveness.	Alschuler and Hattwick, 1943.
11. Avoidance of naturalistic use of colors.	Forced, artificial sociability; tendency to "explode" emotionally.	Klopfer and Kelley, 1946.
12. Emphasis on ornate headgear.	Elaborate social facade.	Machover, 1949.
13. Filling page to margins.	Ambition, initiative, good adjustment (often found with children).	Schmidl-Waehner, 1946.
14. Long human hands, feet, and noses.	Ambition; phallic aggressiveness.	Machover, 1949.
15. Avoidance of rigid geometrical design.	Some elasticity and spontaneity.	Elkisch, 1945.

Descriptive	Interpretive	Source
16. Complexity of design.	Creative.	Elkisch, 1945.
17. Frequency of black human figures.	Aggression and depression problems.	Naumburg, 1947.
18. Profusion of tiny form figures.	Fear of environment.	Klopfer and Kelley, 1946.
19. Tendency to give human figures short necks and thick waists.	Slight superego development.	Machover, 1949.
20. Tendency to present human heads, and often torsos, in profile.	Evasive; shy of getting emotionally involved; "spectator" view of life; problem with mother.	Machover, 1949.
21. Tendency to give female figures relatively short arms.	Feeling of being rejected by mother.	Machover, 1949.
22. Tendency to portray female breasts as excessively prominent and pendulant.	Tendency to regress to an oral-dependent attitude.	Machover, 1949.
23. Rareness of human figures in free movement.	Lack of creative imagination (mature fantasy); immature self-control.	Klopfer and Kelley, 1946.
24. Tendency toward frequent combinations of red and black.	Aggressive impulses working through in fantasy.	Naumburg, 1947.
25. Preference for relatively small form-elements.	Constriction, inhibition, anxiety, maladjustment; but professionally competent.	Schmidl-Waehner, 1946.
26. Avoidance of sharp points.	Repression of aggression.	Bender, 1938. Schmidl-Waehner, 1946.
27. Free portrayal of genital zones and of "phallic symbols."	Lack of repression of genital urges.	Machover, 1949.

Bibliography

Alschuler, R. H., and Hattwick, L. A. "Easel Painting as an Index of Personality in Preschool Children," *American Journal of Orthopsychiatry,* Vol. 13 (1943), pp. 616–25.

Bell, John E. *Projective Techniques: A Dynamic Approach to the Study of Personality.* New York: Longmans, Green and Co., 1948. On pp. 350–398 there is a general review and bibliography of the various methods of projective analysis using drawings and paintings.

Bender, L. "A Visual Motor Gestalt Test and Its Clinical Use," *Research Monographs, American Orthopsychiatric Associations,* No. 3 (1938).

Billig, O., Gillin, J., and Davidson, W. "Aspects of Personality and Culture in a Guatemalan Community: Ethnological and Rorschach Approaches," *Journal of Personality,* Vol. 16 (1947), pp. 153–87, 326–68.

Bowditch, C. P. *The Numeration, Calendar Systems and Astronomical Knowledge of the Mayas.* Cambridge, 1910. In appendices Bowditch reproduces the known variants of the calendrical glyphs; comparing his reproductions, it is notable that he has somewhat regularized and geometrized the Maya originals.

Codex Dresdensis. *Die Maya-Handschrift der Königlichen Bibliothek zu Dresden;* herausgegeben von Prof. Dr. E. Förstemann. Leipzig, 1880.

————. *The Dresden Codex* . . . By William Gates. Baltimore, 1932. Gates geometrizes the original figures; hence for the observation of form, Förstemann's edition is superior, being photographic. Gates, however, claims nearly to have reproduced the original colors.

Codex Peresianus ("Perez"). *Codex Perez* . . . By William Gates. Point Loma, 1909. This edition consists of photographs of photographs of the codex made in 1864; and also Gates's usual geometrized tracings which are chiefly valuable for our purposes in that they claim nearly to reproduce the original colors.

Codex Tro-Cortesianus ("Madrid Codex"). *The Madrid Maya Codex* . . . By William Gates. Photographic edition. Publications of the Maya Society, No. 21 (1933).

————. *Codice Maya denominado Cortesiano* . . . By de la Rada y Delgado. Madrid, 1892. Done in color.

————. *Codice Troano.* Madrid, 1930. Colored facsimile.

————. *The People of Alor.* Minneapolis, 1944.

Elkisch, Paula. "Children's Drawings in a Projective Technique," *Psychological Monographs,* Vol. 58, No. 1 (1945).

Klopfer, B., and Kelley, D. M. *The Rorschach Technique.* Yonkers: World Book Co., 1942.

Machover, Karen. *Personality Projection in the Drawing of the Human Figure.* Springfield: Charles C. Thomas, 1949. This book contains Dr. Machover's only published description of her method. When I wrote the

blind diagnosis, I knew of her work through an illustrated lecture given by her in Philadelphia on November 18, 1948.

Morley, Sylvanus G. *The Ancient Maya.* Stanford University, 1947.

Murphy, Gardner. *Personality: A Biosocial Approach to Origins and Structure.* New York, 1947.

Naumberg, M. "Studies of the 'Free' Art Expression of Behavior Problem Children and Adolescents as Means of Diagnosis and Therapy," *Nervous and Mental Disease Monographs,* No. 71 (1947).

Proskouriakoff, Tatiana. *An Album of Maya Architecture.* Washington, 1946.

Schmidl-Waehner, Trude. "Interpretation of Spontaneous Drawings and Paintings," *Genetic Psychology Monographs,* Vol. 33, No. 1 (1946), pp. 3–72.

Aesthetics in "Primitive Societies"*

DAVID B. STOUT

This paper defines the basic problems confronting the student of primitive art and lists the differences in point of view between anthropologists and non-anthropologists. It also proposes the possibility of certain formal elements or combinations of them arousing universal aesthetic responses.

Dr. Stout was a professor in the Department of Anthropology at the State University of New York at Buffalo where he taught primitive art and primitive religion, and specialized in the areas of Latin America and China. He wrote the chapter on the Choco in the *Handbook of South American Indians* (1948) and several publications on the Cuna, including *San Blas Cuna Acculturation: An Introduction* (1947).

Two of the aims of ethnology are to establish the range of variability in cultural forms possessed by the societies of the world and to discern the regularities of process and the universals, if any, among these forms. For many aspects of culture these aims have been realized, or at least the methodological procedures to be followed are becoming clear, e.g., social organization. We now possess a wealth of descriptive and analytical materials on many hundreds of distinct cultural systems with which hypotheses concerning culture have been and are being tested. But in all this there is very little that makes it possible for us to speak with any degree of conclusiveness or sureness about aesthetic beliefs or standards among the so-called primitive societies. In making this statement, I use the word "aesthetics" in its dictionary sense of referring to the branch of philosophy dealing with the beautiful, chiefly with respect to theories of the essential character of the beautiful and the tests by which the beautiful may be judged. In

* Reprinted from *Men and Cultures, Selected Papers of the Fifth International Congress of Anthropological and Ethnological Sciences, Philadelphia, September 1–9, 1956,* Philadelphia, 1960, pp. 189–91.

short, though the ethnographic literature contains much about the graphic and plastic art *forms* from many primitive societies, it yields little direct information on what ideas the members of these societies hold concerning beauty or aesthetic worth or the criteria by which they judge these forms. Perhaps my complaint, and the main thesis of this paper, can be made more lucid with an analogy: if we inquire into the ethnographic literature on some such issue as disease and its treatment, we can find not only a wealth of data on the cultural forms employed in various societies but also a great deal of reliable information as to what the members of these societies believe to be the nature of disease, what their philosophy on this subject is, and on what premises their logic concerning it is based. The same literature, if approached with the issue of art and aesthetics in mind, yields much technical detail about the art forms, usually well illustrated, considerable interpretation of the symbolic aspect, and penetrating functional analysis of art and the artist in his or her society, but almost nothing about the aesthetic beliefs which these artists had in mind while they worked or which they used as a basis of judgment of their fellows' work.

This lack is all the more surprising in view of the fact that anthropologists have long been prominent in the writing of books and articles about the arts of primitive peoples—the names Boas, Adam, Sayce, Herskovits, Linton, Kroeber, Weltfish, Bunzel, and a host of others come immediately to mind, and Inverarity lists some sixty-odd titles by anthropologists for the years 1952–54 alone in his brief survey article "Anthrolopogy in Primitive Art" which appeared last year. In all of this writing, anthropologists have long since made it clear that the work of the adult artist in a primitive society is *not* to be equated with that of children in our own, or that it is not representative of an arrested state in human aesthetic possibilities, but, rather, that the graphic and plastic arts of each society, primitive or otherwise, are the result of independent developments, each of which is historically valid in its own right. Meanwhile, aestheticians, philosophers, art historians, and dilettantes have continued to proffer interpretations of primitive art, most of them inaccurate and some of them ridiculously ethnocentric: universal symbolism is assumed; primitive art is facilely

equated with folk art of Euro-American societies; or it is regarded as a deviant or incomplete expression of human capacities. And such writings are reinforced with all the weight of prestigeful names ranging from Plato to Suzanne Langer. In short, though ethnologists have already accomplished much in the understanding of primitive art, they still have before them an important problem concerning aesthetics in primitive societies as well as the task of making their findings available beyond the anthropological fraternity.

The quality of this problem may be indicated in the following manner: we can discern that artists employ four major methods to produce emotion and evoke aesthetic responses—(1) employ symbols that have established emotional associations; (2) depict emotion-arousing events, persons, or supernatural entities; (3) enlist the spectator's vicarious participation in the artist's solution of his problems of design and technical execution; (4) employ particular combinations of line, mass, color, etc., that seem capable of arousing emotions in themselves. Usually, these procedures are employed in some combination. The first two require knowledge of the beliefs, value system, etc., if a cross-cultural understanding of graphic and plastic art forms is to be achieved. The third requires knowledge of the technology and its limitations, characteristics of the materials used, and the like, for the spectator to participate vicariously. Anthropologists, as a matter of course, deal with the arts of primitive societies with full and conscious awareness of the first three points above, and most of their writing about primitive art is cast in those terms. Non-anthropologists dealing with primitive art (and they are legion), however, approach and evaluate primitive art with some measure of ignorance concerning the first three procedures but instead judge and select examples of primitive art on the basis of the fourth—the formal aspect—and make their evaluations according to what emotions are aroused or communicated by line, mass, color, and so forth. (Parenthetically, I am sure that anthropologists do this too, not only with art forms from their own society, but also in selecting examples from others, perhaps some primitive society with which they are doing field work, and are also making a personal or museum collection.)

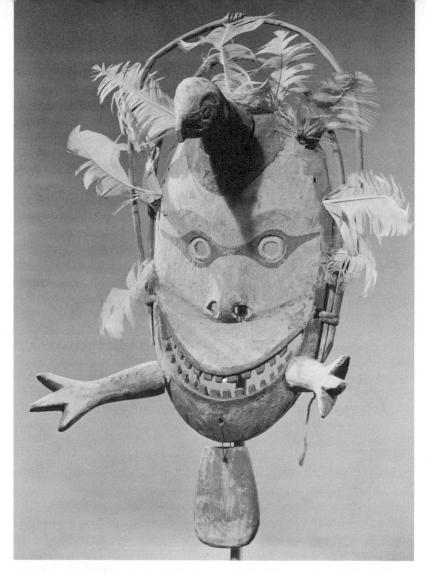

Eskimo dance mask from the Kuskokwim River, Alaska. Wood, paint, feathers, and string. The black mask around the eyes has been said to represent a seal. The feathers and other appendages convey symbolic ideas supplementing the total expression of the spirit represented. Dance masks were used in religious and secular festivals. The dance often was intended to honor the spirits of game animals of primary importance in Eskimo economy, thereby insuring an abundant supply of food. The Brooklyn Museum, New York.

That this should happen, that ethnologists sometimes and others frequently treat primitive art mainly or entirely as pure abstraction and with regard only to its organization of lines, masses, color, or form, while ignorant of all or most of its symbolism and of the techniques involved, suggests strongly to me (as it has to others) that there are indeed formal elements in the graphic and plastic arts which in themselves are capable of arousing emotions and evoking aesthetic responses. But about this matter we know very little beyond the borders of our own society, and what we know within Euro-American society is so ethnocentrically biased that it probably is not applicable elsewhere to any substantial degree.

If it is ever to be shown that particular formal elements or combinations do indeed arouse emotions and aesthetic responses by themselves, and that these are universal, it will only be done through collecting the primitive artist's statements about his fellows' work, through understudying native craftsmen, and through the pursuit of controlled, cross-cultural experiments where objects from one society are presented to members of another for their aesthetic judgments. The present ethnological literature contains a bit of such information (writings by Bunzel, O'Neale, Himmelheber, or Fagg are an example), but we need far more. I chose to bring this topic up at the Congress in the hope that this audience, and the readers of the *Proceedings*, will in their future field work give attention to the problem.

Bibliography

Bunzel, Ruth. *The Pueblo Potter*. New York, 1929.

Fagg, William B. "On the Nature of African Art," *Memoirs and Proceedings, Manchester Literary and Philosophical Society*, 94 (1953), pp. 93–104.

Himmelheber, Hans. *Negerkünstler: Ethnographische Studien über den Schnitzkünstler bei den Stämmen der Atutu und Guru im innern der Elfenbeinküste*. Stuttgart, 1935.

Inverarity, Robert Bruce. "Anthropology in Primitive Art," *Yearbook of Anthropology*. New York: Wenner–Gren Foundation for Anthropological Research (1955), pp. 375–89.

O'Neale, Lila M. "Yurok-Karok Basket Weavers," *University of California Publications in American Archaeology and Ethnology*, 32, I (1932).

Anatomical Interpretations in
African Masks*

PAUL S. WINGERT

This analysis of the masks representing human forms of several African tribes shows the knowledge the artist acquired from his observation of human anatomy, the environmental setting, the effect of light, and other natural elements. The liberties taken with the basic anatomy also indicate a knowledge of actual human form. Therefore, because of his understanding and interpretations of life forms, the tribal artist was able to endow the mask with its expressive power.

Dr. Paul S. Wingert is Professor Emeritus of the Department of Fine Arts and Archaeology at Columbia University. He began his long association with this department, first as a student, later as Curator, becoming Professor in 1958. In 1946 the first of his many books on primitive art was published, *An Outline Guide to the Art of the South Pacific,* followed by *American Indian Sculpture* (1949), *The Sculpture of Negro Africa* (1950), *Art of the South Pacific Islands* (1953), and *Primitive Art* (1962, 1965). Professor Wingert was involved as organizer or supervisor with a number of important pioneer exhibits of primitive art, including "Arts of the South Seas" at the Modern Museum of Art in 1946 and "African Negro Sculpture" at the M. H. De Young Memorial Museum in 1948.

Masks, wherever they are worn, have the dual purpose of concealing one identity and of revealing or symbolizing another. In all cultures the majority of masks are worn over the face, thus replacing the physical features of the wearer by the descriptive or

* Reprinted from *Man,* Vol. 54, No. 100 (May, 1954), pp. 69–71. A portion of this article was read as a paper at the annual meeting of the American Ethnological Society at Yale University, New Haven, Connecticut, in April, 1954. The source for the factual material in this study is Cunningham's *Text Book of Anatomy* by J. C. Brash and E. B. Jamieson (7th ed.; Oxford University Press, 1937). The factual data were checked by A. Warren Jones, M.D., to whom special thanks are due for his contribution.

symbolic forms of the being represented by the mask. It is important to recognize a felt and expressed relationship between the actual physical features of the wearer and the carved ones of the mask. The sculptured forms, for example, correspond with the hidden physical ones behind them, such as the apertures of the eyes and mouth, and the projections of forehead, cheekbones, nose, and jaw. In many primitive masks, particularly in those from Africa, there is evident an important relationship between the carved forms and the anatomical structure of the human head from which they are derived. This relationship is often an interpretation closely associated with anatomical facts. It is therefore worthwhile to examine African masks in order to determine to what extent the sculptured forms are derived from reality.

This paper is concerned only with those African masks representing or expressing human forms; animal masks or those of hybrid animal-human or of abstract forms are not considered. Masks of human form, according to the elements stressed in their rendering, fall largely within one of four basic groups: those which emphasize (1) the structural facial divisions and facial features; (2) the bony structure of the skull; (3) the planes formed by the membrane of the skin and the separation of the setting of facial features from or within those planes; and (4) the fleshy forms and muscles over the bony structure. In every one of these four groups elements of the other three groups appear to a certain extent.

The marked emphasis of structural facial divisions as well as facial features is strikingly evident in many African masks (Figure 1). The eyes, and often the ears, combine to form an upper horizontal division within the ovoid of the face, a division repeated below by the lips of the mouth. These two pronounced parallel horizontals are closely bound together by the vertical of the nose. Reference to the actual structure of the skull, however, shows three horizontal divisions: (1) that of the eye orbit and the nasion surmounted by the superciliary arches and the glabella; (2) the important division formed by the zygomatic bones and arches; and (3) the strong horizontal of the maxillae and mandible processes. In some masks (Figure 2) not only are these three divisions clearly indicated, but other important vertical elements apparent

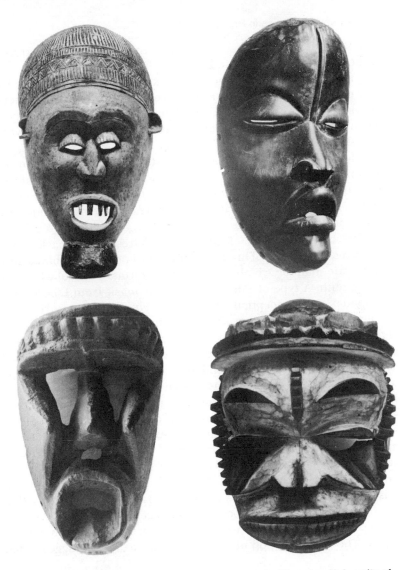

(*Upper left*) Figure 1. Fang (?), Gaboon. The University Museum, University of Pennsylvania. (*Upper right*) Figure 2. Dan, Ivory Coast. Courtesy of The Museum of Primitive Art, New York. (*Lower left*) Figure 3. Poro Secret Society, Liberia. Dan Tribes. Yale University Art Gallery, Gift of Mr. and Mrs. James M. Osborn for the Linton Collection of African Art. (*Lower right*) Figure 4. Ibibio, Nigeria. Courtesy of the Trustees of the British Museum, London.

in the skull are also represented, as the frontal and nasal sutures, and the nasal spine and mental protuberance.

In many instances aesthetic and expressive considerations led to the carving of masks with a selective emphasis of certain facial divisions, structure, and features (Figure 2), so as to render more poignantly apparent the innate rhythmic relationships between these elements. The curve of the upper outline of the head, for example, may establish a motive repeated in varied and inverted rhythmic renderings of structure and facial features. It should be noted that the lack of absolute bilateral symmetry in the disposition and shape of these structures and features corresponds to a like characteristic in nature.

The bony structure of the skull is stressed in masks from many areas in Africa. This representation is often combined in a nonrealistic manner which certain fleshy forms, particularly those of the mouth. A type of Poro secret society mask from Liberia well exemplifies this conception (Figure 3). The deeply set eye orbits are given triangular shape; the superciliary arch is depressed and thrusts forward; while the zygomatic bone is presented as the apex of a slightly spherical triangle with the base lying along the mandible. The two nasal bones and the nasal suture are suggested, and the protruding ellipse of the mouth stresses the obicularis oris, that ringlike muscle around the lips, rather than the lips themselves. It may be said that the surfaces of the large triangle at the sides of the face are an interpretation of the large masseter muscles which reach from the zygomatic arch to the mandible and secure the lower jaw to the skeleton of the head. These muscles give the mouth its mobility in life forms. It should be observed at this point that a distinctive anatomical trait of the Negro is that the facial muscles tend to be more homogeneous than in those of other peoples, that is they function more nearly as a closely related group. The interpretation of muscles in this example suggests that trait.

There is in the Ibibio mask shown in Figure 4 a dramatization of the frontal region, glabella, nasion, zygomatic arch, and nasal spine. Together with the shaping of the maxillae and the eye orbits, these structural forms are expressed as rhythmic aesthetic elements.

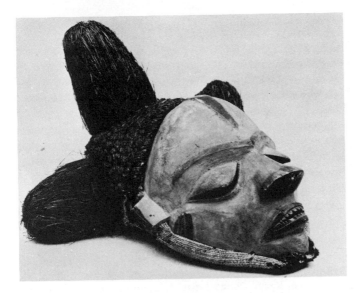

Figure 5. Bapende, Kwilu, Congo Kinasha. Anonymous.

Many Bapende masks from the western Congo also give a strong statement of anatomical structure (Figure 5). But since the lips are described around bared teeth, they can scarcely be considered skeletalized representations. By comparison with other types these masks are, in fact, more expressive of life forms, for, with the exception of the nose, eyelids, and lips, bony structure is stressed over fleshy forms. This is, moreover, presented as covered with a membrane of skin.

Smooth, fluid surface planes are often used in West African masks, particularly in those from Liberia and the Irovy Coast, to describe the envelope of skin covering the fleshy parts and bony structure (Figure 2). In this type of mask the skeletal parts are suggested rather than emphatically stated beneath the surface membranes. The refinement of tight, polished surfaces provides to a large extent the aesthetic appeal of these sculptures. But it is usually possible to detect a solid anatomical basis for the forms.

African masks may be divided into two groups: in one the facial features are set within and integrated with the surface

(*Left*) Figure 6. Baule, Ivory Coast. Buffalo Museum of Science, Buffalo. (*Right*) Figure 7. Bakete, Kasai, Congo Kinasha. Courtesy of the American Museum of Natural History, New York.

planes; in the other, they are separated and project forward from these planes. In examples of the latter group, such as the mask from the Baoulé tribe of the Ivory Coast (Figure 6), the facial features are often so highly stylized as to form a decorative pattern. Of the bone structure, only the frontal region, glabella, and nasion, here stressed with scarification marks, are emphatically indicated. The superciliary arch, the zygomatic bone, and the rami of the mandible are evident but not strongly represented. Although masks of this kind reveal a knowledge of anatomical structure, it is subservient to the treatment of surface planes and details which are rendered to achieve an elegant, decorative effect. In the interpretation of superior Baoulé masks, such as this example, the naturalistic asymmetrical alignment and description of structure and features imparts a vital note to an aesthetic expression of reality.

In other masks, such as the large polychromed Bakete example from the central Congo (Figure 7), there is a spectacular rendering of anatomical parts, surfaces, and facial features. These

three aspects of the human head are almost equally stressed and freely interpreted. The supraorbital margin and the narrowly separated surmounting superciliary arch are carved as parallel shapes which arch high into the frontal region. Between them the frontal suture is represented as a ridge broken by the nasion and then continuing downward as the nasal suture. The mouth is rendered as a geometric protruding form, and the skeletal structure below the eyes is concealed by panels of geometrically carved surface designs. Great size and power is, however, suggested for the mandible. Among the most striking and remarkable features of this type of mask are the enormous projecting conical eyes. They may be considered as dramatized inversions of the eye orbit. An anatomical description of the eye orbit states that it "is a cavity of a shape not unlike a four-sided pyramid laid on one side . . . [with] the base of the pyramid [as] the opening on to the face, and the boundaries of the base [as] the margins of the orbit" (Cunningham, *op. cit.*, p. 143). In this carving the base has been retained but the shape is expressed as a cone instead of a pyramid and its direction of thrust is reversed, that is it is projecting dramatically outward and not inward. It is a particularly good example of the aesthetic and expressive licences taken with anatomical forms, which are nevertheless clearly related to those of reality.

Numerous African masks emphasize the muscular and fleshy forms that cover the bony structure. Examples from the Ogowe River region of Gabun (Figure 8) show an almost naturalistic modeling of surface planes. Although the skeletal parts are clearly apparent, the soft tissue of flesh and muscle is represented as covering them. The heavy-lidded, partly closed eyes are set within an eye orbit surrounded by a depression which may be construed as referring to the obicularis oculi, the ring of muscle around the eye; while the constriction around the base of the protruding lips represents the muscle ring around the mouth. The wide masseter muscle is also expressed by the planes at the sides of the face. This is a highly sensitive example of an aesthetic interpretation of anatomical structure.

A less sensitive and more dynamic rendering is apparent in many masks from the Cameroons (Figure 9). The rings of muscle

(*Left*) Figure 8. Ogowe River, Gabon. Museum für Volkerkunde, Basel.
(*Right*) Figure 9. Grasslands, Cameroon. Formerly Linden Museum, Stuttgart.

around the eyes and mouth are particularly evident, as are also the bony arches above the eyes and the heavy forward-thrusting lower jaw. Fat, puffy cheeks hide the structural character of the zygomatic bones and arches, although they mark their position, and the nasal suture and nasal bones are revealed. In this mask the comparatively few forms singled out and emphasized for expressive effect correspond closely to actual anatomical parts.

The knowledge of the expressive role performed by the muscles, particularly those of the eyes and the mouth, is indicated in many masks. In some, for example, the eye orifice is carved so large that the eye muscles of the wearer of the mask give their expression to the carving. Some few types of masks also have the mouth opening cut away to allow the lip muscles to function in a similar way. In examples where the actual muscles of the wearer do not contribute expressively to the sculptured forms, carved muscles are often rendered to stress the desired expression.

It should also be observed that a mask was not seen or used as a static form. The interpretation of many forms and the emphasis given them was actuated by the realization of the mask as a highly

dynamic form. The wearer not only provided the motive force for the mask, but, in many examples, the human eyes flashing through the carved eye holes also gave the mask a warm vitality. Only a close understanding of life forms and their underlying anatomical character made it possible for the artist to interpret human forms and features in such a revealing manner. That these African masks are not accurate descriptions of life forms is readily seen. They are, instead, interpretations dictated by the consequence of a few very important factors.

Several special kinds of knowledge contributed to an interpretation of anatomical features. In every area the deeply rooted art tradition determined the particular anatomical parts that were represented and stressed. The long and intensive apprenticeship of most African sculptors indelibly imprinted on his conceptual thinking as well as trained his motor responses in the rendering of the traditional patterns required for various types of carved masks. If he was a by-rote artist, that background was sufficient for him to produce sculpture satisfactory in form and detail for all practical requirements; aesthetically, masks carved by artists of this kind are of only moderate interest. If, on the other hand, the sculptor was an artist of discernment and sensitivity, he would enrich the traditional pattern of a mask by an interpretation based on his cumulative perceptive experiences; the aesthetically important African masks give clear evidence of the greater understanding of this group of master artists.

The presence of cannibalism made the human skull in some areas, if not a common, at least a not infrequent sight. It was also known through its preservation in practices associated with ancestor beliefs; in certain regions ancestral skulls were periodically cleaned and rubbed with red earth. Some familiarity with the appearance of the skull was therefore part of the culture pattern in many parts of Negro Africa.

Aside from these direct contacts, numerous other experiences added considerably to a knowledge of anatomical structure. For example, the brilliance of tropical sunlight and the flickering, unsteady light of night fires and torches playing over the facial features of persons in the routine of daily life often dramatically emphasized bony structure, fleshy forms, and their interrelation-

ships. The artist, as an active member of his society, also observed the mobile, vibrant human features during dances and upon ritual occasions when they were under abnormal emotional stress. He thus perceived through these experiences the bony structure of the head and the way in which muscles and fleshy forms are used as means of expression.

Both the direct and the observed knowledge of anatomy became fused in the sensitive sculptor's perceptive understanding of head and facial forms. It is this knowledge upon which he draws in the rendering of the traditional pattern of a mask, and it is this knowledge that gives his interpretation anatomical and expressive power. Although the degree of anatomical reference and the emphasis given to some forms over others differ greatly in the many kinds of African masks representing or derived from human features, all African masks of this category show some interpretation of anatomical knowledge.

It is evident, too, that animal and hybrid animal-human masks show a like basis for their forms in those of reality. But aesthetic considerations in the rendering of his forms and in the use of his knowledge of them were always a motivating force when a sculptor of stature carved a mask. The consequences are among the true masterpieces of primitive art.

A Trobriand Medusa?*

EDMUND R. LEACH

In this article, which provoked an interesting controversy shortly after its publication (see *Man,* 1958, Nos. 65, 90, 160, and 1959, Nos. 66 and 67), Professor Leach states the belief that primitive designs are seldom abstract, but, instead, unusually representational, since they have functional signifi- cance for the artist. His analysis of the Trobriand shield is presented as evidence of this theory, which, he says, must remain circumstantial, since these objects are no longer made. The aesthetic device of the "folding-up" of the human figure and its psychological implications are other points raised.

Professor Edmund R. Leach is the Provost at King's College, Cambridge. A social anthropologist, his major interests are local organization, time reckoning, and symbol systems in the areas of Southeast Asia, Burma, Ceylon, and Borneo. He is a frequent contributor on many topics to a variety of journals. Among his recent and important publications are *Political Sys- tems of Highland Burma: A Study of Kachin Social Structure* (1965); *Structure Study of Myth and Totemism* (1967); *Runaway World* (1968); and *Dialectic in Practical Religion* (1968).

Objects of the type illustrated in Figure 1 are to be found in a num- ber of museum ethnographical collections where they are variously listed as dance shields, shields, and war shields. The type is ex- clusively Trobriand. Published variations include: Finsch (1888), Plate XII; Ratzel (1896–98), Vol. I, p. 236; Edge Partington and Heape (1890–98), Part I, Plate 345; Webster (1900), Figures 13, 17 (the latter also shown in Chauvet [1930], Plate LIII, Figure 191); British Museum *Handbook* (1910), p. 133; Linton and Wingert (1946), p. 148.

Finsch (1888), p. 13, describes the type as already rare; elsewhere (1891), p. 35, he makes it clear that these shields were

* Reprinted from *Man,* Vol. 54, No. 158 (July, 1954), pp. 103–05.

at least sometimes used for warlike purposes, as he mentions a specimen in which were embedded a number of spear points. Malinowski (1920) explains these circumstances:

> Very seldom, and only in the case of very brave and distinguished warriors, were the shields painted. Thus during the last serious war between Omarakana and Kabuaku, in 1899, only two or three men had their shields painted. . . . To have one's shield painted was a challenge, since it was a great honor to split such a shield or to kill such a man. Therefore a painted shield attracted many more spears than a plain one, and it was distinctly dangerous to use this form of bravado. One of such shields used in the above-mentioned war showed as many as fifty-six spear marks. The warriors were decorated with exactly the same feather headdress as is used in dancing. . . .
>
> One very important factor of warfare [was] . . . war magic. . . . In each belligerent district there was a family of experts in war magic, whose members handed down from generation to generation the sacred formulae. When all the men were assembled at the chief's bidding in the main village the magician *coram publico* chanted over the shields so as to impart to them the power of warding off all spears. . . .

Given this social context it seems intrinsically probable that the design painted on the shields was itself of symbolic magical significance, and it becomes a legitimate question to inquire why the design shown on Figure 1 should in fact be deemed by the Trobrianders to have these magical properties.

The design has on several occasions evoked comment, sometimes favorable and sometimes unfavorable, but, so far as I can discover, it has always been taken for granted that the pattern as a whole is an abstraction and nonrepresentational.

The following comments may be noted:

> These rare Trobriand shields are remarkable for the artistic painting (red and black on a white ground) and for the altogether singular design. These shields perhaps represent the most perfect works of painting made anywhere by Papuans.[1]

[1] Finsch (1888), p. 13.

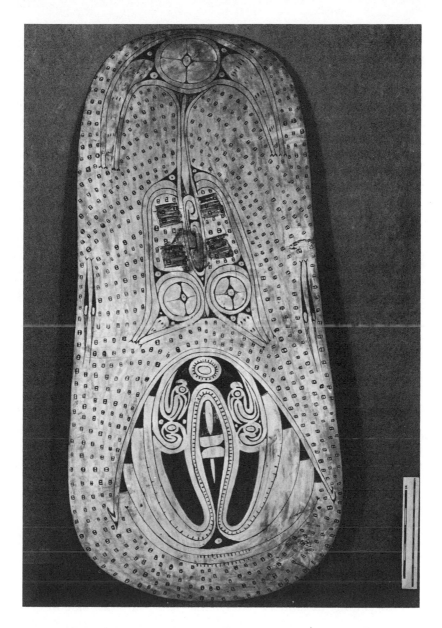

Figure 1. Shield from the Trobriand Islands. University Museum of Archeology & Ethnology, Cambridge.

The shape of the Trobriand shield is very characteristic, sometimes the surface is quite plain. When ornamented the design is simply painted on the smooth and whitened surface of the shield, with black and red pigments.[2]

Haddon, in this same reference, states that shields of this type were known as *vai ova,* but this cannot have been firsthand information. Mr. H. A. Powell, an expert in the Kiriwinan language, informs me that this expression has no obvious significance. He has never heard it used in any context in present-day Kiriwina.

The shields are ovoid in shape with marked convex longitudinal curvature. On the background of white a strictly symmetrical design composed of curvilinear geometric elements is painted in red, black and yellow. This has the characteristic fineness of all Trobriand work, but although the patterns show considerable variety within a basic design they are generally highly formalized and ornate and lack the vitality and verve of other objects from this area.[3]

In what follows two distinct hypotheses are advanced concerning the nature of this design, the second being dependent upon the validity of the first. The hypotheses are: (1) that the seemingly abstract design on the shield is in fact a rationally ordered representation of a winged anthropomorphic figure; (2) that the figure represents a flying witch (Trobriand *mulukuausi*) and that the reported mythology concerning these beings is consistent with the observable character of the shield design and also the magical function of the design suggested in the above-quoted report by Malinowski.

I will discuss these two hypotheses separately.

If we exclude the seemingly debased example of Edge Partington's *Album* all published illustrations of Trobriand *vai ova* shields conform to the same general design, though details vary. Thus all examples include the feature *d* in Figure 2, comprising several parallel lines arranged symmetrically on each side of the

2 Haddon (1894), p. 240.
3 Linton and Wingert (1946), pp. 144 ff.

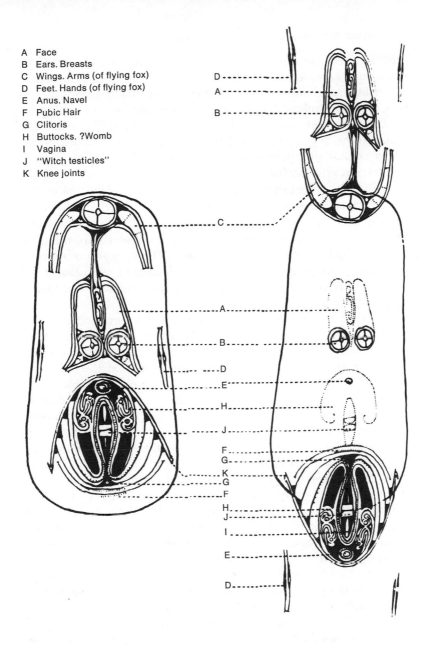

A Face
B Ears. Breasts
C Wings. Arms (of flying fox)
D Feet. Hands (of flying fox)
E Anus. Navel
F Pubic Hair
G Clitoris
H Buttocks. ?Womb
I Vagina
J "Witch testicles"
K Knee joints

Figure 2. An interpretation of designs on the Trobriand Shield.

shield, but the number of lines varies from two on each side to four on each side. Again, all specimens include a motif a in Figure 2, but whereas in some examples this is a clearly defined face, in others it is featureless. I shall proceed therefore to analyze Figure 2 as if it were representative of all particular examples of *vai ova* shields. In the key to Figure 2, left, the various design features are listed $a-k$ and interpreted as anatomical details, e.g., a = face, b = ears, breasts. At first sight some of these interpretations are likely to strike the reader as surprising and arbitrary but the analysis will be found more convincing if reference is made to the more obviously anthropomorphic figure shown in Figure 2, right. It will then be seen that Figure 2, left, can be derived directly from Figure 2, right, by, as it were, "folding the paper." The indications are self-explanatory, but perhaps it should be added that the creature is supposed to have the wings and legs of a flying fox, a creature resembling a bat.

Whether this interpretation will be found convincing or not will presumably depend to some extent upon the individual temperament of the reader. It is not, I think, a matter capable of proof one way or another. It may be noted, however, that the design in its revised form (Figure 2, right) has a certain resemblance to certain other Melanesian designs, for example: Trobriand clubs of the type figured in Firth (1936), p. 96; British Museum *Handbook* (1925); Plate VIc (facing p. 126); Chauvet (1930), Figure 192; the Solomon Islands shields shown in Leenhardt (1947), p. 44; and in *Traditional Art of the British Colonies* (1949), Plate XX.

If this interpretation of the Trobriand design be accepted, we may proceed to inquire what the figure represents and why it should be an appropriate decoration for a shield. My hypothesis is that the figure is a "flying witch" and that it is a shield decoration because of the poisonous emanations that are believed to be emitted by the vulva and anus of such witches. If this suggestion is correct, the witch design on Trobriand shields had the same logic behind it as the story that Perseus carried on his shield the petrifyingly beautiful head of the witch-dragon Medusa.

Our main source of information concerning Trobriand ideas about flying witches (*mulukuausi*) is, as might be expected, Malinowski. The principal references are Malinowski (1916), and

Malinowski (1922), pp. 237 ff. In both cases he stresses that the Trobriand belief closely resembles that reported by Seligman (1910), Chapter XLVII, for Bartle Bay. As a result of his Mailu researches Malinowski (1915), p. 648, was at first critical of Seligman's analysis, but for the Trobriand data he seems to have accepted the correctness of Seligman's views. Fortune, who reported on very similar beliefs current in Dobu, also stresses the close parallels between the Dobuan data observed by himself, the Trobriand data reported by Malinowski and the Bartle Bay data reported by Seligman (Fortune [1932], p. 297).

Malinowski's report (1922), p. 238, is as follows:

> The orthodox belief is that a woman who is a *yoyova* can send forth a double which is invisible at will, but may appear in the form of a flying fox, or of a night bird or a firefly. There is also a belief that the *yoyova* develops within her a something, shaped like an egg, or like a young unripe coconut. This something is called as a matter of fact *kapuwana*, which is the word for a small coconut. This idea remains in the native's mind in a vague, indefinite, undifferentiated form. . . . The *kapuwana* is anyhow believed to be something which in the nightly flights leaves the body of the *yoyova* and assumes the various forms in which the *mulukuausi* appears. . . .

The parallel Dobuan belief is that "if one sleeps touching the legs of a witch a gigantic testicle within her body will pass over, mount the leg, and lodge in the scrotum, hence elephantiasis. The gigantic testicle emerges at night and is seen, a ball of fire, as the witch flies in mid air"; ". . . the *kaiana* fire of witchcraft issues from the pubes of flying witches as they go through the night."[4]

The corresponding Bartle Bay belief is in a witchcraft substance called *labuni* which the witches send forth at night:[5]

> It was said that the *labuni* existed in and was derived from, an organ called *ipona* situated in the flank and literally

[4] Fortune (1932), pp. 296–97.
[5] Seligman (1910), p. 640.

meaning egg or eggs. The *labuni* was said actually to leave the body and afterward to reenter it *per rectum*. Although *labuni* resemble shadows they wear a petticoat which is shorter than that worn by the women in this part of the country.

The Trobrianders, like the Dobuans, believe that the flying witches can be seen as fire flying through the night, but the precise source of the fire is not specified and the clothing of the witch is uncertain.

According to some versions, the *mulukuausi*, that is the witch in her flying state, moves about naked, leaving her skirt round the body which remains asleep in the hut. Other versions depict her as tying her skirt tightly round her when flying and beating her buttocks with a magical pandanus streamer.[6]

If we accept the general hypothesis that our Figure 2 represents a Trobriand flying witch, and that, as a shield design, the pattern is intended as a source of dangerous emanation, it will be seen that the design and the mythology fit very nicely. The exaggerated emphasis given to the anal and vaginal orifices becomes meaningful, and also the fiery red color of the pubes, and the clawlike character of the arms and legs. The two curious egglike objects (Figure 2*j*) are clearly the witchcraft testicles or "coconuts" (*kapuwana*).

My interpretation of the upper half of the design is perhaps much more doubtful, especially the curious design identification between the "ears" and the "breasts" of the creature. It is, however, logically correct that the ears should be strongly emphasized in any representation of a *mulukuausi*. According to Malinowski (1922), p. 241:

By a special sense . . . "a *mulukuausi*" can *hear*, as the natives say, that a man has died at such and such a place, or that a canoe is in danger. Even a young apprentice *yoyova* will have her sense of hearing so sharpened that she will tell her mother: "Mother, I hear, they cry."

6 Malinowski (1922), pp. 241 ff.

CONCLUSION

The interpretation which I have given to an apparently abstract Trobriand design, though highly hypothetical, seems to me to raise a number of points of theoretical interest.

In contradistinction to writers such as Boas and Haddon, I hold that the designs of primitive peoples are seldom abstract in any genuine sense. Designs, both as wholes and as parts, usually have a definite functional significance for the artist who makes them. Frequently of course the design element has moved very far indeed from anything that might be described as photographic realism, but nevertheless the "realistic" element remains. Primitive designs are mostly representational. Given this hypothesis, it is a reasonable proposition to attempt to interpret as functionally meaningful designs, such as that of Figure 2, which at first sight seem to be total abstractions. In this case the evidence that can be adduced is wholly circumstantial, since the objects are no longer made and memory of them no longer survives in their place of origin; in other cases, however, investigation of "abstract" designs for their contemporary functional significance might prove very rewarding. This is certainly an aspect of material culture to which social anthropologists might usefully pay greater attention.

The second point of interest is that, so far as I know, no one has previously recognized the "folding-up" of the human figure (as here postulated) as an aesthetic device. It is, however, only the logical opposite of the extremely important aesthetic device of "unfolding," which figures so prominently in the art of the American Northwest Coast (see Boas [1927], pp. 224 f.), and which has had a powerful influence on many twentieth-century European artists, including Picasso.

The Trobriand technique of "folding-up" has interesting psychological implications since it permits a graphical representation of the association of ideas. Thus, in this case, there is a graphical association: ears = breasts; anus = navel; hands = feet; head = heart; vagina = womb = a folded flower, etc. The whole seems to provide a sort of Melanesian Rorschach test which, at the very least, should be of interest to Kleinian psychoanalysts interested in the "introjection" of "good" and "bad" objects through the medium of the witch-mother's breast!

Bibliography

Boas, F. *Primitive Art.* Oslo, 1927.

British Museum. *Handbook to the Ethnographical Collections* (2nd ed.; London, 1925).

Chauvet, S. *Art de Nouvelle Guinée.* Paris, 1930.

Finsch, O. *Samoafahrten: Ethnologisches Atlas.* Leipzig, 1888.

————. *Ethnologische Erfahrungen und Belegstücke aus der Südsee,* Part 2, supplement to Vol. VI of *Annalen des K-K-Naturhistorischen Hofmuseums.* Wien, 1891.

Firth, R. *Art and Life in New Guinea.* London, 1936.

Fortune, R. F. *The Sorcerers of Dobu.* London, 1932; New York, 1963.

Haddon, A. C. *The Decorative Art of British New Guinea.* Dublin, 1894.

Leenhardt, M. *Arts de l'Océanie.* Paris, 1947.

Linton, R. and Wingert, P. S. *Arts of the South Seas.* New York, 1946.

Malinowski, B. *The Natives of Mailu.* Victoria, 1915.

————. "Baloma; the Spirits of the Dead in the Trobriand Islands," *J. R. Anthrop. Inst.,* Vol. XLVI (1916), pp. 353–430.

————. "War and Weapons Among the Trobriand Islanders," *Man* (1920), p. 5.

————. *Argonauts of the Western Pacific.* London, 1922; New York, 1963.

Partington, J. Edge and Heape, C. *An Album of the Weapons, Tools, Ornaments, Articles of Dress, etc., of the Natives of the Pacific Islands.* Privately Printed, 1890–98.

Ratzel, F. *The History of Mankind.* 3 vols. London, 1896–98.

Royal Anthropological Institute. *Traditional Art of the British Colonies,* catalogue of an exhibition. London, 1949.

Seligman, C. G. *The Melanesians of British New Guinea.* Cambridge, 1910.

Webster, W. D. *Illustrated Catalogues of Ethnographical Specimens* (Bicester), Vol. II, No. 20 (1900).

The Interpretation of
Pakot Visual Art*

HAROLD K. SCHNEIDER

Dr. Schneider believes that before attempting to interpret the art of a tribal people it is necessary for one to understand their standards of beauty. Pakot criteria of beauty include the concepts of embellishment, nonutility, and uniqueness. Although these are similar to the aesthetic beliefs of Western societies, there are others that differ.

Dr. Harold K. Schneider is Professor and Chairman of the Department of Anthropology at Lawrence College. He is a social anthropologist primarily interested in economic anthropology, culture change, art, and Africa. He is coauthor of *Economic Anthropology: A Reader in Theory and Analysis* (1968). An article related to the one below, "The Pakot of Keny: A Model of African Indigenous Economy and Society," appeared in *Comparative Studies in Sociology and History* (October, 1964).

Anthropologists seem agreed that aesthetic sense is universal[1] but most would probably agree that standards relating to what is aesthetically pleasing vary from culture to culture. Nevertheless, in practice scholars who discuss the art of nonliterate people do sometimes seem to impute standards to them or, what amounts to the same thing, try to deduce the standards of beauty of a people by analysis of objects from their cultures. In both cases standards of beauty learned in Western cultures are used as a basis for judging what is or is not art in a nonliterate group. Almost all discussions of the Magdalenian people make reference to the "art" of these cave dwellers.[2] In effect this is the attribution of stan-

*Reprinted from *Man*, Vol. 56, No. 108 (August, 1956), pp. 103–06.

[1] Franz Boas, *Primitive Art* (Dover Publications, 1955), p. 9.

[2] See Leonhard Adam, *Primitive Art* (rev. ed.; London: Penguin Books, 1949), p. 25; or L. Beals and H. Hoijer, *An Introduction to Anthropology* (New York: Macmillan, 1953), p. 539. These examples could, of course, be multiplied greatly.

dards of beauty to Magdalenian people based upon the assumption that their standards were the same as ours. In the study of prehistoric cultures such deductions are inevitable and in fact probably close to the truth, but we can never know for sure.

In the study of contemporary people such deductions are also seemingly common. Since discussions of art seldom include any but an implied note of the standards of beauty of the subjects, it seems possible that what constitutes the art of the people is derived at least in part by deduction.

The present paper is an addition to the limited number of studies of concepts of beauty of nonliterate people. It is proposed to show what Pakot[3] standards are and to define their visual art in terms of them. It is further proposed to illustrate from this how deduction of art may lead to erroneous conclusions if the standards of beauty of a people are not taken into account.

The Pakot distinguish between what is useful in subsistence or the ordinary acts of getting a living and what is an aesthetically pleasing embellishment having no subsistence or utilitarian use except as decoration. In this discussion the term utilitarian may be most conveniently defined as anything which has no aesthetic component. Thus the utilitarian object is one that has any function in living other than an aesthetic function. This distinction became apparent during a discussion of a carved wooden milk pot (*aleput*) which has a projecting lip carved into the rim. Informants said that the pot was *karam*, a word usually translated as "good," and which may be used in a wide variety of situations. When asked to explain further what was meant by "good," one informant said that the pot was useful for holding milk and so was "good to have." This informant further stated, however, that the lip of the jug was *pachigh*, a word which had been previously translated by the

[3] The term *Pakot* is the plural form of which the singular is *Pachon;* to avoid unnecessary confusion only the plural is used in this paper. The Pakot, more commonly known as Suk, inhabit, in the main, the West Suk District of Kenya and belong to the pastoral Nilotic group of tribes of East Africa, being most nearly related to the Nandi. The research upon which this paper rests was carried out in the Ortum area of West Suk in 1951–52 under grants from the United States State Department (Fulbright Act), the Social Science Research Council and the Program of African Studies of Northwestern University.

interpreter as "pretty" or "beautiful" and which, it was explained on this occasion, meant "pleasant to look at" and "unusual." Additional questioning elicited the information that the lip was a recent invention by some unknown inventor, before whose time milk pots had had no lips. The lip is in fact superfluous to the function of the pot when used to handle milk. No other Pakot containers, to my knowledge, have a lip, which is why it is considered unusual. To generalize, the thing which is *pachigh*, in this case, is something pleasant to contemplate, strange or new, and an embellishment. The pot is clearly not considered wholly beautiful and the utilitarian part is plainly distinguished conceptually from the pretty.

Subsequent investigations showed that, with the qualifications discussed further on, the following things were only *karam*, i.e., had useful functions that were nonaesthetic: clay cooking pots, shoes made from old rubber tires or cow hide, spears, headrests which are used as neck pillows to protect the mens' clay headdresses, calabash containers, cotton sheets and other clothing, houses, water holes, and cattle (except for one type). That cattle should be included in this list was surprising since they are the most highly valued of all goods and the attitude of the Pakot toward them might lead one to suppose that they would be considered beautiful.

The term *pachigh* (which refers to a state of being, a condition of a thing) can be applied to two classes of objects which, however, are not separated conceptually by Pakot. First are those things which are considered beautiful but are not made by the Pakot. These include the beauties of nature and objects of foreign manufacture, and in both cases what is beautiful is a part of something that is useful in some other way. For example, with one exception all cattle are *karam*, their value lying in the fact that they provide meat, milk, blood, and certain by-products and that they are useful for obtaining other goods through trade and for "buying" rights in other persons. The colors of the hides of these cattle are *pachigh*. A woman is also "good," but she may have aspects of beauty such as firm, round breasts, a light, chocolate-colored skin, and white, even teeth. The glossy surface of "americani" cloth imported into the reserve is similarly considered pretty, but when it wears off the cloth becomes purely *karam*.

In regard to this last case, the common designation of art as man-made beauty,[4] the definition used here, in contrast to beauty occurring in nature, would exclude the glossy cloth as Pakot art since it is imported in that condition and not applied by Pakot. It may be art to the manufacturer but it is in the nature of a "natural" occurrence to Pakot.

The second class of beautiful objects are those made or obtained by Pakot that are added to utilitarian objects by Pakot themselves. It includes paint which is made and applied to objects by Pakot and also colored beads which are not made by Pakot but which are added by them to utilitarian goods for decoration. A special type of steer called a *kamar*, who is selected for certain admirable qualities and whose horns are warped by his owner, is considered to be wholly beautiful, unlike other cattle, and is kept somewhat like a pet and as a symbol of prestige to his owner. He is not put to subsistence use except under special circumstances and so is thought of by Pakot as an embellishment. Other objects in this class are cowrie shells, which are used to decorate various objects, polished wood surfaces as on spears or headrests, and bits of aluminum and iron or copper that are inlaid on the surface of the headrest to provide decoration. A design incised on any surface is also *pachigh*, as is a house if it is unusual in style or especially carefully and regularly built. Finally, a basket may have a pattern of weaving that is considered beautiful if it is unusual or if it comes from another district where the pattern of weaving is different from that of the area to which it is imported. Some of these objects are always separable from the things they enhance (e.g., cowrie shells) and some are in a sense inseparable after they are added. But all are initially added to utilitarian things by Pakot and are not inherent in them. To reiterate, these *pachigh* things seldom if ever exist of and by themselves but are used to decorate some utilitarian thing. This is not so clear in the case of the prize ox, but he may be regarded as being "added" to his owner or as being an embellishment on his owner's herd.

We may summarize Pakot visual art as consisting of objects having purely aesthetic functions, including necklaces, headdresses and hairdress, pigments, polish or gloss, cowrie shells, bits

[4] Boas, *op. cit.*, p. 12.

of polished iron and aluminum, iron and copper bracelets, ostrich feathers, the *kamar* steer, and unusual regularity and evenness in patterns or designs.

Informants sometimes refer without qualification to such things as a fully decorated adult man as "beautiful," but it is clear that they mean only the aesthetic embellishments. The Pakot tend to atomize the unit (or what might seem to be a unit to us) into its component pretty and nonpretty parts. Thus the term *pachigh* applies to the aesthetic components of a complex like the fully dressed adult man. In fact this atomization goes further, and the *pachigh* aspect may be broken down into its components. Thus a fully dressed man wears a headdress, necklaces, bracelets, etc. In contrast to the collection of aesthetic elements which are called collectively *pachigh*, any single element may be called *pachigha*, the final *a* in the morpheme being added as a modifier to show that the thing referred to is but one element in what may be thought of as a complex. Why this should be necessary is not understood. Neither is it known whether an element that may be *pachigha* in one context may be *pachigh* in another.

The Pakot concept of beauty is relative or a matter of degree. Any beautiful object may be viewed as more or less aesthetically pleasing than something else. Of three colored shirts covered with designs which were shown to informants, the one with the brightest colors, the largest number of colors, and a wealth of surface pattern was considered prettier than the others. Of all cattle those colored pure black are prettier than the others. This is true only for the locality in which the investigation took place where black cattle are relatively rare.

There is general agreement about the beauty of things in broad categories like color. But while informants stated that all colors or pigments are pretty, the colored hides of goats and sheep are not considered to be pretty in any way. Their colors are thought to be too drab and monotonous. Similarly, colored beads arranged in a pattern are usually beautiful. But Pakot have preferences that exclude some arrangements. Some colors are preferred, such as blue in the locality under consideration, but any color may be strung out in a solid line and be juxtaposed with any other solid-colored string and be pretty. When different-colored beads are

strung on the same line an alternation of white and blue or of red and white is acceptable while alternation of red and yellow, red and blue, or yellow and white is not, apparently without regard to pattern. It would seem that the latter groupings are unacceptable because the contrast between colors is reduced and like the colors of goats and sheep they become monotonous. White and yellow provide little contrast but white and blue provide a large contrast.

Although there is general agreement on what is beautiful, there are areas of disagreement. We have already noted the regional variations in opinions about the relative beauty of cattle colors. There is sometimes disagreement about whether a thing is beautiful at all. A notable example is the case of a woman who felt that there was nothing beautiful about cattle, but that a healthy, green field of eleusine plants was beautiful. Most men would take just the opposite position. This difference of opinion apparently derives from the division of labor by sex. Women usually have little control over cattle, resent the menial labor associated with them that they must perform, and derive little prestige from them, while they can control the crops they produce and spend much of their time in the fields. In short, the men and women seem to find aspects of beauty in areas of life that interest them most and to which they willingly give attention. But at least one man was found who was a devoted cultivator and who described a field of eleusine plants as pretty because "the plants are even and regular and green and when a man stands by the field he can look over all of them." It was the panorama of all the plants which, unlike a field of straggling sorghum, can be easily viewed as a whole that appealed to him.

Allusion has been made a number of times to the beauty inherent in unique or unusual objects such as strangely woven baskets, unusually carefully built houses, or the lip on the milk pot. One informant said that European possessions were the prettiest things he had ever seen because he had never seen anything like them before. But not all things that are strange are necessarily beautiful. We have already seen that some strange arrangements of beads are not pretty. Some things which are unusual at first may acquire some utilitarian use and become common, thus losing the quality of *pachigh*. A concrete bridge built by Europeans in the

reserve a few years ago apparently was at first considered to be wholly pretty. Now that the Pakot depend on it to cross the river its beauty has been reduced to certain embellishments such as the "battlements" located along the sides.

New things which are startlingly beautiful are called *wechigha*, while those which are ugly and frightening are *wechipachigha*. It was difficult to find any example of the latter other than the hypothetical case of a man walking down the road carrying his head under his arm, but there was emphatic agreement that this was *wechipachigha*. Not all strange things are thought of as either pretty or ugly. There is disagreement about innovations and no generalization seems possible, except perhaps that when a new item has obvious utilitarian use it is excluded from the area of beauty.

Taken as a whole the Pakot attitude to new things is not so strange. Even among ourselves uniqueness is often a quality that has aesthetic virtue, and like the Pakot we may consider some new thing pretty, such as a late model automobile, until it becomes common and its other functions become dominant. The principal difference between the Pakot and ourselves is that new things are rarer among them. They idolize the status quo and do not encourage change. When an innovation appears it may be especially striking.

Throughout this paper we have spoken only of what I have called visual art. There is a suggestion that the term *pachigh* may be applied to such things as dances and songs but the evidence is too scanty to discuss.

To conclude, Pakot visual art, defined as man-made embellishments with aesthetic appeal, consists essentially of the decoration of objects with no aesthetic qualities. Objects of art are things which are glossy or polished, have an unusual pattern or form (including strange baskets and finely built houses as well as the *kamar* steer), and colors. There are exceptions in that some unusual forms are ugly according to Pakot interpretations and drab colors are not pretty. Further, it seems to be generally true that any form which is useful in getting a living or has some nonaesthetic function is not beautiful. One essential characteristic of the Pakot concept of beauty is that it is an embellishment on the

ordinary nonaesthetic things of life. These objects of art seldom if ever stand alone; they are applied to other objects as decoration.

We have analyzed the Pakot concept of beauty and have isolated their art according to it, using the definition of art as man-made beauty. It remains to consider the possible errors introduced by attempts to deduce aesthetic values in another culture. I myself provide a useful case in point because before the Pakot ideas of beauty were discovered I unwittingly indulged in such deduction. To some extent the deductive approach was successful in that such things as necklaces and bracelets were classified as art objects in agreement with the Pakot. This was probably due to the fact that to a certain extent Pakot and European standards of beauty coincide or that some standards are universal. But a European has a tendency to generalize beauty to a whole object on which embellishment had been made, and thus to fail to recognize the fine distinction that Pakot make between an object and its embellishments. Furthermore, some things which the Pakot consider aesthetically pleasing embellishments were missed, while some were considered beautiful which the Pakot would not. Deductively the lip of the milk pot along with the pot was considered nonaesthetic. This proved to be wrong, the lip being considered by the Pakot as a pretty embellishment. On the other hand, the headrest was deductively classified as an object of art because, although it has nonaesthetic functions, it is carried about by its owner like a decorative cane and is polished and decorated. To the Pakot only the gloss and incised or inlaid design are beautiful. A headrest without these is not beautiful in any way.

This discussion would be incomplete if it were not said that although it may be useful for purposes of ethnography to isolate according to a universal definition the particular area of life of the Pakot that may be called "art," a classification of this kind is liable to be very misleading if not qualified by Pakot concepts of beauty. Pakot do not recognize anything called art as such. There is mere *pachigh* and non-*pachigh* whether man-made or occurring in nature. Our attempts to separate the two for purposes of this paper were highly artificial, in some cases dubious, and a violation of Pakot conceptualization of the universe. In short, we might argue that analysis of Pakot culture would proceed more adequately with

a category of "beautiful" or "aesthetic" things than with a category of "art."

Our discussion suggests that attempts to classify the art of a nonliterate people deductively without determining at first their concepts of beauty are bound to be only partly accurate. On the positive side, securing such information can directly contribute to art theory, as in this case to the old debate over whether the art of nonliterate people is utilitarian or not. As we have seen, Pakot art is never utilitarian if we define utilitarian as having any non-aesthetic function. Beautiful things have only the function of pleasing the eye and only the function of enhancing nonaesthetic things.

Relationships Between Child Training
and the Pictorial Arts*

HERBERT BARRY, III

Dr. Barry was one of the first to attempt a scientific analysis of the relationship between art style and socialization in primitive societies. The method and results of his research are explicitly stated here. The findings of this research have stimulated further study and an extension of Dr. Barry's ideas (see the articles by John L. Fischer, Vytautas Kavolis, and Michael C. Robbins in this volume).

Dr. Herbert Barry, III, is Associate Professor of Cross-cultural Research in the Department of Anthropology at the University of Pittsburgh and Research Associate Professor of Pharmacology in the University's School of Pharmacy. He is currently concerned with the effect of drugs on behavior, an interest reflected in his writings, "Effects of Strength of Drive on Learning and on Extinction," and "Drug Effect on Animal Performance and the Stress Syndrome."

An artist's personality is commonly thought to be expressed in the style of his art creations, so that individual differences in art style are related to individual differences in personality. If this assumption is true, it should be possible to find a correlation between an appropriate index of personality and art style. The index of the artist's personality may include events known to be influential, such as the socialization practices he has undergone. A correlation between socialization and art style, if obtained, may mean that the socialization and art variables are related to the same aspect of the artist's personality.

* Reprinted from the *Journal of Abnormal and Social Psychology,* Vol. 54, No. 3 (May, 1957), pp. 380–83. This paper is a revised version of a thesis presented to the Social Relations Department at Harvard College in partial fulfillment of the requirements for the B.A. degree with honors. The thesis was written under the generous and helpful guidance of Dr. John W. M. Whiting. The revisions were made with helpful suggestions from Dr. Irvin L. Child.

This argument may be generalized from the single individual to the typical or modal individual in a small and relatively homogeneous society. The socialization practices and art styles as aspects of culture are perpetuated beyond the individual's life span by custom, but cultural custom like an individual's behavior develops and may be modified as an adjustment to the personality characteristics of the individuals. The present study was carried out to test for a correlation between severity of socialization and style of art among a sample of nonliterate societies. The measures on socialization have been presented by Whiting and Child (4), and the present investigator independently obtained measures of art style.

METHOD

Thirty nonliterate societies were selected from the list of seventy-six on which Whiting and Child gave socialization data. These thirty societies comprised all those from which the investigator was able to find at least ten works of graphic art, either exhibitions in museums, or as illustrations in ethnographic reports. If ten to twenty works of art were available for a culture they were all rated; if more than twenty were available, representative ones were picked at random. In all, 549 works of art were rated.

Each work of art was rated on eighteen criteria of art style, using a seven-point scale. Since the score on most of the variables was influenced by the material used, the art works of each culture were compared with those of other cultures in the same material, e.g., weaving, woodwork, wickerwork, and pottery. The culture was designated as above or below the median in each variable, combining its score in the different materials but comparing its art in each material only with the art of the other cultures in the same material.

Whiting and Child described five universal systems of behavior: oral, anal, sexual, dependence, and aggression. Two stages of socialization were distinguished for each system: initial satisfaction and socialization anxiety. The resultant ten variables had each been rated on a 1–7 scale by three judges, and the three ratings added together. This combined score for each of the ten

Soul-bearer's disk. Akrafokonmu. Africa, Ghana, Ashanti tribe. Gold, 4 5/16″ in diameter. The Cleveland Museum of Art, Cleveland, Purchase from the J. H. Wade Fund.

variables was transformed into standard scores, using the sample of thirty cultures on which art scores were available. The five scores of initial satisfaction were reversed in sign so that a high score would mean low satisfaction. The ten standard scores were then combined for an overall measure of severity of socialization, with a high score signifying high severity.

RESULTS

Eleven art variables were considered to be measures of complexity of art style.[1] One of these variables, complexity of design, was defined at the upper extreme as a design with many unrepeated figures to form a complex organization of design; the lower

[1] Seven additional variables were rated but are omitted here for the following reasons: three concerned color and there were insufficient cases; two were unreliably rated; two were rated with insufficient variation.

extreme of this variable was defined as a design with few figures or repetition of figures to form a simple organization of design. The other ten variables, which were less directly defined in terms of complexity of art style, are listed in Table 1.

To provide a combined measure of complexity of art, cultures were scored as high in combined complexity if they were rated above the median (in the direction of complexity) in six or more of the eleven separate measures, low if they were above the median in five or fewer of these measures. Table 1 (left-hand column of figures) shows the tetrachoric correlation of each variable with this combined measure, using the table compiled by Davidoff and Goheen (1). The statistical significance was computed by the Fisher-Yates exact test (2).

Table 1. Correlation of the Art Variables with
Complexity of Style and Severity of Socialization
(All of the correlations are positive)

Art Variables	Complexity of Style $(r_{tet}, N = 30)$	Severity of Socialization $(r_{bis}, N = 28)$
Complexity of design	.98**	.71**
Presence of enclosed figures	.91**	.32
Presence of lines oblique to each other	.91**	.13
Presence of sharp figures	.81**	.18
Presence of curved lines	.81**	.07
Representativeness of design	.67*	.56*
Presence of lines oblique to edges	.67*	.45
Crowdedness of space	.67*	.12
Asymmetry of design	.50	.26
Presence of border	.31	.20
Shortness of lines	.31	.11

* $p < .05$.
** $p < .01$.

The biserial correlation of each variable of art style with the overall measure of severity of socialization is shown in the right-hand column of Table 1. For each of the eleven art variables, the direction of high complexity is positively related to high severity of

socialization. Two of the art variables are significantly related to the overall measure of socialization by t test. Complexity of design, which is most closely related to the combined measure of complexity of art, is the art variable showing the highest correlation with severity of socialization. The combined measure of complexity of art has a biserial correlation of $+.47$ with the overall measure of severity of socialization ($t = 2.06; p < .05$).

Table 2. Correlation of the Art Variables with
Measures of Severity of Socialization
(Satisfaction and anxiety measures taken
from Whiting and Child (4))

Behavior System	Satisfaction		Anxiety	
	r_{bis}	N	r_{bis}	N
Oral	$-.59$**	29	$+.35$	27
Anal	$-.32$	23	$+.16$	23
Sexual	$-.05$	28	$+.28$	28
Dependence	$-.46$	27	$+.42$	26
Aggression	$-.04$	30	$+.33$	30

** $p < .01$.

The biserial correlation of complexity of design with each of the ten measures of socialization is shown in Table 2. In all ten cases high severity of socialization is positively correlated with high complexity of design, although the intercorrelations among the five systems of behavior (reported by Whiting and Child) are mostly slight.

Table 3 lists the thirty cultures in this sample, grouped into those above and below the median on complexity of design. The left-hand column of figures for both groups of cultures shows the combined measure of severity of socialization. The right-hand column indicates that complexity of design is correlated with the occurrence of cultures for which some of the socialization ratings were omitted because of insufficient information. Ratings were omitted in none of the fifteen cultures above the median in com-

plexity and in seven of the fifteen culture below the median. This difference is significant by the Fisher-Yates Exact Test ($p < .01$).

Instances of severe socialization practices are generally more dramatic and likely to be reported more fully. Therefore it is probable that omissions of ratings indicate an unreported low degree of severity more often than an unreported high degree of severity. There is evidence for this inference from the fact that the social-

Table 3. Complexity of Design and Severity of
Socialization in the Sample Cultures

Complexity of Design Above Median			Complexity of Design Below Median		
Culture	Socializ. severity	Not rated	Culture	Socializ. severity	Not rated
Ashanti	+ 1.01	o	Hopi	+ .37	o
Chiricahua	+ .77	o	Thonga	+ .34	o
Dahomean	+ .69	o	Navaho	+ .20	o
Alorese	+ .38	o	Paiute	− .05	o
Western Apache	+ .35	o	Masai	− .28	4
Kwakiutl	+ .29	o	Papago	− .30	o
Samoans	+ .26	o	Ifugao	− .45	2
Ainu	+ .12	o	Andamanese	− .54	2
Maori	+ .12	o	Marshallese	− .56	3
Marquesan	+ .09	o	Chenchu	− .58	o
Arapesh	+ .06	o	Yagua	− .62	o
Yakut	− .01	o	Comanche	− .94	o
Balinese	− .21	o	Murngin	− 1.05	4
Trobrianders	− .22	o	Omaha	−	6
Teton Dakota	− .47	o	Zuni	−	8

Note:—Cultures are divided into above and below the median for the art variable of complexity of design. Each culture is listed with its average score on the combined measure of severity of socialization, and the number of socialization variables (out of ten) on which a rating was not made.

ization ratings made with the lower of two specified degrees of confidence were generally below average in severity. If the majority of omissions indicate low severity of socialization, they give further evidence of the positive relationship described above with low complexity of art design. Since the art materials and socializa-

tion information were obtained from different sources, it is unlikely that the correlation indicates a direct causative relationship between inadequate ethnographic information and availability of art works below the median in complexity of design.

DISCUSSION

The correlation between severity of socialization and complexity of design in artworks indicates the presence of a connecting link between these two variables, to which both are related. Cultures with low and high severity of socialization are certain to differ from each other in the typical personality characteristics of their people, if we believe that socialization has an important influence on personality and that our measures of socialization are valid. Therefore, cultures with simple and complex art styles also differ from each other in the same typical personality characteristics of their people. It is reasonable to believe that these personality characteristics influence the style of the artworks created by the people. This belief provides a possible explanation for the correlations between socialization and art variables.

The correlations of the eleven variables of art style with the overall measure of art style suggest the presence of a general factor of complexity or elaborateness in various specific measures of style. This general factor may be a component of the distinction between classicism and romanticism. In nonrepresentative designs, which characterize the majority of the artworks in this sample, romanticism might be described in terms of complexity of design and specific variables such as asymmetry, curved lines, and crowded figures. Most of these eleven variables have been included in a list of variables described by C. Sachs (3) as related to the classic-romantic distinction.

The oral and dependence systems of behavior, shown in Table 2 to have the highest relationships to complexity of design in art, are mainly concerned with adequacy of food, affection, and protection. In the majority of cultures with complex art styles, to draw an implication from this finding, the typical individual learns self-reliant behavior to a high degree and is punished or frustrated for

overt expression of dependence. On the other hand, the systems of behavior with lower relationships to art style (anal, sexual, and aggression) are concerned with prohibition or restriction of pleasurable actions, and imply pressure toward obedient and compliant behavior. The correlation of complex art style with severe socialization thus apparently applies primarily to severe socialization pressures toward independent behavior rather than toward obedient behavior.

The correlations reported in this paper are subject to various alternative interpretations. Such ambiguity can best be reduced by determining with more certainty the meanings of the measures of socialization and art style, as by finding the relationships of these measures to independent measures of personality, aesthetic expression, and other aspects of cultural practices.

SUMMARY

Works of pictorial art of thirty nonliterate cultures were rated on a number of variables of art style. Eleven of these art variables were found to be related to each other on a dimension of complexity of style. The art variables were correlated with a combined measure of severity of socialization from ratings presented by Whiting and Child (4). For each of the eleven art variables the cultures above the median in complexity tended to be above average in severity of socialization, for two of the art variables the correlation was statistically significant. The variable, complexity of design, which was more closely related than any other art variable to the overall measure of complexity, showed a higher correlation than any of the others with the measure of severity of socialization. Cultures above the median in complexity of design tended to be above average in each of the ten separate measures of socialization severity.

A possible interpretation of the results is that a personality characterization is related to severity of socialization and complexity of art style in the individual, and that the cultural custom which perpetuates a pattern of socialization and art style is an adjustment to the personalities of the individuals in the culture.

Bibliography

Davidoff, M. D. and Goheen, H. W. "A Table for the Rapid Determination of the Tetrachoric Correlation Coefficient," *Psychometrica* (1953), pp. 18, 115–21.

Finney, D. J. "The Fisher-Yates Test of Significance in 2 × 2 Contingency Tables," *Biometrika* (1948), pp. 35, 145–46.

Sachs, C. *The Commonwealth of Art.* New York: W. W. Norton, 1946.

Whiting, J. W. M. and Child, I. L. *Child Training and Personality.* New Haven: Yale University Press, 1953.

Art: An Introduction to Qualitative Anthropology*

GEORGE MILLS

Professor Mills defines the art process in the light of a number of aesthetic theories. He distinguishes quality of experience as the element basic to art. He differentiates between the cognitive mode of science and the qualitative mode of art and concludes that an analysis of styles may lead to an understanding of qualitative experience that "may shed light upon the interior articulation of cultures."

Dr. George Mills is Associate Professor of Anthropology at Lake Forest College. He specializes in primitive art, value theory, and cultures of the American Southwest. His particular interest is the relationships between art, culture, and society. He has written *Kachinas and Saints: A Contrast in Style and Culture* (1953), and *Navaho Art and Culture* (1959).

Two independent lines of development are converging in anthropology.[1] The first is concerned with the study of art. The limitations of our treatment of art can be shown by reference to four of its aspects: technique and materials, social function, style, and its nature as a medium of expression. Anthropologists have been interested in the following questions: Is there an evolution of styles from representative to geometric forms or vice versa (Stolpe, Boas), what is the effect of technique upon style (Holmes), how may regional styles be defined (Stolpe, Haddon, Wingert), how do art objects function within the religious, social, and economic life

* Reprinted from *The Journal of Aesthetics and Art Criticism*, Vol. XVI, No. 1 (September, 1957), pp. 1–17.

[1] I am grateful to Professor J. Glenn Gray for permission to take part in his course on aesthetics and to Professor E. Darnell Rucker for the opportunity to attend his course on the philosophy of science. I have drawn on discussions that took place in both of these courses for ideas expressed in this paper. I wish to thank Professor Gray and Mr. Richard Grove for reading and criticizing my manuscript.

of a culture (any good ethnography), what is the nature of the processes by which arts are created (Teit, Bunzel), and how does the definition of the artistic role affect these processes (Himmelheber)? Of the four aspects of art mentioned above, that which has been consistently ignored is the most obvious: art as a medium of expression. One of the basic assumptions of social science is that we can abstract stable, central tendencies—call them patterns, configurations, values, or what you will—from patterns of behavior, regularities of personality, and language usages. None of these sources of data reflects only these central and enduring tendencies; personality, for instance, is shaped in part by the physical characteristics of the human beings who live according to the way of life studied. None of these sources of data fully reflects these central tendencies which can be thoroughly understood only by comparing all sources of information. Much attention, from this point of view, has been given behavior, personality expressions, and language, but art has been ignored—at least by social scientists. It is not surprising that the chapter in *Anthropology Today* that deals with this problem was written by an art historian and that most of the people whose work he discusses are also art historians.

The second line of development has to do with the understanding of a way of life from within. It is recognized that by arranging ethnological facts according to our own habits of thought—under such headings as religion, social organization, economics, life cycle—we make it difficult to determine how a people articulate their own thoughts, feelings, and activities. This realization has led to a new interest in largely affected states, such as the fears of the Eskimos, the anxieties of the Navahos, and the "awayness" of the Balinese; to new methods, such as analysis of personal histories, for examining the inner articulation of cultures; and to new conceptual tools like value, value-orientation, and symbolic act for considering the role of affects in behavior.

David McAllester's *Enemy Way Music* is a recent exemplification of the convergence of aesthetic and anthropological interests, a development which promises to broaden our insight into problems of culture as well as improve our methods for dealing with these

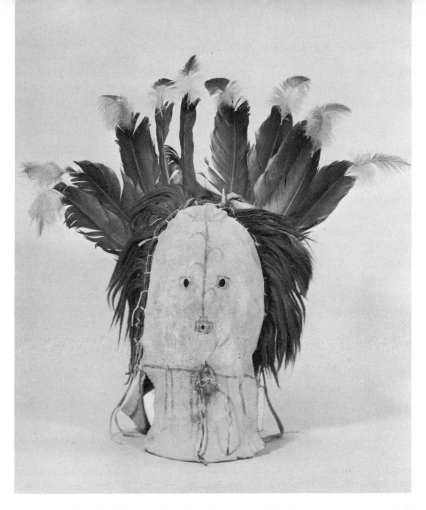

Navaho mask of Yebitsai. Hide with a few painted black lines and ornamented with feathers, fur, and red hair. The mask was worn in the famous curing ceremony of the Navaho known as the Night Chant. The name of this divinity, Hastseyalti, means the Talking God, Talking Elder, or Chief of the Gods. He is also known as Yebitsai, Maternal Grandfather of the Gods. He is the most important character in the Night Chant, and he is the leader of the public dance on the last night. White men commonly speak of this ceremony as the Yebichai dance. He is the god of dawn and of the eastern sky. He is also a god of animals and of the chase. His mask is white, with the symbol of a cornstalk with two ears painted on it. At the back is a fanlike ornament of eagle plumes. The Brooklyn Museum, New York.

problems. The purpose of this paper is to sketch some ideas about art that will make this important human undertaking more intelligible to the social scientist.

THE ARTISTIC PROCESS

It is easy to oversimplify the artistic process. We may base conclusions on a single medium of expression or raid the arts for those features which fit our preconceptions and, by ignoring other facts, give cogency to superficial conclusions. Freud's treatment of Leonardo da Vinci is a classic example, as Abell has shown. Of all the features of style and iconography that appear in Leonardo's work, how few are recognized and used, and yet what large results are achieved. The following diagram, intended to mark off the major turning points in the artistic process, will be used as a basis for discussing various concepts and matters of aesthetic fact.

Summary of the Artistic Process

Artistic roles. In constituting part of the role structure of society, the role of the artist is no different from that of general, policeman, or teacher. Like the rest of us, the artist must live up to expectations or suffer. The individual responsible for the making of drypaintings in Navaho culture has religious and medical functions because art for the Navahos is intimately bound up with the maintenance of health and cosmic organization. Memory for the

traditional, carefully specified designs is more important in this Navaho art than originality. American culture offers a variety of roles for artistic skills. The responsibilities assumed by nonobjective painter, commercial artist, and architect are quite different.

In many cultures, the role of art lover lacks definition because art is not viewed as a separate activity. This does not prevent individuals from attending to and being moved by objects and events in a way that we may call aesthetic. Our own society does provide a fairly well-defined role for the connoisseur and collector, as well as a special sanctuary, the museum, into which they may occasionally retreat with their refined tastes.

Experience of the artist. What is the relation of the quality of the artist's experience to his final product? Does it preexist the manipulation of the medium, or are the quality of the experience and the style of the art so interwoven with the manipulation of the medium as to emerge simultaneously from it? The experience of the artist is the most covert and elusive phase of the entire process. One cannot rely upon even the artist's description of his inner states, for his understanding of these states is unwittingly influenced by the expectations that his role establishes. In a culture that demands originality, the artist will honestly overlook many borrowings. To use a sacramental analogy, the artist's state of mind is the invisible grace of which the work of art is the visible form. Nevertheless, by studying the artist's choice of medium, his products, the definition of his role, and what he says about his work—by studying each of these in the light of all the others, we shall learn a good deal about the artist's inner workings.

Skill. Skillful manipulation of a medium in order to achieve certain effects is the most common criterion of art, implicit even in such a phrase as "the black arts." Skills of perception, memory, tool handling, bodily movement, and organizational ability are part of the makeup of the artist on which the nature of his experience and of his work depends.

Materiality. One can discuss at length what a medium comprises. Materials? The use to which materials are put (oil paint may be applied slickly or crustily)? The complex of images and experiences that the artist selects for expression? One can even argue whether or not the material embodiment is essential to the

existence of art. As for the first question, all three types of fact are important; what is not so important is deciding where the medium ends and analysis of the object begins. As for the second question, since the social scientist cannot deal with unexpressed intuitions, we shall say that art does not exist until the artist has set his hand to a medium and has produced a painting, musical score, dance notation, or other public object. If it is true that the intuition of the artist is formed only through struggles with his medium, then the process of having intuitions is inseparable from the process of making them public.

The idea of embodying an intuition in a medium applies to painting, sculpture, and architecture. In the dance, the artist's body is his medium, and it would be more correct to say that he manipulates this medium in such a way as to make his intuition known. Music presents a different problem. The public object of the musician is not always his own creation. He provides clues, in the form of a score, to the nature of the public object, but the completion of this object may depend upon the skill of a performer. Musical instruments have a similar effect; a composition intended for the harpsichord is qualitatively different when played upon the piano.

These are important differences, for by overlooking them we oversimplify our aesthetics. What mediums are included under the rubric of art? The answer to this question must wait upon a more precise answer to the question, What is art? We may be sure in advance that we shall encounter fuzzy edges, and that some activities may or may not be considered art depending upon the expansiveness of one's sympathies. What are the limitations of each medium? This problem cannot be solved until that Judgment Day when the work of all artists in all mediums can be perused. Before that time, however, we may be able to form opinions about the expressive bias of each medium, and these opinions will help us to understand the more elusive parts of the creative process, for insofar as a choice exists, the selection of a medium means the selection of opportunities to experience in a particular fashion.

The public object. The insistence upon materiality provides us with a public object or event in which all relevant experiences of all possible observers remain potential.

Thomas Munro (p. 354), distinguishes three aspects of the

public object: the presented, the suggested, and the structural. The first includes all that is present to the sense of the individual: shapes, colors, tones, textures, and the like. Suggestion achieves effects that are not immediately sensuous through the presentation of sensuous materials. Through its arrangement of shapes and colors a two-dimensional painting may suggest a three-dimensional object. Suggestion, according to Munro, takes several forms. It may be mimetic, as in *trompe l'oeil* painting; symbolic, as when a cross brings to mind the essentials of Christianity; or it may operate through common and often unconscious associations, as when a zigzag line conveys a sense of motion.

The presented and suggested aspects of the public object are structured or organized. One might define art as a portion of experience small enough to be organized as man would have his whole experience organized. By reducing organization to such principles as repetition, contrast, balance, etc., valuable analytic tools though these may be, or even to dichotomies like romantic and classic types of structure, we misunderstand the chief point about organization: that one element must be considered in relation to all of the others that make up the work. The effect may be chaotic, as in the anti-art products of Dadaism, but it remains deliberate chaos, which is a special type of chaos, meaningful only in relation to the artistic cosmos that it denies. Structure is as significant expressively as the presented and suggested aspects of the object.

Style. A style is a recurrent way of structuring and presenting. It is a regularity, an aesthetic pattern, that is abstracted from a number of works of art. The number of works may range from those executed by a single artist during a period of his life to styles characteristic of whole nations or ages. Although styles differ markedly—and defining the nature of these differences is not easy—one fact is common to all styles: they are not reproductions or literal copies of nature. Commonly a distinction is made between naturalistic and abstract art. This is misleading. First, because it obscures the fact that all art is abstract in the sense that style implies selection of elements from human experience and their reordering in new structures. "Naturalistic" simply means less abstract than "abstract" art. Second, the use of such dichotomies leads you to label an art as either abstract or naturalistic,

although it may be naturalistic in some respects, but abstract in others, as when a Spanish-American attaches a portrait-like head to a body that stylizes the human physique, or a Navaho sand-painter places naturalistic animals beside the geometric representations of Holy People from his mythology. As a result, the term psychical distance, coined by Bullough, is gaining currency. This concept indicates, not two or three possible relations between style and reality, but an infinity of ways and degrees in which style may depart from reality as it is known in everyday life.

Because it requires a medium, and because of its distance from daily life, art has developmental tendencies that may trace, as Kroeber has shown, a trajectory different from those of associated cultural patterns. Little is known about the immanent directioning of aesthetic patterns, but they are of obvious importance for the study of art-in-culture. If they exist, fluctuations of style may be determined by previous states of the art as well as by contemporaneous cultural values.

Utility. Just as the experience of the artist is related to sociocultural demands through the definition of role, so the public object is related to sociocultural demands through its utility. It is important to keep in mind the distinction between the object's utility and its function. Utility is a matter of entering into action, function of entering into awareness. The design of a piece of cloth has utility when the cloth is made into curtains, but it does not function until we take time to comtemplate the curtain. Function is essential to art, utility not. In keeping with this thought, devotees of the fine arts have insisted on cutting away the utilitarian aspect of art. However, from the fact that utility is not essential to art, it does not follow that lack of utility makes an object art. In other quarters, the confusion of utility and function is so thoroughgoing that the elimination of utility seems to do away with all of the uses of art which comes to be defined as an indulgence for the idle. A further result is to lower the quality of the products of utilitarian skill; a great mistake, for utilitarian objects, providing numerous opportunities for aesthetic contemplation, ought to be fashioned with the greatest care. At the same time it is difficult to appreciate arts that have utility, for familiar and useful objects are precisely those we are least apt to see except as they serve practical ends.

The purist says that art is divorced from daily life while the relationist says, with the dogmatism of some theologians, that divorce is a sin. It is possible that both purist and relationist are reasonable and that the important question is not, "Which view gives us the essence of art?" but, "How are these two facts of art related to one another?" Art is fraternal, yea-saying, delighted with commonplace sensuous resources, overjoyed to be the tool worn smooth by a man's hand, the clothing warmed by his body, the cockleshell that bobs between him and the ocean floor. Art has room for criminality and sin as well as cognition and sanctity. No situation or subject matter is alien: religious dogma, ceremonial, eating and sleeping, cities and hermits, saints and storms at sea. Using without being used, it remains embracive but elusive. Our conception of art must cover fishhooks and window shades as well as nonobjective painting and fugues.

Appreciation. This concept is necessary because it makes clear that those who are not artists may profit from art; when we do so, we receive impacts of color, sound, form, movement, perceive relations among these, and entertain suggestions similar to those the artist experiences in the course of his work.

The President, while attending the theatre, is assassinated, and the assassin jumps onto the stage and shouts, "Sic semper tyrannis." If the play which the President was attending happened to be a performance of *Julius Caesar* in modern dress, the reality of the murder and the reality of the play would be confused, and the audience would do nothing to pursue the criminal. This inhibition of practical action before the work of art, so different from the response accorded similar events in daily life, is brought about by another aspect of psychical distance.

Aesthetic experience. If this conclusion about appreciation be true, the experience of the art lover is similar to that of the artist. Is this experience so distinctive that it warrants the use of such terms as aesthetic experience, aesthetic contemplation, and the like? Many have distinguished aesthetic experience by saying that it is intrinsically valuable, whereas other experiences are instrumentally valuable. However, every choice we make is decided in part by anticipating that the chosen course will be more interesting, more valuable for its own sake, than the rejected one. This is not the only standard of choice, and often this one is overborne by

more urgent considerations. We come closer to an important feature of aesthetic experience when we recall the distinction between two kinds of knowing made in French, Spanish, and German: knowing by acquaintance and knowing by understanding. Many skeptics have studied the life of Christ without altering their skepticism, but one moment of knowledge by acquaintance, such as that which came to Saul, may do what years of knowledge by understanding have not accomplished. Art is like the vision of Saul: there is a voice, a presence, an impact. We recall that a basic aspect of the public object is presentational. Suggestion and structure come to us vividly, immediately, sensuously. At first this does not seem to hold true of literature that is not read aloud. However, Joseph Conrad (pp. 707, 708), is not describing his methods alone when he says that all "art . . . appeals primarily to the senses, and the artistic aim when expressing itself in written words must also make its appeal through the senses, if its high desire is to reach the secret spring of responsive emotions."

> . . . My task which I am trying to achieve is, by the power of the written word, to make you hear, to make you feel—it is, before all, to make you *see*. That—and no more, and it is everything. If I succeed, you shall find there, according to your deserts, encouragement, consolation, fear, charm, all you demand—and, perhaps, also that glimpse of truth for which you have forgotten to ask.

The importance of art's function can be studied in terms of the trouble individuals will take to alter their surroundings. Navaho blankets would be just as useful if they lacked the meticulous outlining, found in some styles, which costs much time and labor. The same is true of carved fish floats, painted pots, elaborate eating utensils, projectile points, masks, shields, and countless other objects of daily use. We say that these objects have been embellished, have had decoration added to them. When one considers the cost of the decoration, it appears that what is added is as important as the original object, so that the separation of creation and decoration is arbitrary. It would be more correct to say that a function, which we do not wholly understand, has been added to utility.

Universality. Art appears in all cultures that we know about. A conception that does not prove useful in dealing with arts from cultures other than our own will not be adequate.

BASES FOR DEFINING ART

If we take another look at the diagram, we find that the artistic process has four major aspects: sociocultural context, state of mind, public object, and the link between state of mind and object. Each of these aspects of the process has become the center for theories of art. Marxist views, as in the writing of Plekhanov, tend to make art a passive reflection of conditions of production, thus emphasizing the sociocultural context of creation. Croce's treatment of "intuition" lays stress upon the artist's state of mind, and Dewey's use of "quality" embraces the state of mind of art lovers. The public object becomes the center of iconological definitions of art, as well as of theories of significant from insofar as these are concerned with form. Insofar as they are concerned with significance, and most of them remain obscure about this, they seem to point to the next aspect, the linkage between public object and state of mind. Here we have a variety of definitions: art as the exercise of skills, expressive theories according to which states of mind are given appropriate embodiment, including the psychoanalytic theory of art as a disguised expression of socially unacceptable impulses. Semiotic theories, like theories of significant form, are undecided as to whether the locus of art is in the public object or in some state of mind with which the object corresponds. There are also notions that distribute their definitional emphasis among more than one aspect of the process. Talcott Parsons gives equal attention to role, expression, symbol, and affect. Thomas Munro, having given most thought to the problems of a combined definition, offers a way of differentiating particular arts on the basis of process, medium, and product.

If we agree that definitions vary with the purposes of the definers we are not surprised to see so much contention over the nature of art; what is surprising is that each scholar should treat his own view of the essence of art as the last word that need be said. We must keep all phases of the process in mind, but in order

not to be embarrassed by our riches, we must select one phase of this process as the primary differentia of art and allow the other phases to fall in place alongside it. Such a definition should enable us to distinguish artistic activity from other activities, but it should also help with the specifically anthropological problems mentioned at the start of the paper: relating art to the rest of culture, and making available the methods and conclusions of art historians, aestheticians, and psychologists of art.

The idea of art offered here is not a new one. Emphasizing that aspect of the process summed up in "state of mind," it employs "qualities of experience" as its genus. Recognizing that nonaesthetic as well as aesthetic experiences have a qualitative side, we are obliged to specify that which distinguishes artistic qualities from nonartistic. Qualitative experiences are of two sorts. First, there are those qualities which occur in the course of, and are controlled by, experiences forced upon us by nonaesthetic requirements. Man has to eat to live, so he works to acquire food. He may hunt, gather, farm, or labor for wages, exchanging money for food. Each of these economic activities is qualitatively different from the others. Economic behavior falls within narrow limits set by ability, situational requirements, and cultural patterns, so that preferences based upon taste in qualities of experience have small room in which to operate. Second, there are those experiences that are controlled by qualitative considerations, and we here approximate aesthetic experience. The factor of qualitativeness refers to the immediacy of art—its presence, impact, sensuousness. The factor of control further restricts the qualitative experiences that are covered by the definition of art. These two factors—quality and control—are not sufficient, for we can all think of controlled qualitative experiences that we would hardly consider art. But before proceeding to refine this idea, I must consider the view of John Dewey, who also uses quality as the primary criterion of artistic experience, clarify the meaning of qualitative, and show why the definition offered here is a useful one.

Dewey defines "an experience" as an interactive sequence between creature and environment that runs its course to fulfillment and which is a whole, marked off from other experiences, because it has a dominant quality. The roots of art are found in an experi-

ence which has aesthetic character even though it is not dominantly an aesthetic experience. But how can quality, which is a passive concomitant of action in daily life, attain independent status in the world of art? I say passive because, while for Dewey quality gives unity to an experience by dyeing disparate materials with its color, it does not give shape to an experience. This shape is the result of interaction between creature and environment. The length of the experience, the placing of its climax, the nature of its trajectory are determined by the ease or difficulty which the creature encounters in attaining its end, and the quality of that action is a creaturely reflection of the shape of the experience. If these are the roots of art, it is difficult to see how the roots can ever put forth a flower. Dewey's answer is that art is a prototype of successful action. It can be a prototype because (1) artistic efforts are worthwhile in themselves, as all action should be, and (2) the artist, through his choice of techniques, controls the environment of his action as well as its aim. The first argument is not convincing because, as we have seen, art is not alone in being intrinsically worthwhile. Other pursuits, including philosophy might be taken as the prototype of successful action because—we must assume—the philosopher finds it qualitatively worthwhile and intrinsically satisfying. The second argument adds the virtue of controlling the environment of action as well as its aim. But this is also true of the mathematician who is able to raise a world upon the basis of whatever axioms he chooses. Since mathematics may also have cognitive uses which art appears to lack, it is not clear why art should persist as the prototype of successful action. I believe art has value, not merely as a protoype, but also as a type of successful action, and the problem, not solved by Dewey, is to find wherein this value lies.

Quality is a good word in anyone's lexicon, but we cannot allow eulogistic auras to substitute for clear meanings. Since any art object may prompt long reveries having nothing to do with art, we must insist on limiting ourselves to qualitative experiences that are relevant to the public object. Presentation, suggestion, and structure may all prompt qualitative experiences. Materials arouse sensations—the paint is shiny or dull, the tone sharp or mellow, the color red or blue, the movement fast or slow, the texture rough or

smooth, the shape slim or dumpy. Structures have effects comparable to sensations: tight, swirling, monumental, or chaotic. Some of these structural associations may not be as constant as, say, the association of redness with that patch of material, but where a structure-quality pattern *is* established, the suggestion operates as immediately as does sensation. Structure and presentation conspire to suggest all sorts of things, so that we must add to the qualitative experience of sensuous materials and structures the qualities associated with suggested entities or events. This is how the mistaken conception of art as an imitation of reality arises. If the depicted mountain arouses the same qualitative experience as a real mountain, then the real and depicted mountains may be identified with one another; forms productive of the same quality are experientially equal to one another. Since it is easier to believe that art imitates nature than the reverse, the real mountain may be seen as a whole, while the depicted mountain is excised from the context of the painting and treated as if it were a lesser version of a real mountain. The depicted mountain should be treated as the prompter of a qualitative experience which, insofar as it is isolable, *may* be compared with the qualitative experience aroused by real mountains but which, given the obvious intention of the artist, is better related to the qualitative experience prompted by the materials and structure of the work. Out of this whole arises a whole experience, and not until this act of aesthetic relating is completed should the idea of real mountains enter our minds. Considerations associated with utility of the object are also appropriate matters for suggestion. The effect of a work of art radiates outward in all directions; each suggestion arouses novel emotions, desires, and ideas, the mind moving as rapidly over these as a train climbs its horizontal ladder. In theory we could move in unbroken career from Sassetta's *Journey of the Magi* to the squaring of the circle. In doing so we would cross the boundary of art. A single painting cannot bear the freight of all human experience. This is why, to learn whether or not the promptings of the mind are relevant to the art, we must constantly return to the public object, to the primary, sensuous, structural vehicle, because it is there that the qualitative experience is framed as truly as is the painting.

Why does this treatment of art as controlled qualitative experience serve us better than the notions of art as skill, as expression, or as significant form? First, to fix attention upon other points of the process before the qaulitative culmination is reached leaves the artistic process incomplete, inexplicable. Art involves skill, but precisely why do we lavish skills upon these objects? If, in talking about art as expression, we mean the expression of moods and emotions encountered in experience, we have to ask, "Why trouble to express these in art when they have been expressed in experience?" If art is formal and stylistic, a similar question arises, "Why this particular style and not some other?" Since the answer to these questions lies in the nature of the qualitative experiences which art controls, I take qualitative experience to be the crux of our study of the artistic process.

Second, qualitative experience is the point at which the artistic process relates most profitably to nonaesthetic experiences of interest to the social scientist. Symbols are encountered throughout human experience; why isn't this as good a place to start? Chiefly because we know too little about the nature of artistic symbols. And we shall never understand such symbols until we know something of the experiences underlying them. If art is a sacrament, an objectification of qualitative states that are critical in human behavior, then we may understand the significance of styles only by studying qualities. Since I previously said that qualities can be understood only by studying, among other things, styles, it now appears that the argument has come full circle. No doubt the early stages of art-in-culture rescarch will require some arbitrary assumptions for the control of this circularity.[2] The equality of qualitative experience and style, and therefore the circularity that

2 The necessity for arbitrary assumptions may be illustrated by a problem I encountered in my Navaho work. I had to find a way of relating cultural values to facts of style. The psychology of art contains many assertions of the sort, "These constricted forms express these kinds of anxiety." Such material promised the link I sought but had the drawback of being based on research within our own culture. I made the arbitrary assumption that these form-quality linkages are universal and proceeded to apply them to the Navaho situation. The results, arbitrarily founded though they are, offer new viewpoints on Navaho life and confirm the usefulness of further art-in-culture studies.

obtains between them, is methodological, not vital. Art objects are no more valuable in themselves than barometers; they are exceedingly delicate instruments for recording changes in the qualitative atmosphere.

ART AND THE QUALITATIVE MODE

Experience is largely controlled in ways summed up by two types of statement. The formula for cognitive experience is: "it" (pointing to some entity in the world around us) "is" (or equals) "x" (whatever, as a result of cognition, may be predicated of "it"). The second type of statement gives us the results of a qualitative experience. Though it has the same form as the first (subject, verb, and predicate) it expresses a totally different relation. The predicate is not a qualification of subject but an object which, arousing, attracting, or repelling the subject, is a kind of emotional *agent provocateur.*

Cognitive statements purport to give information about the world regardless of the individual's interest in or proximity to the facts he describes. The observation, "Indians are dirty and lazy" is of the same sort as "The pencil is six inches long." That the first statement may disguise a personal view does not alter the fact that it is phrased so as to offer unexceptionable information about all Indians. Cognitive statements require a symbolic microcosm in terms of which the macrocosm of entities and their relations may be described and understood. The typical cognitive symbol must point to an entity or relation as if it existed independently of the world of discourse. So cognitive structures docilely assume the shape of reality. Yet they are also capable of breaking away and, being more manipulable than brute reality, of assuming independent and novel forms. Though you cannot add apples and oranges, if you replace apples and oranges by numbers, you find that addition and other mathematical operations are feasible. The mind can outrun even the world of numbers so that generalization to the level of symbols like "n" becomes necessary. Heisenberg says that atomic physics has gone beyond the possibilities of its mathematics. Similarly, it has been said that Einstein was able to think without symbols, requiring them only to make his findings public.

We are always looking for more complex and flexible symbol systems with which to try out all of the transformations that the mind invents.

Cognition is extremely useful as compared with animal gropings. A dog is bound to immediate sensing of a fresh spoor, and this knowledge of the nose is small in amount and unreliable. Unlike the dog, a man can report that there are deer or apple trees behind that hill. This capacity for unsensed truths has made possible the development of culture and the importance of learning in human societies. Symbolic systems also facilitate the discovery of totally new relations before it is guessed that they may have significance outside the universe of discourse. Non-Euclidean geometries are pure symbolic structures that seem to contradict all we know about reality. Yet it was such a freewheeling system that Einstein found necessary for propounding his discoveries about the physical world.

Symbolic manipulability is practical because it enables us vicariously to live through situations and reap the fruits of action without incurring its dangers. Because symbol "i" is more hard-headed than I am, it takes more chances in its ideal world than I, surrounded by the angular furniture of this world, can afford to. Death and accident are locked out of the house of animal understanding, yet they enter man's awareness as easily as invited guests. By pushing the limits of space and time infinitely beyond the periphery of our senses, we recall that once we were not as we are now and infer that soon we shall not be either as we are now or as we were then. A strange cocktail party this, the self being locked in a house with death and accident as well as joy. It is no wonder that the host finds its difficult to commune with some of the guests and feels trepidation and sorrow as well as delight in the house of its inheritance.

Insofar as cognition deals with objectivities it has little to do with the self. Or, if it does, as in an autobiography, it transforms the self into an object as much there as a piano is. We talk about the objectivity of a dispassionate mind, and it is worth speculating whether a mind that was freed of its passionate concomitants would retain a sense of self in the face of its tendency to be diffused among the objects of its attention. The scientist makes a

career of disinterest and the saint a life, but for the rest of us the emotions and the sense of self which nucleates them are standard accessories.

In calling them accessories I seem to echo Santayana's remark that emotions are about nothing. It is truer to say that we are here introduced to a qualitative counterpart of cognition that is hardly exhausted by the usual terms emotion and feeling. We have left the realm of "it is x" and are now in the realm of "I x it." Comparison of these two statements makes clear the difference between cognition and qualitative experience. Since the x'ing of the second statement is attached to an ego, the world has drawn in its boundaries again and only those entities and relations are significant that are experienced immediately by the individual. This, as we saw, is one of the outstanding characteristics of art that may therefore be considered a kind of qualitative experience.

How may cognition and qualitative experience be related to one another? Although generally both are distinguishably present in the same experience, there may be experiences in which they merge and lose their identities. Mystic experience is obviously qualitative (the equanimity of the Buddhist, the Christian's peace that passes understanding) but it also purports to be cognitive, providing knowledge of transcendent reality. If the reality is immanent as well as transcendent, this fusion of quality and knowledge is understandable.

When cognition and qualitative experience agree upon an end of action, both may be submerged in the resulting action. If a friend swallows poison and we decide, because of our knowledge of these matters and our anxiety at this turn of events, to run to the corner for an antidote, while running we neither count over our stock of assumptions, concepts, and facts, nor savor the anxiety and sense of speed that constitute our qualitative state at the moment.

It can be argued that qualitative experience is the matrix of cognitive efforts. The foundations of science are aesthetic, and not merely in the sense that observation is a necessary phase and that hunches and feelings are often decisive in scientific choices. The belief that the world is organized, especially the atomic theory that the diversity of its phenomena is reducible to a single substance, is

an article of faith; one that has borne fruit, but an article of faith nonetheless. Coordinating concepts like that of causation are useful inferences from much human experience but also belong with matters of faith. The scientist lives by a calculus of probability, that the world tomorrow will be sufficiently like what it is today for him to complete his experiments. This faith in natural order, a faith that precedes, parallels, and rounds out the work of science, is of the qualitative sort, akin to the structuring of art, because it is grounded in little more than the feeling that the world has to be like this.

It is often said that action is motivated by imbalance in the organism or between the organism and its environment. Cognitively, this imbalance manifests itself in a sense of problem aroused by the failure of a prediction, a conflict of principles, or other contradiction in experience. This sense of contradiction is as qualitative as the clash of colors in a painting or the clash of hunger and anticipated satiety, so that what initiates the most complex chains of thought is not an abstract interest in thought but an immediate experience. The scientist indulges in these chains of thought because they please him; once initiated qualitatively, thought is sustained qualitatively. The sequence completes itself when contradiction disappears and harmony rules the surrogate world of the mind. So compelling is this quality of harmony, that men as eminent as Darwin and Poincaré have said the job of the scientist is not to prove his theory (indeed proof is impossible) but to disprove it and pass on to a larger synthesis.

The two kinds of experience are also related to one another in complex ways throughout human exchanges. Ideas may conform with qualitative states, as when a boy accepts a conventional teaching, say, that all Negroes are dirty and stupid, and reacts with aversion to his Negro classmate. If a class project forces the boy to cooperate with the Negro, he may find that this individual is not dirty and stupid. In time, the disconformity between his qualitative reaction to this Negro and his generalization about Negroes may bring about alterations in his cognitive structure.

Qualitative experience is not epiphenomenal, a bright streamer attached to the juggernaut of intellect. As there are times when only intellect can cope with perplexities, so there are times

when qualitative experiences make all of the difference. Even when the intellectual *yin* grows thinnest beside the bulk of the qualitative *yang,* cognition is there latent, perhaps, yet ready to assert itself. Experience is like a river, one bank of which is cognitive, the other qualitative. It is as incorrect to speak of a cognitive experience or a qualitative experience as it is to speak of a river with one bank. We may speak, however, of experience in the cognitive mode, as when a chess problem is being solved, or in the qualitative mode, as when an epicure is enjoying his first taste of mango.

Experiences in the cognitive mode range from customary ideas, deposits of past discoveries that may no longer be true, to conventional structures like philosophy and science designed for the revision of conventional beliefs. Cognition becomes specialized partly to improve upon the practical results of thinking, partly to advance the careers of those who find this occupation more delightful than any other, and partly to satisfy the qualitative yearning to know how the universe is ordered. If it is true that experience in the qualitative mode may be as decisive as experience in the cognitive mode, it would be surprising if there were no qualitative undertakings analogous to those which science and philosophy represent for cognition, no provision in the human scheme for approaching the mode of qualitative experience in the fullness of wonder. I believe that art is the activity we are looking for, an activity that allows us to experiment with the qualitative mode of experience as the traditions of science and philosophy allow us to experiment with the mode of cognition.

The mode of cognition frees itself from the demands of practical action to take up a position from which nothing escapes scrutiny and criticism. Art shows similar "stages" which we shall follow in the visual arts. There is, first, the qualitative aspect of practical action. When the mother feeds the crying child, the child is gratified not merely because its hunger is appeased but also because the response of the mother assures him that he has well-wishers in his strange environment. We go further when we use blankets, curtains, wallpaper, etc., designed and decorated for a function beyond the utilitarian one. Such objects represent a second stage, for they are concerned, not with qualities *of* action,

but with qualities *in* action. By means of the decorative arts we make daily life an opportunity to experience qualities as we make a garden an opportunity to see flowers.

In the third stage, art ceases to be an incident of daily life and the conditions of daily life become an incident in art. This is shown in landscape painting, most photography, portraiture, program music, certain kinds of poetry, drama, and the novel. If the second stage, that of the "decorative arts," constitutes a qualitative alarm clock reminding us that it is never too late to attend to the qualitative aspect of experience, the arts of the third stage constitute an inquiry into the kind of experiences in the qualitative mode which are possible under the conditions of daily life specified in the art itself. Art does not imitate reality; it uses portions of reality to demonstrate experience in the qualitative mode.

This third stage is comparable to Euclidean geometry. The items of common experience found in such art have a pleasant cogency as do the axioms of Euclid which long convinced everyone that space must be exactly like this. The fourth phase of art is non-Euclidean. The artist makes no attempt to introduce conditions from daily life. Elements of the work of art prompt experiences of qualities, but experience of secondary qualities, those associated with suggested situations and events, is minimized. This type of art is represented by nonobjective painting, most architecture, some kinds of poetry, and nonprogrammatic music.

Can the design of an alarm clock be as significant aesthetically as a quartet or symphony? The question is false because the symphony is designed as a separate experience whereas the alarm clock is thought of as part of a larger whole, as one of a number of well-designed house furnishings. But, you say, no single artist, no man of talent, designs these larger wholes that contain clocks, Hollywood beds, highboys, and now and then an epergne. This art is in the hands of interior decorators and newlyweds who imagine that they are guided by prevailing canons of taste. They are artists in their fashion even though their raw materials are not raw, being objects designed apart from one another as occasions for qualitative experiences. The frequent casualness of these practical wholes, perhaps mixing modern with Victorian, is itself important. Beethoven's Ninth is more rarified than interior decoration but it is

not with you day in and day out. Though we have affairs with masterpieces and marriages with utilitarian objects, both relations, being based on love, have lasting effects.

In some such manner we may follow the transition from the qualitative mode of practical action to the role of the artist who experiments with the qualitative mode of experience freed from utilitarian demands. Qualitative experiences in art are more manipulable than the qualitative mode of daily experience and less risky. Yet art, an experiment with the raw stuff of life, promises the greatest danger of all: that we may discover or create in art qualitative modes of experience that daily life cannot admit, cannot tolerate, and that there may become fixed in our minds that dream, at once the culmination of sanity and the beginning of madness, of remaking life according to harmonies found only in art. What Sapir (p. 347) said of religion applies also to artistic experiences:

> There can be neither fear nor humiliation for deeply religious natures, for they have intuitively experienced both of these emotions in advance of the declared hostility of an overwhelming world, coldly indifferent to human desires.

The cognitive problem is to build a symbolic structure that matches but is more manipulable than the objective world. The problem of aesthetic structures is different. Qualitative experience is immediate. When it occurs in the flux of life it is too intimately bound up with practical objectives to be more than a clue to the successfulness of action. Our understanding of experience in the qualitative mode cannot advance if the experience remains dissolved in activity. Yet we cannot adopt the procedure of cognition and step back into a symbolic microcosm, for this filters out the qualitativeness we wish to understand. Qualities must be made objective in the sense of being rescued from the stream of utilitarian doings and undergoings, but not objective in the cognitive sense. It is this kind of objectivity that art achieves, and it does so not symbolically but conditionally. By controlling or creating the conditions of experience, the artist examines the nature and intensity of the qualitative mode in which he is primarily interested.

Before defining art more closely, let me, by referring to the

"lower sense arts," bring out additional points. Are cooking and sexuality arts? Cooking provides a recipe, as much a public object as a piano score which might be considered a recipe for music. That a recipe may have many associations is seen in the link between commensality and friendship or in the symbolism of the Eucharist. Although the consumption of the blood and body of Christ has important qualitative implications, it would seem a little odd if one exclaimed over the savor of the Host and asked how it was prepared. The qualities of cuisine are specific. One does not seek to repeat the experience of eating apple pie in other forms of activity, as the Buddhist seeks serenity in all that overtakes him. This is why during the last war the patriotic posters which tried to convince our boys that they were fighting for a fifth freedom, the freedom to eat chocolate sundaes, seemed ridiculous. Such qualities are not sufficiently general to be significant except as they become symbols of experiences, like coming home, which prompt more powerful qualitative responses.

Since sexual indulgence is clearly a qualitative experience, why isn't the master amorist who arranges the conditions for this qualitative experience an artist? No permanent object—not even a score, in the form of a *Kama Sutra*—results, yet this is no different from the dance. Lovemaking might be regarded as a kind of choreography, and one with philosophic implications, as in Tibetan representations of copulation between a god and his consort. Treatments of the Bridegroom theme also suggest that sexuality is the closest common equivalent to the qualitative experiences of the mystic. What distinguishes the dance from lovemaking is that the first is performed publicly, the latter not, so that shareability is another essential aspect of art. An idea of an audience—even if it be an imaginary audience—capable of entering into the conditions of the experience provided by the public object or event, and joining in this communal act of appreciation, is part of every definition of the artist's role.

Art then is the creation, by manipulating a medium, of public objects or events that serve as deliberately organized sets of conditions for experience in the qualitative mode. Since the artist is unable to control the suggestions that arise from the presented and structural aspects of his work, as the user of concepts is able to

restrict the meaning of his terms, and since the nature of these suggestions varies with the experience and sensitivity of each individual, I can never be sure that my qualitative experience is the same as that which this object furnishes you or the man who made it. At the same time, if the audience—ideal or not—is as important to the artist as I believe it is, the artist does not leave the effect of his work to chance. Insofar as he uses established form-quality linkages (and this has nothing to do with the originality of his work), the experience of his audience will be in harmony with his own. We may even call art communication if we remember that what is communicated is a *range* of qualities rather than *a* quality. This is to be expected, for the discrimination of qualities does not encourage the military discipline and precision one encounters in the kingdom of ideas.[3]

We may now return to the purist-relationist paradox. The moment the artist loses sight of qualitative experience and makes his art a soapbox or debating society, he adds cognitive—polemic and expository—tasks to his job as an artist. This is possible because cognitive and qualitative are banks of one stream of experience; it is natural because art can make ideas as well as objects the conditions of experience in the qualitative mode. True, works of art from Dante to Dana have enunciated a message and have helped to bring about social changes while losing none of their integrity. The artist may intend or hope for such a result, because to assume that artists are not moved by injustice and do not desire to use their skills in remedying it is foolishness. But he succeeds by remaining an artist, by treating the situation as a condition of the qualitative effect he is creating. If this is what is meant by purism, the purist argument is sound.

The purist does not say that art has no effect upon life. He says merely that the artist cannot treat art, a matter of immediate qualities, as a mediate venture. The relationist position is not ruled out, it is just not clear how it can be true. Mathematics lies between referential symbolism and art. Like symbolism, it does not

[3] This matter of art and communication is important and complex, especially as it relates to the influence arts may have beyond the boundaries of the culture that produces them. Does the artist work for the universal audience of the scientist?

rely upon qualities, but like nonobjective art, it dispenses with references to the real world. The mathematician works with pure structures, as the artist works with vivid structures, and the physicist with referential structures. Physics looks for that mathematical system which best fits the arrangement of the physical world. What would happen if a high school student, aping the physicist, consciously compared the structure of Hamlet's experience with his own? Either the two structures would match or they would not. If they matched, the individual would accept the aesthetic structure. However, the fact of their matching means that the art, as a tasteful elaboration of already familiar experience, would be supererogatory. If the two structures did not match, it is difficult to see what could be done with the aesthetic structure but reject it as irrelevant. This hypothetical, conscious approach to relationism in the arts seems absurd, yet it underlies the popular attitude toward contemporary painting, an attitude summed up in the recurring question, "What does the painting represent?" That is, into what pigeonhole of my past experience does it fit? If the painting is found to be too large for any of these pigeonholes, it will be crammed in by means of joking descriptions like that attributed to Mark Twain—this is a picture of a cat having a fit in a plate of tomatoes.

Art is such that the relating of these two structures cannot be undertaken deliberately, it just happens. The qualitative experience, which is art, slips into the rich earth of personality like a seed. If the seed falls upon stony ground or is eaten up by birds of distraction, the sowing is fruitless. No conscious effort but that of giving oneself to the experience offered by the work can cause the seeds to break open, put out roots, and flower. Insistence upon a particular kind of relatedness makes impossible the transformation of our nature that art brings about.

SUMMARY

Though many cultures do not have a concept of art, all cultures produce art objects. Art, sometimes significant linguistically, is always significant experientially. Because it occurs in all cultures we know anything about, it has its origins in profoundly

human experience. Our problem is to understand the nature of this experience, bearing in mind three possibilities: that, without sacrificing any of its "purity," art may be related to other life processes; that understanding of qualitative experience through analysis of at least the more general aesthetic patterns called styles may shed light upon the interior articulation of cultures; that through this definition of art the methods and insights of art history, aesthetics, and the psychology of art may prove useful to the social sciences.

The more important phases of the artistic process were discussed and reasons given for selecting quality of experience as the nucleus of our definition. Comparison with cognition brought out the nature and importance of those experiences in the qualitative mode with which art is concerned.

Bibliography

Abell, Walter. "Toward a Unified Field in Aesthetics," *The Journal of Aesthetics and Art Criticism,* X, 3 (March, 1952), pp. 191–216.

Bullough, Edward. " 'Psychical Distance' as a Factor in Art and an Esthetic Principle," *British Journal of Psychology,* V (1913). Reprinted in *A Modern Book of Esthetics; An Anthology,* ed. Melvin Rader. New York: Henry Holt and Co., 1952.

Conrad, Joseph. *The Portable Conrad,* ed. Morton Dauwen Zabel. New York: The Viking Press, 1947.

Dewey, John. *Art as Experience.* New York: Minton, Balch and Co., 1934.

Freud, Sigmund. *Leonardo da Vinci: A Study in Psychosexuality.* Trans. A. A. Brill. New York: Random House, 1947.

Kroeber, A. L. *Configurations of Culture Growth.* Berkeley: University of California Press, 1944.

McAllester, David P. *Enemy Way Music: A Study of Social and Esthetic Values as Seen in Navaho Music.* Cambridge, Mass.: Peabody Museum of American Archaeology and Ethnology, 1954.

Mills, George. "Navaho Art and Culture: A Study of the Relations Among Cultural Premises, Art Styles and Art Values." Ph.D. Thesis, Harvard Univ., 1953.

Munro, Thomas. *The Arts and Their Interrelations.* New York: The Liberal Arts Press, 1949.

Sapir, Edward. *Selected Writings of Edward Sapir in Language, Culture, and Personality,* ed. David G. Mandelbaum. Berkeley: University of California Press, 1949.

Some Methodological Considerations in the Study of Australian Aboriginal Art*

RONALD M. BERNDT

Professor Berndt analyzes what can be learned about a society through a study of its art. He discusses the various opposing and supporting theories of other scholars who have concerned themselves with the two aspects of the problem as he defines it: on the one hand the aesthetics of a design, and on the other the communication of meaning through forms and symbols. He illustrates his belief that art can provide a key to a society's value orientations by his comparisons of the art and social organization of three Australian culture areas.

Dr. Ronald M. Berndt is Professor of Anthropology at the University of Western Australia. Political structure and organization, social control, culture change, religion, and mythology are his major interests, and he specializes in the cultures of the Aborigines of Australia and New Guinea. The ideas found in this article have been modified in his book *Australian Aboriginal Art* (1964) and in *First Australians* (1964–68), of which he is the coauthor with his wife Catherine. Ronald and Catherine Berndt are also the authors of *Sexual Behavior in West Arnhem Land* (1951) and *Aboriginal Man in Australia* (1965).

Social anthropologists only occasionally turn their attention to art, and then usually with some uneasiness. There is the lurking suggestion that this interest, however indirect, might on the one hand undermine their scientific approach, and on the other call forth from their colleagues one of the current terms of disparagement: ethnologist or ethnographer, with museum or "cultural" leanings. I realize of course that there are outstanding exceptions;[1] but it still

* Reprinted from *Oceania*, Vol. 29, No. 1 (September, 1958), pp. 26–43.

[1] E.g., R. Firth (1951, Chapter V); E. Leach (1956, III). See also M. Schapiro, in Kroeber ed. (1953, pp. 287–312).

In this paper I shall be speaking specifically of what is often called visual or graphic and plastic art, leaving aside other categories, such as poetry, literature, and song, which are often included under the broader heading.

seems necessary to emphasize that art is a legitimate topic for anthropological consideration, and one which has not had the attention it deserves.

People in many nonliterate societies spend a great deal of time and energy in the production of objects which may or may not be designed with a "practical" purpose in mind, but which, while not being *objets d'art* can be referred to as "artistic," in the sense that an aesthetic element is involved. This is not necessarily because such objects are referred to by some term like "beautiful," but because they are culturally congenial, in accordance with the local canons of good taste.[2] They strike a special chord of "meaning" relevant to the members of the social unit concerned. In other words, such productions have significance in social as well as in cultural terms: whether highly conventionalized or naturalistic, they are symbols that convey meaning. They tell us something about the kind of society and culture in which they are found, in much the same way as does, for instance, oral and written literature, or ritual and ceremony. This, however, is a question not only of aesthetics, but also of values and of style.

Since this is not a study of the empirical context of Australian Aboriginal art, I shall not discuss the many excellent works on this subject.[3] Nor does this paper deal with the subject of one people's response to the art of another. The question whether the decorative productions of societies other than our own constitute art in our terms, and the problems of "art" in contrast to "craftsmanship," or of art as essentially nonutilitarian, are therefore irrelevant here.

Among the Australian Aborigines, as among other peoples, literate or nonliterate, aesthetic expression takes a great variety of forms. In Japan, for instance, the common teapot, the *netsuke*, *tsuba*, and *inro* are just as important aesthetically as the *kakemomo*. In Arnhem Land, North Australia, the paddle, the dillybag, the pipe, and the spearthrower vie artistically with the bark and cave paintings, the totemic emblems, and so on. There is a comparabil-

[2] See e.g., H. K. Schneider (1956, pp. 103–06).

[3] E.g., A. P. Elkin (1954, pp. 222–43); A. P. Elkin, R. and C. Berndt (1950); F. D. McCarthy (1948/56), (1957, pp. 3–22). These works not only indicate specific art regions, but give a general picture of the wide sweep of Australian Aboriginal art and its intimate association with the life of the people. Further references are given in R. Berndt (1958*b*).

ity about them in that they represent media of aesthetic expression that we can call art. But in Aboriginal Australian languages there are no separate words for "art" or, for that matter, for "artist," and no separate category of persons specializing in this activity. In one sense it is quite misleading to speak of "art" in this connection, since the very use of such a term connotes preconceived views, not least in the matter of evaluation. This is a problem which enters into all translation, as such, and is not confined to the field of art. The point is that although most men in, for example, an Aboriginal Australian society can paint, carve, incise, and so on, there are usually some who are regarded as being better than others, or as having prescriptive rights through age, status, or ritual prestige to practice "art" or one aspect of it, that is, to paint rather than carve, to make ceremonial objects rather than everyday utensils, to paint or incise one design or pattern, or even one subject or range of subjects in preference to others. Two points should be noted: in the first place, because "art" is not categorized as such and artists do not constitute a specific occupational "class," art is subsumed under other activities that can be identified in our terms as religion, economics, magic, sex, and so on, and can be understood only in relation to one or more of these. In the second place, art can be understood in terms of its social implications, i.e., in terms of persons, "artists," sharing this particular role, while their other roles diverge, they occupy other statuses within their society. The social aspects of art have been adequately indicated from this point of view by, for instance, Firth[4] and Leach.[5] In other words, artistic activity is a cultural ingredient which colors and gives meaning to the social dimension, and in this respect it is not unlike other cultural features.

However, I do not wish to pursue this point, but to discuss the

[4] R. Firth (1951, e.g., pp. 172–73). He speaks (p. 173) of "the essentially social character" of nonliterate art, in that there is almost an entire absence of landscape, and where this is used it is subsidiary: emphasis, he says, is on persons. In Aboriginal Australia, I suggest, the social environment is that of man in nature; man in relation to man, and also man in relation to his natural environment and to all the species within it; when man depicts the world about him, through a culturally defined medium, both these aspects are given a more or less equal weighting.

[5] E. Leach, e.g. (1956, p. 22), considers it in terms of statuses in hierarchically ordered nonliterate societies.

problem of what a people's art can tell us about their society and culture, not only what it says about their social interaction and organization. There are two issues of which one hears a great deal in relation to the artistic productions of both literate and nonliterate peoples. On the one hand there are references to "creative" art, on the other to art as a spontaneous expression, with the assumption that people draw, paint, or carve "for pleasure." The term "creative" implies a certain ingenuity, a "newness" in expression that involves turning aside in some degree from orthodox or stereotyped paths, a departure from, if not a reaction against, traditionalism. In Aboriginal artistic expression the artist is always confined to a set of rules (irrespective of limitations as regards techniques and material) that are traditionally defined in terms of both design and subject matter. This does not necessarily imply fixity, since variation within a certain range is usually taken for granted, even though it may not be explicitly encouraged. There is always the "stamp" of one artist as against another: no two artists treat the same subject in exactly the same way; differences, subtle or otherwise, are nearly always observable. Nevertheless, individual expressiveness in a "creative" sense is restricted, and can flourish only to a limited degree. This in itself tells us something about that particular situation, as contrasted with others. What it tells us is relevant not only to the individual artist but to members of the social unit or units to which he belongs.[6] In this sense, then, finding the "meaning" of a given item of art is not just a matter of identifying its subject matter.

Like language, art, as I am using the term, cannot exist without communication, and like language too, it is limited by and to some extent reflects its social and cultural context. In its very structure, in the way sentences are formed, in the choice of words and in their positioning, the parallel between language and art is striking. Language, like art, may be held to embody a people's "genius," its "spirit" or "ethos." This is so in Aboriginal Australia,

[6] The personal element in art, so obtrusive in our own society, is played down to a minimum in an Aboriginal Australian society, even in the representation of a private dream or incident (see R. Berndt, 1951, pp. 71–84; Elkin, Berndt and Berndt, 1950, Plates 10 A and 11 A) the social aspect is paramount. But see C. H. Berndt (1958) in reference to New Guinea (Eastern Highlands) ceremonial emblems.

whether we are concerned with relatively naturalistic or with highly conventionalized art. The conveying of symbolic meanings through this medium, as through language, represents a way of communicating; it is semantically significant. But the way in which it is phrased, the way in which these symbolic meanings are conveyed, brings in a further dimension to which I shall return presently.

Mountford (1956, p. 6) holds that one of the reasons that Arnhem Landers paint is for the sheer pleasure of it.[7] The position, however, is not as clear-cut as this. On the one hand, if this suggests that it is a spontaneous, or primarily personal affair, with no social pressures involved, then it is hardly applicable to the Australian Aboriginal. In the traditional context, that is, apart from such relatively recent developments as the "Hermannsburg School," he operates within the confines of established conventions, using media agreed upon and recognizable by other members of his community. I am using "recognizable" in a broad sense, in reference to designs that may or may not at once convey such meaning. On the other hand, if the suggestion is that he obtains "pleasure" in carrying out a particular piece of work to the satisfaction of himself and/or others, so that it conforms to local taste and is acceptable, then possibly this feeling is common enough. The key word is "acceptable," implying as it does the relevance of at least one person other than the artist, and also some standard or criterion against which it may be measured. In other words, it points to the social context.

All Australian Aboriginal art is, basically, utilitarian. It is specifically designed to have some use, or some direct or indirect purpose or effect. This does not necessarily affect its aesthetic quality or the "pleasure" it may give both artist and others. In Aboriginal Australia, and Arnhem Land is no exception, the range of items, as mentioned above, through which artistic effort may be manifested is fairly wide; for example, there are bark paintings and emblems used in a religious context; sacred designs painted on flat-bladed spears, so that game killed by means of them is tabu to all but those who own the designs; and figures painted on sheets

7 This is the view of art as "play," insofar as it is self-justifying. See e.g., R. Redfield, in H. L. Shapiro (1956, p. 366). However, cf. his remarks on p. 377.

of bark or on cave walls for various magical purposes, or as a "statement" verifying a particular story.

Much of Aboriginal painting, carving, and such like, has a mythological significance, although some is concerned primarily with everyday activities, hunting and food-collecting, camp life, mundane situations, sexual activity, et cetera, which have no direct connection with myth and ritual. But any one Aboriginal community having at its disposal this relatively wide range of topics for visual representation, can be said to use as a vehicle for its expression a more or less specific "style,"[8] which, except in subject matter, does not show essential differences within that range. I shall return presently to this point also.

Aboriginal art, whether in a religious, magical, or secular context, is frequently representational, but much too, particularly in the religious category, could be called abstract,[9] or highly conventionalized. Abstract, in the sense in which the word is used here, means removal from the representational or naturalistic perspective, however this may be conceived in a particular tradition, to a stylized or conventionalized design which may involve symbolism.[10] Of course, the purely representational may be symbolic, but the "abstract" is a further generalization. This is particularly the case with the clan and linguistic group designs, and the sacred emblems of Northeastern Arnhem Land; or with the bark paintings relating to sorcery from Western Arnhem Land (*vide* Elkin, Berndt and Berndt, 1950, Plates 15 and 16).

As Firth (1951, p. 177) has pointed out, not all art of nonlit-

[8] A. P. Elkin (1954, p. 243) infers this when he speaks of "schools" of art: McCarthy (1957, e.g., pp. 16–17) also discusses briefly various Aboriginal art styles.

[9] Leach (1956, pp. 32–33) makes the point that the art of nonliterate people "is definitely representational rather than abstract. It is intended to be understood . . ." Also see Leach (1954, p. 105). This is not the case in e.g., Arnhem Land, where both representational and "abstract" are intended to be understood and are indeed understood. There is no reason that one should be more difficult to comprehend than the other when both concern local "style"; both are part of the traditional pattern, even though the one corresponds much more closely than the other to its counterparts in the "real" world. See also, e.g., M. Herskovits (1948, p. 382).

[10] Firth (1951, p. 175) has written that "art necessarily implies selection and abstraction from reality": and these refer to "the social proportions of a subject."

erate peoples is symbolic, and this is true too for Arnhem Land: there is much that can be viewed as simply descriptive, and much that is simply design or motif without any direct or admitted meaning. But throughout Arnhem Land there is much too, especially in a religious or magical context, that is symbolic; and it is this symbolism expressed through art that has social implications for, as stated earlier, all art is a way of communicating between members of a particular community. The meaning of most representational and some abstract art may be understood at different levels by the members of that community, depending on whether or not additional explanations concerning content are necessary. A painting may be understood immediately in terms of its subject matter; for instance, human beings, animals, trees, or "abstract" symbols for clouds, rain, camps, and so on may be immediately identified; but it will possibly be necessary to explain the context or situation in which these representations and symbols appear in combination; in other words, the story or stories relating to them. On the other hand, this latter element may be revealed only to a select company: to members of a linguistic unit, for instance, and not to "outsiders." Or particular designs may be shown only to men and not to women, or only to men of certain categories; or the symbolic meanings of various designs may be revealed, or change their context, in accordance with a man's progression through age-grading rituals, or with his ritual and ceremonial position in adult life. Not only the designs themselves, but also the symbolic interpretations, may vary. Moreover, sex differentiation, social and ritual status, and prestige are involved here. Thus art as communication can tell us something about social positioning. In any artwork of the kind I am discussing, there must be some element of shared recognition in the symbolism, even if that recognition varies according to social categories of persons. For this there must be acknowledgment that certain designs or patterns, or figures (representational or "abstract") are distinguishable in terms of meaning, and this hinges to some extent on aesthetic judgment. In other words it is dependent on form and style.

In some circles it has been suggested that nonliterate peoples are especially adept at handling and understanding symbolic statements through art, ritual, or speech, and that this marks them off from the literate world as people who think "mythically" and

"poetically."[11] This is in itself an example perhaps of "poetic," but certainly of imprecise or inexact thinking. Our own language and our art contain an abundance of symbolic allusions, which is part of our traditional heritage as Western Europeans, and this is much the same in Arnhem Land or elsewhere. Some people have more, some less, and the development of scientific precision or growing emphasis on technology does not necessarily diminish it; nor is this a question merely of nonliterate as contrasted with literate.

Representational or "abstract" art designed to convey meaning either to an entire community, or to certain categories of persons within it, can be understood only by those belonging to that society, and sharing its particular tradition. To be able to interpret the design and its symbolic significance there must be shared recognition, otherwise such designs and symbols become meaningless, or may be accorded quite different meanings. There is a further parallel here with language: We can hear the sounds, but unless we know the language we cannot hope to understand those sounds, to derive meaning from them. Likewise we cannot infer the meaning of any one design, particularly of a stylized kind, simply by observing or analyzing a specific situation or action-sequence in the society that has produced that design, anymore than we can understand the language used by members of one society by observing the art productions of that society. The method used by Leach (1954) to elicit the meaning of a Trobriand Island shield design,[12] is one which draws only in part on the

[11] A recent example of this view, in the anthropological field, is afforded by E. Leach (1956, pp. 29–30): "The illiteracy (by which he presumably means nonliteracy), of primitive (sic) peoples is also significant in another way. Whereas we are trained to think scientifically, many primitive peoples are trained to think poetically. Because we are literate, we tend to credit words with exact meanings—dictionary meanings. Our whole education is designed to make language a precise scientific instrument . . . But in primitive society the reverse may be the case . . ." This oversimplification could be attacked on many counts, and certainly represents an ideal or normative statement rather than a statement of "actuality." Literacy as such does not infer preciseness of meaning.

[12] It seems to me that this is what Leach has done in imputing a specific meaning to a stylized design on a Trobriand shield (1954, pp. 103–05). See R. Berndt (1958a).

relevant material. The procedure, for instance, would be quite unrewarding if, using descriptive material from Western Arnhem Land culture, we were to explore the meaning of the bark painting illustrated in Elkin, Berndt and Berndt (1950, p. 77, Plate 15); apart from identifying it as anthropomorphic, little else could legitimately be said about it. In such an interpretation much depends, as it did in the case of the Trobriand shield, on the functional significance of the object on which the painting or design appears: it is this that provides the "key," so to speak. Since the procedure here is arbitrary, and since there are too many "uncontrolled" factors, this cannot be regarded as a legitimate method of Social Anthropology. Even so there is no reason entirely to discard it, provided we recognize it for what it is.

We are at this juncture faced with a twofold problem. On the one hand there is the question of aesthetic appreciation; on the other, there are the form and nature of the design, which may or may not be taken to be meaningful. In the first case, some system of standards or values must be operating, against which "good" and "bad," satisfying or dissatisfying, can be measured.[13] In other words there must be social relevance, or recognition.

In the second case, the question hinges on "style" (e.g., Leach, 1956, pp. 36, 37; Herskovits, 1948, pp. 398–413): the style or form itself may, for instance, be regarded as expressive of ethical ideals. Thus the protuberant "phallic" nose of the Sepik area (New Guinea) may be regarded as a tangible manifestation of a dominant aesthetic value. that long-nosed persons are physically attractive, and that this particular trait is linked with a number of other desirable characteristics; the style of the mask, ancestral figure, or prepared head expresses or symbolizes that value.[14] Or, in the case of Pahari or Northern Indian art, with its vogue for pictures relating to the great Hindu epics, particularly the *Gita Govinda* of Jayadeva and the general literature of love: Archer (1952, p. 5) suggests, in rather broad terms, that this "can only be explained in terms of Rajput society, its repressed wishes,

13 See C. Kluckhohn in Parsons and Shils eds. (1952, pp. 388 *et seq.*, 394, 411).

14 G. Bateson (1936, pp. 163–64). But see also D. Fraser (1955, pp. 17–20).

its emotional needs, its poetic values, its dominant attitudes; and it is hardly surprising that the paintings which reflected these pre-occupations should develop a distinctive style." A Coomaraswamy (1956, e.g., p. 34; and also *Mārg*, 1957) gives an example of the relationship of art of the Gupta period to certain aspects of social and cultural life, although his discussion relates primarily to content.

Style, to Schapiro (1953, p. 287), is "a system of forms with a quality and a meaningful expression through which the personality of the artist and the broad outlook of a group are visible. It is also a vehicle of expression within the group, communicating and fixing certain values . . . through the emotional suggestiveness of forms." In Baroque art, "a taste for movement determines the loosening of boundaries, the instability of masses. . . ." (1953, p. 292). Leach (1956, p. 37) touches on this point in drawing atten-tion to the flamboyant totem pole art of British Columbia, the elaboration of Maori spiral and circular ornamentation, and the artistic taste of mid-nineteenth-century England, and states that such resemblances are not altogether accidental, that they are expressive or reflective of common moral values, since each society was "characterized by notions of a class hierarchy coupled with much social competition."[15]

On this point there is a difference of opinion among anthro-pologists. At one extreme there is the position adopted by Nadel (1951, e.g., p. 89), who holds that art style is an "autonomous" cultural activity or "dimension of action" which, unlike the "con-

[15] Levine (1957, pp. 949–63) gives promise of adopting this line of approach (see especially pp. 949, 954), stating as his thesis that if there is an association between art style and culture (society), and this can be demonstrated in relation to Aboriginal Australia (on the basis of Arnhem Land material), in other words, if Aboriginal art style "says something" about Aboriginal society and culture, then what does the style of prehistoric art tell us about the culture and society that produced it. Of course here there is the "Trobriand Medusa" dilemma (Leach, 1954; R. Berndt, 1958a), that Levine does not consider; further, the rest of his paper commits the anthropological fallacy of interpreting the significance or meaning of pre-historic art on the basis of what we know about contemporary Australian Aboriginal culture and art.

A much more cautious attempt is made by A. F. C. Wallace (n.d., pp. 3–22), in an article that examines certain points of style, using them as projective data that may provide clues to Maya personality.

tents or operational aspect" of art, bears no relation whatever to social or even to other cultural features. The "only . . . kind of nexus" which can be established here, he says, is "of purely intrinsic nature." His unwillingness to admit even the possibility of a relationship, and his very choice in this connection of the dogmatic word "autonomous," contrast with his enthusiasm for tracking down linkages of a no more obvious kind in regard to other social and cultural phenomena (Cf. his "thread of meaning" discussion—*ibid.*, e.g., pp. 324–25). However, his view rests on a narrow interpretation of the problem, since in separating this "autonomous" zone "from the two-dimensional entity which is culture and society," his "unambiguous" criterion is the "essential fact . . . that they do not require specific group relationships for their realization" (*ibid.*, pp. 89–90). This appears to be quite different from the approach suggested by Lévi-Strauss (1953, p. 62), who envisages a "grammar of style" that "must be understood by itself," but in which "correspondence can be found . . . between the systematized forms . . . abstracted on the different levels." The solution as he sees it lies in developing "mathematical methods" to provide more efficient explanatory models; structural linguistics, he says, has already made some progress along these lines. Nevertheless Nadel touches on the same issue when, in speaking[16] of "logical consistency in behavior," he says that even in respect of "formal traits" there may be "some organizing principle underlying the modes of expressing diverse contents."

Outside the general range of anthropology there has been some concern with this problem;[17] but within it the main interest has been shown by "cultural," as contrasted with "social," anthropologists.[18] Their exploring of possible relationships here does not

[16] S. F. Nadel (1951, p. 260); but cf. his cursory reference (pp. 260–61) to "instances of a purely formal consistency, as when . . . the same style pervades the whole field of art."

[17] I do not want to go into details and references here: for a short summary of certain aspects of it, see M. C. Albrecht (1954, pp. 425–36; e.g., pp. 426, 427–28, 430–31, 435).

[18] See e.g., E. Carpenter (1955, e.g., pp. 140–45); C. Kluckhohn and D. Leighton (1946/48, e.g., p. 226); D. Fraser (1955, pp. 17–20).

Some of Fraser's remarks might also have been designed to provoke the response of "subjective" or "highly emotional," and to confirm the suspicions of social anthropologists who distrust this type of study. E.g., in referring

necessarily stem from any preoccupation with functionalism in the Malinowski sense, but it does indicate their reluctance to accept as "given," not questioned, the "autonomy" of any aspect of culture. If some of their efforts are open to criticism, this does not mean that the question itself is not worth pursuing. After all, the study of social phenomena too, especially in its earlier efforts, is not beyond reproach: methodology and techniques in this sphere have been rather slow in developing. The impressionistic state of the field at present, then, is a matter for concern only if acknowledgment of this does not lead to consistent attempts to improve it.

This is not a problem that can be solved by the simple method of asking people questions about it, since it lies outside the range of ordinary "homemade models," or constructs. It is one for a social, or cultural, scientist, well acquainted with the data, interested in searching for the kind of relationship which is not as a rule explicitly articulated or conceptualized, and of which the people themselves in any given society may not be at all aware. The problem becomes more complicated in societies such as our own, with so many crosscurrents and mixtures of styles in various fields; but for preliminary consideration at least, as in other spheres of inquiry, an area like Aboriginal Australia may present a rather less confusing picture.

Art, whether naturalistic or stylized, is always an abstraction from reality—from the empirical situation: it is a statement about something, expressed in a specific way, and the ways of saying it vary as do languages and other aspects of culture generally. But within a particular society, although variation takes place through

to the Mundugumor head illustrated in Plate B(c), he says: ". . . one is not surprised that cannibalism, extensive headhunting and an atmosphere of intratribal hostility lie behind this cruel face." See also Fraser's comments on the style of coastal (Bisman) art, as compared with that of the Lorentz river area, in his review of van Renselaar's volume (1957, p. 143).

I am not referring to such approaches as the Goodenough "draw-a-man test," or the Machover figure test, since these rest primarily on content rather than on style (e.g., on an evaluation of what is or is not included in drawings of the human figure, against an arbitrarily defined normative standard). Nor am I taking into account, in this discussion, the fact that the boundaries of "a society" and "a culture" rarely coincide: for my purpose here, I am concerned primarily with the social dimension, and secondarily with the cultural content.

time as well as through the growth of "schools," an art style may provide us, in abstract, with a "key" to the value orientation.[19] It is linked with the concept of "ethos," expressive of the outlook of the society for which the style is valid.[20] It is too early to know just how rewarding such an approach might be, since relatively little consideration has been given to this topic by social and cultural anthropologists; and the method of investigation needs careful working out, if it is to represent more than just guesswork. Nevertheless, there is enough material to hand to suggest that the relations between aesthetic expression (or style) on the one hand and social phenomena and belief systems (or values) on the other are certainly worthy of study.[21]

In Mountford's volume (1956), as in Elkin, Berndt and Berndt (1950), the art of two adjacent regions is contrasted: Western Arnhem Land (centered on Oenpelli), and Northeastern Arnhem Land (centered on Yirrkalla). The areas are close enough to have been subject to cross-fertilization over the years.[22]

19 I.e., in the sense defined by Kluckhohn (1952, p. 411).

20 L. Mair's brusque dismissal (1957, p. 233) of this whole question, with the claim that "in the formulation of problems it has nothing in common with the study of society," evidently stems from her reluctance to admit the relevance of "culture" in social anthropology. Note, by the way, her reference to the study of society as "essentially that of socially regulated *interpersonal* relationships" (my italics).

21 Two psychological studies of aesthetic appreciation among Southwestern Arnhem Land Aborigines have made their appearance in recent years: W. A. McElroy (1952, pp. 81–94), (1957, pp. 269–72). These are, however, not relevant to the present study since they add nothing to the basic problems I am exploring. The first comes to the conclusion that "good taste" (or aesthetic appreciation) is almost entirely determined by the cultural conditioning of perception; this has long been recognized by both anthropologists and art historians. The second paper concerns the question of "compulsive" orderliness (the practice of covering areas with round or oval dots, which is a feature of some Western Arnhem Land art). McElroy points out that this cannot be correlated with "anxiety connected with excreta," and that compulsive orderliness in behavior is here found without psychoanalytic complexes of the anal type.

22 In any such contrast, a matter of crucial importance is what happens where the two regions adjoin. In other words, can we distinguish the differences in question within the border area, or is there a blur or merging? The "intermediate" zone in this case can be taken as the area stretching south from Cape Stewart, part of it occupied traditionally by the Barara or Burara, with whom no systematic work has been done. What information

If we consider the bark painting, we can say the techniques and mediums in the "east" and "west" do not differ radically; or, with a few exceptions, does the type of subject matter. Yet in the matter of style the contrast is on the whole quite noticeable.[23] Reference may be made, in the case of Western Arnhem Land, to Mountford (1956), for example Plates 51, 54, 56, 61, 69, 71, 72, 76, 79, or Elkin, Berndt and Berndt (1950), Plates 2, 15, 16, 17; and for Northeastern Arnhem Land, Mountford, Plates 89, 93, 98, 99, 100, 107, 116, 117, 119, or Elkin, Berndt and Berndt, Plates 10 A, 10 B, 11 A, 11 B, 12 A, 12 B, 14.[24]

we have seems to suggest that, culturally at least, it is composite: people from the west include the Barara within their social perspective, as having the same general social orientation, while those from the east include them in theirs. Further, there is no adequate series of bark paintings available from the Cape Stewart area. South, toward the upper reaches of the Goyder River, with the Rembraŋa (Rainbarŋa) on the west and the "Malarg" people on the east, quite typical Western Arnhem Land bark painting has been illustrated by Wilkins (1928, facing p. 156). In that area there is not sufficient information to indicate an intermediate zone. Immediately west of Cape Stewart lies the Liverpool region, and as far as we can tell from material available this is of "real" Western Arnhem Land type (see R. and C. Berndt, 1951). Immediately to the southeast of Cape Stewart lies Milingimbi Mission Station which, although predominantly part of the eastern bloc, has been visited consistently by the Barara (Burara) (apparently since 1926–29, Warner, 1937). It is possible that Western Arnhem Land influence here has resulted in some modification of "typical" Eastern Arnhem Land art style. Although here again no full series of bark paintings is available, the examples I have seen suggest a rapprochement between the two relatively distinct styles. On the other hand, Warner's field work was carried out primarily at Milingimbi, and his data provide a basic "pattern" for what has been broadly identified as Eastern Arnhem Land. The same tendency toward rapprochement or synthesis is currently in evidence at Elcho Island, which has had considerable influence from Milingimbi. The bark paintings that I collected there early this year (1958), apart from a general deterioration of traditional art (paralleling the growth of an "adjustment" movement in that island), show less preoccupation with detail, which is still (early in 1958) much in evidence at Yirrkalla.

23 A. P. Elkin (1954, pp. 234–36) speaks of contrasting design between Western and Eastern Arnhem Land.

24 R. and C. Berndt (1957) contrast Northeastern with Western Arnhem Land art. Photographs are available of the seventy paintings shown in the exhibition and price will be supplied by the University of Western Australia upon application.

The Western Arnhem Land artist ordinarily makes no attempt to cover the complete surface with design. He prefers open spaces, so that his subjects stand out boldly unhampered by superfluous detail; and, generally speaking, he selects fewer features for illustration on any one bark than does his counterpart in the east. He concentrates on the main figure or figures rather than on their setting. When there is detail it is subordinated to the main design, which receives careful treatment, usually against a plain red-ochred background. The subject matter includes human beings and animals in action; in fact, the device of leaving the maximum of space, so that the eye focuses readily on individual figures, gives an impression of suddenly arrested motion. This tendency has possibly led to an emphasis on relatively naturalistic figures, with a minimum of stylization. This is true, too, for the anthropomorphic sorcery paintings, and for the so-called X-ray designs indicating the internal organs of human beings, animals, fish, the fetus within a pregnant woman, and so on. There is a preference for curves and "roundness" (including the use of dots), rather than for angles and straight lines.

In the case of Northeastern Arnhem Land, the artist usually attempts to cover almost the complete surface of his sheet of bark with design, leaving little or no open space. I say "almost," because in many cases he is apparently not satisfied with the boundaries provided by the length and width of the bark. Instead he tends to shape his design within a self-imposed framework, often roughly square or rectangular, just as he does in body paintings, e.g., on chest or abdomen, where no such clearly defined "natural" limits are present. The Western Arnhem Lander, on the other hand, does not ordinarily "frame" his design in this way, leaving the outer edges unrestricted except as regards the limits of bark itself. In the Northeast, the central designs receive careful attention, and there is considerable detail; but there is not as a rule the delicacy of treatment that is so apparent in the West, and the background of most figures is filled with cross-hatching or crisscrossing of lines. Even if this is not done, as much as possible is crammed into this background, even to the extent of design repetition.[25] Aesthet-

25 Cf. R. Bunzel, in F. Boas (ed.) (1938, e.g., pp. 560–61).

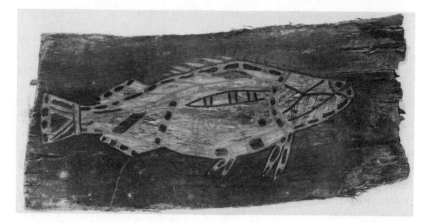

Bark painting of a Barramundi fish painted in white with outline and other details in pale red, ochre, and black on the natural brown surface of the bark. X-ray style showing inner organs. Northwest Arnhem Land, Australia. The Brooklyn Museum, New York.

ically, blank spaces on such a drawing seem to be unpleasing to artist and observer; but the material used to fill them is never meaningless. There is little in the way of movement or action in design. There is a tendency, much more noticeable than in the West, to repeat both central and subordinate figures, as well as minor motifs, giving the effect of a pattern, as in, for example, European-type textile design. Where such figures or motifs stand out from their background, this is achieved not as a rule by separating them spatially from it but by the use of contrasting colors to outline or fill them, whereas in the West both devices are employed. Further, there is a "playing down" of naturalism, with a corresponding concentration on stylization, and symbolism expressed in varying degrees of complexity to suit a society that is hierarchically graded in respect of religious knowledge. Specialization in design is much more noticeable in this part of Arnhem Land, where the various clans and linguistic units have their own particular designs; but although these may be fairly easily distinguished from one another in respect of minor differences, they are all relatively uniform in style.

I have not indicated all the features of each style; but if what I said earlier is valid, these contrasting styles should bear some relation to the social and cultural situation in the two regions. I shall mention, tentatively, one or two points which seem to be relevant here.

The main differences between the two regions in the matter of social alignments can be briefly summarized as follows.[26] In the West the language unit, conforming to what is conventionally called a "tribe," is not exogamous. Within and beyond it, reference to patrilineal affiliations is confined to the *namanamaidj* or *(j)igurumu*, traditionally associated with specific localities. The named matrilineal moieties, subdivided into named phraties[27] also with matrilineal descent, have incorporated a subsection system of relatively recent introduction. In the East, within the framework of two named patrilineal moieties the largest social unit is the *mala*, or clan, associated with several *mada*, linguistic or dialect units, each of which in turn comprises several linked patri-lines; all these are exogamous. As in the West, the subsection system is an additional feature.[28] All this, far more so than in the West, presents a crisscrossing of affiliations not unlike the cross-hatching so common as background in the bark designs. Apart from the major moiety division, one could almost see this as an arrangement of small overlapping compartments: structural interconnections between *mala* and *mada* take the form of a number of conventional combinations, some of them depending for instance on ideal marriage types, which however take into account also marriage "rules"

26 Of necessity I must speak very generally. As far as the barks are concerned, those collected by Mountford (1956) and discussed in his volume are not allocated to specific "tribes," or, except in a few cases, are those for Northeastern Arnhem Land allocated to specific clans and linguistic units. All bark paintings collected by Berndt are accompanied by the name of the artist and his tribal (Western Arnhem Land) or clan and linguistic unit (Northeastern Arnhem Land) affiliations. In this particular paper, however, when I speak of Western Arnhem Land I am thinking primarily of the Gunwiŋgu who represent the major part of the population in and around Oenpelli.

27 See A. P. Elkin, R. and C. Berndt (1951, pp. 253–301); R. and C. Berndt (1951).

28 W. L. Warner (1937, e.g., pp. 15–51); R. Berndt (1955, pp. 84–106), (1957, pp. 346–51).

based on kin and, now, subsection affiliations. Also, because of differing *mala* affiliations, the land associated with any given *mada* may not be "all of a piece," but may be intersected by territory belonging to other units.

The preponderance of detail in the East, the avoidance of open spaces within the limits of a drawing, are paralleled by the numerous totemic associations of clans and linguistic units, with "inside" (esoteric) and "outside" (exoteric) terms for objects, beings, or concepts: not just one or two, but several, each with associated symbolic meanings, used in different contexts, with relevant "singing" words as well. There is a liking for reiteration and symbolic reference, one within another, like a Chinese nest of boxes, the full impact of which is not attained in a general translation.[29] The great substantiating myths with associated ritual are shared sectionally among the clans and linguistic units, each concerned with its own detail, but often duplicating that belonging to others; on the one hand sure of its separateness and identity as contrasted with all others, but on the other acknowledging the ideal of the interdependence of all such units during the big ceremonies. In this region a man's progression through life from before birth until after death, until part of his spirit enters the appropriate Land of the Dead, and even after that, is, or was until just recently, marked by fairly well defined "stages" of religious significance. On the one hand, status and prestige hinged on these, as representing layers of revelation in the accumulation of sacred knowledge; and on the other on strength gained through successful competition in trade, accentuated by alien contact, and on a reputation as a fighting man. Superficially, these two ways of attaining power and social recognition appear incompatible and indeed conflicting; but a closer glance reveals that going through these stages and acquiring the knowledge associated with them, apart from the obligatory initial rituals, involved an outlay of goods and gifts. It was not possible to progress socially and religiously without paying fairly heavily for it.

The Western Arnhem Landers have a great variety of totemically-based emblems, but the ritual and ceremonial contexts in which they appear are not as numerous, and do not show the same

[29] See R. Berndt (1948, pp. 16–50), (1952); C. Berndt (1950, pp. 286–332).

detail and reiteration as those we find further east. It seems likely, moreover, that this wider range has become available only through the intermingling of tribal remnants, probably as a result of alien impact.[30]

In Western Arnhem Land life is not, or rather was not, arranged in a series of ritual stages from birth to death and after, except for obligatory initiation. Religion is not the permeating force it so obviously is in the Northeast; it is still extremely important, but here the distinction between "sacred" and "nonsacred" for general purposes is more clearly drawn, whereas on the eastern side when it can be made at all it is decidedly blurred. Status and prestige, although closely connected with religious aspects, depend primarily on "secular" considerations: on sexual prowess, on one's potentiality as a fighter, and on wealth.[31] Fighting in the West, apart from merely interpersonal affairs, was relatively direct, often

[30] The traditional ritual objects of the Gunwiŋgu of Western Arnhem Land seem to have been relatively plain: a good example of this would be the *ubar* drum or gong (see R. and C. Berndt, 1951). However, the *maraiin* rituals have associated with them a much larger series of sacred objects than those found in Eastern Arnhem Land: and many of them have intricate patterning which at times exceeds that found elsewhere in Arnhem Land. (See for example B. Spencer, 1914, Plates facing pp. 218, 220, 222, 224; contrast with those in Warner, 1937, Plate III B). And although the *maraiin* cult possibly had its origin in Eastern Arnhem Land, it has apparently been well established among the Gunwiŋgu and other Western units for some considerable time, at least since Spencer's survey of 1912.

But to focus attention on art style only as manifested through bark painting is to oversimplify the problem of comparison. It becomes much more difficult when one begins to take into account varying art styles in one "society," as in the case of the *maraiin* objects of Western Arnhem Land, and their relative complexity of design and treatment. Although this is another issue which cannot be explored here, we might see on one hand, in the cultural dimension, increasing ceremonial complexity through the westward drift of the Gunwiŋgu and Liverpool River people to the Oenpelli region; and on the other hand, in the social dimension, the acceptance of the Eastern Arnhem Land patrilineal moiety divisions, retaining their original names, for ritual and ceremonial purposes. The spread of the subsection system into both regions, with the use of closely similar terms, represents a further aspect which they now hold in common. (See Elkin, Berndt and Berndt, 1951, pp. 260–64).

[31] That is, speaking generally. The Gunwiŋgu is not such a "straightforward," secularized, and materialistic person, but it is the "impression" conveyed, the construct, which I am now considering.

unsupported by religious sanction and ceremony. In the East it was linked with mythology, and to a certain extent ritualized, especially in relation to the settling of disputes.[32]

Although in the West there are "sacred" and "secular" renderings of certain words, there is not the cumulative sequence, with varying symbolic references, of the eastern area. Neither do we find there the elaborate structure of the eastern poetic song versions, arranged in cycles, and containing, in addition to many "singing" words, a fair amount of ordinary conversational material—to be seen perhaps as a filling in of the background, a building up of small details, against which the main symbolic allusions are set. Instead we find the succinct, more or less "typical," Aboriginal songs: plenty of repetition, but concepts sparsely enunciated in the shape of "key" words. The "gossip" songs are an exception; they are frankly expressive, straight to the point, though not lacking in innuendo.[33] They have, however, a counterpart in a series of "contemporary" songs on the eastern side, which have been composed within the last fifteen years or so.

Then there is the matter of language.[34] In the East the various dialects, differing from one another mainly in regard to vocabulary, are easily learnt up to a certain point; beyond it, because so much is left to the understanding of the listener, a knowledge of context is essential. Verbs, or action words, for instance, are virtually uninflected; there are no noun classes; and although communication seems to proceed fairly well between people who share the same conversational "background," of which speech is only one form of expression, yet where more than observable or concrete material is concerned it offers certain difficulties to strangers. On the western side, to take Gunwiŋgu as an example, there are four noun classes; and by affixing various particles to ordinary verb stems, it is usually possible to indicate not only the number or person of the originator of a certain action, but also the number or person of those affected by that action, or the thing so

32 See, e.g., L. Warner (1937, pp. 155–90).

33 R. and C. Berndt (1951, pp. 211–40).

34 Compare the two papers: C. H. and R. M. Berndt (1951, pp. 24–52) and C. Berndt (1952, pp. 216–39; 275–89).

affected.[35] Certainly in the West, once one has learnt the "rules," translation offers fewer pitfalls, or fewer alternative possibilities, than in the East. Although here too there is a certain amount of "talking around the point," this seems designed to achieve greater precision or at least to avoid misinterpretation. It is much easier to be vague, to avoid specificity, in the East than in the West. Gunwiŋgu, too, like certain other western languages, has a special vocabulary for use between a man and his actual or classificatory mother-in-law, enabling them to communicate directly without intermediaries. A similar situation appears in respect of kinship terminology. In both East and West there is the ordinary series of kinship terms, of address and reference. But over and above these, in the West, is another, though not entirely distinct, set of reference terms, known as *gundebi,* which depend on the relationship between the person spoken to and the person spoken about. This again is an attempt to avert misunderstanding, to specify exactly without leaving too much to the imagination.

In broad terms, as compared with the East, there is a more obvious directness in the West, a dislike for detail except where it has direct relevance, as for instance in the treatment of the central figure of a design or in an X-ray drawing. The effort at clarity in approach, the greater preciseness in language, the lack of elaborate symbolism and so on, suggest naturalism in art style, action in representation, and a straightforward approach to the subject, unhampered by a crowded setting in which it might be in danger of losing to some extent its individual identity.

There is a certain degree of "fit" between the social and cultural context and style in each of these cases; but it is obvious that much more needs to be said, including consideration of the criteria involved in evaluation.

To take one last example: from the Aranda of Central Australia. The sacred flat stone *tjuruŋa* with incised design is possibly best known, and has its counterpart in wood, of varying lengths, over much of the desert and semidesert inland of the continent.

[35] There are also more expressions of doubt in the West, such as words which could be translated as "perhaps" or "maybe": and this might be associated with the pervasive Rainbow Snake mythology, with its recurrent theme of death.

Designs vary considerably even within the Aranda constellation itself, but predominating are "concentric circles and portions thereof, such as the U-within-U figure, sets of parallel, straight, curved, and spiral lines, often encircling and twining in and about other elements, lines of chippings, rows and panels of dots, and tracks of birds and animals."[36] And much the same motifs are duplicated or extended on their sacred ground paintings,[37] their emblems and so on. In other words, the elementary designs are at first glance simple: deceptively so, since they are symbolic representations having indirect reference to a relatively complex ideology and belief system that gives little indication of the simplicity so characteristic of the art style.[38] The style itself *is* simple, especially in contrast to Arnhem Land. Yet it has been remarked that the range of designs, which may be assembled with so few elements, and to which different meanings are attached, is quite remarkable.[39] We say that such designs are symbolic, and hence convey meaning to the community within which that symbolism is valid; but this is not entirely so, since it is the context that is important as far as meaning is concerned. They are, rather "concrete" non-naturalistic expressions of a set of relatively abstract ideas.

A parallel may be drawn between this particular style and Central Australian society and culture. I shall mention only a few features, and these are not entirely absent from most Australian Aboriginal societies and cultures.[40] Here we have a traditionally seminomadic people, interested primarily, prior to European con-

[36] See e.g., F. D. McCarthy (1948, pp. 30–31, fig. 16).

[37] T. G. H. Strehlow (1947, Plate 4); McCarthy (1948, fig. 20). (I am not distinguishing here between the various Aranda groups.)

[38] T. G. H. Strehlow (1947).

[39] F. D. McCarthy (1948, p. 31).

[40] E.g., although all Australian Aborigines are seminomadic, those in the so-called desert areas are much more mobile; and this is particularly so when contrasted with those in Western and Northeastern Arnhem Land; further, because their natural environment is so much harsher than that of the northern coast, much less rich in food supply, they are more dependent on the fluctuation of the seasons. Their relationship to the environment is linked with a philosophy of totemism that is rather different from that existing in Arnhem Land. See T. G. H. Strehlow (1947, 1956).

tact, in the necessities of life, and orienting its existence around those needs; possessed of few material goods, and desiring only the bare minimum since too many would impair freedom of movement and the daily task of food-collecting; living close to nature, not only feeling a strong bond with the land and all within it, but having a philosophy, a totemic view, which classified man along with other natural species, not as superior but on equal terms, whereas on the Arnhem Land coast the major mythological beings are predominantly in human form. Conservative as they were, and with all queries categorically answered, the "typical" Aboriginal conception of time that saw the past and future as part of the present was even more noticeable here. They showed a simplicity, a certain frankness in outlook, comparable to their *tjuruŋa* designs, but, like these, perhaps deceptively simple and naïve. There is no need to labor this point. One need recall only the succession of age-grading rituals and those of revelatory intent, the ceremonial life, sacred and nonsacred mythology and song, and so on,[41] certainly much less rich than in Arnhem Land, for instance, but nonetheless in striking contrast to the paucity of material objects and restricted or limited techniques. We could say, perhaps, that their art style, composed as it is of simple combinations of circles, semicircles, spirals, concentric circles, and lines, expresses the relative homogeneity of their society, the compactness of its structure, the intimacy of relationship among those within it, the essential conservatism and traditionalism was a dominating feature in "desert" social living. But these remarks, like the designs I am speaking of, do in reality give a "false" impression. I mean here that we get a glimpse of only the social patterning, and not of the vividness of its cultural content: it is "false" only in this respect. Essentially art style is an abstraction[42] in indigenous terms, with a linkage between it and the empirical dimension.

What I have said for the Central Australian Aranda society is true too over most of Northwestern South Australia, across the Great Victoria Desert in Western Australia and over the greater part of the central-western sector of that State. Minor variation in

41 See, for instance, B. Spencer and F. J. Gillen (1938), T. G. H. Strehlow (1952–54).

42 M. R. Cohen and E. Nagel (1949, p. 371 *et seq.*).

art style does occur throughout that region, but these are relatively insignificant until one reaches the northern end of the Canning Stock Route (in the vicinity of Balgo Hills, Billaluna, and Sturt Creek). Here, although the basic Central Australian designs are present and in fact dominant, meandering motifs are much more noticeable, with a range of angular and semiangular geometric designs.[43] Actually, this design-complex covers a relatively wide area, once associated with a large number of tribes with differing social organizations and cultures, although linked with basic themes. When we speak of this particular art style, then, numerous difficulties arise as soon as we try to link it with one particular society, culture, or "world view." Even concentrating on the Balgo Hills area, among people most of whom have come into this Mission from the Canning "desert" as well as from around Lakes Hazlett, White, and Mackay, the correlation is not clear-cut. What I have said for the Central Australian people is also relevant here. But there are some obvious differences, mainly due to their contact with the northern peoples located in the Southern Kimberleys and in the pastoral station country of the Northern Territory. Linking the basic designs of spirals and concentric circles are the meandering lines and/or linked meandering geometric patterns, signifying the wanderings of ancestral beings, the tracks of snakes, or masses of clouds, and so on. All this is simply illustrative material for a relatively narrow range of mythology and ritual activity. Although there are a number of highlights in this mythology, the greater part is concerned with the wanderings of beings across the country from one water to another, with much the same actions repeated over and again. And insofar as the environment outside the Mission and pastoral stations is concerned, a striking parallel could be drawn between the events mirrored in the mythology, excluding the magical elements, and the actual everyday life of the people: an extreme dependence on the natural resources of the country, with enforced mobility, associated with an "inwardness" in their way of looking at the world, and a lack of concern for issues that are not directly related to the quest for minimum physical satisfaction. A conservatism bred of necessity, much more rigid than that of eastern Arnhem Land, has direct implications in respect of their

[43] See F. D. McCarthy (1948, pp. 45–48; figs. 31, 33, 37, 39) for illustrations of this style; also H. Petri (1954, pp. 92, 93, 122).

social and cultural adjustment to changing ways. In other words, internal change can have little encouragement, and enforced alien change can result only in increasing disorganization. Receptivity to new ideas under such a system is difficult, while emphasis on traditionalism is paramount. We could term this culture "repetitive," where focus is on maintaining what is in terms of what has been. Much of what I have said here is relevant to other "desert" societies and cultures, but here the manifestation is more apparent. True, much of what I have said too has been impressionistic, but this is only because space does not permit me to substantiate this thesis with empirical material, for example, songs, linguistic material, and so on. The designs, which take the form mostly of incising on sacred boards of various kinds, express or directly symbolize this relationship; and their repetitive nature, the complexity of meandering lines and figures themselves, mark the productions quite distinctively in terms of style.

Art style offers one sort of key to the broad patterning of social relations and its cultural content. I am not suggesting that we could expect to find a one-to-one correlation. The extent to which we can identify this rests, partially at least, as it must do, on the empirical content. And it seems to me that only when we know that content are we able to infer the abstraction we term style. In one respect, we could view art style as a kind of "shorthand" summary of the particular society and culture in which is flourishes.

My references to Arnhem Land and to the "desert" area, compressed as they are, must appear impressionistic and subjective. They represent, admittedly, *ad hoc* interpretations; it is not difficult to read what we know in one sphere into the manifestations we find in another, and to conclude that "these *must* be the same thing, merely expressed in different ways." The crucial test comes in considering "different" styles that appear to have the "same" social and cultural setting, or vice versa, and in taking into account the necessity for prediction. Because of the dangers inherent in this sort of problem, with the tendency to "jump" enthusiastically from data to interpretation, there is a tendency to neglect it, even to the extent of separating form from content, as Nadel did, and categorically stating the one to be completely "autonomous" and independent of the other. This separation is an

arbitrary one. "Meaning" depends, surely, on "style plus content": or, rather, it is meaningless to speak of one without the other: the way in which a statement is presented is, when it comes to questions of "meaning," an essential part of what that statement "says."

The problem of "style" in relation to its social and cultural context is not one to be tackled at the beginning of a field survey. Ideally, insofar as possible answers, as distinct from questions, are concerned, it demands the maximum of knowledge about a given empirical situation, and about the ways in which the problem has been approached by other workers in other situations. I suggest that we have enough material now on a few areas of Aboriginal Australia to provide a basis for a study of this kind, and I put forward this paper in the hope of stimulating more systematic attention to it.

Bibliography

Albrecht, M. C. "The Relationship of Literature and Society," *American Journal of Sociology*, LIX (1954), 5.

Archer, W. G. *Indian Painting in the Punjab Hills*. London: Victoria and Albert Museum, 1952.

Bateson, G. *Naven*. Cambridge, 1936.

Berndt, C. H. "Expressions of Grief Among Aboriginal Women," *Oceania*, XX (1950), 4.

———. "A Drama of Northeastern Arnhem Land," *Oceania*, XXII (1952), 3 and 4.

———. "The Ascription of Meaning in a Ceremonial Context, in the Eastern Central Highlands of New Guinea," for publication in a volume of essays in honor of Dr. H. D. Skinner, entitled *Anthropology in the South Seas* (1958).

Berndt, C. and R. "An Oenpelli Monologue: Culture Contact," *Oceania*, XXII (1951), 1.

Berndt, R. M. "A Wonguri-Mandjikai Song Cycle of the Moon-Bone," *Oceania*, XIX (1948), 1.

———. *Kunapipi*. Melbourne and New York, 1951.

———. *Djanggawul*. London, 1952.

———. "'Murngin' (Wulamba) Social Organization," *American Anthropologist*, 57 (1955).

———. "In Reply to Radcliffe-Brown on Australian Local Organization," *American Anthropologist* (1957), 59.

———. "Comment on Leach's 'Trobriand Medusa,'" *Man*, LVIII (1958a), 65.

————. "The Mountford Volume on Arnhem Land Art," *Mankind* (1958b), 5, 6.

Berndt, R. and C. *Sexual Behaviour in Western Arnhem Land,* Viking Fund Publications in Anthropology, No. 16. New York, 1951.

———— and ————. *Arnhem Land, Its History and Its People.* Melbourne, 1954.

———— and ————. *An Exhibition of Australian Aboriginal Art, Arnhem Land Paintings on Bark and Carved Human Figures.* Perth, 1957.

Bunzel, R. in F. Boas (ed.). *General Anthropology.* Boston, 1938.

Carpenter, E. "Eskimo Space Concepts," *Explorations,* Studies in Culture and Communication, No. 5 (1955).

Cohen, M. R. and E. Nagel. *An Introduction to Logic and Scientific Method.* London, 1949.

Coomaraswamy, A. *Introduction to Indian Art.* Mulk Raj Anand (ed.). Adyar, 1956.

Elkin, A. P. *The Australian Aborigines.* Sydney, 1954.

————, Berndt, R. and C. *Art in Arnhem Land.* Melbourne and Chicago, 1950.

————, and Berndt, R. and C. "Social Organization in Arnhem Land, 1. Western Arnhem Land," *Oceania,* XXI (1951), 4.

Firth, R. *Elements of Social Organization.* London, 1951.

Fraser, D. "Mundugamor Sculpture . . . ," *Man,* LV (1955), 29.

————. Review of Van Renselaar's "Asmat: Art from Southwest New Guinea," *Man,* LVII (1957), 177.

Herskovits, M. *Man and His Works.* New York, 1948.

Kluckhohn, C. in Talcott Parsons and E. A. Shils. *Towards a General Theory of Action.* Cambridge: Harvard University Press, 1952.

———— and Leighton, D. *The Navaho.* Cambridge: Harvard University Press, 1946/48.

Leach, E. "A Trobriand Medusa?" *Man,* LIV (1954), 158.

————. "Aesthetics," *The Institutions of Primitive Society* (ed.) E. E. Evans-Pritchard. Oxford, 1956.

Levine, M. H. "Prehistoric Art and Ideology," *American Anthropologist,* 59 (1957), 6.

Lévi-Strauss, C. in *An Appraisal of Anthropology Today* (eds.) S. Tax *et al.* University of Chicago Press, 1953.

Mair, L. *Man and Culture. An Evaluation of the Work of Bronislaw Malinowski* (ed.) R. Firth, London, 1957.

McCarthy, F. D. *Australian Aboriginal Decorative Art.* Sydney: Australian Museum, 1948/56.

————. "Theoretical Considerations of Australian Aboriginal Art," *Journal and Proceedings of the Royal Society of N.S.W.,* Vol. 91, Part 1 (1957).

McElroy, W. A. "Aesthetic Appreciation in Aborigines of Arnhem Land," *Oceania,* XXIII (1952), 2.

————. "Aboriginal Orderliness in Central Arnhem Land," *Oceania,* XXVII (1957), 4.

Mountford, C. P. *Records of the American-Australian Scientific Expedition to Arnhem Land*, 1. *Art, Myth and Symbolism*. Melbourne University Press, 1956.

Nadel, S. F. *The Foundations of Social Anthropology*. London, 1951.

Petri, H. *Sterbende Welt in Nordwest-Australien*. Braunschweig: A. Limbach, 1954.

Redfield, R. in *Man, Culture and Society* (ed.) H. L. Shapiro. Oxford University Press, 1956.

Schapiro, M. in *Anthropology Today* (ed.) A. L. Kroeber. University of Chicago Press, 1953.

Schneider, H. K. "The Interpretation of Pakot Visual Art," *Man*, LVI (1956), 108.

Spencer, B. *Native Tribes of the Northern Territory of Australia*. London, 1914.

—— and Gillen, F. J. *The Native Tribes of Central Australia*. London, 1938.

Strehlow, T. G. H. *Aranda Traditions*. Melbourne University Press, 1947.

——. "Aranda Phonetics and Grammar," *The Oceania Monographs*, No. 7 (1952/54).

——. "The Sustaining Ideals of Australian Aboriginal Societies," Melbourne, 1956.

Wallace, A. F. C. "A Possible Technique for Recognizing Psychological Characteristics of the Ancient Maya from an Analysis of Their Art," *American Imago*, 7 (n.d.), 3.

Warner, W. L. *A Black Civilization*. New York, 1937.

Wilkins, G. H. *Undiscovered Australia*. London, 1958.

The Aesthetics of Traditional African Art*
ROY SIEBER

Recognizing the aesthetic power of African art, Professor Sieber notes that admiration alone can lead to misinterpretation. African art can only be understood in its cultural context. It is traditional in nature and integrated with the value system of its society. Skill in technique is the African's major criterion for evaluating art.

Dr. Roy Sieber is a professor In the Fine Arts Department of Indiana University, where he teaches courses on the arts of Africa, Oceania, and Pre-Columbian America. He has often served as a consultant on exhibitions of African art and is a Trustee of the Museum of African Art in Washington, D.C. He has written "African Art" (*African Studies Bulletin,* May, 1962), "Masks as Agents of Social Control" in *The Many Faces of Primitive Art* (1968), "The Insignia of the Igala Chief of Eteh, Eastern Nigeria" (*Man,* 1965), and *Sculpture of Northern Nigeria* (1962).

The greatest acknowledgment of the aesthetic power of a work of art is that it can still move us when it is presented totally out of context in the highly artificial atmosphere of a museum. Yet art is a cultural manifestation finally to be understood (as distinguished from "appreciated") only in the light of its cultural origins. The work of art is both the point of departure and the point of return, but the search for understanding must encompass the various levels at which it functions and utilize the several methods by which It may be analyzed.

Admiration in isolation easily leads to misunderstanding, and African art, its functions only vaguely apprehended, has fallen prey to the taste of the twentieth century. While noting the vitality and strength of purpose that pervade it, its admirers misread con-

* Reprinted from *Seven Metals of Africa* by Froelich Rainey (Philadelphia: University Museum, University of Pennsylvania, 1959).

servatism for spontaneity and commitment to style for freedom. It has become a foil for rebellion and expressionism, and the object of a cult of age, purity, and patination. Such adulation springs from a Western aesthetic rooted in a romantic love for exotic precocity, and, perhaps inevitably, has developed into fashionable cliché taste. Evidence of this lies in the remarkable number of "masterpieces" that are at best second-rate examples, the over-evaluation of late, especially nineteenth-century, Benin bronzes, and the infatuation with certain types endlessly rereproduced in catalogues and books—in short, the easy admiration wherein every adze-cut becomes the stroke of genius.

It is not my intention to dismiss connoisseurship or the right of each age to its ethnocentric aesthetic, but to note that the history of taste is a story of constantly shifting attitudes which are not cumulative, and which are neither inevitable nor infallible beyond the moment they are in favor.

Against the vagaries of fashionable taste is ranged a growing corpus of factual data and interpretation: anthropological studies of inestimable value as a record of the cultural functions of the arts; stylistic, archaeological, and historical studies as well as the less frequent attempts to probe the aesthetic of the African. Such will serve not only understanding and interpretation but will establish a base line for the study of African arts in transition.

In the attempt to understand the aesthetic of African art one point cannot be overstated. Unlike recent art in the Western world, traditional African art is an act of cultural integration. The artist neither castigates nor condemns the normative values of his culture, nor does he reject through inversion that culture's concept of the image of reality.

Like most art in the history of the world, African art is deeply involved in the sensible and spiritual goals of human beings. Instancing and symbolizing security, it lies at the center of a hard core of beliefs. To the African who holds those beliefs there is no need for analysis and dissection of art. He need not toil to understand it, discuss the motivation of the artist, probe the aesthetic attitude, or seek to determine the social utility of the product. It is taken for granted that art, almost without exception, reinforces the positive aspect of his world view, participates actively in the ful-

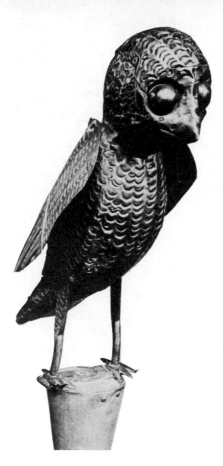

The top of a staff from the Fon of Dahomey in the form of a wide-eyed bird with tremulous wings. Cut and assembled from thin brass plates, this is a beautiful specimen of tribal work. Courtesy of The Museum of Primitive Art, New York.

fillment of his needs, however these may be defined. (It should be noted that his needs are usually couched in intensely practical terms: wealth, prestige, health, children, wives, crops, and perhaps, a glimpse into the future.)

With reference to the art of a given cultural framework, normally the tribe, these goals are known, understood, assumed, shared. They underlie and inform the conscious aesthetic of the African with a richness and complexity that belies the apparent simplicity of his words.

An Igala tribesman, after careful scrutiny of a mask, offered

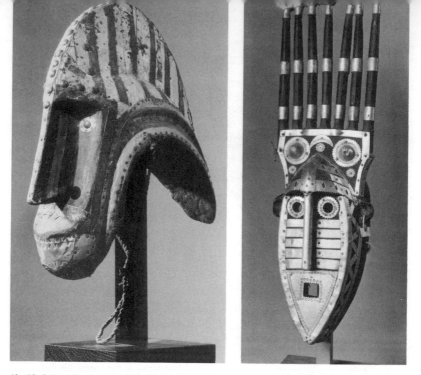

(*Left*) A handsome and highly stylized wooden dance mask from the Dogon decorated with hammered-down metal plates and brass-headed nails. Courtesy of The Museum of Primitive Art, New York. (*Right*) Wooden dance mask from the Marka, a sub-tribe of the Bambara in the French Sudan. Decorated with thin tin and brass plates affixed to the mask with iron nails. The Olsen Foundation, New Haven.

his critique in two words: one identified the mask type, the other indicated it was well done. However curt, the observation was based on familiarity with a preexistent style, knowledge of a predetermined function and critical awareness of comparative excellence. His statement indicated only the degree to which the work fulfilled certain prerequisites. It did not spell out his expectations, nor did it indicate the weight of authority that lay behind them. It is not surprising then that a voiced aesthetic can consist of an identification of the object, which implies its functional aptness, and an evaluation of the skill of the artist.

Skill springs from the one unshared aspect of art, the act of creation, and thus sets the artist apart from his fellow beings. Because it is a variable and eludes the expectancy pattern of style and function, it permits critical evaluation.

As a basis for critical evaluation it becomes a dominant aspect of the African's voiced aesthetic. As it sets the artist apart, it is the basis of the concept of specialism. Indeed, much of the social reward accorded the artist is based on his specialist role, for the layman stands in respectful awe of the artist's ability. I once questioned a member of the compound of a brasscaster about the latter's technique. Although he had lived for years alongside the caster and watched him at work countless times, he indicated with a gesture of astonishment and resignation that it was all far too complex to understand unless one were a brasscaster. He stood in awe, not of an expressive soul, but of a specialist's knowledgeability.

However, it must be noted that the artist is not the only specialist, and similar prestige is awarded to all specialists. So much so that in groups which no longer support an active art the prestige of the artist seems now accorded the clerk, the carpenter, and the bicycle repairman.

Thus traced, the aesthetic of the African both explicitly and implicitly substantiates the concept of traditional African art as a positive, integrated cultural manifestation.

Work, Leisure, and Creativity*

MARGARET MEAD

In this article the idea of creativity in leisure as opposed to the repetitiveness of work is questioned and illuminated by examining the integration of art into Balinese life, the compulsive attitudes toward work of the Manus, and other examples. The idea of newness in many levels and variations seems to be related to creativity in a number of societies. When everyone becomes a painter this newness is lost. Reproduction also destroys freshness. A series of proposals is made recommending courses of action which would permit wide participation in meaningful creativity in our own society.

Dr. Margaret Mead is now Professor of Anthropology and Chairman of the Social Science Division of the Liberal Arts College at Fordham University, after serving for many years as Curator of Ethnology at the American Museum of Natural History. Culture and personality, applied anthropology, education, mental health, psychosomatics, sex, national character, and the family are her major subjects of interest. Among her many honors and awards she has received the National Achievement Award for Women, the Geographers Medal, and the Viking Medal for General Anthropology. She has written extensively and the best known of her many publications are *Male and Female* (1949); *Growing Up in New Guinea* (1930, 1962); *Coming of Age in Samoa* (1928, 1961, 1968). Her essay, "The Bark Paintings of the Mountain Arapesh of New Guinea" in *Technique and Personality* (1963), is of particular interest to students of primitive art.

One of the contexts within which the word creativity is invoked is in answer to the questions: "What are people going to do with their leisure? Can we make them more creative?" I should like first to question the usefulness of the simple dichotomy of work and leisure, with work being those things that man has to do to earn his daily bread, and leisure everything he does with the time that is left over. For if we follow this way of looking at life, peculiar to our

* Reprinted from *Daedalus* (Winter, 1960), pp. 13–23.

own narrow tradition, we are then faced with placing such activities as the worship of the gods, or the performance of a tragedy, in either one category or the other. Some peoples have solved this by vocabulary. For the Balinese life consists of work—for which a harsh short word is used when it is done by low-caste people in everyday life, and an elegant word when the activity is performed by high-caste people or for the gods. The word for feast then becomes a noun from this verb which describes activity by or for those to whom one looks up. An echo of this kind of classification can be found in the English word amateur, with its implication that activities which can be performed freely by those whose livelihood comes from some other source, are lowered and tainted if done for gain.

So, we may start with the freedom to pray or carve, act or paint or sing, and end with its degradation or, as the Balinese do, emphasize not whether an activity is for pay or not, but rather who engages in it and under what circumstances. Appropriately enough there are no amateurs in Bali; there are young girls who do not dance very well, but those who dance badly are as seriously committed to the requirements of style as those who dance well; they are simply less gifted, less practiced, or less well taught. When a temple club or a raja pays for the dancing of those who dance well—while the dancing of the less gifted is simply a part of temple ritual—the payment goes not to the individual but to the group, for new musical instruments, or new costumes. The club group with a good set of dancers practices harder, gets better teachers, is in demand for more performances, and always runs the danger of suffering from popularity which will make the dancers, so continuously in demand, become conceited, stop practicing, and sink back again into anonymity. Teachers must be paid, club members who give many days to traveling performances will receive expenses, performances will be offered to the gods in the temple to which they belong. But the expert individual members do not draw their livelihood from these activities. The lines are drawn in many places, always with precision down to the last little bronze penny.

People labor, as they must, for their livelihood, for special purposes beyond a livelihood, in response to the demands of the

Flute figure from Mundugumor,
Yuat River area, New Guinea. The Museum
of Primitive Art, New York.

community—as corporation and as temple—and as members of groups devoted to the arts or sometimes as individuals, grown so skilled that a dancing teacher, a musician, a carver of masks, will be frequently called away from his rice fields. But the system provides for just such freedom of movement. There are rice-harvesting clubs that may be called in to help with the harvest; there are rice-harvesting clubs that one may join if one is short of cash; exemption from work for the village or the temple may always be bought for a small "fine"; when a hundred men have been called together to chop up one pig, ten will not be missed, and the fines they pay will be useful. Sometimes when a man has a special skill, like the ability to scrape the great bronze gongs to tune them, the village may exempt him from ordinary work on the roads, and citizens of a high caste may be asked only to perform activities which are skilled, or be permitted to make contributions in kind.

Visitors to Bali, anxious to explain the interpenetration of art and life, have ventured many explanations, only to find that one simple contrast between Bali and the West is not enough, and leads instead to spurious statements about the evils of the modern world, with our slavery to clocks.

For on another South Sea island, Manus, I found in 1928 a people without clocks, without a calendar, with only the simple rhythm of a three-day market and the monthly rush of the fish over the reef, who nevertheless drove themselves from one unrecognized and unremarked year to the next, seeing feasts as harder work than days which had no feasting. To them the white man's periodicity of hours to start work and hours to stop came as a blessed relief and the Christian Sabbath as a day of undreamed-of rest. They spoke with enthusiasm of the bells that punctuated the hard labor on European-owned plantations: "When the bell sounds at noon you can stop, and you don't have to work again until the bell sounds to return to work."

The Manus live in a tropical environment, where no seasonal snows fall, but the version they have constructed of man's place in nature is both puritanical and driven—and strangely like our own.

In almost comic caricature, the Manus bought and sold the artistic productions of neighboring tribes, but they made nothing

beautiful themselves. Where in Bali a prince may be the best actor or finest carver of them all, and his wife excel in weaving, in Manus the richest and the poorest members of this near egalitarian society might buy and sell, but did not practice the arts for themselves.

Each well-described culture provides evidence of the many ways in which activity can be categorized: as virtuous work and sinful play, as dull work when done alone and happy gaiety when the same activity (fishing or hunting or housebuilding) is done in a group, as work when for oneself, and delight when for the gods, or as, at most, pleasant and self-propelled when done for oneself but horrid when done at the behest of the state. There are as many kinds of classification as there have been civilizations, each having its significance for the place of the arts in the life of any particular human group.

Any attempt to order these classifications must always be limited also by the perspective of the moment, by the categories within which one must address oneself to the relevant audience. One significant variable is a sense of freedom: what one does of his own free will must be separated from anything done under coercion, by the need to eat, or survive, or by the will of others. So hunting for food would be work, and hunting for the joy of the hunt would be leisure. Planting a garden for food would be work, but done for the pleasure of boasting about the size of one's cabbages, it becomes leisure activity.

The attempt to classify activities in terms of their intrinsic "creativity," so often resorted to by those who, in search of a world more hospitable to the arts, castigate the lack of creativity in modern work, brings us out little better. If we take the set of criteria so often used, work to be creative must make something new and something made must not be made too often, or the words "repetitious" and "uncreative" will be introduced. Cooking the daily midday meal is repetitious, but preparing special foods for a feast is creative. This distinction is pleasantly blurred in the house of the rich gourmet; the food that is feast food for the common man becomes daily food for him. His cook then becomes a chef and an

artist. The distance from cottage to castle has turned labor into an art.

Still the idea of something made new, and rarely, recurs throughout all the confusing dichotomies and continua of many civilizations. Among one people the slight decoration of every doorway may be a craft, widely practiced, possibly lucrative, slightly honored. But in the next tribe there may be only one man who has the skill and the will to paint a single bark panel with his version of the house decorations of his neighbors. He is not a craftsman; he practices no art grown simple and habitual by long usage; he is instead an artist, occasionally and painfully producing something new—new to him, and new to his fellow tribesmen who cluster around him. Or it is possible to introduce the same slight sense of distance and newness by a device such as that used by the Mundugumor of New Guinea, who had decreed that only a male child born with the umbilical cord around his neck might be an artist. As the tribe was small, and there was no provision that each male child so born be trained as an artist, in the end there would be only one or two men in a generation with the cultural right to paint a design on bark, which might have been a common craft, practiced often and unrewarded, among a neighboring tribe.

The gardener in England lives upon newness and difference. One flower or a border blooms earlier or later, and another is not there at all. The light catches on a new clump of larkspur, and the garden is new made. And in New Guinea the dusty old woven basketry masks are hauled out of the attic of the men's house, and made new again with fresh feathers and bright flowers arranged in new combinations, with small, graceful, painted birds made of a corklike wood and poised lightly on swaying reed stems. Even among the puritanical Manus, where feast clothes were mourning clothes, all validated by hard earned money, and ornaments were made from the hair and bones of the dead, there was a sense of freshness in the air when they were worn. Skins usually dull from work and only dutiful ablutions shone a little to match the woven armlets that held pieces of the rib bones of the dead.

I should like to propose that we look at this element of fresh-

ness, of newness, of strangeness, as a thread along which to place the activities of the consciously creative artist, the conscious patron and critic of the creative artist, and the common man— common in the sense that he has no specified part in creation or criticism. If we make one criterion for defining the artist (as distinct from the craftsman and the trained but routine performer of dance, drama, or music) the impulse to make something new, or to do something in a new way—a kind of divine discontent with all that has gone before, however good—then we can find such artists at every level of human culture, even when performing acts of great simplicity. The conclusion has sometimes been drawn that in some societies, for example the Bush Negroes of Dutch Guiana, "every man is an artist," or, as in Bali, that "every man is a musician." Where any art has reached the state in which it is required behavior for some category of human beings (if all women must make offerings, all young men carve if they are to be eligible for marriage, or all men play some instrument in a temple or village orchestra) then the making of offerings, the carving of wooden wands, or the playing of musical instruments ceases to be a field for the artist in the simple way it was before. Those who deserve the name of artist will move on to the invention of new offerings (while their sisters make old ones) or the development of new designs or new ways for a whole orchestra (in which each musician is a faithful practitioner but not a composer) to play the old pieces.

The difference in quality between the single bark painting made by an artist in a tribe in which no one else paints on bark, painted with tenseness and desperate eagerness, and the beautifully executed traditional design of the craftsmanship of many men in the next tribe, will not give us the clue as to which tribe depends on craftsmen and which on the occasional artist to produce a painting on bark. If we have only one of each, the chastening hand of tradition may well resemble the individually disciplined vision of the single artist; the traditional will often appear to our eye—to which each is fresh—as more of an individual vision, as we are unable to distinguish between freshness to us and freshness to the man who made it. We have here two situations, one that of the difference between the painter who

makes something new and the painter who executes the old with faithful skill, the other that of the spectator who, without a large set of paintings to guide him, cannot tell the single object made with great creative energy from the repetition of some object in a style grown beautiful by the contribution of many painters and many critics. We can add a third. Granted that an object has been the outcome of a single artist's or a group of artists' desire to make something new and fresh, it will then matter enormously what happens to the object.

It may be quickly destroyed, having been a stage set for a single production of a play, or a design for a triumphal or centenary ceremony to be held only once. In this case, part of the freshness will come from everyone's knowledge of the brief life that the arch of flowers, the floats of paper, the giants of confectionery, the cunningly contrived stage sets, are to have. Tomorrow or the next day, all this will be dismantled, faded, or even eaten up. Only those who are there that day will ever see it; it will linger on only in the delighted memories of those who made it—to underlie later new creations or new applications by those who saw and enjoyed it once before.

Or it may be set permanently in a special place, behind a high altar, in a palace hall, in a public building, or in one of the many rooms of a private house of the very rich. Here the sense of freshness of the masterpiece is maintained by the difference between those who live near it and those who have seen it only once at some great ceremony or when they journeyed from a great distance on a pilgrimage, for a coronation, or to see a capital city, or to attend the university graduation of a son. For most people, such a painting or statue will be seen only once or twice in a lifetime; those who live close to it—the rich private owner, those who attend Mass each Sunday beneath the startlingly lovely altar piece, those who work in the old Guild Hall with its murals—live and feed on the freshness that is contributed by the new visitors. The rich man takes his guests through the gallery, the resident takes a visitor to the picture gallery, or to see the village church where the vicar recounts for the thousandth time the story of an especially beautiful window. So for those who live close to a masterpiece there may be either a protective caution which blocks off a too continuous

dwelling on its beauty or the reinforcement of its newness to others, so that they live a happily parasitical life on the delight of those who see it for the first time.

For several decades at the end of the last century and the beginning of this, we added a new and temporary dimension of freshness, that of partial and bad reproduction, by photography. This replaced the earlier ambiguities of copies, which ranged all the way from the same picture painted by the same great master, in which all that was different was the church in which it hung or the name of the patron who ordered it, to the humble little lady traveler who painted all day in the Louvre to capture one painting, in part, and take it home as partly her own, now, for her brush had worked at it. The black-and-white reproductions of the late nineteenth century played a similar role; here the traveler sought to capture and keep for himself and those who had stayed behind a reminder of original freshness and delight. The reproduction was often no more than a hook on which to hang exclamations and judgments exchanged between men who had seen Athens and those who had not; but on the walls of those who had never been there it became a kind of promissory note of the future: "Someday, when I am grown, I will see the Colosseum, climb the hill to the Parthenon, really see the Night Watch, learn how Raphael painted." These early reproductions were not good enough to detract from the memory of the original or the promise that it might one day be seen. Faulty and incomplete and unpretentious, except when used only to prove one had traveled or had taste, they were pleasant to have on the walls, and could well compete for delight with the kind of "original" one could afford—in most cases the holiday effort of a relative who was a poor amateur painter.

The relationship of the arts to leisure in American nineteenth-century society was therefore quite simple; those who had leisure traveled to the places where art was to be found, those who had money sometimes bought it and brought it back, and they, or some of those who visited the museums to which it eventually found its way, learned to enjoy it. Those who had not traveled, and probably would not travel, were taken to museums as children, or shown slides, and were exposed to very tentative promissory notes in the form of black-and-white reproductions on the walls of schools.

Coming from homes in which there was no temporary artistic effort to be constructed and destroyed, and no craftsmanship out of which necessary skill could be distilled, the relationship between the common man and the visual arts was almost completely destroyed. Children might be taken in groups to the Altman collection in the Metropolitan Museum, and of these some would see other work by the same painters some day, others would treat this as an experience without any meaning for themselves, and once in a while some child might make the extraordinary leap of believing that he or she might someday *paint*. To paint meant, very simply, to go away from everyone to some faraway place where paintings were made, where there were people who painted. Out of generations of this well-documented nostalgia of the man who would paint, in a civilization that made nothing of the visual arts, or failed, as England did, to recognize that gardening, which trained the eye to loveliness and the mind to criticism of form and color, was an art, have come the extremes of the present day, accentuated by our contemporary processes of exact reproduction both of lovely craftsmanship and of the isolated vision of the artist in many other lands and periods.

For almost overnight (for Americans) it has become possible to acquire reproductions, not only of the pottery and fabrics of other peoples, in which the cunning of the machine can repeat over and over what the hand once had to learn, but also of individual works, which once drew their beauty from their singleness. Van Gogh's *Sunflowers* blaze on a thousand walls, day after day, collecting not even a faint film of dust beneath their protective glass. From the spectator of such reproductions nothing is required. He neither fetches the paint nor carries the stones nor holds the scaffold on which the painter stands. He need make no pilgrimage, even on the subway, to see a painting. Nor is it any longer a matter of individual choice of the too brilliant reproduction which one purchases for one's own wall and becomes strangely tired of and yet lets it hang. For there are all the other walls, in the dentist's office and in the homes of all one's friends, and the bank poster on the bus. What was once sought diligently and seen seldom is now staled by continuous unsought experience.

It is said that the public has never been so "interested in art."

This is only too true, and yet is this interest, expressed in the reproduction of objects never meant for reproduction and totally unrelated to their owners, a way of closing the gap between artist and critic and the common man, or of widening it? The most casual visit to our campuses where "modern art" is produced by the yard would suggest that the gap is really widening while it might seem superficially to be closing.

Is it possible that what has gone wrong is just here, in the control of freshness? It is undoubtedly a good thing that many people, as children, as young adults, and as elderly people with new leisure, should be given a chance to "create," to stand before an easel and wrestle with an attempt to make the world anew. But what is happening today is that in these thousands of studio situations the painter does no such wrestling; it is not individual vision but the ability to replicate a strange commodity—individuality— which is being practiced. Like the Christmas cards of the intelligentsia, each painting must be different—a photograph of our dog instead of your dog, our children instead of your children. A slight difference, within an agreed-upon range, has been substituted for newness.

Second, the very quantity defeats us. If thousands of people are to produce in a form once sufficiently rare so that some church walls remained bare for lack of a painter and only the state rooms of the palace had murals, the sense of coming glut oppresses our spirits as we listen to the enthusiasm with which still another friend takes up painting or sculpture. There is no place to put the million individual works of those who are trying to participate in an activity where once only the rarely gifted worked.

When every man practices an art, it becomes a craft, and for crafts there is a place, either in space or in time: in space, a bed for the embroidered bedspread, coffee to be drunk from the painted cups, and soup to be sipped from the hammered spoons; in time, a delight to match the temporary structure of snow or flowers, the delicately executed Christmas card that is cheap enough to throw away at Twelfth Night. In such exercises, the common man, who may of course be a physicist or the governor of a state in his own professional personality, may experience for an hour or a day an appropriate nuance of the creativity of the artist, making some-

thing new—at the moment of making—either for later quiet, undemanding use, or for quick destruction.

But because of the plethora of reproduction, the distinction between the rare vision which must remain rare—to someone— and delight in producing form and color has been obscured.

It is revealing to look at the present recourse of those whose delight contains an extra component of the esoteric. On their walls are large black-and-white reproductions of blown-up cameos, once so small it took a microscope to appreciate them, or telephoto photographs of some detail high up on an Indian temple wall, unseen since some loving hand carved it ten centuries ago. Deprived of the individual experience of seeing a great painting for the first time, they will at least see something that no one, even the man who made it, ever saw in this way before. With the marvels of modern photography—the photographer perched at some unlikely angle where no man ever stood before to catch the sunlight on the Parthenon—the spectator participant tries to reestablish the freshness of the experience, in ways even stranger than those once used by the kind of miser prince who kept a masterpiece behind a curtain for his own eyes alone.

But this is a mere temporary expedient, for the hundred people who come to the cocktail party to appreciate the freshness of this photographic abolition of distance and scale may all go home, buy a copy of the same miracle, and put it on their walls.

Is not perhaps a different answer to be found than this abuse of freshness which is seen on every side? Is not part of the solution to be found in shifting the freshness from the singleness of the work of art, now effectively nullified by cheap and perfect reproduction, to the considered choice of the spectator? For those who wish to use part of their leisure, part of the time when they are freed from making a living, to become actively a part of the world of the visual arts, there should be a far wider temporary field— walls to be painted anew every week, stage sets for every occasion —as the Balinese work for days on beautiful panels of contrasting greens which will lose the design when the cut leaves fade to the same dullness. It will not matter then if one mural is very like another, as it does when the attempt is made to wring individuality out of an obedient reproduction of some recognized style. There

will be only one mural on the wall at a time, and its freshness will be adequate for a week, to carry it along, or add pleasure to its destruction so that it can be replaced. The Balinese, who give their acclaim to the occasionally highly gifted, carry their critical appreciation in hands and feet that do not attempt the impossible but often gaily, "from delight," make beautiful things that are not meant to last.

But we will need a second development to complement this: the painter whose creativity is great enough to justify his giving his whole lifetime to it must come to include, in the vision of what he does, the process of reproduction. As poets write to be printed, so painters must come out of the manuscript stage and paint for reproduction. A painting meant for reproduction is no more demeaned by reproduction that is a poem by reprinting. But a poem written only to be read by the author, designed for the single uniqueness of such perfectly realized cadence, is too precious for other lips. Poets long ago, when writing was invented, were humble enough to surrender their lovely lines to the stumbling reproductions of others, whose lips moved slowly and ineptly, as images other than the poet meant crawled or danced through their minds. Perhaps, indeed, poets were more willing to do this than we know, after centuries in which a minstrel had to repeat the same poem over and over before a different set of carousing, feasting lords. But when the poets bowed to print, their poems were quietly put away in books. Now with a recording, we can listen when we wish to a poem read beautifully, sometimes even by the poet who wrote it. But who could bear to encounter perhaps twice a day the "Ode to a Nightingale," or one of Eliot's *Quartets,* sounding uninvited from some corner of a room, however faithfully the reader attempted to render the lines? Any lover of poetry would rebel at once against such unsought experience, and yet we acquiesce in putting vivid reproductions on our walls for the helpless visitor or captive child to stare into meaninglessness, perhaps forever.

There is a related responsibility that Americans have never taken, responsibility for the landscape which others see when they look out of their windows or walk down a street. We have so

sedulously sought each his own view, swept clear of the hand of man, that we have failed to recognize to what extent our house or garden has become the "view" of others in this crowded world. We none of us take joint responsibility for the city streets, the combination of water tanks and occasional pleasant pinnacles which we call a skyline, on which our children's eyes must be fed, and so we learn to turn a blind eye to ugliness. Our unplanned towns and sprawling developments, our unwillingness to adapt a new building to the line of the buildings already there, have bred a people who expect beauty to be a piece of private property for which they take no responsibility.

These are possible steps which those who give direction to the last half of this century might well take: stress the value of participant production of ephemeral things, a mural for a night, an individual greeting card that will go quickly to an honorable grave, a sketch on the edge of a letter to a distant friend; emphasize the importance of painting *for* reproduction, rather than making exact reproductions in which the single masterpiece is still intended; protect the single masterpiece from the vulgarization of unintended, unresponsive contemplation by keeping reproductions in books that can be opened at will, or for occasional enjoyment in a temporary frame; and develop a structured responsibility for our towns and cities, in which we build the shared man-made landscape in which eyes become accustomed to beauty, rather than immune to intrusive ugliness.

Formal and Symbolic Factors
in the Art Styles of
Primitive Cultures*

HERSCHEL B. CHIPP

Pleasure in form and the need to symbolize religious meaning are two important motivations in the production of art objects and significant influences in the development of art styles. The art of the Maori and the Plains Indians are compared in this essay with relation to (1) craftsmanship and aesthetic appreciation, and (2) mythology and ritual. Dr. Chipp thus clearly reveals the usefulness of the analytical method and its value as a way of seeing the interaction between style, symbol, and the creative process.

Dr. Herschel B. Chipp is a professor in the Department of Art at the University of California, Berkeley. His field of research is twentieth-century painting and sculpture. He has written many exhibition catalogues and has contributed articles to most of the major art journals. He is the editor of *Theories of Modern Art: A Source Book by Artists and Critics* (1969).

I. THEORIES AND METHODS IN THE STUDY OF PRIMITIVE ART

Studies of the art of primitive peoples during the past three or four decades have clearly demonstrated that its motivating forces do not flow solely from the religious meaning of the objects, but that pleasure in their formal qualities, whether in making or contemplating them, is an important factor in the production of art. This is an important element even in determining the characteristics of the tribal style.

More than half a century ago von den Steinen criticized students for what he called their excessive zeal in overinterpreting the symbolism of primitive art, and in his work he stressed the role of aesthetic pleasure in primitive cultures.[1] Many other writers

* Reprinted from *The Journal of Aesthetics and Art Criticism*, Vol. XIX, No. 2 (Winter, 1960), pp. 150–66.

[1] Karl von den Steinen, *Unter den Naturvölkern zentral Braziliens* (Berlin, 1894), pp. 243–94; cited by Robert J. Goldwater, *Primitivism in Modern Painting* (New York, 1938), pp. 21–22.

followed. Luquet went so far as to claim that the idea of artistic representation antedated even the appearance of magic and that, in paleolithic animal painting, magical efficacy was simply applied to an art tradition that already existed.[2] Lowie cites American Indian examples in which the forms of the religious art had actually exerted a reverse influence and substantially altered religious concepts. He was convinced that the aesthetic impulse was "one of the irreducible components of the human mind, as a potent agency from the very beginnings of human existence."[3] Even those, such as Semper, who postulated the development of art from the practical techniques of making useful objects implied the presence of an aesthetic sense as the transforming agent, although they could not bring themselves to consider the primitive works as art.[4]

Of all the several important studies concerned with aesthetic qualities, Boas' *Primitive Art* (1927) comes closest to providing some sort of method useful to the ethnologist or theoretician of art. Boas applied his own diffusionist theory to a study of the distribution of both style motifs and the meanings attributed to them. But valuable as this work has been in the comparison of the art motifs of different tribes, its treatment of the art objects themselves is limited by the very factor that makes the statistical study so valuable: the attempt at complete objectivity. Boas accordingly sees the main determinants of style in such technical factors as the motor habits of the tribe or the techniques of handling the materials.[5] These limitations confine his analysis of an art style to

[2] G. H. Luquet, *L'art et la religion des hommes fossiles* (Paris, 1926), pp. 126–27.

[3] Robert H. Lowie, *Primitive Religion* (New York, 1924), p. 260.

[4] Gottfried Semper, *Der Stil in den technischen und tektonischen Künsten oder Praktische Aesthetik* (Munich, 1861–1863), I, p. 5, cited by Goldwater, *op. cit.*, p. 16.

[5] Franz Boas, *Primitive Art* (Oslo, 1927), p. 17 ff. and p. 144 ff. An important study which had preceded Boas' work, Paul Guillaume and Thomas Munro, *Primitive Negro Sculpture* (New York, 1926), was based upon the aesthetics of abstract art and the method of formal analysis developed in the early 1920's at the Barnes Foundation. The authors' method is concerned with a visual analysis of the formal characteristics of the sculpture to the exclusion of the meaning of the objects or facts about them. Although the effects of religious concepts upon the art that embodies them are not con-

elementary decorative motifs and to general formal characteristics. Although the application of this method yields some valuable matter-of-fact descriptions of the essential features of an art object, it tends to set up as criteria such nonartistic ideals as perfection of form or virtuosity in technique. Thus, although the object may be well described and analyzed, the relation of its formal characteristics to the culture as a whole is ignored; and hence a definition of style in the deeper sense of the term is not possible.

Studies in the meaning or the symbolism of primitive art, unlike primitive music, are extremely rare, mainly because of the almost complete lack of a clear relationship between the form and the meaning. Further, the traditional method of investigation, by personal interview with members of the tribe, deals with conscious, rationalized interpretations that are subject to numerous unpredictable distortions. Boas says that meaning is usually "read into" a motif, even though the elements of the motif may bear little or no relation to the meaning. Different tribes may attribute quite different meanings to the same motif, and meanings for the same motif vary widely even among members of the same tribe. On the other hand, important concepts that are shared by many tribes may be represented by as many different motifs.[6]

Although some studies on meaning in primitive art have been made recently by psychologists as well as anthropologists, most of the standard works that deal at all with the problem simply identify and classify the particular meanings attributed to particular motifs.[7] In studying the distribution of motifs and their interpreta-

sidered, this book was the first systematic study of the inherent qualities of the objects themselves. It thus marked a new phase in the study of primitive art, when it began to be considered as a major art.

A valuable and generally reliable classification of African tribal styles was made by Carl Kjersmeier, *Centres de style de la sculpture nègre africaine,* 4 vols. (Copenhagen and Paris, 1935–1938), although the question of artistic quality is often ignored in favor of consistency in the application of the method. Frans Olbrechts developed a sound comparative method of stylistic analysis according to specific anatomical features similar to the Morellian method of art history in *Kunst van Vroeg en van Verre* (Bruges, 1929), and *Plastiek van Kongo* (Antwerp, 1946), and, although limited largely to the art of the Belgian Congo, his methods are widely used by Belgian students.

[6] Boas, *op. cit.,* pp. 123, 128.

[7] See for example, J. C. Ewers, *Plains Indian Painting* (Calif.: Stanford University, 1939), pp. 63–65. Several books considering religious and psy-

tions, Boas went only so far as to say that individual tribes may show only general tendencies in their interpretations of certain motifs.[8]

Fagg attributes the scarcity of comprehensive studies on meaning to the absence of adequate works on primitive philosophy and metaphysical beliefs.[9] However, the very nature of primitive beliefs, dependent as they are upon indefinable spiritual forces to give meaning to the phenomenal world, seems to preclude the possibility of a systematic equation of images and meanings such as art historical research has accomplished with civilized traditions.[10]

Both of these factors discussed above—pleasure in form, and the need to symbolize religious meaning—will be considered here as important motivations in the production of art objects. They are also significant influences in the formation of tribal styles. Lowie has demonstrated that it is as possible for art forms to have a

chological aspects of primitive society as factors in the art appeared in the 1920's in Germany. They were by Herbert Kühn, Eckart von Sydow, and Ernst Vatter. These authors recognized the importance of the aesthetic aspects of primitive art, but were mainly concerned with seeking a primitive "world view," where general ideas about economic, religious, and psychological motivations were loosely associated with the art.

In recent years psychologically trained anthropologists have revealed new and deeper levels of meaning in primitive beliefs, especially George Devereaux, *Reality and Dream* (New York, 1951), but studies of a similar thoroughness have not been applied to the art. William Fagg has sought in several essays to define scientific methods of procedure in correlating cultural features with the art, and to describe common formal features: *The Webster Plass Collection of African Art* (London, 1953); "The Study of African Art," *Allen Memorial Art Museum Bulletin* (Oberlin, Ohio [Winter 1955–1956]). A method more recognizant of artistic quality but less certain of ethnographic backgrounds is: Margaret Trowell, *Classical African Sculpture* (London, 1954). She defines two general attitudes of African art, "spirit regarding" and "man regarding," and describes certain stylistic features accompanying each. From the point of view of theories and methods the study of the art of primitive cultures other than African has advanced but little, but the several books of Paul S. Wingert have utilized sound art historical methods of stylistic analysis in dealing with South Pacific and American Indian, as well as African art.

8 Boas, *op. cit.*, p. 105.

9 Fagg, *op. cit.*, pp. 54–55.

10 The concept of "vital force" is advanced as the motivation for all life activity for the African Bantu peoples by P. Placide Tempels, *La philosophie Bantoue* (Elizabethville, Belgian Congo, 1945), p. 27 ff.

retroactive influence upon the religious concepts that they embody as it is for the original religious meaning to condition the images of art.[11] Hence, it can be postulated that most primitive art styles have been formed in response to both these motivations, although combined in widely varying proportions. By relating the art to the tribal concepts of craftsmanship and aesthetic appreciation of formal characteristics on the one hand, and to mythology and ritual on the other, it may be possible to reveal deeper levels of both of these as they appear in the art.[12] As examples of the predominance of each of these motivations we shall consider two cultures about which we have considerable ethnological information: the Maori of New Zealand and the Plains Indians of North America.

II. THE MAORI OF NEW ZEALAND

The Maori artist was a component part of the economic and social structure of the tribe, according to Firth, a worker for the community in the same sense as the fisherman, housebuilder, warrior, or priest.[13] The Maori had many work songs, usually sung by the women, which eulogized the various occupations and their value to the tribe. In these songs the work of the sculptor, tattooer, or stoneworker assumed an important place along with practical and ritual activities. In the organization of the tribe, work was the focus of most of the social and even religious activities. Work projects that concerned the entire village were participated in by most of the population. When the season for bird snaring or fishing approached, a community house was consecrated as a

[11] Lowie, loc. cit.

[12] I am deeply indebted in the theoretical aspects of this subject to discussions with Professor Meyer Schapiro, and especially to a study of his basic essay on art historical research in primitive art: "Style" in Anthropology Today, ed. Sol Tax (Chicago, 1953). I am also indebted to Professor Paul S. Wingert of Columbia University, and Professors Richard F. Salisbury and Jacques Schnier of the University of California, Berkeley, for stimulating conversations on the subject of meaning in primitive art.

[13] The economic background in this paper is based upon Raymond W. Firth, Primitive Economics of the New Zealand Maori (New York, 1929).

working place, at which all the men assembled to prepare the nets or the snares. The building and launching of a war canoe involved most of the population, from the lowest slave or captive who might be ritualistically sacrificed beneath the vessel in order to consecrate it, to the various classes of workmen, and to the chief himself who sanctified the launching by his presence. According to an old Maori proverb, "When commoner and chief work together, the task is done."[14]

When a chief decided to undertake the building of a new house or canoe and had provided himself with enough food for the feasts and gifts for the skilled workmen, the tohunga—the master craftsman who was both supervisor and priest—was charged with the direction of the actual work. First of all, the *tapu* had to be lifted ritually from the forest so that a particular tree might be felled and permission requested from the deity of the forest—all according to prescribed ritual.[15] The *tapus* were strict conservation measures that also regulated such activities as the season when bird snaring or fishing was allowed. Firth points out the coincidence of the lifting of these *tapus,* which to the Maori are purely magical, with the actual seasons when it is most economical to engage in these activities, when the birds are full grown or after the fish have spawned.[16] Concomitantly, the mating and nesting season was protected by *tapus* so powerful that, even if inadvertently broken, might cause the entire village to become contaminated. The most severe measures were taken against the violator or supposed violator of the *tapu;* not only the village but the forest itself had to be purified ritualistically.

In addition to the elaborate system of *tapus,* omens continuously impressed upon the mind of the workmen the necessity for accurate work.[17] It was a bad omen if a tree fell in a direction different from that intended, or if when it fell the trunk did not

14 *Ibid.,* p. 192.

15 *Ibid.,* p. 236; R. C. Barstow, "The Maori Canoe," *Transactions and Proceedings of the New Zealand Institute,* Vol. XI (1878), pp. 71–76.

16 *Ibid.,* pp. 258–59.

17 A detailed account of omens is in Elsdon Best, "Omens and Superstitious Beliefs of the New Zealand Maori," *Journal of the Polynesian Society,* Vol. VII (1898), pp. 119–36, 233–43.

come free from the stump. Both these occurrences were inter-
preted by the workmen as supernatural signs of ill fortune, and
magical means had to be sought to counteract the evil spell. To the
civilized Western mind, and perhaps to the tohunga also, these
minor mishaps indicate merely poor workmanship, and suggest
that the solution lies in greater care and skill by the workmen.
However, the primitive mind, generally considered as lacking the
scientific attitude linking a real effect with a real cause, attributes
the real effect to an imaginary cause. The logic is the same, as
Boas, Lowie, and other students in the 1920's insisted, but the
primitive lacks only the detached observation of nature that per-
mits an empirical appraisal of causes.[18] Further, the subconscious
or the dream world is as real or more real to the primitive than the
conscious or waking one, and the ancestors and spirits that inhabit
the other world are believed to control happenings in the physical
one. Therefore an accident meant that the workmen had incurred
the wrath of a deity. They must then resort to magic ritual to
attempt to regain the good will of the offended spirit. This ritual
was closely bound up with the craft of woodcutting, since the
ritual was passed on by a master to his apprentices in the work-
shop and was considered identical with accurate workmanship
and the application of approved methods of procedure. The
solution to difficulties precipitated by poor workmanship lay in the
tapus of the craft itself; namely, that good workmanship precluded
the possibility of the occurrence of bad omens.

Maori sculptors would not have understood Michelangelo's
belief that the subjects of sculpture are mental images that are
only imprisoned in the material; the Maori considered the material
itself as the prime element. The chips hewn away from a log
represented both the skill of the carver and the living substance of
the tree, and were of equal value with the object itself. For that
reason the sculptor could not clear away chips that had fallen to
the ground, nor could he even blow or brush them away from his
work, but should allow them to fall freely where they would.[19]
Such an attitude toward the material and the technique of carving
wood, even if the reasons were magical, produced a stringent

[18] Lowie, *op. cit.*, p. 138 ff.
[19] Best, *op. cit.*, p. 130.

discipline among the workers and elevated the technical process to a sanctified position.

The carver's tools participated in this ritualistic attitude toward work, being described by Linton as "animate, intelligent beings and conscious collaborators in the act of creation."[20] They acquired great prestige for fine work in the same way as did the carver himself, and some tribes evolved lengthy genealogies for their favorite tools. This practice was most common in those areas of Polynesia where genealogy was most important to the nobility and the chiefs; indeed, the veneration of fine tools occupied an analogous place in the material culture. Linton describes how the Marquesan carvers often chanted to their tools the line of descent of the distinguished tool ancestors that had produced excellent work.

In Maori thinking there is no distinction between "practical" and "fine" art. In their minds there is only good or bad work, and a common bird perch may bear carved designs that are as fine as those on the posts of the ceremonial house. However, the Maori did appreciate the aesthetic difference between a simple utilitarian form and a highly elaborated ritual object, these being varying grades of complexity in the same technical tradition. This technique was well known to the people as a whole, since every man participated to some extent in wood carving. The public, then, was highly enlightened, fully appreciating the craftsman's artistry and applauding his frequent displays of virtuosity. Linton tells of watching carvers observing another man's work, and how they unconsciously moved their arms as they were seized with an empathic response to it and reenacted the execution of the carving.[21]

Only the most accomplished carvers were permitted to render the final adzing of the surface of an important work. Best describes the great variety of patterns produced by different strokes of the adze, each with its own characteristic name associated with such natural textures as waves, foliage, or basketry.[22] When a canoe

[20] Ralph Linton, "Primitive Art," *Kenyon Review*, Vol. III (Winter, 1941), p. 38.

[21] *Op. cit.*, p. 42.

[22] Best, *The Maori Canoe*, Dominion Museum Bulletin, VII (Wellington, 1925).

was completed, the master carver tossed in a pebble, symbolically representing the knowledge that had gone into the work.

In addition to the technical *tapus* that ensured the maintenance of high quality in the work, other *tapus* enforced the consecration of workers to the task. At the outset of a new community project, all unnecessary work was suspended and the attention of the people directed toward the new task. A communal house was made *tapu* to all activities except the immediate work. Such mana-destroying influences as women or cooked food were especially *tapu* to the work house. Frequently the men were forbidden contact with women or even to reside in their homes while the work was in progress. Best says that a weaver of ceremonial cloaks had to work only in daylight, for darkness could steal away his knowledge. Only the thread might be prepared after sunset; the fabric itself had to be covered and put away after work had ceased. No cooked food might be brought into the presence of the weavers, and smoking was strictly *tapu* unless the loom was first dismantled and covered.[23] Thus the work itself became the sole object of their vital energy, and sometimes was even considered their progeny.

The *tapus*, taught as an integral part of the craft training in the school for apprentices, were powerful magical forces, and hence operated as traditionalizing agents that tended to perpetuate existing art motifs. Here is an analogy to the powerful influence of the sacred School of Learning on tribal lore and ritual. Best says that the purpose of the school was to conserve traditional knowledge and transmit it in an absolutely unchanged form. Any deviation, even unintentional, from traditional teachings was a serious breach of the *tapu*, for it endangered the very source of the spiritual power of the tribe. According to an old legend a sage swore to his pupils: "Should any person condemn or deny the knowledge I have passed on to you, then may the sun wither him, may the moon consign him to the pit of darkness."[24] To prevent this occurrence, the school, the students, and all the exercises were strictly controlled by rigid *tapus*. The student's powers of memorization were developed to the highest possible degree, so that knowledge might be accurately conserved. Similarly, the sculptors

visualized the complex carving designs so clearly that they could execute them without even the necessity of making a preliminary sketch on the block. Observers report that sculptors sometimes felt the need to go into isolation to contemplate a design before carving it.[25]

The highly skilled specialist was a part of the work organization but on a higher level quite clearly defined from those of lesser skills. This distinction had certain prerogatives. The carver of the highly ornamented prow and stern pieces of the war canoe was not required to work on the site where the canoe was being hollowed. He was therefore freed from the general *tapus* that imposed a rigid discipline upon the other workers. The work of the master carver generally required a longer time than that of the canoe itself, and therefore could be developed at a pace determined by him. In some ways the master carver and the tohunga had as much prestige as the chief, for their names were often perpetuated in legendary accounts of great artists.[26] Even though the individual nature of the master carver's work permitted him the freedom from the rigid *tapus* of the house where the project was being carried on, he was in no sense released from the heavy responsibility of his position. Indeed, both his superior technical skill and his greater knowledge of the *tapus* of his craft reinforced each other to set up a standard of excellence higher than that of the ordinary carver. It is not difficult to understand why most of the legendary accounts of the origin of carving say that it was invented by the gods.[27]

The high valuation attributed to craftsmanship by the workmen is readily apparent in their sculptures, the most important of which were the monumental architectural carvings covering the

25 W. J. Phillipps, *Maori Carving*, Dominion Museum Monograph (Wellington, 1941), p. 5.

26 According to a firsthand observer the tohunga often had more power than the chief because of his control over the instruction of apprentices: Lt. Col. Gudgeon, "The Tohunga Maori," *Journal of the Polynesian Society*, Vol. XVI (1907), pp. 63–91. See also Firth *Primitive Economics . . . , op. cit.*, p. 294; W. J. Phillipps, *Carved Maori Houses of Western and Northern Areas of New Zealand*, Dominion Museum Monograph, Vol. IX (Wellington, 1955).

27 One of the myths tells of the gods disputing on the purely technical question of what to do with the dust and chips of wood. Firth, "The Maori Carver," *Journal of the Polynesian Society*, XXXIV (1925), p. 284.

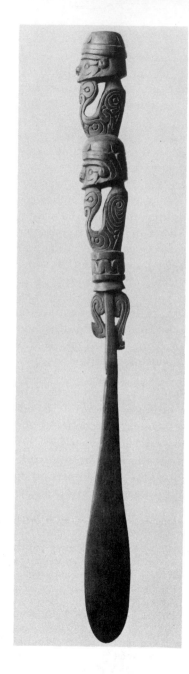

(*Left*) Figure 1. Lime spatula with handle carved with stylized human figures and spiral designs. Massim region, New Guinea. The University Museum, University of Pennsylvania. (*Above*) Figure 2. Paddle with stylized forms based on the human figure. Marquesas Islands. From K. von den Steinen, *Die Marquesaner und ihre Kunst,* III (1928).

surfaces of the community houses, and the elaborate prow and stern pieces of the war canoes. Almost every weapon, utensil, or other useful object was decorated with the traditional designs. The result of the uniformly careful attention given to all these articles was a homogeneous style characterized by great precision and richness of detail. The technical virtuosity of the carver was demonstrated by the ease with which the typical spirals and organic curvilinear forms were cut in the pine planks, even to the point of multiple perforations of the block of wood, and by the density of the subsidiary patterns usually covering the entire surface in a fantastic elaboration of the basic motifs.

This high quality and degree of elaboration are unique even among Polynesian styles, which are typically precise in workmanship and which employ small geometric motifs repeated exactly in overall patterns. The exuberant curvilinearity of Maori motifs, as contrasted with the static rectangularity of those of Polynesia, is generally explained as reminiscent of the Indian or Southeast Asian ancestors of the Polynesians. The curves are believed to have been preserved among the Maori by reason of their extremely isolated location. Skinner cites numerous examples of similar curvilinear elements in Melanesia, especially from the eastern Massim area of New Guinea (Figure 1) along the presumed routes of the eastward migrations from Asia.[28]

In Polynesia the art style most related to Maori carving is that of the Marquesas Islands, which is also closely related culturally. Although basically rectilinear in composition, the Marquesan reveals a taste for curved elements as seen in typically rounded contours. The major motifs, as with the Maori, are based upon stylizations of the human figure and various fragments derived from it (Figure 2). The Marquesan style may therefore be considered an intermediary stage between the severely rectilinear motifs of Polynesia and the involved curves of the Maori.

A second formal characteristic of Maori art allied to careful workmanship is the close structural relationship between the sculptures and the objects or forms on which they are carved. The

[28] H. D. Skinner, "The Origin and Relationships of Maori Material Culture and Decorative Art," *Journal of the Polynesian Society*, Vol. XXXIII (1924), pp. 229–43.

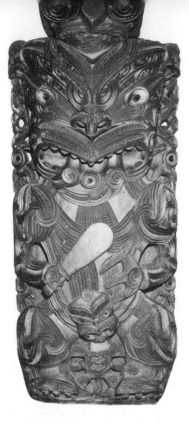

(*Left*) Figure 3. Ancestor figure from a house built in 1842. New Zealand, Maori. Dominion Museum, Wellington. (*Below*) Figure 4. Canoe prow. New Zealand, Maori. Otaga Museum, Dunedin. (*Top right*) Figure 5. Door lintel representing an ancestor figure with two flanking mythological beings. New Zealand, Maori. Courtesy of the Trustees of the British Museum, London. (*Center right*) Figure 6. Knife with traditional carving designs. New Zealand, Maori. Courtesy of the Trustees of the British Museum, London. (*Far right*) Figure 7. Portrait image of Rahuruhi Rukupo from a house built in 1842. New Zealand, Maori. Courtesy of the Trustees of the British Museum, London.

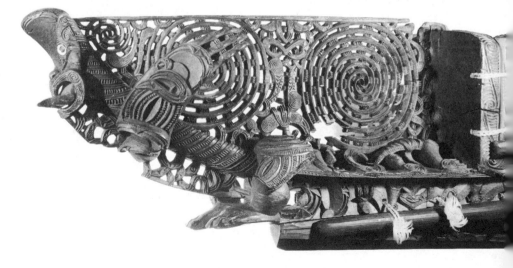

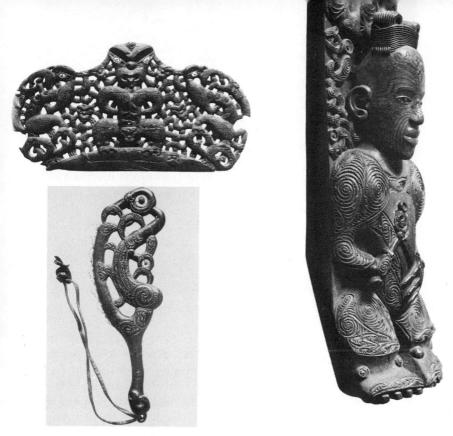

ancestor figure carved from a plank (Figure 3) is part of the
aesthetic structure of the interior of the house, although the plank
is only attached to the actual supporting post. The canoe prow
carving (Figure 4) conforms to the lines of the vessel, and the
mythological figure on the front assumes a three-dimensional form
quite different from that of the house carvings. When the human
figure is only one part of a composition, as in a typical doorway
lintel from a ceremonial house (Figure 5), it may be almost com-
pletely merged into an involved interlace of organic forms that are
apparently derived from a stylization of the parts of a typical
figure. How the pervasiveness of the powerful carving style can
obliterate even the distinction between a human figure and a
decorative pattern may be seen in a knife (Figure 6), in which the

forms only vaguely suggest eye, body, or limb. The sequence of stages between a representational ancestor figure and a decorative pattern has stimulated some scholars to envisage an evolutionary development where the decorative forms grew out of the human figure, and where the original human form persists alongside those that developed from it.[29] This change cannot be explained simply by the limitations imposed by the shapes of the objects upon which the carving exists or by the usage to which an implement is put, since all stages of the sequence often exist in a single carving. The lintel is a form that is not rigidly limited by the necessities of the architectural design, and yet it includes almost the full range of styles. Since it fulfills mainly a decorative and not a structural function, the contour does not conform to the general rectangularity of other architectural forms, but rather submits to a centrifugal projection of the curvilinear character of the interlaced organic forms that make up the composition.

To study the motifs further it is necessary to consider the meaning of the various figures. A portrait of a chief, Rahuruhi Rukupo (Figure 7), is a part of a community house. A chief is generally portrayed with the face in a fairly realistic style, although conforming to typical rather than individual facial features. The other, nondistinctive parts of the body are, however, treated in the traditional stylized manner with the surface covered with spiral motifs. The ancestor figure from the same house (Figure 3) is an image of a being of the spirit world, and hence is composed of the traditional stylized head and appropriate figure forms and is covered with designs of a high degree of stylization. A *manaia*, a mythological creature variously associated with animal,

29 Gilbert Archey has assembled considerable evidence that both the fantastic creature, the mania, and the spiral form have evolved from the typical human figure. But since no chronology of Maori art forms exist, it cannot be proven that the evolutionary process proceeded in this direction and not in the reverse. "Evolution of Certain Maori Carving Patterns," *Journal of the Polynesian Society*, Vol. XLII (1933), pp. 171–90; and Vol. XLV (1936), pp. 49–62. Chief opponent of this theory is W. Page Rowe, who points out that, with neither a chronology nor an explanation of a motivation for this change, the sequence might as well have been in any other order than that arranged by Archey. "The Origin of the Spiral in Maori Art," *Journal of the Polynesian Society*, Vol. LXVII (1938), pp. 129–33.

fish, and bird deities, is often portrayed in heraldic positions flanking an ancestor figure (Figure 5). With the exception of the chief none of these figures is specifically identified by name or associated with specific powers. Neither do they include iconographical features that would connect them with specific figures in the tribal hierarchy of mythological deities. Apparently they do not represent the magical powers of the gods at all, but rather only the general class of ancestors; hence they are not idols but architectual decorations for the ceremonial house and witnesses to the ritual life of the village that takes place there.

The avenues by which the meaning of a figure is conveyed seem to depend largely upon the formal characteristics of the carving—in other words, upon those stylistic features determined by the sculptural tradition rather than upon iconographical elements. These stylistic features determined by tradition are: (1) the position of the carving in the community house, with the chief after whom the house is named portrayed on the central supports, and the ancestors arranged along the interior walls; (2) the position of figures in the composition, as in the lintel, in which the ancestor figure is in a central position flanked by the *manaia;* and (3) style, in which the chief is represented with a realistic face, the ancestor by a traditional figure highly stylized in form and decoration, and the mythological *manaia* by a being of fantastic form but also composed of the traditional stylized motifs.

Both Boas and Lowie have produced considerable evidence that the most sacred concepts in primitive religion are often not represented in the art at all; or, if they are, they are concealed by geometric designs that bear only a symbolic relation to the meanings. Boas even suggests that "the very sacredness of the idea represented might induce the artist to obscure his meaning intentionally, in order to keep the significance of the design from profane eyes."[30] According to Best, the Superior Religion of the Maori is addressed to an unnameable being who is never portrayed, and he states that the most powerful magic often operates through common untreated objects such as stones or "sacred

[30] Boas, "The Decorative Art of the North American Indians," *Popular Science Monthly* (October, 1903), p. 485.

bundles" composed of any ordinary material.[31] He goes on to describe the carvings in the community house as representative of the pantheon of ancestor and nature deities belonging to the lower level of religion, which is available to the people as a whole. Hence we may assume that these figures by their presence in the community house perform a secular function for the people as much as a specifically religious one. Thus they need not be directly associated with individual gods. Because their status is largely social—a matter of prestige—the degree to which they are given aesthetic elaboration becomes of primary concern. This may explain why useful objects as well as ritual ones are elaborated far beyond the necessities of their function, and it may partly explain why a dazzling display of the carver's virtuosity may result in carvings in which the identity of the figures is submerged beneath the traditional motifs of the powerful sculptural style. Finally, it should be remembered that magic is not at all absent from Maori art, although its operation is largely limited to enforcing the canons of fine craftsmanship.

III. THE PLAINS INDIANS OF NORTH AMERICA

The only images that could be painted on the tepees of the Sioux tribes of the American Plains are those that had appeared in the dreams of the owner.[32] The only dreams that were considered significant were those that fell into the pattern of the tribal culture; other dreams of a personal meaning were disregarded. Thus the ideas did not necessarily originate in the dream but actually took their form from the body of the myths already a part of the religion, even though they may have been intentionally induced by a dream quest.[33] Lincoln calls such dreams "culture-pattern"

[31] Best, *The Maori School of Learning*, Dominion Museum Monograph, Vol. VI (Wellington, 1923). Evidence for the presence of a sacred meaning in conventionalized geometric designs is provided by Ettie Rout, *Maori Symbolism* (New York, 1926), who recorded the interpretations of an old Maori believed to be a reliable informant. He described mostly sex symbols which he stated were to be concealed within the design (p. 199 ff.).

[32] J. O. Dorsey, *A Study of Siouan Cults*, Bureau of American Ethnology, Vol. XI (1894), pp. 394–409, cited in Lowie, *op. cit.*, p. 262.

[33] J. S. Lincoln, *The Dream in Primitive Cultures* (London, 1935), p. 326.

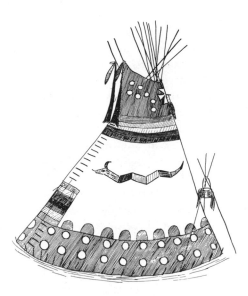

Figure 8. Tepee painted with a water monster and symbolic designs. Blackfoot Indians, American Plains. From a drawing in C. Wissler, *Ceremonial Bundles of the Blackfoot Indians* (1911).

dreams, such as a meeting with an animal or a spirit that may become the totem of the dreamer.[34] After the dream had been interpreted by the shaman—thus ensuring its conformity to the culture pattern—it could be painted on the tepee. The water monster and the several symbolic designs on a Blackfoot tepee are of such an origin (Figure 8). Because of the importance given to the dreamer as an intermediary, the designs that originated in the dreams of important men may have thereby acquired an added prestige and could then enter directly into the body of accepted tribal hierarchic symbols.

It has been often demonstrated that among primitive men the threshold between the dream world and the real world is slight or even nonexistent. Lincoln's studies indicate that the dream is often considered even more real than actuality, since the dream world is the abode of the ancestor and other spirits that control events in the real world.[35] Since dreams and mystical experiences are the main avenues of contact with the spirits, it is natural that these

[34] Lincoln, *op. cit., passim.*
[35] Lincoln, *op. cit.*, pp. 99–100.

should have been the immediate sources of much of mythology and art. Many images in Northwest Coast art—Kwakiutl masks for example—like the myths, represent mystical encounters between supernatural beings that are part human and part animal. The Tsimshian explain the origin of the bear totem by a legend told as though it were an actual event, although it is fully understood that it occurred in a dream or a vision by a clan ancestor.[36] According to the legend, a man met a bear and was taken to the animal's house, where he was instructed in the animal's hunting secrets. The lack of a distinction in the primitive mind between men and animals is indicated by the fact that the association had caused the man to be transformed into a bear that could reassume human form only by the action of a shaman.[37] The bear frequently appeared in visions of the man to offer supernatural guidance in his most important activities, such as the hunt and warfare. Eventually, in order that the clan retain the animal's favor, the chief ordered representations of the bear painted on the house fronts, woven in the blankets, and carved on ritual objects. This particular bear, and ultimately the bear species, became the totem of the clan and was accorded the same veneration, by means of magic rituals in the winter ceremonials, as that given to other benevolent spirits. The first ritual painting of the bear was a sacred image, and became the accepted model for succeeding representations. A scene representing a similar mythological episode involving the thunderbird, killer whale, wolf, and lightning-snake is seen in Figure 9.

Magic to the primitive mind is often said to be a connecting link between observed events in the actual world and their believed causes in the spirit world. Boas has clearly stated a belief shared

[36] Lincoln, *op. cit.*, p. 57.

[37] The fact that supernatural or human-animal beings appear to the primitive mind as entirely real creatures faithful to traditional ideas, and not as fantastic ones, is demonstrated in L. Lévy-Bruhl, Trans., *The Soul of the Primitive* (London, 1928), p. 53 ff.

Numerous examples of human-animal beings may be found in other primitive cultures; the Northwest Coast animal double masks, which when opened revealed a human face within is perhaps the closest analogy. Even in paleolithic cave painting figures such as the "Sorcerer" in the cavern of Trois Frères manifest both human and animal characteristics, and are interpreted as supernatural beings partaking of both animal and human characteristics.

by most ethnologists, that the mental processes of linking an imaginary cause to a real effect is the same as linking an empirically proved one to it. In that respect the primitive mind is in no way inferior to the civilized mind. But this invocation of the imagination in the search through the spirit world for the directing forces of the actual world is of significance for the images that appear in primitive art. The Northwest Coast house painting (Figure 9) and Crow shield design (Figure 10) objectify a mystical contact with the spirit world that endows the images with magical power in themselves. The protection afforded by the shield was believed to be derived from the painting itself more than from the actual rawhide covering. Therefore, art assumed an importance analogous to that of the myths and legends, since it had a similar origin and since it fulfilled similar ritual and spiritual functions.

Since the importance of Plains Indian painting resided primarily in a sacred meaning, the technical means by which the images were realized were often of the simplest order. Craftsmanship was necessary only to the point where it produced forms that adequately suggested or symbolized the all-important meaning. Art was therefore strictly limited in the degree to which forms were given aesthetic elaboration, and was often confined to the simplest arrangement of geometric lines and circles. Boas, with his concern for technical and formal aspects of art, suggests that a work of art is achieved only when it is technically perfect or shows a striving after a formal pattern. Although Indian designs are charged with meaning, it would be quite wrong to imply that they are devoid of artistic quality. Nevertheless the motifs are of an elementary order: lines, circles, and geometric figures, which may be either stylizations of natural forms such as men, animals, or mountains, or purely geometric shapes without reference to actual things. The Blackfoot water monster, with horizontal bands bearing regular decorative patterns at top and bottom, symbolized a complex and profound mystical experience (Figure 8). Each of the motifs and each of the colors could be "read" by the owner of the tepee who thus reconstructed the episode. Even greater magical power was attributed to the Crow buffalo hide shield in which a bear was represented warding off a hail of bullets just as the shield was expected to do in a combat (Figure 10). This particular type of image was also customarily derived from a mystical experience. As an

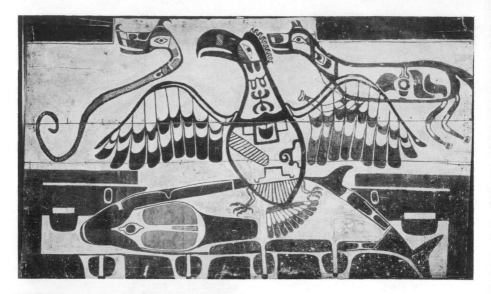

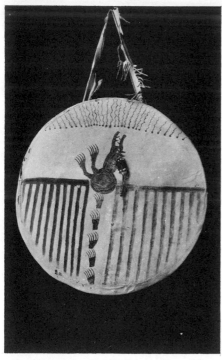

(*Above*) Figure 9. House painting on wood of mythological animals: Thunderbird (*above*), Killer Whale (*below*), Lightning Snake (*left*), and Wolf (*right*). Nootka Indians, Vancouver Island, British Columbia. Courtesy of the American Museum of Natural History, New York. (*Left*) Figure 10. Buffalo-hide shield painted with a bear warding off bullets. Crow Indians, American Plains. Chicago Natural History Museum, Chicago.

enhancement of the potency of the protective magic of the image, a sacred bundle was attached to the face of the shield.

Boas concludes from his studies of the art of the Plains Indians that there is no fixed relationship between the formal characteristics of the motifs and the meanings given to them.[38] An identical form among several tribes or even among individuals of the same tribe may be given quite different interpretations, and a general concept that is universally recognized may be attributed by different tribes or persons to quite different forms. Meaning in this art, therefore, is cast in terms of an individual as well as a tribal experience; hence both the interpretations and the style vary widely. However, since the interpretation of the dream by the shaman was made in terms of the body of traditional tribal concepts, the meaning would naturally fall within the range of accepted ideas. Similarly, the image painted by a dreamer would be constructed of forms already within his visual experience.

The Northwest Coast Indians of British Columbia also derived many of their art forms and myths from dreams and other visionary experiences. But because of their more settled life and richer material culture than those of the Plains Indians, the Northwest Coast tribes developed a much more elaborate art that provided an enormously rich ornamentation for both ritual and useful objects. The immediate agency most stimulating to the production of art was the obsessive desire on the part of the men for social prestige. The possession of art objects elaborating totemic animals of the family or clan was the most impressive means of attaining prestige; hence arose a powerfully competitive patronage demanding works of art. Boas suggests that this external factor may even be as important as the aesthetic impulse: "Who can tell whether the association between social standing and the use of certain animal forms—that is the totemic aspect of social life—has given the prime impetus to the art development or whether the art impetus has developed and enriched totemic life?"[39] It is true that the meaning embodied in the art was religious, but the powerful desire to give it a highly elaborated and even dramatic form was the result of an aesthetic impulse that was fortified by the enor-

[38] Boas, *Primitive Art,* p. 128, and *passim.*
[39] *Ibid.,* pp. 280–81.

mous personal prestige inherent in works of art; hence the dramatic character of dance masks and the great size of totem poles and house paintings. Although all these were given a high degree of elaboration far beyond the necessity to represent the symbolic animals concerned, the original meaning was seldom obscured. Northwest Coast art, therefore, although richly endowed with precise and elaborate detail like the Maori, maintained, like the Plains Indian art, the original symbolic meaning that was the reason for the existence of the image.

IV. FORMAL AND SYMBOLIC FACTORS

The complex Maori work organizations controlled both technical and iconographical factors in their art, providing a drastic limitation upon the field within which the artist's own personal inventiveness had to be confined. Although dreams and visionary experiences were an important part of the contact with the spirit world, they were not considered to have any special bearing upon the art images. The personages portrayed by the Maori sculptor were secularizations of the general idea of the ancestor, and therefore were not specifically associated with an individual being and were not believed to be imbued with a high degree of magical power. Magic was a force in Maori sculpture mainly in the authority given to the precepts of good workmanship by means of the system of *tapus* and omens. By his understanding of these precepts, the sculptor attuned himself to the flow of spiritual power to the tribe. Hence the commission of a technical error—a mistake by a priest in reciting a ritual or by a sculptor in observing traditional procedures of work—might interrupt or destroy the customary channels of communication with the spirit world, and might be atoned for with penalties as severe as death.[40] Precautions against a catastrophe of this sort were provided for in the rigid training of the apprentices simultaneously in the technique of their craft and in the *tapus* that gave it magical support. The incorporation of the carver into the discipline of the tribal work organizations bound

[40] S. Percy Smith, "The Tohunga Maori," *Transactions and Proceedings of the New Zealand Institute*, Vol. XXXII (1899), p. 262.

him even more firmly to the community ideals of technical excellence.

The individual culture-pattern dreams or visionary experiences of the Plains Indians were the primary sources of images in their art. Since these images depended upon an individual experience, new ones might suddenly appear among those already sanctified. Lacking the elaborate stylistic conventions and the magical support to the canons of good craftsmanship of the Maori, the style and the quality of the Plains Indians' paintings fluctuated according to the proficiency of the artist. And since art was a symbol for the spiritual power of the deities, it did not receive special elaboration or conform precisely to stylistic conventions. Whatever the form, it was related to tribal religious concepts by reason of the origin of the image within the context of the culture-pattern dream, and as the dream experience was interpreted by a shaman. However, art was also intimately associated with the spiritual life of the individual, since it came into being as a result of a personal encounter with a supernatural spirit. This latter aspect, together with the overwhelming importance of symbolic meaning to the art, allowed a complex body of interpretations to be applied even to simple motifs.

These two motivations are taken here as separate avenues of approach to the study of primitive art. While they cannot be considered opposites in the sense of Wölfflin's polarities of formal characteristics, they include the significant aspects of both major elements; the aesthetic qualities of the art objects, and the associated meanings attached to them. A study of the aesthetic qualities of the objects cannot ignore Boas' method of dealing with the influence upon form of materials and methods of working, or his descriptive account of decorative motifs. These still provide a valuable discipline in treating the elementary aspects of the art styles. But they only begin to explain the more significant aspects that have to do with a definition of the art style in relation to the culture. Finally, one must undertake a visual stylistic analysis of the objects in terms of art-historical method.

Meanings may be studied by reference to existing accounts of tribal religion, mythology, and the actual ritual in which the art object is a part. When these can be related to the art object, the

student may then attempt to determine the level of meaning; the secularization of the subject or the degree of magical power believed to be actually present in the object. Following Lowie's theory, one may then inquire into possible influences in either direction between the religion and the art.

Thus, by studying primitive art in terms of these two proposed motivations—insofar as ethnological material is available— the student may begin tentatively to define stylistic features that not only characterize the objects themselves but also refer to their cultural origins.

Art Styles as
Cultural Cognitive Maps*

JOHN L. FISCHER

The relationship of art style to social organization is documented here in a
paper derived from Barry's earlier research. Dr. Fischer discusses the
association of art styles with three aspects of social relations: the develop-
ment of social hierarchy, the relative prestige of the sexes, and the form of
marriage. He concludes from the evidence that social conditions are deter-
minants of art styles and that if further research is pursued along these lines
it would offer great promise not only for ethnological research but as an
additional means for reconstructing the lives of extinct peoples now known
only through the archaeological analysis of their material culture.

Dr. John L. Fischer is Professor and Chairman of the Department of
Anthropology at Tulane University. His interests are social and expressive
culture, psychological anthropology, linguistic change, and mythology, and he
has done research in the Pacific Islands and Japan. He has written "The
Sociopsychological Analysis of Folktales" (*Current Anthropology*, 1963), and
is the coauthor of *The Eastern Carolines* (1957, 1966), and of *New Englanders
of Orchard Town, U.S.A.* (1966).

Students of the history of the visual arts have long postulated
connections between art forms and sociocultural conditions. Such
a connection is often obvious in respect to overt content: e.g., the

* Reprinted from *American Anthropologist*, Vol. 63, No. 1 (February,
1961), pp. 79–93. The author wishes to thank the following persons for
reading a draft of this article and offering helpful suggestions and criticisms:
Herbert Barry, III, Irvin L. Child, Clyde Kluckhohn, George P. Murdock,
David Riesman, and John Whiting. This article is a revision of a paper
presented at the annual meetings of the American Anthropological Associ-
ation in Mexico City, December, 1959. The author also wishes to thank a
number of people who made verbal comments at that time, some of which
he hopes he has heeded, even while lacking adequate notes to give them
credit. Barry deserves special thanks for making his findings available to the
author.

religious art of the Middle Ages. But connections between social conditions and general features of style have also been postulated: romanticism versus classicism, for instance, have been explained as related to the position of the individual in society and to the rapidity of social change. While these explanations of style are often convincing and appear profound, from an anthropolgical point of view they suffer from being limited, for the most part, to artistic data from various branches of European civilization, or in some cases certain other extremely complex societies such as the Oriental civilizations. The study of art in a widely distributed sample of primitive, relatively homogeneous societies would seem to offer valuable evidence for testing theories of the relationship of art style to social conditions. This paper is intended as a modest contribution in this direction, making use of objective statistical tests.[1]

Two sets of variables are used in the tests reported below. The judgments on the art styles were made by the psychologist, Herbert Barry, III, and formed the basis originally of his undergraduate honors thesis at Harvard carried out under the direction of John Whiting. Barry later published some of his findings in a paper on "Relationships Between Child Training and the Pictorial Arts" (1957). Judgments on the social variables are from Murdock's article, "World Ethnographic Sample" (1957). Since both sets of judgments were made independently without, moreover, any intent to test the specific hypotheses to be discussed below, it can be fairly stated that the positive results are not to be explained by bias of the judges in favor of the hypotheses.

The sample of primitive societies used below is determined by the overlap of Barry's and Murdock's sample. Thanks to the large size of Murdock's sample all except one of Barry's societies are also represented in Murdock. Barry's sample itself consists of those societies with sufficient art data from the larger cross-cultural sample of Whiting and Child (1953). It is somewhat biased geographically in favor of well-covered parts of the world—North America and the Pacific, but I personally doubt that this seriously

[1] For useful discussion of the methodological problems involved in investigation of this type, see Murdock (1949), Whiting and Child (1953), and Whiting (1954). For further information or statistical methods used, see Siegel (1956).

affects the validity of the conclusions, since for many of the art variables both extremes of values can be found in the same continental area. A total of twenty-nine societies are available for testing, although for stratification Murdock makes no rating for the Thonga for lack of specific data.

The general theoretical position behind this paper is that in expressive aspects of culture, such as visual and other arts, a very important determinant of the art form is social fantasy, that is, the artist's fantasies about social situations that will give him security or pleasure. I assume that, regardless of the overt content of visual art, whether a landscape, a natural object, or merely a geometrical pattern, there is always or nearly always at the same time the expression of some fantasied social situation that will bear a definite relation to the real and desired social situations of the artist and his society. Incidentally, while this point of view that man projects his society into his visual art will not seem especially revolutionary to many anthropologists or to psychoanalysts, it is one that is by no means universally accepted among art critics, who often emphasize historical relationships, the stimulus of forms in the natural environment, or the limitations of the material worked with. I would not discount these other influences entirely but would point out that almost any society has a variety of materials to exploit, and cultural and natural forms to serve as models. It may be more important to ask not "What is in the environment" but "Why do these people notice items A and B and ignore items C and D in their environment?"; to ask not "What materials do they have to work with in their environment?" but "Why have they chosen to work with wood and ignore clay, even though both are available?"

In a sense, the hypotheses tested below may be said to deal with latent content of art as opposed to the overt ("representational") content. I do not assume that the artists themselves are necessarily or usually fully aware of the significance of their art as representative of fantasied social situations. There is, on the contrary, reason to believe that this awareness is usually repressed. On the other hand, if some sort of fairly regular connection between some artistic feature and some social situation can be shown, this would constitute plausible evidence for a repressed significance to a work of art which the artist might deny if questioned directly,

although one would assume that further and better confirmation of the repressed meaning could be obtained by psychiatric interviews, life histories, projective tests, etc., from individual artists and their public.

A word about the assumed relation of the artist to his society is in order here. It is assumed that the artist is in some sense keenly aware of the social structure and modal personality of his culture, although of course he cannot necessarily or usually put his awareness into social science jargon or even commonsense words. It is not assumed that the artist's personality is a simple duplicate of modal personality for the group; in fact in many societies artists appear to have rather unusual personalities. However, I do assume that all sane persons inevitably participate to a considerable extent in the modal personality of the group, and that the successful artist has a greater than average ability to express the modal personality of his public in his particular art medium. Perhaps under special circumstances he would also have the ability to express his private personality too, but in most societies there are fairly strict social and traditional controls on art production; personal isolation of the artist and encouragement of individual expressiveness to the degree typical of modern Western society are not found to my knowledge in any of the societies in Barry's sample.

I assume that the latent social meaning of visual art refers primarily to people, especially to characteristic physical configurations and to characteristic gestures and motor patterns. Conceivably socially important objects may be also involved to some extent, although because of the variety of artifacts and possessions in most cultures it would probably be hard to pick out general Gestalten from material objects that could influence art styles.

Two examples will be given of the ways social conditions may be reflected in art. The first and statistically more striking involves the reflection of the development of social hierarchy. We may postulate two ideal types of societies with respect to the development of social hierarchy.[2] In the authoritarian type, social hier-

[2] These ideal types are set up for the purpose of simplifying the exposition and derivation of hypotheses. There is no intent of course to claim that any real human society can be categorized as purely hierarchical or egalitarian. On the contrary, all real societies fall at various intermediate points

archy is positively valued. Society is seen as differentiated into groups of people lower than ego, who will serve ego and whom in turn ego must protect and help, and others higher than ego, whom ego must serve but who also in return will help and protect ego and glorify him by their association with him. These groups of higher and lower people, of course, are further differentiated internally along the same lines: there are those in both the lower and the higher group with whom ego has direct and regular contact; there are others too low or too high with whom contact is most often through intermediaries. The comfortable, secure situation in such a society is one where the relative rank of each individual is known and is distinct from the rank of each other individual.

The opposite ideal type of society is the egalitarian society. In this type of society, hierarchy as a principle of organization is rejected. While differences of prestige between individuals inevitably exist, it is bad taste to call attention to them. Work involving two or more people is organized as cooperation between equal partners rather than as service upward or help downward. A "bossy" individual is seen as a threat to security rather than as a strong and wise leader.

If we assume that pictorial elements in design are, on one psychological level, abstract, mainly unconscious representations of persons in the society, we may deduce a number of hypothetical polar contrasts in art style. These are listed below, briefly discussed, and the results of statistical tests of them given in Table 1:

1) Design repetitive of a number of rather simple elements should characterize the egalitarian societies; design integrating a number of unlike elements should be characteristic of the hierarchical societies.

along a continuum between the two poles. On an impressionistic basis I would guess that if there is any tendency of societies to cluster it is near the center of the continuum—a balance between the two structural principles—rather than near either or both extremes. Even in this central group, however, any two societies can be compared as to their relative nearness to the two poles, and their art styles can then be investigated to see whether they differ in the predicted direction. The statistical summaries given herein do this on a group basis.

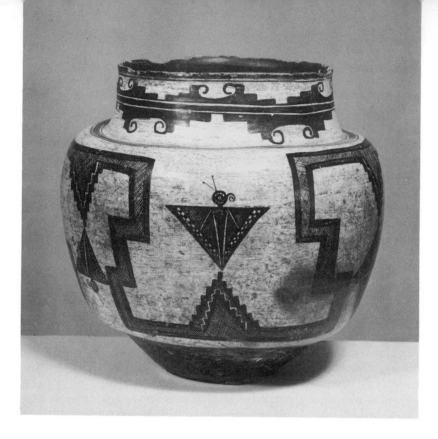

Pottery water jar with painted decoration of snails and cloud design in black and red on white slip. Zuni Indians. The Brooklyn Museum, New York.

2) Design with a large amount of empty or irrelevant space should characterize the egalitarian societies; design with little irrelevant (empty) space should characterize the hierarchical societies.

3) Symmetrical design (a special case of repetition) should characterize the egalitarian societies; asymmetrical design should characterize the hierarchical societies.

4) Figures without enclosures should characterize the egalitarian societies; enclosed figures should characterize the hierarchical societies.

The reasoning behind the first hypothesis, an association be-
tween visual repetition and egalitarian societies, is perhaps obvi-
ous. Security in egalitarian societies depends on the number of
equal comrades ego possesses. By multiplying design elements one
symbolically multiplies comrades. That the repeated design ele-
ments themselves will tend to be simple rather than complex also
follows from the basic assumption that design elements are sym-
bolic of members of the society, since, first, it is easier to maximize
repetition with simple elements than with complex elements, and
second, with the need to de-emphasize actual interpersonal differ-
ences in the society, typical persons would be conceived of as
relatively simple, with emphasis on their relatively few near-
uniform features, and will be symbolized in art accordingly.[3] Con-
versely, in the hierarchical society, security depends on relation-
ships with people in a number of differentiated positions in a
hierarchy. In art these can be symbolized by a design integrating a
variety of distinct elements. Moreover, the more complex the ele-
ments in the design representing members of the society, the
greater the possible differences between elements of the design,
and the greater, therefore, the symbolic emphasis on personal
differentiation. Note that even if one does not accept the human
symbolism of the design elements but regards them instead as
symbolic of valued objects or artifacts the argument leads to the
same results: in the egalitarian society group harmony is promoted
by an abundant supply of the same property for everyone—plenty
of the same shelters, clothes, etc.; in the hierarchical society group
harmony is promoted by every member keeping his place and
having his own distinctive paraphernalia.

The second hypothesis, the association of empty space with

[3] Although of course important individual personality variation due to
differences in inherited constitution and life history is to be found in all so-
cieties, this simplistic conception of people postulated here, I believe, has a
definite effect in actually reducing personality variation among members
of egalitarian societies. Therefore, even though simplicity in art design is far
from a complete representation of the personality of its producers and con-
sumers, I believe that the relationship between simplicity of art design on the
one hand and personality and social structure on the other should be, as the
data cited suggest, positive (the more A, the more B), not negative or anti-
thetical (the more A, the *less* B).

egalitarian societies, assumes that for members of such societies
other people are either comrades or nothing at all. If they are not
comrades one tries to avoid contact with them. This implies a
shrinking away from members of other groups, from foreigners.
There are several reasons that one would be led to postulate that
egalitarian societies tend to be more fearful of strangers. For one
thing, such societies are necessarily small, and hence it is more
likely that external aggression can totally disrupt them. Also, small
societies are on the whole economically independent with respect
to subsistence and therefore have less positive attraction to for-
eigners to counteract their fear. From a sociopsychological view-
point, in small, close-knit, cooperative societies with intense face-
to-face contact with a limited number of people, one would expect
the generation of a considerable amount of in-group aggression
which could not be directly expressed, and would in consequence
be projected (in the technical psychoanalytic sense) onto for-
eigners and supernaturals—anyone outside the in-group—with
resultant fear of the supposedly hostile out-group. The ideal situa-
tion for security is then one in which one's own group is numerous
but well isolated from other groups. This isolation presumably can
be symbolized by an empty space around the design.[4] In the hier-
archical societies, on the other hand, security is produced by
incorporating strangers into the hierarchy, through dominance or
submission as the relative power indicates. Isolation of one's group
implies that there may be other groups whose relative position is
unclear. In fantasy the hierarchical society seeks to encompass the
universe.[5]

[4] One might be tempted to argue that enclosed figures should character-
ize the art of egalitarian societies as a means of symbolizing the isolation
desired and often achieved relatively well. However, one must consider that
the isolation desired by these people is isolation of the whole in-group, while
within the in-group close contact is desired with other individuals. At most
this might lead one to hypothesize a tendency to frame the entire design in
an enclosure but not to enclose separate figures within the design, I believe.
For reasons too lengthy to discuss here I am doubtful about hypothesizing
even the framing tendency.

[5] Clyde Kluckhohn has pointed out that empty space is characteristic of
at least some Japanese pictorial art and asked how this may be reconciled

The third hypothesis, an association of symmetry with egalitarian societies, is posited on grounds similar to the first, symmetry being a special case of repetition. However, since symmetry tends to put a limit on the number of repetitions, one might expect that the association would not be as strong. Note also that bilateral symmetry can be said to involve an "original" image and a mirror image that is the opposite or negative of the first. This could suggest an egalitarian society perhaps but with an emphasis on competition between ostensible equals, i.e., some interest in establishing a hierarchy, but without success in stabilizing it.

The fourth hypothesis, association of enclosed figures and hierarchical society, assumes that in the hierarchical society boundaries between individuals of different ranks are important. Higher are protected from lower and vice versa by figurative boundaries of etiquette and prescriptions of time, place, and nature of association, and also often by physical obstacles such as walls and fences, doors, moats, etc.

with the interpretation given here. One question which arises is whether Japanese art is really characterized by empty space in terms of Barry's scale. As it happens, Barry did include Japan in his initial ratings but later dropped it because he felt that the country was too diverse and there was no guarantee that the artworks rated were characteristic of the particular segments of the society from which the Whiting and Child socialization data came. Barry put Japan on the "crowded" side of the dichotomy, about intermediate between median and extreme. This suggests that while Japanese graphic art has much empty space by Western standards, it is still relatively crowded compared to the art of many primitive societies.

Another problem which arises is that Barry's sample was limited almost entirely to simple and middle-level societies. The only literate society included was Bali (also, incidentally, on the crowded side of the dichotomy). Perhaps in stable, large-scale, literate societies relationship to a social hierarchy is taken for granted more than middle-level hierarchical societies. If so, the artist might safely engage in compensatory fantasies of temporary withdrawal from the hierarchy, the withdrawal being represented artistically by the empty space. But one would not expect this withdrawal to be extreme. The withdrawal of the simple primitive from foreigners should be more drastic psychologically than the withdrawal of man in civilized society from his obligations and restrictions. If this reasoning is correct the emptiest art should be found in simple societies, the most crowded art in middle-level societies, and somewhat emptier art again in complex, stable societies.

Table 1. Relation of Social Stratification (Murdock, Col. 14)
to Variables of Art Style (Barry)
STRATIFICATION OF PEERS

Art Style	Low (A, O)	High (W, C, H)	
Simple design	13	1	p is less than .005
Complex design	6	8	

(Note: Since there are in fact more societies with low stratification than high in the sample, one would expect more with simple art styles. If one increases the number of societies with simple styles by moving the point of dichotomy up the scale of complexity, the distribution is as follows.)

	Low	High	
Simple design	16	1	p then becomes .000045
Complex design	3	8	

	Low	High	
Space empty	12	2	p is less than .05
Space crowded	7	7	

	Low	High	
Design symmetrical	12	2	p is less than .05
Design asymmetrical	7	7	

	Low	High	
Enclosed figures	7	7	p is less than .05
No enclosed figures	12	2	

Fisher-Yates test used for probabilities.

As is shown in Table 1, all four of these hypotheses are supported at statistically significant levels, especially the first.[6]

[6] If one tests a large enough number of hypotheses it is to be expected by chance alone that one will receive confirmation of some of them at "significant" statistical levels. Statements of probability levels of confirmation of hypotheses are therefore questionable unless accompanied by a statement as to the total number of tests from which the reported significant tests were selected. For this paper the total number of hypotheses from which the six tests reported in Tables 1 and 2 were selected was twenty. None of the other fourteen hypotheses was supported or contradicted at a statistically significant level.

A second variable of social structure of considerable psychological importance is the relative prestige or security of the sexes. As a measure of this, types of residence as categorized by Murdock may be used. These may be dichotomized into those which favor male solidarity in residence strongly and those which do not. The former are patrilocal and avunculocal, while the latter are all others occurring in our sample (Murdock, Column 8:P, A *vs.* V, Z, N, B, X, M). The hypotheses below assume that individuals of both sexes find it advantageous to live with their own blood relatives if possible. Even where, as is usually true, the younger relatives must serve and obey the older, the younger have their own old age to look forward to, when they will be honored and cared for. In general, the spouse living with blood relatives has an advantage over the in-marrying spouse in obtaining support from other members of the household or family, so the side of the family chosen by married couples to reside with would seem to be a sensitive index of the relative security of the sexes. This choice is also a measure of the prestige of the sexes, insofar as one measure of prestige is deference to the wishes of the person with higher prestige by persons of lower prestige. There are often sound economic reasons, of course, that influence residence choice, as well as other rational and irrational considerations, but even where these exist I believe that there will *also* be an interpersonal prestige significance of considerable weight to the decision. From this reasoning two hypotheses were made, as follows:

1) Straight lines, representing the male form, as opposed to curved, should be associated with societies which strongly favor male solidarity in residence.

2) Complex, nonrepetitive design, representing a hierarchical society, should be associated with societies which strongly favor male solidarity in residence.

Reasoning behind the first hypothesis was that if the society gave high prestige to males and favored close association of males, a fantasy suggesting numerous males should produce security.

The reasoning behind the second hypothesis involved an association between male dominated and hierarchical societies. In man and the primates generally, dominance hierarchies are most

developed among males. Also, it seems more likely that the man-wife relationship will be regarded as hierarchical in societies with male solidarity in residence. The data on complexity of design cited above already suggest that hierarchical societies are associated with complex design.

Testing of these two hypotheses yielded the results shown in Table 2.

As will be seen, the first hypothesis is strikingly *dis*confirmed and the opposite association supported. The second hypothesis is confirmed at a more modest statistical level.

Table 2. Relation of Marital Residence (Murdock, Col. 8)
to Variables of Art Style (Barry)
MALE SOLIDARITY IN RESIDENCE

Art Style	Low (M, X, B, N, Z, U)	High (A, P)	
Straight lines	14	1	*p* is less than .005
Curved lines	6	8	
	Low	High	
Simple	13	2	*p* is less than .05
Complex	7	7	

Fisher-Yates test used for probabilities.

An ex post facto explanation of the association between curved lines and male solidarity in residence is slightly more complicated but, I believe, more plausible. We may assume that when an adult individual is psychologically secure he will be extroverted and look for pleasure by seeking out members of the opposite sex. In fantasy a man will be creating women and vice versa. When, on the other hand, one sex is relatively insecure psychologically, members will be introverted and more concerned in fantasy with improving their own body image and seeking successful models of their own sex to imitate. Thus, to take polar extremes, in societies favoring male solidarity (and sociopsychological security) the men are looking for women as love objects

and the women are looking for women as models for self-improvement, while in the societies favoring female solidarity in residence both sexes are looking for men. In visual art, I assume, this concern manifests itself as a relatively greater concern with curved and straight lines respectively.

The reader may have noted that I have grouped with matrilocal residence here some forms of residence, such as bilocal and uxoripatrilocal, which are logically intermediate between matrilocal and patrilocal residence. In the initial test I regarded these as intermediate but on examination found that they grouped with matrilocal rather than patrilocal residence, and amended the hypothesis to its present form. I believe that this finding suggests that the presence or absence of peer support may be more important for adult men than for adult women. If the woman is in an equal position with her husband as far as support of adult relatives goes, as would be the case in bilocal residence, for instance, she is still in a favorable position in the family because of the support of the children. In the family, it would seem, the wife tends to have the children more strongly on her side, the Oedipus situation being generally more severe for males, because of the strength of early ties to the mother of children of either sex.

On reading an earlier draft of this paper, Irvin Child, Professor of Psychology at Yale, has called my attention to two psychological reports bearing on sex difference in preference for shapes. One of these (McElroy, 1954) reports a study of Scottish school children in which it was found that significantly more boys than girls preferred designs with rounded shape and more girls preferred designs with straight, angular shapes; also that the difference between the sexes in preference became significantly more marked after puberty. The other report (Franck, 1946) dealt only with college girls but included a questionnaire designed to get at attitudes toward sex roles as well as asking for preference of paired similar pictures differing only in respect to abstract sex symbols in the design. In this the investigator found that those girls who were more accepting of their own sex role significantly preferred more of the "male" pictures. The findings of both of these studies would fit in with the point of view reached above that

sexual instincts affect preference for visual forms differently for the two sexes, but that these preferences can be reduced or even perhaps reversed by socially induced sexual conflict.

As an extension and further test of the above theory it later occurred to me to investigate the relationship between form of marriage (monogamy, polygamy, etc.) and art style. One might assume that in societies where one man may marry two or more women the heterosexual drive of the men is more freely expressed and the men more secure than in those where a man may marry only one woman at a time;[7] that therefore there would be more curved designs in polygynous societies and more straight-line designs in monogamous societies; likewise in the polygynous societies there should be more complex design as a consequence of male hierarchical dominance. Both of these hypotheses are in fact supported by the Barry and Murdock ratings at a statistically significant level, as shown in Table 3.

There is, however, one important qualification. This is that societies with sororal polgyny are distinct from other polygynous societies. In their preference for curvature of line sororal polygynous societies are roughly intermediate between the extremes, and they go with monogamous societies rather than other polygynous societies as far as simplicity of design is concerned. Sororal polygyny is different from ordinary polygyny in that the wives tend to form a united front against the husband in case of conflict. The husband cannot so easily play one off against the other, and is not in such a secure position as other polygynous husbands. Sororal polygyny can be regarded as a compromise between the man's desire for heterosexual relationships and the woman's desire for congenial comrades and co-workers of her own generation. The intermediate position of societies with sororal polygyny in respect to curvature of line therefore seems reasonable.

However, evidently sororal polygyny can work well only in

[7] There are grounds for questioning this assumption also. Some might argue that polygyny is comparable to what the psychoanalysts have described as Don Juanism; that it is a sort of overcompensation for feelings of sexual inadequacy. This is a complex question, but I would simply suggest here in reply that there may be a considerable difference between a Don Juan who conquers many women only to spurn them and a polygynous husband who has lasting responsible ties with two or three wives.

relatively simple egalitarian societies, with at most age-grading as the main legitimate manifestation of the hierarchical principle. In hierarchical societies competition between siblings tends to be too severe to permit sororal polygyny to function: a wife would get along better with an entirely new rival than with her sister, an old rival from childhood. This, I believe, is why the societies with sororal polygyny nearly all have relatively simple art styles, as do the monogamous ones in this sample.

Table 3. Relation of Form of Marriage (Murdock, Col. 9)
to Variables of Art Style (Barry)
FORMS OF MARRIAGE

Art Style	Nonsororal polygyny (GNL)	Sororal polygyny (ST) Polyandry	Monogamy (M)
Simple design	2	7	6
Complex	10	4	—
Straight lines	3	5	6
Curved lines	9	6	—

Using the extremes and omitting the middle column p is less than .01 for both hypotheses using the Fisher-Yates test.
(Note: The hypothetical effect of polyandry is subject to alternate interpretations, but this is of little practical importance here, since there is only one society in the sample, the Marquesas.)

Incidentally, it is not necessary to assume that most men in a polygynous society have more than one wife in order to affect the sociopsychological security of the sex roles. As long as it is understood by a married couple that the husband may legitimately take a second wife, or probably even a mistress, if his first wife is not agreeable enough, this gives even the men in monogamous marriages a considerable psychological advantage. Relatively speaking, in a society in which polygyny is common, a second wife is usually available sooner or later to a man who wants one badly enough, regardless of the lack of a demographic surplus of women. This is so because there is usually a marked difference in marriage age between the sexes, women marrying earlier. In a manner of speaking, young men pay by prolonged bachelorhood for the polygyny

of middle-aged men. The characteristic age difference between spouses where polygyny is common gives the man another psychological advantage.

Moreover, in the relatively complex societies that have non-sororal polygyny the best art is generally produced for the upper class and must be adapted to their taste. If upper-class people have polygyny while lower do not, it will probably be the upper-class polygynous art that gets collected for museums and reported in ethnographies on the whole. In such societies one would expect distinct class differences in art consistent with the findings about cross-cultural differences described here. Fieldwork directed at this question in a series of appropriate societies would provide a useful further test of these hypotheses.

My colleague, Henry Orenstein, has noted that it would be desirable to have information on the sex of the artists in testing cross-cultural hypotheses about sex symbolism in art. I can only agree that this would be highly desirable, but plead that the ratings were not available in advance. In addition to the considerable work involved, if I made them now myself I should be in danger of biasing ratings in favor of the hypotheses or overcorrecting for impartiality. I should, however, expect systematic differences to show in the use of curved and straight lines by the sexes in most cultures. Incidentally, I might report a casual observation that at a recent exhibit of contemporary American artists at the Newcomb College Art Department (Tulane University) I found myself able to predict fairly well from a distance without reading the labels whether the artist was male or female by noting the relative predominance of curved or straight lines. The men seemed to have more straight lines and the women more curved. One might conclude from this that both sexes in modern American society are insecure in their sex roles. One could also guess that the form of marital residence favored solidarity of relatives for neither sex, as is of course the case.

The question arises as to the relationship between Barry's published findings on art style (1957) and the findings reported here. As his title implies, his original study was concerned with predicting aspects of art style from socialization data. Barry concluded that, in his sample of societies, complexity of art style was

positively related to general severity of socialization as rated by Whiting and Child (1953), and notes that this measure of severity of socialization applies especially to severe pressure on the child toward independence rather than toward obedience.

This is consonant with the interpretation offered here of the relationship between art complexity and social stratification. In the cooperative, egalitarian society there is a fear of the independent, self-reliant person as well as of the "bossy" person. Strength and success are achieved by unity of approximate equals, who must be regarded as powerless alone, for if someone felt competent working by himself he might not cooperate with others when needed. Moreover, since directions for work are given on the whole as subtle suggestions rather than as firm commands, a strong trait of obedience and responsiveness to the wishes of others is highly valued and useful. In the hierarchical societies on the other hand, at least those in which there is substantial practical opportunity to improve one's place in life, obedience and responsiveness to others do not have to be so strongly ingrained, since there are public and explicit means which can ensure compliance. Commands can be stated clearly, with their punishments and rewards. The proper working of the hierarchical society depends on the presence of interested and efficient people in a variety of different independent statuses. This means that each person must be trained to be self-reliant within his own special sphere of competence, and widespread personal ambition is useful in ensuring that the key positions are filled with competent people.

It is interesting to note that Barry conceived of a sort of relationship between social complexity and complexity of art, on the grounds that technical artistic development might accompany general sociocultural development. To test this he examined the relationship of his art complexity ratings to thirty variables of Murdock's "World Ethnographic Sample," at the time in a preliminary unpublished draft. Barry observed that the relationships of art complexity to social stratification and also to nonsororal polygyny (as well as to two other variables, discussed below) appeared to be significant at the five percent level. He did not, however, pursue the significance of these relationships, I gather, because the results on many of the variables were poor and be-

cause statistically more satisfying results were obtained by choosing socialization severity in advance as an independent variable. One of the statistically significant results he obtained by this wholesale testing, an association of complex art with root rather than grain crops, seems on the face of it implausible to me and I assume it is a sampling accident. The other result, an association of complex art with sedentary rather than nomadic residence, fits in with the social stratification hypothesis in an obvious way.

Barry may have also felt that if socioeconomic variables were relevant to art style, they exercised their effect through their influence on child training and personality, not directly. He and his colleagues have since pursued the question of the relationship of child training to subsistence economy with notable success (Barry, Child, and Bacon, 1959).

The general point of view of art styles exemplified here, and in Barry's work from which this is derived, gives high emphasis to social conditions of various sorts as determinants of artistic fantasy or creativity. As such it is in opposition to those views of art that see the development of art style as primarily a matter of technical evolution, or of historical diffusion, or of the influence of the physical environment as model or source of materials. If art style is determined primarily by current social factors this does not invalidate the study of relatively trivial technical details as evidence for historical connection between cultures, and I would not deny the great usefulness of such evidence for some purposes. It does, however, cast strong suspicion on the use of general features of art style to establish historical connections, or on the use of known historical connections alone to explain the similarities of art styles of two distinct cultures. Practically all cultures are evidently exposed to a variety of art styles among their neighbors, and also possess within their own tradition a variety of models that could be developed in various directions. If a neighboring art style at a certain period of history proves congenial no doubt the society will adopt it by importation and imitation, but we must still explain why culture A rather than culture B provides the model, and why the diffusion of style did not proceed in the reverse direction. It is here, I suggest, that similarity of social conditions, and relative order of development of these, plays a major role.

These findings suggest that we may regard a work of art as a sort of map of the society in which the artist—and his public— live.[8] To be sure, unlike a geographic map, a wide, though not unlimited, variety of concrete works of art may represent the same social structure. Also, even in a fairly abstract sense, the works of art are not always isomorphic with aspects of social structure. One would not conclude, for instance, that a preoccupation with rounded female forms indicated a numerical preponderance of women in the society; one would simply conclude that the social structure encouraged the artist's interest in women. We might then speak of a work of art as a selective cognitive map of the society with predictable distortions.

The question may be raised whether the artist should not be said to be depicting a wish rather than social reality. I would concede that the wish-fulfillment aspect of art is in some sense primary, but would at the same time urge that wish-fulfillment and reality are closely related, even in fantasy. For art to be effective as wish-fulfillment it must attain a certain degree of plausibility by at least making a rather close compromise with reality. If the artist in a simple egalitarian society finds pleasure in repeating the same simple design over and over again, it is because he can in reality find whatever security and pleasure he knows in a repetitive, un-differentiated social structure. If the artist in a polygynous society becomes preoccupied with curved female forms it may be because he knows he has in the long run a good chance of obtaining secu-

8 I do not intend to claim that the social factors identified here as relevant to various factors considered in art design are the sole relevant factors. Art is a complex enough phenomenon so that I would not expect to be able to comprehend thoroughly and explain even a fairly limited aspect of it within the scope of a study of this size. The evidence cited suggests, however, that I have a plausible explanation for a good part of the variance for specific factors studied. Of course, as in all statistical studies of phenomena with complex causes, decisions as to the validity of a hypothesis are unaffected by limited numbers of contradictory cases, and such cases can be expected to occur unless the factor one is studying is unusually strong. Also, it is generally true that a statistical relationship can be interpreted as evidence for more than one set of theoretical explanations, although by no means for just any set. If the reader can propose another set of assumptions which is congruent with the findings reported, further investigation will be required to determine which set is the more powerful.

rity and pleasure from relationships with women. Of course, the questions of relating to peers in an egalitarian society and obtaining women in a polygynous society are also frequent sources of frustration. Problems as well as sources of pleasure are involved, but there are also culturally prescribed solutions which, if not infallible, are usually seen as the best possible.

For an anthropologist, one of the most exciting possibilities that the study of art styles and social conditions opens up is the application to extinct cultures known only through archaeology. If we can learn enough of the panhuman implications of art styles for social structure and the resulting psychological processes, we should eventually be able to add a major new dimension to our reconstruction of the life of extinct peoples known only from their material remains.

Appendix. Barry Ratings of Pictorial Art Variables Used in This Paper

Note: For a description of the manner in which the ratings were made see Barry (1957). In the following lists the order of the societies corresponds to their rank with respect to the art variables, the most extreme being at the beginning and end of the lists. The ratings deal only with graphic art, not with three-dimensional sculpture. For ratings on the social structure variables consult Murdock (1957). The Kwakiutl, while rated by Barry and listed below, are not included by Murdock and not used in the statistical tests above.

Simple	Empty	Symmetrical	No Enclosed Figures	Lines Straight
Andamans	W. Apache	Yakut	Andamans	Navaho
Chenchu	Chenchu	Teton	Ashanti	Ashanti
Masai	Chiricahua	Omaha	Chencku	Teton
Yagua	Comanche	Ainu	Yagua	Thonga
Paiute	Omaha	Paiute	Zuni	Yagua
Papago	Ainu	Comanche	Murngin	Paiute
Thonga	Paiute	Navaho	Navaho	Marshalls
Navaho	Thonga	Zuni	Comanche	Hopi
Murngin	Yakut	Hopi	Thonga	Ifugao

Complex	Crowded	Asymmetrical	Enclosed Figures	Lines Curved
Marshalls	Teton	Arapesh	Hopi	Chenchu
Hopi	Hopi	Andamans	Maori	Maori
Zuni	Marshalls	Thonga	Masai	Zuni
Comanche	Masai	Marshalls	Paiute	Omaha
Omaha	Zuni	Yagua	Papago	Andamans
Ifugao	Ifugao	Chenchu	Omaha	Samoa
Ainu	Navaho	Kwakiutl	Teton	Ainu
W. Apache	Papago	Samoa	Alor	Marquesas
Chiricahua	Dahomey	Maori	Trobriands	W. Apache
Ashanti	Andamans	Marquesas	Marshalls	Masai
Teton	Ashanti	Murngin	Ainu	Comanche
Arapesh	Murngin	Papago	Ifugao	Murngin
Maori	Arapesh	W. Apache	Marquesas	Papago
Trobriands	Kwakiutl	Chiricahua	Dahomey	Yakut
Kwakiutl	Yagua	Ifugao	Kwakiutl	Chiricahua
Alor	Alor	Trobriands	Arapesh	Alor
Dahomey	Samoa	Ashanti	W. Apache	Arapesh
Samoa	Trobriands	Masai	Bali	Kwakiutl
Bali	Maori	Bali	Yakut	Bali
Yakut	Bali	Dahomey	Samoa	Dahomey
Marquesas	Marquesas	Alor	Chiricahua	Trobriands

Bibliography

Barry, Herbert, III. "Relationships Between Child Training and the Pictorial Arts," *Journal of Abnormal and Social Psychology*, 54 (1957), pp. 380–83.
———, Child, I. L., and Bacon, M. K. "Relation of Child Training Subsistence Economy," *American Anthropologist*, 61 (1959), pp. 51–63.
Franck, Kate. "Preferences for Sex Symbols and Their Personality Correlates," *Genetic Psychology Monographs*, 33 (1946), pp. 73–123.
McElroy, W. A. "A Sex Difference in Preferences for Shapes," *British Journal of Psychology*, 45 (1954), pp. 209–16.

Murdock, G. P. *Social Structure*. New York: Macmillan, 1949.

————. "World Ethnographic Sample," *American Anthropologist*, 59 (1957), pp. 664–87.

Siegel, Sidney. *Nonparametic Statistics for the Behavioral Sciences*. New York: McGraw-Hill, 1956.

Whiting, J. W. M. "The Cross-Cultural Method," *Handbook of Social Psychology*, ed. G. Lindzey. Cambridge, Mass.: Addison-Wesley, 1954.

————, and Child, I. L. *Child Training and Personality*. New Haven: Yale University Press, 1953.

Art and Mythology: A General Theory*

GEORGE DEVEREUX

Art is stylized communication. As it communicates, art conforms in content and form to the conventions and rules of its society. At the same time, it meets a social need, for it permits the expression of the forbidden in acceptable ways. Both the nature of its content and the pattern of its style reflect basic culture attitudes. The psychoanalytical study of art can therefore be an extremely effective way to study man in society.

Dr. George Devereux is Professor of Research in Ethnopsychiatry, Temple University School of Medicine. He has worked with the Hopi and Mohave Indians, the Karuama and Roro of Papua, and the Sedang-Moi of Indochina. His fields of interest are culture and personality, psychoanalytic anthropology, and the mental disorders of primitives. He has written *Therapeutic Education* (1956), *Mohave Ethnopsychiatry and Suicide* (1961), and *From Anxiety to Method: Reality and Dream Psychotherapy of a Plains Indian* (1951, 1969).

The study of the relevance of art for the investigation of problems of culture and personality is severely handicapped by the inadequacy of basic studies which seek to clarify:

1) The nature of art,
2) The sociocultural function of art,
3) The psychological function of art.

The entire field is so poorly understood that Freud himself "threw in the towel" in a study devoted to Leonardo da Vinci, and declared that the explanation of the nature of genius is, for the time being, beyond the powers of psychoanalysis (Freud, 1910, 1930). With a few exceptions, the relevant studies on art compare

* Reprinted from *Studying Personality Cross-Culturally*, ed. Bert Kaplan (Evanston, Illinois: Row Peterson, 1961), pp. 361–403. This article constitutes the second (1959) Géza Róheim Memorial Award Lecture.

unfavorably with the conceptual tautness and methodological rigorousness of psychoanalytic and/or culture and personality investigations of science, such as Sachs's (1942) essay on the delay of the machine age. Last but not least, both cultural and psychological studies of the most essential of all arts—music—are, on the whole, more disappointing and also much less numerous than are similar studies devoted to the other arts.

ART VERSUS EXPRESSIVE BEHAVIOR

The first distinction to be made in clarifying the nature of art pertains to the difference between art and expressive behavior, including quasi-artistic projective tests. If mere "expressiveness" and/or "projecting" were the criteria whereby one determines whether a given product is art or something else, then the bellowing of an agitated catatonic—the almost uninhibited expression of a hypothalamic storm—would be the most genuine of all arts. Conversely, were style and other conventions the true criteria of art, then classroom exercises in strict counterpoint would represent the summit of artistic behavior.

DEFINITION OF ART

Ideally, the dynamic criterion of art is the straining of pure affect against pure (culturally structured) discipline, and the incidental evolving of new rules that permit the less and less roundabout manifestation of more and more affect and also of hitherto artistically unusable affect segments within an expanded, but internally even more coherent, discipline. The discipline itself—the rules of the game—is the means whereby society determines whether a given expressive act represents art or something else, and also whether the product in question is good, mediocre, or bad art. The relevance of the first of these functions of the "discipline" is best highlighted by the fact that folk and primitive arts have only recently been recognized as genuine art, though artistic objects of that type have existed long before they were recognized as art.

The arbitrariness of the rules whereby an item is adjudged to

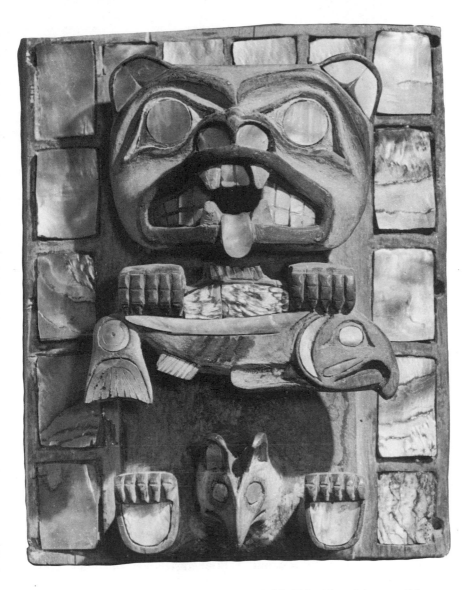

The front piece of a chief's headdress, probably Tsimshian. A bear, a fish, and possibly a tufted-ear owl are portrayed. Carved and painted wood inlaid with abalone shell. 7 3/8" high. Carvings on headdress plaques are considered by some to represent the crests of clans, by others to illustrate tribal myths. Courtesy of The Museum of Primitive Art, New York.

be good art is revealed by the fact that Beethoven's *Violin Concerto* was derisively called a "concerto for tympani" because—most "improperly"—the first *solo* instrument heard is the tympani. Hanslick ironically called Liszt's *First Piano Concerto* a "Triangle Concerto," because Liszt conspicuously used that instrument as part of the percussion section. Even the kind and the amount of affect demanded or allowable is culturally regulated. An early critic called Beethoven's *Violin Concerto* "vulgar." The intellectually brilliant and musically impeccable "romantic" music criticism of Schumann and of Berlioz used, side by side with purely musical considerations, also the quality and intensity of affect as a yardstick of musical excellence. Today's music criticism is as conscious of affect as Schumann's was, but appraises affect negatively. It considers an emotional deep freeze—and a "well aerated" score—the acme of excellence, and demands a spuriously baroque music for spuriously baroque organization men. This, by the way, may explain why those who also seek affect in music sometimes take refuge in the hypothalamic orgies of modern jazz, so as to sate the affect hunger left unstilled by listening to tinny filaments of sound emitted by poorly balanced chamber orchestras.

It is implicit in the preceding considerations that art is basically a medium of communication, and conforms to certain rules which represent the grammar and syntax of a kind of metalanguage. This finding raises further questions as to the legitimacy of treating "Draw a Man" or "TAT" tests as art forms. It is my view that, insofar as such tests represent art, they are communications directed at an audience of one—the tester. Moreover, the testee's communication is couched in a "language" whose grammar and vocabulary the tester must decipher, the way Champollion deciphered the Rosetta stone. Indeed, in test productions a kind of Alice in Wonderland system holds sway: Things mean only what the test subject unconsciously intends them to mean. This point is important enough to warrant a brief discussion of "tests and art."

A number of tests exist in which the subject is called upon to create "art" or else to respond to "art"; the first type being represented by Draw-a-Man and related tests, the second by the TAT and perhaps also by the Rorschach tests. It is my thesis that these

tests do not really meet the basic criteria that differentiate art from other activities.

1) The subject's behavior is primarily expressive rather than an act of communication. Insofar as he communicates at all, he has an audience of one: the tester. Moreover, the validity—qua test—of the subject's productions decreases as his orientation to the tester increases and as his productions become communication rather than expression.

2) In optimum cases—in the testing sense—the production is pure expressive behavior, which is then transformed by the tester into a communication—or, more specifically, into information. The tester is, thus, *not* functioning like a person addressed in normal communication. In the case of the latter, the communicator makes an effort to couch his communication in terms understandable to his interlocutor. He uses a language known to the latter, an audible intensity of voice production, etc. What "noise" there is, is largely filtered out and is meant to be filtered out. Moreover, both the speaker and the listener usually agree on what is information and what is noise. The opposite is true in testing: What, to the subject, is information, which he communicates, may be largely "noise" to the tester, and what may seem "noise" to the testee may represent information for the tester. Moreover, the "grammar" of that portion of the testee's communication which is of interest to the tester must be reconstructed by the tester himself. It is not a "given," except empirically, in the sense in which certain Rorschach responses have been empirically found to "mean" the presence of a certain trait.

Practically none of the considerations discussed in this section are applicable to genuine art, whose language is, by definition, conventional. Whether this convention demands that the human figure remain more or less undistorted, or that it be distorted according to certain rules; whether it demands—as early nonunison music theory did—nothing but parallel fifths, or whether it taboos parallel fifths—all this is irrelevant. What is relevant, is that there is a kind of convention, and that this convention must be viewed in a historical perspective, as an elaboration of, or as a reaction against, the rules of an earlier period. The taboo on parallel fifths outlaws the basic rules of an earlier practice and at

least some of the objectives of modern "neoclassical" music are those of the romantics turned upside down (Barzun, 1950).

The culturally standardized "discipline" of art is therefore of prime concern to the student of culture and personality. The rules of artistic communication, of which this discipline is made up, must be understood as cultural conventions. The anthropologist must study the grammar, the syntax, and even the chosen vocabulary of art. He must trace changes in the ratio between consonances and dissonances, between "noble" and "four-letter" words, etc. Moreover, he must realize that the intrusion of four-letter words into the artist's vocabulary did not expand the verbal palette of literature. The genuine expressive gain represented by these crude terms was balanced by an impoverishment of the palette in such words as "noble," "elevated," "sublime," and the like, dear to romantics. The student of culture may neither approve nor lament this change. Rather must he stress that the evolution of every style represents a patterned enrichment in one direction and impoverishment in another direction, both as regards the building blocks at the artist's disposal, and the range of affects deemed artistically acceptable by society. This impoverishment, balanced by enrichment, is never random and is—as Kroeber (1957) apparently did not fully realize—the very essence of style. Indeed, "let us have a roll in the hay" and "we shall walk hand in hand under the starry sky" mean the same thing behavioristically . . . and, now and then, even emotionally, alas. What concerns the student of culture is simply this: Which of these two utterances is accepted as artistic (and authentic) by a given society, at a given point in history?

At this juncture we must realize that, insofar as a style represents both an enrichment and an impoverishment, insofar as style is a method of selection, it inevitably implies a *distortion*. In relatively unsophisticated art, the distortion affects primarily the substantive content of the statement or utterance: the sculptor may shorten the legs of the human figure; the novelist may populate his human scene with ideally pure women and double-dyed villains; the composer of a canon may discard an inspired passage which comes to his mind, because it would disrupt the orderly development of a strict canon; the writer of a sonnet may remold an image in order to submit to the rhyme

pattern and may short circuit his chain of thought in order not to exceed fourteen lines. In some cases the artist's physical material (medium) itself imposes distortions upon the utterance: the fragility of marble and its inability to stand much stress calls for a far more compact structure than does bronze. Hence, in some marble statuary certain elements are included solely in order to support the weight of a jutting body or limb. A truly great artist—like the sculptor of Laocoön—makes these structural additions seem indispensable and integral parts of his utterance, so that it is felt to be "communication" rather than "noise." The lesser artist asks us to *ignore* the presence of an inexplicable truncated pillar under the belly of a rearing horse.

In a Beethoven piano sonata the high treble imitation of a motif, first played at a middle level, is changed because, in Beethoven's time, the piano keyboard did not extend as far up as it does at present. Hence, many modern pianists play that passage not the way Beethoven actually wrote it, but the way he *would have* written it, had he had a modern, extended keyboard piano at his disposal. In some instances certain earlier material or performer limitations of the artistic utterance are consciously exploited by the modern artist to produce striking effects. The Hungarian peasant singer, whose untrained voice has a smaller range than has that of a concert singer and who, moreover, does not know enough about music to transpose a song so that its range will not exceed the range of his voice, sometimes replaces a step of a second downward, which is too low for him, with a leap of a seventh upward. This "clumsiness" of peasant singers was transmuted into an artistic device by Bartók. Examples of such octave displacements in Bartók's violin sonatas are given by Stevens (1953), who cogently remarks: "This device is not resorted to indiscriminately; in the First Sonata it gives the distinctive shape to the waltz-like second member of the principal thematic complex, and is thereafter used, with very few exceptions, only for reference to that member." An image inspired by the rhyme pattern is a comparable phenomenon, revealing the creative side of technique.

In oversophisticated art the medium itself is subjected to distortion. Such manipulations range from maximal but spurious nondistortion, as in *trompe l'oeil* paintings, to Liszt's passion for

experimenting with out-of-tune pianos,[1] to Joyce's schizophrenoid experiments with language and to those of some modern poets with punctuation. The latter maneuver reaches a pathetic climax of absurdity in a semipornographic French novel, in which a sexual act between a woman and an ape is "described"—for nearly a whole page—exclusively by means of punctuation marks, somewhat as follows: ".!..!!...?!!!??!, etc."

We shall return later on to the problem of balance between substantive utterance and style-and-technique. For the moment it suffices to stress that the artist himself is as keenly aware of the social-cultural rules governing *artistic* distortion as the writer of parodies and pastiches . . . and sometimes experiences the boundaries set by society as confining. It is said that the leading Victorian purveyor of ethereal guff, Lord Tennyson, wrote obscene poetry for private consumption. To the indignation of his contemporaries, Heine often concluded a lofty poem on a jarring note of derision—conspicuously in the exquisite poem: "Jesus walks on the waters." Prokofieff "steps on the throat" of his own melodies, which usually start in a lyrical vein and end in a sneer. Beethoven composed an impressively and unmistakably Beethovenesque—and also musically inferior—rondo "in anger over a mislaid penny." An aging or ailing artist, whose best work had a distinctively personal style, often ends up by simply imitating himself, long after he has run out of inner tensions leading to authentic utterances. Thus did the dying Chopin "chopinize" in some parts of his very last works.

Needless to say, the culturally prescribed distortion (style) glaringly reflects the tensions and problems of the artist's milieu. Given the unquestionable technical expertness of the African sculptor, his distortion of the human figure is not due to a technical inability to represent reality—in the sense in which pre-Renaissance painters distorted space because of their ignorance of the laws of perspective. The African, Melanesian, Maori, Marquesan, Kwakiutl, Aztec, Maya, or Inca artist distorted his figures intentionally and in accordance with cultural rules governing artistic utterances. Moreover, as regards certain African, Melanesian, and

[1] In this respect—as in many others—Liszt was a precursor of the most modern music of our times, such as Cage's pieces for "prepared" pianos.

medieval gargoyle carving artists, their nightmare vision of the human body—reflected in its artistic distortion—is closely related to what I, for one, view as their nightmare vision of the universe and of life. This process is, of course, paralleled also on the individual level. There is reason to believe that the painter Bosch was psychotic, which explains his—at that time no longer culturally demanded—gargoyle like distortions of the human body. The case of Toulouse-Lautrec is even more instructive. Dysplastic as a result of having been thrown by a horse, Toulouse-Lautrec—perhaps through the mechanism known as "identification with the enemy" (Anna Freud, 1946)—sneeringly distorted the human body, but created almost ideally perfect horses. This convergence between culturally required and individually determined distortions raises, of course, the question to what extent the gargoyle carver obeyed a cultural mandate and to what extent he expressed in his carving of distorted bodies also his private nightmare vision of human flesh. Perhaps the most practical way of solving the problem is to say that in great art the cultural and the idiosyncratic converge, in so-called academic art the cultural holds the center of the stage, while in freak art—comparable to a frankfurter drowned in oceans of mustard—the idiosyncratic overshadows all over considerations.

Closely related to the problem of whether or not a certain distortion is artistic, is the problem of its *conventional* "plausibility"—a matter already touched upon elsewhere (Devereux, 1948). It should be stressed from the start that the plausibility of a work of art is distinct from the plausibility of reality.[2] The Greeks found centaurs quite plausible in mythology; one suspects, however, that, had they met one in their backyard, they would have found the centaur as implausible as did the physiologist Du Bois-Reymond, who protested against mammals with three pairs of limbs. For the medieval Catholic the existence of angels was a dogma—but he would have been as startled by the appearance of his guardian angel as was Maurice d'Esparvieu in Anatole France's *La révolte des anges* and he would have found the angel as implausible as La Barre (1954) does on anatomical grounds. The discrepancy be-

2 The fact that this view is directly related to the subsequent discussion of the repudiability of art was pointed out to me by Miss Elizabeth de Szinyei Merse.

tween artistic and real life plausibility is the key theme of *Don Quixote*. In brief, when writing poetry, the poet may experience as plausible a Belovèd with stars for eyes, bunches of grapes for hair, pearls for teeth, and coral for lips—but, to paraphrase Dorothy Parker, "men seldom crave kisses from pearl-toothed Misses," or from ladies with abrasive lips of real coral.

One major obstacle to cross-cultural aesthetic experiences is precisely the difference between the artistic plausibility concept of the artist's culture and that of the art consumer's culture. The profusion of amok scenes in the Malay prose epic *Hikayat Hang Tuah* fits the Malay's concept of artistic plausibility, but not that of Bostonians, or of Mohave Indians. Only in a society acutely conscious of sibling rivalry would the theme of the cannibal baby strike a responsive chord. Even the choice of a "proper" theme is related to matters of plausibility. Using Róheim's (1941) insightful distinction, we may say that some societies prefer narratives about fathers (myth) at one time, but may come to prefer, later on, stories about sons (folk tales); the *Odyssey* appears to have had a—now lost—sequel, in the form of a *Telemacheia*.

In brief, art is a stylized (distorted) communication, recognizable as art by artist and connoisseur alike.[3] In fact, it is recognizable as such by everyone except U.S. customs and postal authorities and by the Watch and Ward Society. Indeed, in one of the defensive essays which protectively surround his sickening novel, *Lolita*, Nabokov rightly stresses that true pornography *must* be inartistic if it is to achieve its aim. In brief, an invitation to make love can be crude insolence or lofty art, depending on whether or not its wording fits the rules of the game. That which is, or was, a scandalous dissonance on the downbeat, is viewed as subtle and correct art when it occurs on the upbeat—due exception being made for dissonances on the downbeat in syncopation, and in related devices. Moreover, these exceptions are highly significant for an understanding of one's adherence to formal rules as a means of alibiing the content of one's utterance: Theories of art always hobble behind practice, painfully thinking up new and

[3] The specific nature of this communication will be discussed further below.

devious ways of justifying unusual, but effective and meaningful, modes of communication—witness some truly singular theoretical "explanations" of revolutionary musical practices. One is forcibly reminded here of the perhaps apocryphal story that the French Academy hastened to give its seal of approval to the Empress Josephine's solecism, who once said *l'harricot* instead of *le harricot*.

It is clear, then, that style—the hallmark of artistic quality—plays the role of an alibi. The aesthetical value of the experience bribes the superego just as humor bribes it in wit (Freud, 1905). However, society lays down definite rules as to what may be perceived as artistic, exactly as it lays down rules for what may be considered funny. It also appraises the social tolerability of an utterance in terms of the intensity of the artistic-aesthetic quality of the product—exactly as a modern lady may say that she is willing to listen to a naughty story if it is *really* funny. Cross-cultural differences in ways of alibiing improper utterances by means of art or humor explain why one sometimes fails to see that an alien artistic product is art, or that a foreign joke is funny. In fact, as regards the cross-cultural understanding of humor, we are no better off today than we were some thirty-five years ago, when Kroeber (1925) first pointed out this gap in our information.

SOCIETY'S STAKE IN ART

Every society—even the acultural small town of the Middle West is concerned with art, be it but negatively, as was Plato, who proposed to banish poets from his Republic. The plain fact is that art—like the grocery store—exists because it meets a social need not gratified by other cultural activities. The safety valve function of art was perceived most clearly perhaps by Cardinal Mazarin who, on hearing that songs were sung against an unpopular new tax, said in his inimitable Franco-Italian jargon: *Ils cantent, ils pagaront* ("they sing [and therefore] they will pay"). This epigram both minimizes the effectiveness of art as a means of social action and maximizes its effectiveness as a harmless safety valve. It also dispels some of our illusions about governmental *respect* for a free press (or art), because, where the press is truly

influential, it is always quickly made unfree. The American press and the American artist are free only because they have either muzzled themselves—or else have nothing upsetting to say.

In addition to viewing art as a harmless safety valve, society and the artist alike consider the artistic utterance as *unrepudiable* in regard to *form*, but *repudiable* as to *content*. A Sedang-Moi girl who, together with others, took advantage of my daily walks, to gather forest produce under the protection of my gun, once improvised a little song to tell me that they were tired and wished to go home. Asked why she did not tell me this in ordinary language, she replied that to do so would have been rude. Apparently, by expressing her wish in the form of a song, she left me free to decide whether to hear it only as a bit of vocal music, or to take cognizance also of its conceptual content. A talented young friend of mine—uncertain as to how his communication would be received were it made in prose—first declared his love to the girl of his choice in a rather good poem, whose content he could always repudiate by saying: "It is just a poem; it is not a declaration of love." At the other extreme of repudiability, a neurotic young boy spoke only "Donald Duck language" (squawk speech), until granted permission to voice his hatreds (to squawk) in plain language—whereupon he became quite fluently abusive in perfectly normal English. In his case there was a naked communication of affect which was, however, not clothed in ordinary speech capable of conveying the conceptual equivalent of his anger (curses) (Devereux, 1956a).

In brief, art can function as a social safety valve precisely because, like wit, it is a compromise and is, moreover, repudiable as to intent and content. It permits the artist to say—and the consumer to hear (or to see)—the forbidden, provided only that:

1) The utterance is formulated in a manner which a given society chooses to call "art,"

2) The actual content of the utterance is officially defined as subordinate to its form, and

3) The utterance is understood to be repudiable.

"Let us roll in the hay" differs from: "Oh come with me and be my love" only in that the second of these statements, by submitting to the conventions of Victorian art, provides itself with a social alibi. The utterance is thereby turned from an idiosyncratic

into a conventional, from a nonrepudiable into a repudiable, from a straightforward into an ambiguous, from a private into a public, and from a personal into an impersonal statement.[4]

This statement can be further clarified by contrasting private acts with ritual ones. The announcement: "Miss Jones and I plan to sleep together" is scandalous because it is an improperly publicized private utterance. The announcement: "I take thee to be my wedded wife," followed by "and the twain shall become one flesh," is sacred, because it is ritualized (= stylized), and *de-individualized*. The term "de-individualized" is of prime importance in this context. Miss Jones, invited to participate in a "roll in the hay," perceives the pointedly personal nature of the invitation, as does everyone else. By contrast, "Oh come with me and be my love" has a broader scope and validity—any and every girl may respond to it with affect . . . as millions of girls have responded to "I take thee to be my lawful, wedded wife," which has echoed down the corridors of history as an impersonal, collective, ritual utterance. The point I seek to make is that practically all rites are conventionalized acts of sacrilege. This is strikingly demonstrated by the fact that the only *real* (ritualized) Mohave *wedding* is that of persons who—being cousins—should not marry at all, since their extramarital cohabitation is unequivocally defined as incestuous (Devereux, 1960). These data suggest that art is socially explosive because it presumes to deal *privately* with matters so sacred (= dangerous) that they are usually handled only by the group as a whole, ritually or legally. This, in turn, explains why society insists on socializing and on regulating art (*Index librorum prohibitorum*, Comstock Act, etc.).

Art is even closely related to etiquette, in that it prescribes polite ways for saying impolite things; it provides ways for expressing the inexpressible. The Victorian lady would never have said "legs"—she may even have concealed the improperly suggestive legs of the piano under little skirts—but she did utter the term

4 The ambiguousness of art is determined by the doubt as to whether its center of gravity—and/or objective—is its offensive content or its acceptable form. This, by the way, may explain why the substantive content of technically revolutionary works is often so timorous and insipid: The melodies of Stravinsky are often appallingly static and impoverished and the plot of *Finnegan's Wake* would disgrace Elynor Glyn.

"limbs" (= legs) quite "brazenly." The word "trousers" was certainly taboo for her—but the acceptable term "inexpressibles" did provide her with a proper means for expressing the inexpressible.

Style—as the means whereby art comes into being—is, thus, best seen as a grammar and rhetoric of circumlocutions—and never more so than in the crudest "earthy" works, in which an innocent "spade" is circuitously referred to as a "bloody shovel."

ART AND TABOOS

Having demonstrated that art provides a safety valve for the expression of that which is tabooed, we must next seek to define the tabooed subjects that find expression in art. These subjects belong to three main layers:

1) The generally human taboos: Incest, in-group murder, etc.

2) The culture specific taboos: Sex in puritanical society, avariciousness in Mohave society, cowardice in Plains Indian society, etc.

3) The idiosyncratically (neurotically) tabooed: Repressed wishes, etc. It is hardly necessary to add that the nature of idiosyncratically tabooed wishes depends to an appreciable extent also upon the dictates of the individual's cultural milieu (Devereux, 1956b).

Each and every one of these taboos must, to a certain extent, find expression in a work of art. Where the idiosyncratically tabooed factor is minimal, the work of art lacks flavor and individuality.[5] Where the culturally tabooed substance is minimal, the wine has no "body." It is timeless but also lifeless; it is not metacultural but simply rootless. By observing no particular code

[5] It is conceivable that difficulties in attributing an early Italian painting to artist A, rather than to artist B, may be partly due to the minimal subjective involvement of these artists, who had just begun to emerge from the anonymous craft art of the medieval Church craftsman. However, it may also be due in part to our lack of subjective empathy with the individuality of the artists of that remote period, in the sense in which "all Chinamen look alike to us." This, in turn, suggests that the study of depth psychology is an indispensable part of the art historian's equipment (Kris, 1952), as is the study of culture and personality.

of plausibility, it has no plausibility at all. Where the universally human tabooed material is infinitesimal, the work of art is simply "arty-crafty." It is wine without alcoholic content.

In brief, one unmistakable hallmark of all great art—of art whose validity and appeal transcend time, space, and cultural barriers—is that, in real masterpieces, these three sets of tabooed materials are perfectly expressed, by means of a complex and balanced interlocking of all three of these elements. Such art has transcultural and diachronic validity. It appeals powerfully to Philadelphian, Roman, Parisian, Chinese, and Hottentot alike— though without doubt Aeschylus meant something else to the ancient Athenian than to the modern New Yorker, and what it did mean to the Athenian is probably lost without retrieve. Thus, the Sedang Moi, who love music, rapidly came to prefer Mozart's C major "Dissonant" Quartet (K. 465) to 1933 jazz songs, even though they were at first fascinated by the human voice emerging from a talking machine, simply because Mozart was more "basic" and more universally human than were the 1933 equivalents of "Purple People Eater."

There are, of course, appreciable barriers to cross-cultural artistic communication, comparable to the barriers that prevent even a highly acculturated honorary Mohave like myself from understanding just what is so funny about the Mohave way of referring to a visit to one's in-laws as "I am going to wash the hips of my relatives." The sense of alienness in the face of the artistic products of other people, and even of a past period, can have four major sources:

1) The alienness of the latent subject matter, which is determined by the consumer's nonrepression of that which the artist's culture (or neurosis) does repress. Thus, the sexually uninhibited Mohave found the plots of *Tristan* and of *Romeo and Juliet* ridiculous and even disgusting. They simply could not see why there was so much fuss about these lovers being united, in or out of wedlock. In other cases the sense of alienness is due to the excessive specificity of the artist's private taboo system. This extreme specificity also explains why the utterances of neurotic minor poets are so perishable, are so easily "dated," and have so limited an appeal.

2) The alienness of plausibility conventions (see above).

3) The alienness of artistic conventions. In such cases the nonresponsiveness of the consumer betokens extreme cultural rigidity. Thus, according to Rhodokanakes (1948), when Rabindranath Tagore visited Athens, he gave the Parthenon a passing glance and then ignored it, apparently because the artistic convention incarnated in that temple was not perceived by him as "artistic," perhaps because Indian art is florid rather than lean, and multiplies detail instead of emphasizing structure.[6] In exactly the same sense, the Western visitor seldom senses the "exquisite courtesy" of the act of greeting a friend in parts of West Africa by spitting into his hand, nor is he properly moved when a Bantu affectionately calls him "my ox."

4) As we saw, techniques are conventionalized means for producing items susceptible of being recognized as art by society and by culture. An adequate technique permits one to express that which one would have to repress, if one lacked technical excellence. In this sense, then, technique (= artistry) is legal tender for bribing the superego, on the personal level, and for bribing the guardians of society's morals, on the cultural level. However, since this "legal tender" varies from society to society, the occidental mind usually refuses to be bribed with Indian artistic rupees, perceives some Hindu religious sculptures only as obscene representations of coitus, unredeemed by any trace of artistic quality, in the occidental sense of that term. Hence Westerners react *only* to the tabooed utterance itself.[7] The same happens also when the

[6] Of course, had Tagore visited Athens in classical times, when the Parthenon was not yet a skeleton of lean beauty, but was painted and loaded down with ornaments as gaudy as those of an Italian village church, he might have responded differently. It is well to recall that the lean beauty of classical Greek art, as we see it today, required the cooperation of time, which peeled off the paint, and the aesthetic dedication of pillaging Roman legionaries, who mercifully stole the chryselephantine gingerbread. What Greek statues really looked like in the heydays of Greece, is shown by a marble miniature reproduction of a statue of Athena; the headgear worn by this surviving miniature beggars description and outdoes in garishness anything that ever adorned even Carmen Miranda's locks.

[7] In the same sense, a person is said to have a peculiar sense of humor, not appreciated by others, if his "private currency" for bribing his superego with "wit" is not accepted as "wit" by the superego of his listener. In such cases, his check "bounces."

conservative consumer of art is faced with a hypermodern work, whose new artistic technique is not accepted by his superego as a bribe offered in legal tender. This explains the anger and disgust wherewith modern works are usually rejected by the artist's contemporaries.

Dynamically speaking, the anthropologist studying art functions as a genuine student of culture and personality when he investigates:

1) The types of tabooed materials that society views as the "proper" subject matter of art—and thereby comes to understand, e.g., why the Mohave have practically no love poetry, while we, alas, have too much—and much too bad—poetry of that sort.

2) The rules of the game for expressing tabooed impulses— the subterfuges which enable one to be crude and yet be rated as a poet.

3) The technical skills needed for complying with the rules of the artistic game: The amount of musical training one needs in order to allow oneself to become publicly flatulent by writing a brilliantly scored staccato passage of brass instruments, and especially the tuba. The amount of plastic skill needed to enable one to erect a symbolic phallus in public and to persuade the people to call it an obelisk, or to paint a nude and have her accepted as Golden Aphrodite and not as a barroom nude.

4) Changes in the content of the ethnic unconscious (Devereux, 1956b) and in the rules for turning the forbidden into art.

This manner of investigating art is clearly cultural in scope and yet provides massive information about the psychological climate of the culture: about its nuclear areas of conflict and typical defenses.

THE UGLY

Mathematicians, since the time of Abel (Bell, 1937), are familiar with the technique of "inverting the problem" that is refractory to ordinary approaches: It consists in taking as one's point of departure that which one actually seeks to prove and then working back from that point to the premises. A comparable

approach can be effectively used also in scrutinizing the problem of beauty in terms of ugliness.

It is generally felt that artistic technique transmutes truth into beauty, or adds the quality of beauty to that which has the quality of felt (inner) or objective (outer) truth. Unfortunately, no one appears to ask why truth should have to be beautified, or the lily gilded. The only reasonable answer to this question is that only painful or upsetting truth needs to be "varnished." This means that the beauty of an utterance is, in itself, prima facie evidence of the upsetting quality of the substance of that utterance.

An illuminating sidelight is shed on this problem by Freud's hypothesis that man's original olfactory interest in the genitalia was gradually replaced by a repression of this interest in its original form and the displacement of that interest (in terms of beauty) to the rest of the body. Freud saw this repression and displacement as a consequence of man's assumption of an erect posture. However, I feel that the erect posture could not have come into being without a *previous* repression of the humanoid's compelling olfactory interest in the genitalia. Be that as it may, Maslow (1939, 1940), in demonstrating that the capacity to perceive the genitalia as beautiful is highly correlated with sexual dominance, indirectly highlighted also the fact that most people cannot perceive the genitalia as beautiful.

The problem of ugliness in art is therefore of prime importance. An item professing to be art, can be apprehended as "ugly" in two highly distinct senses:

1) The substance of the utterance itself may be too little disguised for the taste of the times, as in the so-called ashcan school of painting, and the like. In such instances, even though the public makes a predominantly ethical or "moral" judgment, the product itself is rejected as *art*. Thus, the courts often rule that a given work is too obscene to cover its scandalous nakedness with what meager scraps of artistry it does contain. The work is said to be "ugly" = *not* art.

2) The means whereby the artist seeks to smuggle his utterance past the inner—and also past the social—censor, the manner in which he is "art-ing," may be at variance with social and superego standards, which test the artist's "artistic" alibi as care-

fully as that of the criminal. At work with a deviant alibi is said to be "ugly," to = *bad* art, even where the substantive utterance itself is insipid enough, as it is in many of Stravinsky's later works.

These two meanings of the term "ugly" radically differ from each other and pointedly highlight the focus of the entire problem of beauty in art. On the whole, a work is accepted as (primarily) artistic if it satisfies the following criteria:

1) The artist first experiences a mood capable of *contaminating* his audience; this mood is the conscious repercussion of an unconscious wish or impulse also present in others and must be accompanied by unconscious fantasies (visual, auditory, etc.) which, while at variance with those of his audience ("originality"), are susceptible of being retranslated by the audience into private images and moods referable to the same specific wish (communicability). He allows these images or fantasies to erupt into his conscious (Kris, 1952) and then reorganizes them by means of a technique of art acceptable to the superego as a bribe, tendered in legal currency. Moreover, the final—and now "artistic"—utterance is such that it is still able to communicate a mood in all its intensity; otherwise stated, it still "contaminates" the audience with the artist's initial mood. Hence, figuratively speaking, the poet must not strive to be a logician; he must seek to give the impression that he is a musician. He achieves this goal by using seemingly conceptual communication as a means for achieving genuine affective contamination.

2) The consumer is able to empathize with the artist's mood; his unconscious wishes and impulses resemble those of the artist. Moreover, he is able to bribe his own superego with the artistic currency placed at his disposal by the artist himself, and yet is able to retranslate the formal conceptual communication (imagery, or "wisdom") of the work into its unconscious referents: A mood and the unconscious wish or impulse underlying that mood. This is genuine "brainwashing," of the Spence, Klein, and Smith (1959) type.

The artist's creative process unfolds in the following characteristic sequence: Conscious mood, reflecting the mobilization of an unconscious wish, and also of unconscious fantasies pertaining to that wish. Eruption of the unconscious fantasies into the con-

scious in the form of imagery, melody, "ideas," and so forth (Kris, 1952). Reworking of this intruding material by means of an artistic technique, which the artist's superego is willing to accept as a bribe, but which not only does not destroy the material's capacity to induce a comparable mood in the audience, but even heightens it by making it ego syntonic, and does not distort or "purify" the imagery to the point where it can no longer be retranslated by the audience into the basic wish to which it pertains. Kubie's (1958) researches suggest that this blending of unconscious substance with conscious technique takes place in the preconscious.

It is extremely important to realize—as Kris (1952) pointed out—that the wishes in question are always pregenital and never genital ones. Now, it is a basic characteristic of pregenital wishes that they involve only a minimum of object libido, if any, and seldom have truly interpersonal dimensions. It appears to be the essence of artistic creativity that it manages to sublimate these basically autistic wishes in such a manner that they become object directed and endowed with the object-libidinal qualities of genital wishes. This process represents, to my mind, the very essence of sublimation. Novel as this view is, it fully dovetails with the more and more often voiced view (Menninger, 1942, etc.) that only pregenital impulses are capable of being sublimated, while genitality is not, since it is, in itself, a completely mature and reality adequate psychological position.[8]

Returning to the problem of the art "consumer," his task consists in:

1) Learning to bribe his superego with the artistic currency placed at his disposal (music and art appreciation courses); and

2) Referring back the artist's "distortion" of the underlying unconscious wish to a similar wish in his (the consumer's) unconscious. In a way, the consumer must learn to un-distort the artist's distortion of that wish; his astigmatism must, so to speak, compensate for that of the artist. Needless to say, no consumer's

[8] In terms of this scheme, cheaply sentimental "art" (?) peddles mere affect, detached from any kind of basic utterance, which is totally lacking in such works. The genuine utterance is destroyed and replaced by a phony and derivative pseudo-utterance.

personal astigmatism *exactly* compensates for that of the "distort-ing" artist, which explains why an artistic item means different things to different consumers and also why it means different things to the same consumer at different times, even though he perceives the artist's distortion as aesthetically satisfying at all times. This, as I see it, is the psychoanalytic meaning of Copland's (1939) cogent remark, that a great work of art is inexhaustible, and means something different every time one hears it. We may well add that this inexhaustibility also implies that, in great art, the underlying wish is a very basic and intense one.

A concrete example may help us to pin down this idea more definitely. It is well known that the genuine "statue" of a Greek deity was not the artistic marble displayed in the public portion of the temple; it was the crude and inartistic hewn log, kept in a sacred and reserved precinct. We might almost say that, in classi-cal Greece, the aesthetic statue was a public statement about a secret log statue, and comparable to an allusion to esoteric matters in a lay poem. In the public statue beauty replaced sacredness as alibi and connotation. This, in turn, implies that there can be no bona fide art that is not separated from esoteric utterances; from religion and from profanity alike. It was nonidolatry that permitted occidental church statuary to achieve the status of art; where there is idolatry, the evolution of religious statuary into art inevitably marks the decline of religion and also the loss of the statue's reli-gious relevance and content.

SIGNALING METHODS

It is seldom recognized that the artist habitually uses certain formal devices for signaling that his product is "art," which carries the "imprimatur" of the superego. A very simple example of this is the traditional way of beginning a tale: "Once upon a time" in England, "Cric—crac" in Haiti, and the like. A symphony does not start like a jazz tune. A pornographic novel does not open with the lyrical description of a landscape. In other instances, such as in brilliantly foreshortened figures, in five-part fugues, etc., technical virtuosity is used as a signal that "This is art; I am art-ing." An, alas, very common device of signaling that "This is serious art," is

simply to be dull, just as the device of countless footnotes and references and an even greater dullness often seek to signal: "This is scholarship." Such signaling devices are often used even where the actual content is quite trivial and are resorted to—interestingly enough—also in many so-called revolutionary works. As regards the latter, a moment of thought will show that so-called *musique concrète* is, in many ways, an urbanized bastard descendant of the bird call passages in Beethoven's *Pastoral Symphony* and of many lesser works of a similarly imitative nature. In fact, even a certain type of ugliness—of content or of execution—can be used at various points in the history of culture as a token of "artistry." A good example of this are contrapuntal monstrosities for twenty-four voices—or so the composer tells us—which are not only devoid of beauty, but cannot even be perceived by the ear (as distinct from the eye) as having even half a dozen voices, let alone twenty-four. Yet art—incomprehensibly—claims such works as its own, but barely grants second-class citizenship to certain genuinely remarkable jazz compositions, because the latter distort the basic (erotic-aggressive) utterance either inadequately, or else by technically and stylistically unconventional means, which are inacceptable to the "square" superego as a "bribe."

THE MEDIUM

Art is communication that works *directly* through the medium of the senses. However, it is noteworthy that, even though fine cooking and perfumery are sometimes referred to as "arts," in essence all real art involves only sound and sight, or is—like the dance—in some manner subordinated to, or correlated with, sound or sight. Poetry speaks to us through images and through "music"; dance always associates itself with music and makes it appeal to the eye, being a plastic art in motion. It is my thesis that a sphere of the senses can become a medium for art only if it is not (phylogenetically and ontogenetically) so archaic and organismally so "basic" as to obstruct the path of sublimation. This explains why pure bodily sensations—be they kinesthetic, coenesthetic, or tactile—as well as the olfactory and gustatory sensations, are not media suitable for the *sublimated* expression and com-

munication of basic impulses. Moreover, all of these sense spheres are mobilized already *in utero*. Of the remaining two senses, hearing and seeing, hearing can also be stimulated already *in utero*, but is both phylogenetically and ontogenetically less archaic than are all other senses, sight always excepted. Apparently hearing is activated just late enough and is just distinct enough from the most archaic and basic senses to permit a degree of sublimation. By contrast, the sensations of the more archaic sense organs are so intense that they are best coped with by repression, rather than by sublimation. At the same time, hearing is close enough to archaic intrauterine experiences to possess an affect mobilizing power which exceeds that of the only other sublimable sense-sphere. This may explain why no art has had to impose upon itself a technical straightjacket comparable in intensity, complexity, and plain obsessive irrationality to that of music.[9] Sight, being mobilized only after birth is, of all senses, the one most closely related to reality testing (Devereux, 1949). It is therefore less hallucinatorily evocative than is hearing. This explains, in turn, why the rules of painting are less rigid than those of counterpoint.

This is a good time for a minor aside, to justify my having called music the art par excellence, apart from the fact that hearing is already stimulated *in utero*. In no other art is creativeness hedged about by so many "rules" bordering on obsessive ritual and having no aesthetic validity whatsoever. There is hardly a student of counterpoint who did not hear his teacher say: "Beautiful—musical—but against the rules." In no other art do truly great creative artists, as distinct from hacks, write technical exercises for the executant (Liszt's *Études*), or displays of purely contrapuntal virtuosity (Bach's *Kunst der Fuge*), or ukases sanctioning the use of a particular tool (Bach's *Well-Tempered Clavichord*) *and* manage to persuade the multitude to *accept it* as "art." I hold that the obsessiveness of music rituals (theory)—the elaborateness of the conditions under which a musical utterance is accepted as art—is prima facie evidence that music utters most directly the

9 The fantastic rigors of early poetical rules may—apart from their mnemonic function—reflect attempts to curb the magico-evocative, irrational, and autistic potentialities of language. The liberation of the poet from this linguistic-poetic straight jacket may have resulted from the increasing use of language for the communication of rational information.

most basic of forbidden impulses. Hence, in no other art is the conflict between utterance and means of utterance so constantly in the fore of artistic preoccupations.

THE CONTRACT BETWEEN ARTIST AND CONSUMER

Turning from the psychological problem of art in culture to the relationship between producer and consumer, several basic points must be discussed.

We can best distinguish between artist and consumer by recognizing the existence of a binding contract between the two. Both parties agree that the artist shall be permitted to make an objectionable public confession, provided that his confession has a built-in escape clause,[10] implying the repudiability of the basic utterance. Only if there is such a built-in repudiability, can the consumer—and the executant artist as well—accept the creative artist's utterance and make it, in a way, his own, without guilt over being an accessory to a crime. The situation is strictly comparable to the "conspiracy" between "virtue" and "vice," which permits the sale of certain pharmaceutical items with the "understanding" that they are sold, purchased, and used "for the prevention of disease only." An extraordinary example of such a "built-in escape clause" is the intentionally vague mystico-religious (= erotic) correspondence between Julian Sorel and the Maréchale de Fervacques, in Stendhal's book, *The Red and the Black*. In some instances the consumer can even turn the tables on the artist and exploit to the utmost the "escape clause" provided by the artist himself: The previously mentioned young poet, who declared his love in fine verses, was shocked when, on pressing for tangible tokens of his Belovèd's affection, the latter—a cynical scalp hunter—replied with wide-eyed "innocence": "But I thought these were simply lyrical poems!" In other instances repudiability is achieved by hiring poets to write letters and poems to one's Belovèd, as did the aging Henri IV of France, when, while courting his niece-by-marriage, the Princesse de Condé, he asked his court poet to throw the mantle of romance over his senile infatuation. Still another way of exploiting repudiability may consist in humming love lyrics

[10] Compare the Oriental preamble: "Majesty, may I speak and live?"

into the ear of one's dancing partner. This technique of approach leaves the partner free to accept the humming of the "official text" as a purely "artistic" activity, and not as a proposal.

A point of equal importance is the intrusion of artistic material into the unconscious, which has been noted by Freud (1913) and, later on, by Lóránd (1935, 1937), both of whom studied the appearance of fairy tale material in dreams. Fairy tales do, of course, express tabooed impulses, identical with those of the dreamer himself. The real problem is, however, that this material appears in dream in a *borrowed* (culturalized) guise and *not* in a purely subjective wording. I hold that the appearance in dream of artistic day residues—of fairy tales, of something read the night before—is a kind of intrapsychic alibiing. "Not I but my culture (as represented by its artists) has such wishes"[11] is combined with "Well, I may have such wishes, but they are at least culture-syntonic and artistic" (Devereux, 1956b, 1957). It is, thus, a particularly ego-syntonic type of dream work to use prestylized, and artistically culturized material in dream, as a means for the construction of the manifest dream content. As stated elsewhere (Devereux, 1956b), from the consumer's point of view, folklore, art, and the like provide "cold storage" for those of the noncreative man's impulses that he cannot quite handle by means of *subjective* defenses. Whenever he responds to this material, and even incorporates it into his dreams, the consumer achieves two ends:

1) He can pretend that the impulse itself is a borrowed, ego-alien one, in the very precise sense in which a sadistically obstructionistic bureaucrat will "sincerely" say: "I'd like to help you, but Article 27, paragraph 2, forbids me to do so," and

2) He can "borrow" the impulse *complete with* the sanctioned (artistic) defenses against (or compromises with) it that society itself officially recognizes as adequate, presentable, and housebroken. This parallels the maneuver of a half-breed Indian (Devereux, 1956b), who managed to voice his private oedipal hatred of his father quite openly, by couching it in terms which were "respectable" in at least parts of American culture: "A lousy

11 The titillating spuriousness of this pretense is revealed by the naïve public's need to "hiss the villian," though the actor is clearly only a mouthpiece.

Indian (= father) has no business to cohabit with a pure white woman (= mother)."

The thrill of the consumer is vicarious, or, more precisely, is imagined to be vicarious. When listening to a poem of intense eroticism, when entranced by the sensuous loveliness of a Rodin statue, he can forever bribe his superego with the alibi: "In the first place, this is not my doing, but that of Baudelaire or Rodin, and, in the second place, mine is an artistic, and not a lecherous, experience." This alibi is akin to that of the sex-obsessed members of anti-obscenity societies, except that the second part of *their* alibi is: "This is the condemnation of lechery and not its enjoyment."

THE GREATNESS OF ART

The last problem to be discussed is the one which psycho-analysis has not yet solved and which caused Freud to declare that genius is not explicable. I believe that Freud threw in the towel prematurely, since it is self evident that there is, indeed, both a cultural and an intrapsychic distinction between the experiences of a musical person who listens to Berlioz' *Romeo and Juliet* love scene and those of a member of an Orwellian "Junior Anti-Sex League." This difference is not only explicable, specifiable, and meaningful, but is also pertinent to the understanding of genius.

The basic issue is the crucial distinction between the artist's perception of his utterance as subject matter and of his utterance as "artistic." We already saw that even his "improper" subject matter is closely related to his culture, in that culture determines what, beside universally taboo items, is to be repressed. It would be hard to imagine a contemporary U.S. poet achieving fame by singing the praises of property, though near-artistic defenses of property were common enough when the rising middle classes struggled to displace the feudal lords as the prime economic force of society. Horatio Alger is today a topic of art only for literary Piltdown Men—as phony as the "original" one. The great artist achieves a complex and organic blending among the three layers of his subject matter—the universally human repressed impulses, the culturally (and historically) repressed ones, and the privately (idiosyncratically, neurotically) repressed ones. This blending

may be massive and monolithic as in Aeschylus, or it may be subtly contrapuntal as in Shakespeare. But a blending—presumably preconscious (Kubie, 1958)—there must be and flaws in this blend are flaws in the latent subject matter.

The artist's perception of the rules of this game and his alibi maneuvers, which turn his "obscenity," "rebellion," or "blasphemy" into art, are also significant. In the case of some artists, there is so wholesale an acceptance of the rules that their manipulation becomes an end in itself. Both genius and cobbler can take this road, witness Bach's *Art of the Fugue* and Kaikhosru Sorabji's even more recondite contrapuntal obsessions. There can also be a wholesale rejection of one *type* of rule, and its replacement with *another* set of *equally binding* rules. Schoenberg got rid of one set of rules, only to invent a perhaps even more obsessive set of rituals, the twelve-tone system. Innovators of technique alone are very much like the famous "rebel without a cause" (Lindner, 1944), in that they unify their works not by means of a logico-affective internal continuity, as did Shakespeare or Berlioz, but by external technical devices.

Hence, apart from the problem of having to interlock three sets of tabooed wishes, the artist must also possess supreme skill in "skating on thin ice." Indeed, the better the skater, the thinner can be the ice (of rules of art) on which he can skate. In other words, the better an artist masters his craft, the nearer he is able to come to expressing, *without loss of affect*, the tabooed. Moreover, by covering it with the thinnest—and most exquisitely wrought—veneer of artistic convention, which suffices to make his utterance both culture- and ego-syntonic, he often actually heightens the intensity of its experienced affect. But veneer there must be, differentiating the love scene in Berlioz' *Romeo and Juliet* from a rutting bull elephant's "musht"—endocrine actuated—trumpeting.

The artist is, thus, constantly confronted with the choice between:

1) Skating on ice so thin that it will break and cause the forbidden utterance to erupt from behind the stylistic alibi; and

2) Freezing his real utterance over with a crust of ("artistic") ice so thick as to cause the elemental utterance, and the

affect pertaining to it, to be lost . . . thereby turning the boiling lake into a refrigerated indoor rink, where figure skating—pattern making on the ice—becomes the real goal.

Here, too, there are major cultural and historical differences to be noted. There is, at one end, the volcanic eruptiveness of "romantic" art, and, at the other end, the icy technical virtuosity of "neoclassical" watchmakers. Personally, I feel that in the greatest of great art the lake is truly boiling, but erupts in a beautifully patterned column, or, if the lake is frozen over with technique, the ice is paper thin, of exquisite purity and incised with magnificent figure-skating patterns. Whether the experience of beauty is the product of a controlled eruption: of a boiling lake foaming up like the waterspouts of Versailles, or of a creative control: of the incising of patterns on paper thin ice, the basic artistic experience is the same. *There is a sense of the imminent closeness of danger*, the feeling that at any moment the controls may lapse and the love song turn into a rutting bull elephant's elemental and quite unartistic proboscidian fanfare. In this frame of reference, the experience of beauty is a product of *the sense of imminent instinctual danger controlled down to the finest hairline*. As Hanns Sachs (1942) wisely said, the problem of beauty is to *endure* it, rather than to *understand* it.

Two major aspects of art are relevant in this context:

I. *Art is socially creative and cohesive*. This, of course, is a descriptive and empirical statement and not an explicatory one. Nonetheless, it must be borne in mind that:

1) Art is a sublimation and not an ordinary defense. As such, it has three major characteristics: a) It is, unlike other defenses, strengthened and not weakened by psychoanalysis (Jokl, 1950). b) It liberates energies and is not, like the defenses, parasitical on them. c) It is primarily in the service of the ego and not of the instincts (as in lechery or blind hate) or of the superego (as in a self-appointed guardianship of public virtue).

2) The impulses and wishes perpetuated by art are the same as those that actuate the normal, the neurotic, the compulsive rebel, and the inhibited Puritan. However, these impulses are neither distorted, not negated, nor are they permitted to erupt in the form of a brute, almost subcortical discharge. They are disci-

plined without being negated. They are not dissipated, but are discharged in such a manner that there occurs a kind of "feedback" that automatically increases: a) The ability to mobilize and to discharge affect; and b) The technical proficiency of achieving a *disciplined* discharge.

These latter two findings are, in general, characteristic of all sublimations, as listed above, and especially fit criterion 1b. Moreover, the technique of the discharge implies creative outgoing communication, receptivity, and *object relations*—three processes which presuppose, and are uniquely characteristic of, maturity. Great art is always art *directed at* an audience; though, in the case of great innovators, it is often directed at an as yet nonexistent audience. The socially evolved and provided technique is recognized as of external origin, is assigned a place in the preconscious and is internalized adequately, but without its ever becoming a panicky compulsion. The new techniques one originates are, moreover, intended to have transpersonal validity.[12]

This observation explains also the constant evolution of art and, moreover, does so in terms which presuppose the thesis already discussed, that all great art is inexhaustible. It is one of the basic characteristics of all great art—be it a Mozart quartet which I happen to hear today for the fiftieth time, or a Bartók quartet whose beauty is, because of its novelty, only partly accessible to me on first listening to it—that it gives one simultaneously an uncanny sense of *déjà entendu* or *déjà vu* and a complete and startling sense of something utterly new. It is increasingly recognized in psychologically sophisticated critical circles that all major themes are eternal. This is but another way of saying that the number of wishes important and intense enough to require or deserve artistic "distortion" is limited. Each such wish is a perpetual challenge, which each period meets to its own partial satisfaction, and yet in a manner that leaves the problem unsolved for all future generations. Each new twist of plot or melody, each new artistic manipulation, each restatement of the human figure, represents, on the one hand, a new attempt to solve an ageless

12 Although I do not happen to like Schoenberg, I recognize that he did evolve his technique in a *teachable* form, and with the *intention* of teaching it. All this does presuppose object libido.

problem and a partial repudiation of previous solutions. At the same time, a new attempt at turning a tabooed wish into art is also a protest against the kind of boredom that past and hackneyed solutions induce in us. A further major cause of artistic revolutions is the fact that, due to culture-historically determined changes in the composition of the unconscious and of the conscious of successive historical periods (Devereux, 1956b), past solutions no longer fit the present psychic constellation of the new artists and their audiences and therefore fail to provide an adequate defense against, or compromise with, the unconscious wish. Once the problem is formulated in this manner, it does not matter in the least whether the eighteenth-century solution of such emotional conflicts repelled Victorians because of its coldly hedonistic sensuality, or whether the Victorian solution strikes us as inadequate because of the amount of repression it demands from us. All that matters is that the single true cause of changes in art is the eternal nature of the eternally ungratified and therefore eternally challenging wishes underlying it.

II. *Art demands an integration of the personality.* In the best cases there is, on the one hand, a complete interlocking of the three forms of humanly, culturally, and subjectively tabooed impulses, and on the other hand, a meshing of these "topics" with ego-syntonic and highly organized means of expression (ritual or style of art), without loss of affect, the whole being directed at an audience, which implies object libido. In this sense, then, *art is the perfect medium for the most highly individualized contribution man can make to culture,* and the cultural element—the factor that proclaims a given product as "art"—is: Style, which presupposes technique. In fact, in one sense at least, style is *behaviorally* the pattern of techniques.

Technique may, thus, be thought of as that which differentiates a brute, elemental but static utterance from dynamic art. Its real function is revealed by a remark I sometimes make to adolescent analysands wantonly rebelling against not overly obnoxious social rules:

"Your bones admittedly limit the flexibility of the arm. They are, in a way, like constricting rules. But if your arm had no bones whatsoever, you could not use it at all."

CONCLUSIONS

In terms of communication theory, art is a message in which the basic information is overlaid by a special kind of (pseudo) "noise," which is actually a kind of metalanguage, conveying supplementary information ("beauty") and which, like a contrapuntal voice, comments and highlights the *cantus firmus* of the basic utterance.

In terms of psychoanalytic theory, art—like love—deepens and broadens the psychic scope of the instincts, by placing at their disposal the immense resources of the ego.

In terms of the theory of culture, art is the means whereby a healthy society manages to put to a constructive use man's seemingly least socializable impulses, and even to augment their ultimate intensity, by placing at their disposal the vast resources of culture, thereby making them both expressible and culturally productive.

It is therefore probable that, in the long run, the psychoanalytically oriented culture and personality study of art will become one of the most effective means for the study of man in society.

Bibliography

Barzun, Jacques. *Berlioz and the Romantic Century.* 2 vols. Boston: Atlantic-Little, Brown, 1950

Bell, E. T. *Men of Mathematics.* New York: Simon and Schuster, 1937.

Copland, Aaron. *What to Listen For in Music.* New York: McGraw-Hill, 1939.

Devereux, George. "Mohave Coyote Tales," *Journal of American Folklore,* 61 (1948), pp. 233–55.

———. "A Note on Nyctophobia and Peripheral Vision," *Bulletin of the Menninger Clinic,* 13 (1949), pp. 85–93.

———. *Therapeutic Education.* New York: Harper, 1956a.

———. "Normal and Abnormal," In Anthropological Society of Washington (ed.), *Some Uses of Anthropology, Theoretical and Applied.* Washington, D.C.: Anthropological Society of Washington, 1956b.

———. "Psychoanalysis as Anthropological Field Work," *Transactions of the New York Academy of Sciences,* Series II. 19 (1957), pp. 457–72.

———. "Mohave Ethnopsychiatry and Suicide," *Bureau of American Ethnology Bulletin.* No. 175 (1960).

Freud, Anna. *The Ego and the Mechanisms of Defense.* New York: International Universities Press, 1946.

Freud, Sigmund. "Wit and Its Relation to the Unconscious," *The Basic Writings of Sigmund Freud.* New York: Modern Library, 1938.

———. *Leonardo da Vinci.* New York: Dodd, Mead, 1932.

———. "The Occurrence in Dreams of Material from Fairy Tales." *Collected Papers,* IV. London: Hogarth, 1925.

———. "Ansprache im Frankfurter Goethe Haus." In *Gesammelte Werke,* XIV. London: Imago Publishing Co., 1948.

Jokl, R. H. "Psychic Determinism and Preservation of Sublimation in Classical Psychoanalytic Procedure," *Bulletin of the Menninger Clinic,* 14 (1950), pp. 207–19.

Kris, Ernst. *Psychoanalytic Explorations of Art.* New York: International Universities Press, 1952.

Kroeber, A. L. "Introduction." In Parsons, E. C., *American Indian Life.* New York: Viking, 1925.

———. *Style and Civilization.* Ithaca, N.Y.: Cornell University Press, 1957.

Kubie, L. S. *Neurotic Distortion of the Creative Process.* Lawrence, Kan.: University of Kansas Press, 1958.

La Barre, Weston. *The Human Animal.* Chicago: University of Chicago Press, 1954.

Lindner, R. M. *Rebel Without a Cause.* New York: Grune and Stratton, 1944.

Lóránd Sándor. "Fairly Tales and Neurosis," *Psychoanalytic Quarterly,* 4 (1935), pp. 234–43.

———. "Fairy Tales, Lilliputian Dreams and Neurosis," *American Journal of Orthopsychiatry,* 7 (1937), pp. 456–64.

Maslow, A. H. "Dominance Feeling, Personality and Social Behavior in Women," *Journal of Social Psychology,* 10 (1939), pp. 3–39.

———. "A Test for Dominance Feeling (Self-Esteem) in Women," *Journal of Social Psychology,* 12 (1940), pp. 255–70.

Menninger, K. A. and J. L. *Love Against Hate.* New York: Harcourt, Brace, 1942.

Rhodokanakes, K. P. (also Rhodochanachi, C. P.). *Athens and the Greek Miracle.* London: Routledge, Kegan Paul, 1948.

Róheim, Géza. "Myth and Folk-Tale," *American Imago,* 2 (1941), pp. 266–79.

Sachs, Hanns. *The Creative Unconscious.* Cambridge, Mass: Sci-Art, 1942.

Spence, D. P., Klein, G. S., and Smith, G. J. W. "Subliminal Effect of Verbal Stimuli," *Journal of Abnormal and Social Psychology.* Vol. 59, No. 2 (1959).

Stevens, Halsey. *The Life and Music of Béla Bartók.* New York: Oxford University Press, 1953.

The Science of the Concrete*

CLAUDE LÉVI-STRAUSS

Professor Lévi-Strauss isolates and defines aspects of primitive thought and makes distinctions between magic and science. He sees art as halfway between scientific and mythical, or magical, thought. One of its essential characteristics is miniaturization or simplification by reduction in scale or properties. The creative process consists of the transformation by the artist of an event into a structure. A more complete explanation shows that the event or object represented is but one part of a contingent that affects the outcome of the work of art. Occasion, execution and materials, and use are the elements that are integrated into the structure, or work of art, or model, materials, and user. All forms of art allow all three aspects but in varying proportions. Primitive art corresponds most closely with the second and third, professional or academic art with the first.

Claude Lévi-Strauss is Professor of Social Anthropology and of Comparative Religions of Nonliterate People at the Collège de France, and is Director of the Laboratory of Social Anthropology of the Collège de France and l'École Pratique. His fields of research are kinship, religion, mythology, art, and social organization, and he has specialized in the peoples of North and South America. He is possibly the anthropologist exerting the greatest influence on the field today primarily through his brilliant publications, *Anthropologie Structurale* (1968), *La Pensée Sauvage* (1962), *Structures Elementaires de la Parente* (1967), *Totemism* (1963), and *Tristes Tropiques: An Anthropological Study of Primitive Societies in Brazil* (1964).

. . . Classifying, as opposed to not classifying, has a value of its own, whatever form the classification may take. As a recent theorist of taxonomy writes:

> Scientists do tolerate uncertainty and frustration, because they must. The one thing that they do not and must not

* Excerpted from the chapter "The Science of the Concrete" in *The Savage Mind* by Claude Lévi-Strauss (Chicago, 1966).

tolerate is disorder. The whole aim of theoretical science is to carry to the highest possible and conscious degree the perceptual reduction of chaos that began in so lowly and (in all probability) unconscious a way with the origin of life. In specific instances it can well be questioned whether the order so achieved is an objective characteristic of the phenomena or is an artifact constructed by the scientist. That question comes up time after time in animal taxonomy. . . . Nevertheless, the most basic postulate of science is that nature itself is orderly. . . . All theoretical science is ordering and if, systematics is equated with ordering, then systematics is synonymous with theoretical science (Simpson, p. 5).

The thought we call primitive is founded on this demand for order. This is equally true of all thought but it is through the properties common to all thought that we can most easily begin to understand forms of thought which seem very strange to us.

A native thinker makes the penetrating comment that "All sacred things must have their place" (Fletcher 2, p. 34). It could even be said that being in their place is what makes them sacred for if they were taken out of their place, even in thought, the entire order of the universe would be destroyed. Sacred objects therefore contribute to the maintenance of order in the universe by occupying the places allocated to them. Examined superficially and from the outside, the refinements of ritual can appear pointless. They are explicable by a concern for what one might call "microadjustment"—the concern to assign every single creature, object, or feature to a place within a class. The ceremony of the Hako among the Pawnee is particularly illuminating in this respect, although only because it has been so well analyzed. The invocation that accompanies the crossing of a stream of water is divided into several parts, which correspond, respectively, to the moment when the travelers put their feet in water, the moment when they move them, and the moment when the water completely covers their feet. The invocation to the wind separates the moment when only the wet parts of the body feel cool: "Now, we are ready to move forward in safety" (*idem.*, pp. 77–78). As the information explains: "We must address with song every object we meet, because Tira'wa

(the supreme spirit) is in all things, everything we come to as we travel can give us help. . . ." (*idem,* pp. 73, 81).

This preoccupation with exhaustive observation and the systematic cataloguing of relations and connections can sometimes lead to scientifically valid results. The Blackfoot Indians for instance were able to prognosticate the approach of spring by the state of development of the fetus of bison which they took from the uterus of females killed in hunting. These successes cannot of course be isolated from the numerous other associations of the same kind that science condemns as illusory. It may however be the case that magical thought, that "gigantic variation on the theme of the principle of Causality" as Hubert and Mauss called it (2, p. 61), can be distinguished from science not so much by any ignorance or contempt of determinism but by a more imperious and uncompromising demand for it which can at the most be regarded as unreasonable and precipitate from the scientific point of view,

> As a natural philosophy it (witchcraft) reveals a theory of causation. Misfortune is due to witchcraft cooperating with natural forces. If a buffalo gores a man, or the supports of a granary are undermined by termites so that it falls on his head, or he is infected with cerebrospinal meningitis, Azande say that the buffalo, the granary, and the disease, are causes which combine with witchcraft to kill a man. Witchcraft does not create the buffalo and the granary and the disease for these exist in their own right, but it is responsible for the particular situation in which they are brought into lethal relations with a particular man. The granary would have fallen in any case, but since there was witchcraft present it fell at the particular moment when a certain man was resting beneath it. Of these causes the only one which permits intervention is witchcraft, for witchcraft emanates from a person. The buffalo and the granary do not allow of intervention and are, therefore, whilst recognized as causes, not considered the socially relevant ones (Evans-Pritchard *1*, pp. 418–19).

Seen in this way, the first difference between magic and science is therefore that magic postulates a complete and all-embracing determinism. Science, on the other hand, is based on a distinction

between levels: only some of these admit forms of determinism; on others the same forms of determinism are held not to apply. One can go further and think of the rigorous precision of magical thought and ritual practices as an expression of the unconscious apprehension of the *truth of determinism,* the mode in which scientific phenomena exist. In this view, the operations of determinism are divined and made use of in an all-embracing fashion before being known and properly applied, and magical rites and beliefs appear as so many expressions of an act of faith in a science yet to be born.

The nature of these anticipations is such that they may sometimes succeed. Moreover they may anticipate not only science itself but even methods or results that scientific procedure does not incorporate until an advanced stage of its development. For it seems to be the case that man began by applying himself to the most difficult task, that of systematizing what is immediately presented to the senses, on which science for a long time turned its back and which it is only beginning to bring back into its purview. In the history of scientific thought this "anticipation-effect," has, incidentally, occurred repeatedly. As Simpson (pp. 84–85) has shown with the help of an example drawn from nineteenth-century biology, it is due to the fact that, since scientific explanation is always the discovery of an "arrangement," any attempt of this type, even one inspired by nonscientific principles, can hit on true arrangements. This is even to be foreseen if one grants that the number of structures is by definition finite: the "structuring" has an intrinsic effectiveness of its own whatever the principles and methods that suggested it.

Modern chemistry reduces the variety of tastes and smells to different combinations of five elements: carbon, hydrogen, oxygen, sulphur, and nitrogen. By means of tables of the presence and absence of the elements and estimates of proportions and minimum amounts necessary for them to be perceptible, it succeeds in accounting for differences and resemblances that were previously excluded from its field on account of their "secondary" character. These connections and distinctions are however no surprise to our aesthetic sense. On the contrary they increase its scope and understanding by supplying a basis for the associations it already

divined; and at the same time one is better able to understand why and in what conditions it should have been possible to discover such associations solely by the systematic use of intuitive methods. Thus to a logic of sensations tobacco smoke might be the intersection of two groups, one also containing broiled meat and brown crusts of bread (which are like it in being composed of nitrogen) and the other one to which cheese, beer, and honey belong on account of the presence of diacetyl. Wild cherries, cinnamon, vanilla, and sherry are grouped together by the intellect as well as the senses, because they all contain aldehyde, while the closely related smells of wintergreen, lavender, and bananas are to be explained by the presence of ester. On intuitive grounds alone we might group onions, garlic, cabbage, turnips, radishes, and mustard together even though botany separates liliaceae and crucifers. In confirmation of the evidence of the senses, chemistry shows that these different families are united on another plane: they contain sulphur. A primitive philosopher or a poet could have effected these regroupings on the basis of considerations foreign to chemistry or any other form of science. Ethnographic literature reveals many of equal empirical and aesthetic value. And this is not just the result of some associative madness destined sometimes to succeed simply by the law of chance. Simpson advances this interpretation in the passage quoted above; but he displays more insight when he shows that the demand for organization is a need common to art and science and that in consequence "taxonomy, which is ordering par excellence, has eminent aesthetic value" (*loc. cit.*, p. 4). Given this, it seems less surprising that the aesthetic sense can by itself open the way to taxonomy and even anticipate some of its results.

I am not however commending a return to the popular belief (although it has some validity in its own narrow context) according to which magic is a timid and stuttering form of science. One deprives oneself of all means of understanding magical thought if one tries to reduce it to a moment or stage in technical and scientific evolution. Like a shadow moving ahead of its owner it is in a sense complete in itself, and as finished and coherent in its immateriality as the substantial being that it precedes. Magical

thought is not to be regarded as a beginning, a rudiment, a sketch, a part of a whole that has not yet materialized. It forms a well-articulated system, and is in this respect independent of that other system which constitutes science, except for the purely formal analogy that brings them together and makes the former a sort of metaphorical expression of the latter. It is therefore better, instead of contrasting magic and science, to compare them as two parallel modes of acquiring knowledge. Their theoretical and practical results differ in value, for it is true that science is more successful than magic from this point of view, although magic foreshadows science in that it is sometimes also successful. Both science and magic however require the same sort of mental operations and they differ not so much in kind as in the different types of phenomena to which they are applied.

These relations are a consequence of the objective conditions in which magic and scientific knowledge appeared. The history of the latter is short enough for us to know a good deal about it. But the fact that modern science dates back only a few centuries raises a problem which ethnologists have not sufficiently pondered. The Neolithic Paradox would be a suitable name for it.

It was in neolithic times that man's mastery of the great arts of civilization—of pottery, weaving, agriculture, and the domestication of animals—became firmly established. No one today would any longer think of attributing these enormous advances to the fortuitous accumulation of a series of chance discoveries or believe them to have been revealed by the passive perception of certain natural phenomena.[1]

Each of these techniques assumes centuries of active and methodical observation, of bold hypotheses tested by means of endlessly repeated experiments. A biologist remarks on the rapidity with which plants from the New World have been acclimatized in the Philippines and adopted and named by the natives. In many

[1] An attempt has been made to discover what would happen if copper ore had accidentally found its way into a furnace: complex and varied experiments have shown that nothing happens at all. The simplest method of obtaining metallic copper which could be discovered consisted in subjecting finely ground malachite to intense heat in a pottery dish crowned with an inverted clay pot. This, the sole result, restricts the play of chance to the confines of the kiln of some potter specializing in glazed ware (Coghlan).

cases they seem even to have rediscovered their medicinal uses, uses identical with those traditional in Mexico. Fox's interpretation is this:

> . . . plants with bitter leaves or stems are commonly used in the Philippines for stomach disorders. If an introduced plant is found to have this characteristic, it will be quickly utilized. The fact that many Philippine groups, such as the Pinatubo Negritos, constantly experiment with plants hastens the process of the recognition of the potential usefulness, as defined by the culture, of the introduced flora (R. B. Fox, pp. 212–13).

To transform a weed into a cultivated plant, a wild beast into a domestic animal, to produce, in either of these, nutritious or technologically useful properties which were originally completely absent or could only be guessed at; to make stout, watertight pottery out of clay which is friable and unstable, liable to pulverize or crack (which, however, is possible only if from a large number of organic and inorganic materials, the one most suitable for refining it is selected, and also the appropriate fuel, the temperature and duration of firing, and the effective degree of oxidation); to work out techniques, often long and complex, that permit cultivation without soil or alternatively without water; to change toxic roots or seeds into foodstuffs or again to use their poison for hunting, war, or ritual—there is no doubt that all these achievements required a genuinely scientific attitude, sustained and watchful interest, and a desire for knowledge for its own sake. For only a small proportion of observations and experiments (which must be assumed to have been primarily inspired by a desire for knowledge) could have yielded practical and immediately useful results. There is no need to dwell on the working of bronze and iron and of precious metals or even the simple working of copper ore by hammering that preceded metallurgy by several thousand years, and even at that stage they all demand a very high level of technical proficiency.

Neolithic, or early historical, man was therefore the heir of a long scientific tradition. However, had he, as well as all his predecessors, been inspired by exactly the same spirit as that of our own

time, it would be impossible to understand how he could have come to a halt and how several thousand years of stagnation have intervened between the neolithic revolution and modern science like a level plain between ascents. There is only one solution to the paradox, namely, that there are two distinct modes of scientific thought. These are certainly not a function of different stages of development of the human mind but rather of two strategic levels at which nature is accessible to scientific inquiry: one roughly ada⌐ ᵉd to that of perception and the imagination: the other at a remove from it. It is as if the necessary connections, which are the object of all science, neolithic or modern, could be arrived at by two different routes, one very close to, and the other more remote from, sensible intuition.

Any classification is superior to chaos and even a classification at the level of sensible properties is a step toward rational ordering. It is legitimate, in classifying fruits into relatively heavy and relatively light, to begin by separating the apples from the pears even though shape, color, and taste are unconnected with weight and volume. This is because the larger apples are easier to distinguish from the smaller if the apples are not still mixed with fruit of different features. This example already shows that classification has its advantages even at the level of aesthetic perception.

For the rest, and in spite of the fact there is no necessary connection between sensible qualities and properties, there is very often at least an empirical connection between them, and the generalization of this relation may be rewarding from the theoretical and practical point of view for a very long time even if it has no foundation in reason. Not all poisonous juices are burning or bitter nor is everything that is burning and bitter poisonous. Nevertheless, nature is so constituted that it is more advantageous if thought and action proceed as though this aesthetically satisfying equivalence also corresponded to objective reality. It seems probable, for reasons which are not relevant here, that species possessing some remarkable characteristics, say, of shape, color, or smell give the observer what might be called a "right pending disproof" to postulate that these visible characteristics are the sign of equally singular, but concealed, properties. To treat the relation

between the two as itself sensible (regarding a seed in the form of a tooth as a safeguard against snake bites, yellow juices as a cure for bilious troubles, etc.) is of more value provisionally than indifference to any connection. For even a heterogeneous and arbitrary classification preserves the richness and diversity of the collection of facts it makes. The decision that everything must be taken account of facilitates the creation of a "memory bank."

It is moreover a fact that particular results, to the achievement of which methods of this kind were able to lead, were essential to enable man to assail nature from a different angle. Myths and rites are far from being, as has often been held, the product of man's "myth-making faculty,"[2] turning its back on reality. Their principal value is indeed to preserve until the present time the remains of methods of observation and reflection that were (and no doubt still are) precisely adapted to discoveries of a certain type: those which nature authorized from the starting point of a speculative organization and exploitation of the sensible world in sensible terms. This science of the concrete was necessarily restricted by its essence to results other than those destined to be achieved by the exact natural sciences but it was no less scientific and its results no less genuine. They were secured ten thousand years earlier and still remain at the basis of our own civilization.

There still exists among ourselves an activity which on the technical plane gives us quite a good understanding of what a science we prefer to call "prior" rather than "primitive," could have been on the plane of speculation. This is what is commonly called "bricolage" in French. In its old sense the verb "bricoler" applied to ball games and billiards, to hunting, shooting, and riding. It was, however, always used with reference to some extraneous movement: a ball rebounding, a dog straying, or a horse swerving from its direct course to avoid an obstacle. And in our own time the "bricoleur" is still someone who works with his hands and uses devious means compared to those of a craftsman.[3] The character-

2 The phrase is from Bergson, "fonction fabulatrice" (Trans. note).

3 The "bricoleur" has no precise equivalent in English. He is a man who undertakes odd jobs and is a jack-of-all-trades or a kind of professional do-it-yourself man, but, as the text makes clear, he is of a different standing from, for instance, the English "odd-jobman" or handyman (Trans. note).

istic feature of mythical thought is that it expresses itself by means of a heterogeneous repertoire which, even if extensive, is nevertheless limited. It has to use this repertoire, however, whatever the task in hand, because it has nothing else at its disposal. Mythical thought is therefore a kind of intellectual "bricolage"—which explains the relation that can be perceived between the two.

Like "bricolage" on the technical plane, mythical reflection can reach brilliant unforeseen results on the intellectual plane. Conversely, attention has often been drawn to the mythopoetical nature of "bricolage" on the plane of so-called raw or naïve art, in architectural follies like the villa of Cheval the postman or the stage sets of Georges Méliès, or, again, in the case immortalized by Dickens in *Great Expectations* but no doubt originally inspired by observation, of Mr. Wemmick's suburban "castle" with its miniature drawbridge, its cannon firing at nine o'clock, its bed of salad and cucumbers, thanks to which its occupants could withstand a siege if necessary . . .

The analogy is worth pursuing since it helps us to see the real relations between the two types of scientific knowledge we have distinguished. The "bricoleur" is adept at performing a large number of diverse tasks; but, unlike the engineer, he does not subordinate each of them to the availability of raw materials and tools conceived and procured for the purpose of the project. His universe of instruments is closed and the rules of his game are always to make do with "whatever is at hand," that is to say with a set of tools and materials that is always finite and is also heterogeneous because what it contains bears no relation to the current project, or indeed to any particular project, but is the contingent result of all the occasions there have been to renew or enrich the stock or to maintain it with the remains of previous constructions or destructions. The set of the "bricoleur's" means cannot therefore be defined in terms of a project (which would presuppose besides, that, as in the case of the engineer, there were, at least in theory, as many sets of tools and materials or "instrumental sets," as there are different kinds of projects). It is to be defined only by its potential use or, putting this another way and in the language of the "bricoleur" himself, because the elements are collected or

retained on the principle that "they may always come in handy." Such elements are specialized up to a point, sufficiently for the "bricoleur" not to need the equipment and knowledge of all trades and professions, but not enough for each of them to have only one definite and determinate use. They each represent a set of actual and possible relations; they are "operators" but they can be used for any operations of the same type.

The elements of mythical thought similarly lie halfway between percepts and concepts. It would be impossible to separate percepts from the concrete situations in which they appeared, while recourse to concepts would require that thought could, at least provisionally, put its projects (to use Husserl's expression) "in brackets." Now, there is an intermediary between images and concepts, namely signs. For signs can always be defined in the way introduced by Saussure in the case of the particular category of linguistic signs, that is, as a link between images and concepts. In the union thus brought about, images and concepts play the part of the signifying and signified respectively.

Signs resemble images in being concrete entities but they resemble concepts in their powers of reference. Neither concepts nor signs relate exclusively to themselves; either may be substituted for something else. Concepts, however, have an unlimited capacity in this respect, while signs have not. The example of the "bricoleur" helps to bring out the differences and similarities. Consider him at work and excited by his project. His first practical step is retrospective. He has to turn back to an already existent set made up of tools and materials, to consider or reconsider what it contains and, finally and above all, to engage in a sort of dialogue with it and, before choosing between them, to index the possible answers that the whole set can offer to his problem. He interrogates all the heterogeneous objects of which his treasury[4] is composed to discover what each of them could "signify" and so contribute to the definition of a set which has yet to materialize but which will ultimately differ from the instrumental set only in the internal disposition of its parts. A particular cube of oak could be a wedge to make up for the inadequate length of a plank of pine or it could be a pedestal—which would allow the grain and polish of the

4 Cf. "Treasury of ideas" as Hubert and Mauss so aptly describe magic.

old wood to show to advantage. In one case it will serve as extension, in the other as material. But the possibilities always remain limited by the particular history of each piece and by those of its features which are already determined by the use for which it was originally intended or the modifications it has undergone for other purposes. The elements that the "bricoleur" collects and uses are "preconstrained" like the constitutive units of myth, the possible combinations of which are restricted by the fact that they are drawn from the language where they already possess a sense which sets a limit on their freedom of maneuver (Lévi-Strauss, 5, p. 35). And the decision as to what to put in each place also depends on the possibility of putting a different element there instead, so that each choice which is made will involve a complete reorganization of the structure, which will never be the same as one vaguely imagined nor as some other which might have been preferred to it.

The engineer no doubt also cross-examines his resources. The existence of an "interlocutor" is in his case due to the fact that his means, power, and knowledge are never unlimited and that in this negative form he meets resistance with which he has to come to terms. It might be said that the engineer questions the universe, while the "bricoleur" addresses himself to a collection of oddments left over from human endeavors, that is, only a subset of the culture. Again, Information Theory shows that it is possible, and often useful, to reduce the physicists' approaches to a sort of dialogue with nature. This would make the distinction we are trying to draw less clearcut. There remains however a difference even if one takes into account the fact that the scientist never carries on a dialogue with nature pure and simple but rather with a particular relationship between nature and culture definable in terms of his particular period and civilization and the material means at his disposal. He is no more able than the "bricoleur" to do whatever he wishes when he is presented with a given task. He too has to begin by making a catalogue of a previously determined set consisting of theoretical and practical knowledge, of technical means, which restrict the possible solutions.

The difference is therefore less absolute than it might appear. It remains a real one, however, in that the engineer is always

trying to make his way out of and go beyond the constraints imposed by a particular state of civilization while the "bricoleur" by inclination or necessity always remains within them. This is another way of saying that the engineer works by means of concepts and the "bricoleur" by means of signs. The sets that each employs are at different distances from the poles on the axis of opposition between nature and culture. One way indeed in which signs can be opposed to concepts is that whereas concepts aim to be wholly transparent with respect to reality, signs allow and even require the interposing and incorporation of a certain amount of human culture into reality. Signs, in Peirce's vigorous phrase "address somebody."

Both the scientist and "bricoleur" might therefore be said to be constantly on the lookout for "messages." Those which the "bricoleur" collects are, however, ones that have to some extent been transmitted in advance—like the commercial codes which are summaries of the past experience of the trade and so allow any new situation to be met economically, provided that it belongs to the same class as some earlier one. The scientist, on the other hand, whether he is an engineer or a physicist, is always on the lookout for *that other message* which might be wrested from an interlocutor in spite of his reticence in pronouncing on questions whose answers have not been rehearsed. Concepts thus appear like operators *opening up* the set being worked with and signification like the operator of its *reorganization,* which neither extends nor renews it and limits itself to obtaining the group of its transformations.

Images cannot be ideas but they can play the part of **signs** or, to be more precise, coexist with ideas in signs and, if ideas are not yet present, they can keep their future place open for them and make its contours apparent negatively. Images are fixed, linked in a single way to the mental act that accompanies them. Signs, and images which have acquired significance, may still lack comprehension; unlike concepts, they do not yet possess simultaneous and theoretically unlimited relations with other entities of the same kind. They are however already *permutable,* that is, capable of standing in successive relations with other entities—although with only a limited number and, as we have seen, only on the condition

that they always form a system in which an alteration that affects one element automatically affects all the others. On this plane logicians' "extension" and "intension" are not two distinct and complementary aspects but one and the same thing. One understands then how mythical thought can be capable of generalizing and so be scientific, even though it is still entangled in imagery. It too works by analogies and comparisons even though its creations, like those of the "bricoleur," always really consist of a new arrangement of elements, the nature of which is unaffected by whether they figure in the instrumental set or in the final arrangement (these being the same, apart from the internal disposition of their parts): "it would seem that mythological worlds have been built up, only to be shattered again, and that new worlds were built from the fragments" (Boas, *1*, p. 18). Penetrating as this comment is, it nevertheless fails to take into account that in the continual reconstruction from the same materials, it is always earlier ends that are called upon to play the part of means: the signified changes into the signifying and vice versa.

This formula, which could serve as a definition of "bricolage," explains how an implicit inventory or conception of the total means available must be made in the case of mythical thought also, so that a result can be defined which will always be a compromise between the structure of the instrumental set and that of the project. Once it materializes the project will therefore inevitably be at a remove from the initial aim (which was moreover a mere sketch), a phenomenon that the surrealists have felicitously called "objective hazard." Further, the "bricoleur" also, and indeed principally, derives his poetry from the fact that he does not confine himself to accomplishment and execution: he "speaks" not only *with* things, as we have already seen, but also through the medium of things, giving an account of his personality and life by the choices he makes between the limited possibilities. The "bricoleur" may not ever complete his purpose but he always puts something of himself into it.

Mythical thought appears to be an intellectual form of "bricolage" in this sense also. Science as a whole is based on the distinction between the contingent and the necessary, this being also what distinguishes event and structure. The qualities it

claimed at its outset as peculiarly scientific were precisely those which formed no part of living experience and remained outside and, as it were, unrelated to events. This is the significance of the notion of primary qualities. Now, the characteristic feature of mythical thought, as of "bricolage" on the practical plane, is that it builds up structured sets, not directly with other structured sets[5] but by using the remains and debris of events: in French "des bribes et des morceaux," or odds and ends in English, fossilized evidence of the history of an individual or a society. The relation between the diachronic and the synchronic is therefore in a sense reversed. Mythical thought, that "bricoleur," builds up structures by fitting together events, or rather the remains of events,[6] while science, "in operation" simply by virtue of coming into being, creates its means and results in the form of events, thanks to the structures which it is constantly elaborating and which are its hypotheses and theories. But it is important not to make the mistake of thinking that these are two stages or phases in the evolution of knowledge. Both approaches are equally valid. Physics and chemistry are already striving to become qualitative again, that is, to account also for secondary qualities which when they have been explained will in their turn become means of explanation. And biology may perhaps be marking time waiting for this before it can itself explain life. Mythical thought for its part is imprisoned in the events and experiences which it never tires of ordering and reordering in its search to find them a meaning. But it also acts as a liberator by its protest against the idea that anything can be meaningless with which science at first resigned itself to a compromise.

The problem of art has been touched on several times in the foregoing discussion, and it is worth showing briefly how, from this point of view, art lies halfway between scientific knowledge and mythical or magical thought. It is common knowledge that the

5 Mythical thought builds structured sets by means of a structured set, namely, language. But it is not at the structural level that it makes use of it: it builds ideological castles out of the debris of what was once a social discourse.

6 "Bricolage" also works with "secondary" qualities, i.e., "second hand."

artist is both something of a scientist and of a "bricoleur." By his craftsmanship he constructs a material object that is also an object of knowledge. We have already distinguished the scientist and the "bricoleur" by the inverse functions that they assign to events and structures as ends and means, the scientist creating events (changing the world) by means of structures and the "bricoleur" creating structures by means of events. This is imprecise in this crude form but our analysis makes it possible for us to refine it. Let us now look at this portrait of a woman by Clouet and consider the reason for the very profound aesthetic emotion that is, apparently inexplicably, aroused by the highly realistic, thread by thread, reproduction of a lace collar (Figure 1).

The choice of this example is not accidental. Clouet is known to have liked to paint at less than life-size. His paintings are therefore, like Japanese gardens, miniature vehicles and ships in bottles, what in the "bricoleur's" language are called "small-scale models" or "miniatures." Now, the question arises whether the small-scale model or miniature, which is also the "masterpiece" of the journeyman, may not in fact be the universal type of the work of art. All miniatures seem to have intrinsic aesthetic quality—and from what should they draw this constant virtue if not from the dimensions themselves?—and conversely the vast majority of works of art are small-scale. It might be thought that this characteristic is principally a matter of economy in materials and means, and one might appeal in support of this theory to works that are incontestably artistic but also on a grand scale. We have to be clear about definitions. The paintings of the Sistine Chapel are a small-scale model in spite of their imposing dimensions, since the theme that they depict is the End of Time. The same is true of the cosmic symbolism of religious monuments. Further, we may ask whether the aesthetic effect, say, of an equestrian statue which is larger than life derives from its enlargement of a man to the size of a rock or whether it is not rather due to the fact that it restores what is at first from a distance seen as a rock to the proportions of a man. Finally even "natural size" implies a reduction of scale since graphic or plastic transposition always involves giving up certain dimensions of the object: volume in painting, color, smell, tactile impressions in sculpture, and the temporal dimension in both

cases since the whole work represented is apprehended at a single moment in time.

What is the virtue of reduction either of scale or in the number of properties? It seems to result from a sort of reversal in the process of understanding. To understand a real object in its totality we always tend to work from its parts. The resistance it offers us is overcome by dividing it. Reduction in scale reverses this situation. Being smaller, the object as a whole seems less formidable. By being quantitatively diminished, it seems to us qualitatively simplified. More exactly, this quantitative transposition extends and diversifies our power over a homologue of the thing, and by means of it the latter can be grasped, assessed, and apprehended at a glance. A child's doll is no longer an enemy, a rival, or even an interlocutor. In it and through it a person is made into a subject. In the case of miniatures, in contrast to what happens when we try to understand an object or living creature of real dimensions, knowledge of the whole precedes knowledge of the parts. And even if this is an illusion, the point of the procedure is to create or sustain the illusion, which gratifies the intelligence and gives rise to a sense of pleasure which can already be called aesthetic on these grounds alone.

I have so far only considered matters of scale which, as we have just seen, imply a dialectical relation between size (i.e., quantity) and quality. But miniatures have a further feature. They are "man-made" and, what is more, made by hand. They are therefore not just projections or passive homologues of the object: they constitute a real experiment with it. Now the model being an artifact, it is possible to understand how it is made and this understanding of the method of construction adds a supplementary dimension. As we have already seen in the case of "bricolage," and the example of "styles" of painters shows that the same is true in art, there are several solutions to the same problem. The choice of one solution involves a modification of the result to which another solution would have led, and the observer is in effect presented with the general picture of these permutations at the same time as the particular solution offered. He is thereby transformed into an active participant without even being aware of it. Merely by contemplating it he is, as it were, put in possession of other pos-

Figure 1. François Clouet: *Portrait of Elizabeth of Austria.*

sible forms of the same work; and in a confused way, he feels himself to be their creator with more right than the creator himself because the latter abandoned them in excluding them from his creation. And these forms are so many further perspectives opening out on to the work which has been realized. In other words, the intrinsic value of a small-scale model is that it compensates for the renunciation of sensible dimensions by the acquisition of intelligible dimensions.

Let us now return to the lace collar in Clouet's picture. Everything that has been said applies in this case, for the procedure necessary to represent it as a projection, in a particular space, of properties whose sensible dimensions are fewer and smaller than that of the object is exactly the reverse of that which science would have employed had it proposed, in accordance with its function, to produce (instead of reproducing) not only a new,

instead of an already known, piece of lace but also real lace instead of a picture of lace. Science would have worked on the real scale but by means of inventing a loom, while art works on a diminished scale to produce an image homologous with the object. The former approach is of a metonymical order, it replaces one thing by another thing, an effect by its cause, while the latter is of a metaphorical order.

This is not all. For if it is true that the relation of priority between structure and event is exactly the opposite in science and "bricolage," then it is clear that art has an intermediate position from this point of view as well. Even if, as we have shown, the depiction of a lace collar in miniature demands an intimate knowledge of its morphology and technique of manufacture (and had it been a question of the representation of people or animals we should have said: of anatomy and physical attitudes), it is not just a diagram or blueprint. It manages to synthesize these intrinsic properties with properties which depend on a spatial and temporal context. The final product is the lace collar exactly as it is but so that at the same time its appearance is affected by the particular perspective. This accentuates some parts and conceals others, whose existence however still influences the rest through the contrast between its whiteness and the color of the other clothes, the reflection of the pearly neck it encircles and that of the sky on a particular day and at a particular time of day. The appearance of the lace collar is also affected by whether it indicates casual or formal dress, is worn, either new or previously used, either freshly ironed or creased, by an ordinary woman or a queen, whose physiognomy confirms, contradicts, or qualifies her status in a particular social class, society, part of the world, and period of history . . . The painter is always midway between design and anecdote, and his genius consists in uniting internal and external knowledge, a "being" and a "becoming," in producing with his brush an object which does not exist as such and which he is nevertheless able to create on his canvas. This is a nicely balanced synthesis of one or more artificial and natural structures and one or more natural and social events. The aesthetic emotion is the result of this union between the structural order and the

order of events, which is brought about within a thing created by man and so also in effect by the observer who discovers the possibility of such a union through the work of art.

Several points are suggested by this analysis. In the first place, the analysis helps us to see why we are inclined to think of myths both as systems of abstract relations and as objects of aesthetic contemplation. The creative act that gives rise to myths is in fact exactly the reverse of that which gives rise to works of art. In the case of works of art, the starting point is a set of one or more objects and one or more events that aesthetic creation unifies by revealing a common structure. Myths travel the same road but start from the other end. They use a structure to produce what is itself an object consisting of a set of events (for all myths tell a story). Art thus proceeds from a set (object + event) to the *discovery* of its structure. Myth starts from a structure by means of which it *constructs* a set (object + event).

The first point tempts one to generalize the theory. The second might seem to lead to a restriction of it. For we may ask whether it is in fact the case that works of art are always an integration of structure and event. This does not on the face of it seem to be true, for instance, of the cedarwood Tlingit club, used to kill fish, that I have in front of me on my bookshelf (Figure 2). The artist who carved it in the form of a sea monster intended the body of the implement to be fused with the body of the animal and the handle with its tail, and that the anatomical proportions, taken from a fabulous creature, should be such that the object could *be* the cruel animal slaying helpless victims, at the same time as an easily handled, balanced, and efficient fishing utensil. Everything about this implement—which is also a superb work of art—seems to be a matter of structure: its mythical symbolism as well as its practical function. More accurately, the object, its function, and its symbolism seem to be inextricably bound up with each other and to form a closed system in which there is no place for events. The monster's position, appearance, and expression owe nothing to the historical circumstances in which the artist saw it, in the flesh or in a dream, or conceived the idea of it. It is rather as if its immutable being were finally fixed in the wood whose fine grain allows the reproduction of all its aspects, and in the use for which its

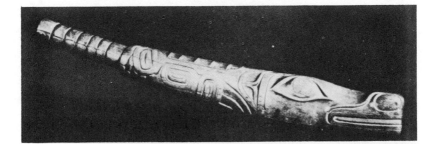

(*Top*) Figure 2. Club used for killing fish.
(*Above*) Figure 3. Detail of club.

empirical form seems to predetermine it. And all this applies
equally to the other products of primitive art: an African statue or
a Melanesian mask . . . So it looks as if we have defined only one
local and historical form of aesthetic creation and not its funda-
mental properties or those by means of which its intelligible rela-
tions with other forms of creation can be described.

We have only to widen our explanation to overcome this
difficulty. What, with reference to a picture of Clouet's, was provi-
sionally defined as an event or set of events now appears under a
broader heading: events in this sense are only one mode of the
contingent whose integration (perceived as necessary) into a
structure gives rise to the aesthetic emotion. This is so whatever

the type of art in question. Depending on the style, place, and period the contingent plays a part in three different ways or at three distinct points in artistic creation (or in all of them). It may play a part in the occasion for the work or in the execution of the work or in the purpose for which it is intended. It is only in the first case that it takes the form of an event properly speaking, that is, of contingency exterior and prior to the creative act. The artist perceives it from without as an attitude, an expression, a light effect, or a situation, whose sensible and intellectual relations to the structure of the object affected by these modalities he grasps and incorporates in his work. But the contingent can also play an intrinsic part in the course of execution itself, in the size or shape of the piece of wood the sculptor lays hands on, in the direction and quality of its grain, in the imperfections of his tools, in the resistance that his materials or project offer to the work in the course of its accomplishment, in the unforeseeable incidents arising during work. Finally, the contingent can be extrinsic as in the first case but posterior, instead of anterior, to the act of creation. This is the case whenever the work is destined for a specific end, since the artist will construct it with a view to its potential condition and successive uses in the future and so will put himself, consciously or unconsciously, in the place of the person for whose use it is intended.

The process of artistic creation therefore consists in trying to communicate (within the immutable framework of a mutual confrontation of structure and accident) either with the *model* or with the *materials* or with the future *user* as the case may be, according to which of these the artist particularly looks to for his directions while he is at work. Each case roughly corresponds to a readily identifiable form of art: the first to the plastic arts of the West, the second to so-called primitive or early art and the third to the applied arts. But it would be an oversimplification to take these identifications very strictly. All forms of art allow all three aspects and they are only distinguished from one another by the relative proportion of each. Even the most academic of painters comes up against problems of execution, for example. All the so-called primitive arts can be called applied in a double sense: first,

because many of their productions are technical objects and, second, because even those which seem most divorced from practical preoccupations have a definite purpose. Finally, as we know, implements lend themselves to disinterested contemplation even among ourselves.

With these reservations, it is easy to show that the three aspects are functionally related and that the predominance of any one of them leaves less or no place for the others. So-called professional painting is, or believes itself to be, quite free so far as both execution and purpose are concerned. Its best examples display a complete mastery of technical difficulties—which, indeed, can be considered to have been completely overcome since Van der Weyden; the problems which painters have set themselves since then amount to little more than a game of technical refinement. In the extreme case it is as though, given his canvas, paints, and brushes, the painter were able to do exactly what he pleased. On the other hand, he also tries to make his work into an object independent of anything contingent, of value in itself and for itself. This is indeed what the formula of the "easel picture" implies. Freed from the contingent both with regard to execution and purpose, professional painting can, then, bring it to bear upon the occasion of the work, and indeed if this account is correct it is bound to do so. Professional painting can therefore be defined as "genre" painting if the sense of this expression is considerably widened. For, from the very general viewpoint we are taking, the attempt of a portrait painter—even of a Rembrandt—to recapture on his canvas his model's most revealing expression or secret thoughts belongs to the same genre as that of a painter like Detaille, whose compositions reproduce the hour and order of battle and the number and disposition of the buttons distinguishing the uniforms of each arm. To use a disrespectful analogy, "opportunity makes the thief"[7] in either case. The relative proportions of the three aspects are reversed in the applied arts. In these, first place is given to purpose and execution, contingent factors playing an approximately equal part in each, in the examples we

7 In the original: "l'occasion fait le larron" (Trans. note).

consider the most "pure," at the same time the occasion of the work plays no part. This can be seen from the fact that a wine cup or goblet, a piece of basketwork or a fabric seems to us perfect when its practical value manifestly transcends time and corresponds wholly to its functions for men of different periods and civilizations. If the difficulties of execution are entirely mastered, as is the case when it is entrusted to machines, the purpose can become more and more precise and specific and applied art is transformed into industrial art. We call it peasant or folk art if the reverse is the case. Finally, primitive art is the opposite of professional or academic art. Professional or academic art internalizes execution (which it has, or believes itself to have, mastered) and purpose ("art for art's sake" being an end in itself). As a result, it is impelled to externalize the occasion (which it requires the model to provide) and the latter thus becomes a part of the signified. Primitive art, on the other hand, internalizes the occasion (since the supernatural beings which it delights in representing have a reality that is timeless and independent of circumstances) and it externalizes execution and purpose which thus become a part of the signifying.

On a different plane we therefore find once more this dialogue with the materials and means of execution by which we defined "bricolage." The essential problem for the philosophy of art is to know whether the artist regards them as interlocutors or not. No doubt they are always regarded as such, although least of all in art that is too professional and most of all in the raw or naïve art that verges on "bricolage," to the detriment of structure in both cases. No form of art is, however, worthy of the name if it allows itself to come entirely under the sway of extraneous contingencies, whether of occasion or purpose. If it did so it would rate as an icon supplementary to the model) or as an implement (complementary with the material worked). Even the most professional art succeeds in moving us only if it arrests in time this dissipation of the contingent in favor of the pretext and incorporates it in the work, thereby investing it with the dignity of being an object in its own right. Insofar as early art, primitive art and the "primitive" periods of professional painting are the only ones that do not date, they owe it to this dedication of the accidental to the service of

execution and so to the use, which they try to make complete, of the raw datum as the empirical material of something meaningful.[8]

It is necessary to add that the balance between structure and event, necessity and contingency, the internal and external is a precarious one. It is constantly threatened by forces that act in one direction or the other according to fluctuations in fashion, style, or general social conditions. From this point of view, it would seem that impressionism and cubism are not so much two successive stages in the development of painting as partners in the same enterprise, which, although not exact contemporaries, nevertheless collaborated by complementary distortions to prolong a mode of expression whose very existence, as we are better able to appreciate today, was seriously threatened. The intermittent fashion for "collages," originating when craftsmanship was dying, could not for its part be anything but the transposition of "bricolage" into the realms of contemplation. Finally, the stress on the event can also break away at certain times through greater emphasis either on transient social phenomena (as in the case of Greuze at the end of the eighteenth century or with socialist realism) or on transient natural, or even meteorological, phenomena (impressionism) at the expense of structure, "structure" here being understood as "structure of the same level," for the possibility of the structural aspect being reestablished elsewhere on a new plane is not ruled out.

[8] Pursuing this analysis, one might define nonrepresentational painting by two features. One, which it has in common with "easel" painting, consists in a total rejection of the contingency of purpose: the picture is not made for a particular use. The other feature characteristic of nonrepresentational painting is its methodical exploitation of the contingency of execution, which is claimed to afford the external pretext or occasion of the picture. Nonrepresentational painting adopts "styles" as "subjects." It claims to give a concrete representation of the formal conditions of all painting. Paradoxically the result is that nonrepresentational painting does not, as it thinks, create works that are as real as, if not more real than, the objects of the physical world, but rather realistic imitations of nonexistent models. It is a school of academic painting in which each artist strives to represent the manner in which he would execute his pictures if by chance he were to paint any.

The Value-Orientations Theory
of Artistic Style*

VYTAUTAS KAVOLIS

This essay is an attempt to formulate a theory of the linkage of values (social) and form (art styles) using three dimensions of value orientations: activity, relational, and time. Dr. Kavolis uses art-historical examples as illustrations and evidence in support of his thesis and incorporates the research of previous authors concerned with the cross-cultural analysis of art, particularly Wallace, Mills, Chipp, Barry, and Fischer.

Dr. Vytautas Kavolis is an Associate Professor of Sociology in the Department of Sociology at Dickinson College. Religion, sociology of art, and comparative social pathology are his fields of interest. He is the author of *Artistic Expression: A Sociological Analysis* (1968), and the coauthor and editor of *Comparative Perspectives on Social Problems* (1969), and of *Lietuviskasis Liberalizmas* (1959).

References to the effects of economic, social-structural and political conditions on artistic style are abundant (e.g., Tomars, 1940; Hauser, 1957, 1959; Fischer, 1961). Linkages between a variety of cultural conditions and art styles have also been traced (Dvorák, 1928; Sorokin, 1937; Mukerjee, 1951; Worringer, 1953). Some of these observations appear capable of being synthesized into a general anthropological theory of art style. The value-orientations schema (Kluckhohn and Strodtbeck, 1961) will be used as a basis for such theory.[1]

* Reprinted from *Anthropological Quarterly*, Vol. 38, No. 1 (January, 1965), pp. 1–19.

[1] "Value orientations are complex but definitely patterned (rank-ordered) principles, resulting from the transactional interplay of three analytically distinguishable elements of the evaluative process—the cognitive, the affective, and the directive elements—which give order and direction to the ever-flowing stream of human acts and thoughts as these relate to the solution of 'common human' problems" (Kluckhohn and Strodtbeck, 1961, p. 4).

"Visual schemas . . . contain the bases of the whole world picture of a people" (Woelfflin, n. d., pp. 13, 237). A "psychology . . . of the need for style," not yet written, "would be a history of the feeling about the world . . ." (Worringer, 1953, p. 13). As basic categories of organization of attitudes toward the world, the value orientations may be assumed to be linked, in some way, with distinguishable characteristics of artistic style.

The data available for an attempt to formulate a synthetic conception of the value-form linkages consist mainly of (1) experimental studies of the relationship between personality needs and form preferences; (2) correlations between data on the value orientations of individual artists and the distinctive characteristics of their style; and (3) comparative analyses of the dominant value orientations of sociohistorical units and of formal characteristics of their art.

The synthesis attempted here allows a tentative integration of data from art history as well as cultural anthropology with those of experimental psychology, within a coherent theoretical framework. Some speculative reinterpretation must be done to integrate materials from diverse disciplines, but such integration provides opportunities for cross-checking as well as differentiation or expansion of the scope of the findings, and the methodological risk of the possibility of some "fantasy production" seems worth the gain in theoretical substance, particularly since the latter is wholly amenable to further testing.

In the interest of brevity, and also because most adequate data are available in these areas, variations in art style will be related to only three out of the five dimensions of value orientation distinguished in the schema. Not much rigidly tested cross-cultural evidence is available to be cited in support of the theoretical framework to be developed. The hypotheses are therefore advanced as exploratory formulations. It is hoped, however, that this survey will facilitate work of increasing quantitative precision.

I. ACTIVITY ORIENTATION

The activity orientation defines the generalized directions of culturally valued action. The Doing alternative holds out the expectation that men will act purposively to change the environ-

ment in accordance with "standards conceived to be external to the acting individual"; the Being mode sanctions "spontaneous expression of what is conceived to be 'given' in the human personality"; and the Being-in-Becoming orientation demands that efforts be made to develop "the self as an integrated whole" (Kluckhohn and Strodtbeck, 1961, pp. 16–17).

It is initially hypothesized that each value orientation will be associated with form characteristics suggesting personality qualities (cf. Mills, 1957) which "feed into" the value orientation in question.[2] More specifically, it is expected that the Doing orientation will be associated with form characteristics suggestive of energetic action; the Being orientation, with forms suggesting low-pressure spontaneity; and the Being-in-Becoming orientation, with forms evocative of internal tension.

The available data bring out the hypothesized relationships in greater precision.

It may be assumed that the Doing orientation (as exhibited in fantasy productions or actual behavior) is closely related to what is measured by psychological tests as the need for achievement.[3] Aronson (1958, p. 252) reports high n Achievement to be linked with a "preponderance of single, unattached, discrete lines" in doodle drawings. Cardinet has found persons with "an assertive attitude in social relationships" to prefer "paintings with straight line strokes" (summarized in Frumkin, 1960, p. 108). In these experimental studies, the Doing orientation is associated with characteristics suggestive of purposive action. (Stressed *dividing* lines, however, appear to be indicative of a Lineal orientation. See Section II.)

A high n Achievement (see below) is associated with smaller margins at the bottom, more diagonal configurations, and more S shaped (two-directional, nonrepetitive) lines: "The drawings of the 'highs' suggest motion, are nonrepetitive, unrestricted in space

[2] Cardinet has observed in an experimental study that "people like in a picture the representation of situations or moods which correspond to their expressed tendencies . . ." (Frumkin, 1960, p. 108).

[3] Need for achievement is operationally defined as a characteristic of an individual's motivational system inferred from the relative frequency of achievement-related imagery in his fantasy productions. The concept can be applied to spontaneous as well as experimental productions of both individuals and groups.

. . ." (Aronson, 1958, p. 264). Similarly, Cardinet has observed the "liking for movement" to be correlated with "self-assertion and drive" (Frumkin, 1960). Forms suggestive of powerful motion may therefore be linked with the Doing orientation.

Some historical cases may be offered in support of the experimental findings. In much of traditional Japanese art, "we are aware of violent activity," whereas in traditional Chinese art "everything [is] in its place and nothing to excess" (Lee, 1962, p. 6). The value orientations presumably underlying this difference may help account for the rapidity with which Japan has applied modern technology. The diagonal design, which suggests motion also to art historians, is one of the characteristics distinguishing Baroque from High Renaissance art (Woelfflin, n. d.). One of the main centers of Baroque painting was the seventeenth-century Dutch culture; while its Puritan and commercial character must not be exaggerated, it seems reasonable to regard it as more Doing-oriented than the Italian culture around 1500, when the Renaissance was at its height. Lastly, the finding that in contemporary American art "a significant majority of the abstract paintings display a dynamic pattern" (Kolaja and Wilson, 1954, p. 250)[4] may be a reflection of the predominance of the Doing orientation in American culture.

The experimental data available do not entail a distinction between the Being and the Being-in-Becoming orientations. Persons with low n Achievement produce overlaid, fuzzy lines, larger margins at the bottom, fewer diagonal lines, and more multiwave (one-directional, repetitive) lines. Their drawings "seem to be immobile, restricted in space, and redundant in movement" (Aronson, 1958, p. 264). As a low n-Achievement, in the absence of a tradition of strong other-worldly asceticism, seems to imply an emphasis on Being values, I shall assume that, in this sample, a low n Achievement is indicative of the Being orientation.[5] On this

4 "By the dynamic pattern is meant any pattern which stimulates in the onlooker an idea of motion, action, conflict, disequilibrium, etc." This corresponds with Cardinet's (Frumkin, 1960), but not with Aronson's (1958) operational definition of dynamism.

5 In the n Achievement school, the tendency is to combine what we separate as the Being-in-Becoming and the Doing orientations. McClelland (1961, p. 49) contains "continued striving to improve one's self" with the

assumption, the Being orientation appears to be linked with style characteristics suggestive of restriction, immobility, and acceptance of monotony.

A cross-cultural test given to boys in Germany, Brazil, and Japan has revealed that "the Discrete-Fuzzy line count" is the best single index of n Achievement (McClelland, 1961, p. 308). In general, the cross-cultural validity of these indices appears to have been borne out.

It may be assumed that strongly religious periods, as the Romanesque or the Gothic, will emphasize the Being-in-Becoming values, while the relatively irreligious periods (the Rococo, Impressionism) will tend to minimize this orientation. A search for characteristics present in the first, and absent in the second type of periods suggests the double hypothesis that (a) heavy, thickset lines and (b) angular rigidity may be linked with the Being-in-Becoming orientation. These characteristics are generally prominent in Expressionist painting, which Tillich (1959) regards as imbued with a religious quality; they are common in some of the most intensely religious painters (El Greco, Rouault). "Elongated rigid . . . and often angular figures" have been described as characteristic of "the greatest religious sculpture" of China (Grousset, 1953, pp. 114, 116). Their equivalents can be found in the European Gothic. The decline in references to "impulse control" in the literature of Hellenistic as compared with Archaic Greece (McClelland, 1961, p. 123) is correlated with the disappearance of the early rigidity in Greek sculpture. Finally, on the basis of Wallace's (1950, p. 19) interpretation of the "tendency to outline form elements carefully in black" as indicative of "repression of aggression," we may at least hypothesize (c) that black outlining is related to the Being-in-Becoming orientation. In general, our very hypothetical materials indicate that the Being-in-Becoming orientation may be linked with style characteris-

struggle "to achieve" in one interpretive category. Our identification of low n Achievement with the Being orientation is thus "purer" than that of high n Achievement with the Doing orientation. Nevertheless, since few Americans are presumably committed primarily to Being-in-Becoming, the identification of high n Achievement with the Doing orientation appears tentatively justified.

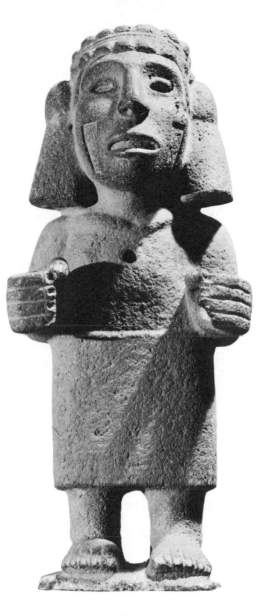

Statue of Chalchiuhtlicue, the Aztecan goddess of flowing water. Volcanic rock, coated with red ochre, the sacred color of the Aztecs. Albright-Knox Art Gallery, Buffalo, New York.

tics suggestive of internal restraints and repressed aggressiveness.
With respect to color, Knapp (1958) has reported that prefer-
ence for red is consistently associated with low n Achievement
while preference for blue is associated with high n Achievement,
and (1962) that time-driven persons prefer somber blue and green
designs, while brighter yellow and red designs are preferred by
individuals with reported ease in the management of time. The
Doing orientation appears to be linked with the "cold" colors
suggestive of the attitude of affective neutrality, and the Being
orientation is associated with the "warm" colors suggestive of
affective spontaneity.

There is some evidence of cross-cultural validity of this
interpretive scheme, particularly for the association between a
preference for green and high n Achievement (McClelland, 1961,
pp. 311–12) or the Doing orientation. A recent questionnaire study
has revealed the "gold and yellow" colors to be (verbally) preferred
in the Buddhist, and green in the Moslem countries of Asia
(Winick, 1963). However, green seems to have been most visible
in early (seventh and eighth century) Moslem art, of minor impor-
tance thereafter, and to have been almost completely displaced by
light-toned red and yellow in the period of decline of Moslem
culture, from the sixteenth to the eighteenth centuries (Etting-
hausen, 1962, pp. 18–27, 180–81).[6] This is to be expected if, in
contrast to the early Mohammedans, the contemporary "Arab is
primarily a person of words rather than actions" (Hamady, 1960,
p. 215). In general, "people in hotter climates dislike dark colors
and people in colder climates dislike lighter colors" (Winick, 1963,
p. 368). Content analysis of folk tales has revealed that the hot
climate peoples also tend to have lower n Achievement (McClel-
land, 1961, p. 384).

In the absence of tested data, it is hypothesized that the Being-
in-Becoming orientation may be associated with brown and gray
(or black) colors. When El Greco began painting "the spasms of
the life of the soul" (M. Barras), "he abandoned his warm, golden

[6] Verbal statements about color preferences are less significant than the
actual use of color, as clues to value orientations. The Moslem religious pref-
erence for green seems to have originated at a time when green was fre-
quently used in Arab art.

coloring . . . suppressed their blues, retaining only the yellow ochre, reddish brown tints, and especially the two fundamental colors of the old Byzantines, black and white" (Colombo and Diehl, n. d., pp. 45–46). In the transition from his sensual naturalistic style to the religiously inspired mannerism of his old age, Tintoretto also gave up his "golden" in favor of a "gray-green" palette (Dvořák, 1928, p. 268). The brown and gray colors are prominent in Romanesque art—more, I think, in Spain than in Italy—and in the painting of the Chinese gentlemen scholars, preoccupied with self-perfection through scholarship and contemplation (Cahill, 1960);[7] also in Rembrandt and the young Van Gogh.[8] The Impressionists, however, who were not much concerned with any but artistic virtues, tended to exclude precisely these colors (Serullaz, 1960). "In both North and South America, brown and gray colors are relatively unpopular. . . . People in Latin America seem to feel that brown and gray have a tendency to heighten muddiness and sallowness of the skin" (Winick, 1963, pp. 366–67), which may suggest an "anti-life" quality, the renunciation of the sensuous pleasures of Being.[9]

The interpretations presented in this section are summarized in Table 1. The attributes put down under "quality suggested" may be thought of, from one side, as *action dispositions* held by individuals with strong value orientations of a particular kind, and, from the other side, as *fantasy preoccupations* suggested (ideally, to psychological testers, but, in some cases, to me) by particular formal characteristics. The connecting nexus between value orien-

[7] Before the eleventh century, however, one finds in the Chinese painting (at that time still largely in the hands of professional craftsmen), a "blue-and-green" tradition, together with a clear line, frequently a diagonal structure, and, in the eighth century, even an "action-painting" school (Cahill, 1960, pp. 27–42).

[8] His early letters reveal a strong Being-in-Becoming orientation that later appears to have been transformed into an intense need for artistic Doing. In an early letter he expresses a strong dislike of green and blue, but later describes himself as "not afraid" of these colors (Stone, 1960, pp. 1, 160).

[9] The diagnostic validity of color analysis presupposes the recognition (and technical availability) in a particular cultural tradition of the main elements of the color spectrum, as defined in Western culture. This is, in other cultures, not always the case.

Table 1. Activity Orientations and Art Forms

Value Orientation	Quality Suggested	Form Characteristic
Doing	Purposiveness	Straight discrete lines
	Powerful (self-assertive) motion	Diagonal lines (and configurations)
	Variety-seeking	Nonrepetitive (S-shaped) lines
	Intolerance of unused resources	Small bottom margins
	Affective restraint	Green and blue colors (and somber tones)
Being	Tendency to "muddle along"	Overlaid, fuzzy lines
	"Undynamic" motion	Nondiagonal lines
	Contentment with sameness	Repetitive, multiwave lines
	Tolerance of unused resources	Larger bottom margins
	Affective spontaneity	Red and yellow colors (and bright tones)
Being-in-Becoming	Strong internal restraints	Heavy, thickset lines
	Internal tension	Angular rigidity
	Repressed aggression	Black outlining
	Alienation from "life"	Brown and gray (black) colors

tations and stylistic characteristics will be thought of as a "psychological congruence"—similarity in emotional quality—between particular action dispositions and particular fantasy preoccupations.

II. RELATIONAL ORIENTATION

The relational orientation provides culturally preferred models for man's behavior with regard to other men. In the Individualistic variant, stress is put on the autonomy of the personality. In the Lineal variant, the line of authority is empha-

sized. In the Collateral view, preferential value is given to the solidarity of equals.

We may expect to find Individualistic orientations associated with style characteristics suggesting freedom of action; Lineal values, with forms evocative of limitations imposed by powerful authority figures; and Collateral orientations, with suggestions of universal similarity. The available data allow more precise statements about the form characteristics that seem to be associated with relational orientations.

The specific styles linked with Individualism in the art-historical literature, such as impressionism or surrealism (Hauser, 1957, 1959; Gehlen, 1960), are generally characterized by "subjectivity," or the expression of perceptions tending to be private rather than universal.[10] This, together with Barry's observation (cited in Fischer, 1961) that pressures toward independence in child training are associated with complexity of art style, implies that the Individualistic orientation may be linked with both subjectivity and complexity (cf. Tomars, 1940, p. 189). These form characteristics are suggestive of the autonomy of the personality and of a high degree of differentiation of the social order. Expectably, subjectivity (though not complexity) in art is anathema in authoritarian political systems. It seems to be the former characteristic that is uniquely a projection of Individualistic values.

In the art-historical literature, political autocracy is frequently related to characteristics of style described as frontality,[11] formalism, and restraint, which may be conceptualized as a preference for rigidity (Hauser, 1957, 1959; Tomars, 1940). For example,

[10] Subjectivity in art was rejected by the early twentieth-century Russian painters with strongly Collateral views. Alexei Gan has proclaimed as the goal of Communist art "an object of only utilitarian significance [which] will be introduced in a form acceptable to all." It may be because the Collateral values of so many Russian painters that "there was extraordinarily little expressionist painting in Russia" (Gray, 1962, pp. 286, 182), in contrast to most Protestant countries.

[11] "By 'frontality' we mean that law governing the representation of the human figure . . . according to which, in whatever position the body is depicted, the whole chest surface is turned to the onlooker so that the upper part of the body is divisible by a vertical line into two equal halves" (Hauser, 1957, 1, pp. 40–41). It is characteristic of traditional, but not modern autocracies.

"Chinese painting, Persian painting, and Mogul painting were court art, dignified and restrained. . . ." (Mukerjee, 1951, p. 205). The same could be said, with even more justification, of Egyptian, Mesopotamian, and Byzantine art. The Mamlûk dynasties in Egypt and Syria—feudal organizations with elaborate hierarchy and a highly centralized state—had the "most rigidly composed art of the Islamic world," marked by "complex geometric configurations" and a preoccupation with "strict order and rigid formality" (Ettinghausen, 1962, p. 143). Upper-class art is generally complex, imperial art also "colossal" in scope (Tomars, 1940, pp. 171, 324). Lineal orientations appear to go with formal characteristics— rigidity, complexity, and large dimensions—that are suggestive of immovable monumentality, of the power of the ruling class in a highly differentiated society. However, since complexity is also associated with Individualistic art, the most characteristic artistic expressions of Lineal values seem to be formal rigidity and a monumental scale.

A more precise cross-cultural investigation (Fischer, 1961) has demonstrated that the art of hierarchic tribal societies is characterized by designs integrating a number of unlike elements (nonrepetitive complexity),[12] little irrelevant space, and enclosed figures.[13] Lineal orientations appear to be linked with art forms suggestive of a high degree of social differentiation, of tendencies toward total control of the sphere of action, and of clearly defined interpersonal barriers. These findings are both psychologically comprehensible and consistent with the art-historical observations cited before.

In relatively egalitarian tribal societies (Fischer, 1961), art has designs with repetition of simple elements (repetitive simplicity), large amounts of empty and irrelevant space, and figures without enclosures. In his reanalysis of Greek art, Tomars (1940) has associated strong communal feelings with tendencies toward

[12] If "complexity of design" is indicative of "creativity" (Wallace, 1950, p. 19), it might be worthwhile to explore the hypothesis that Lineal and Individualistic cultures will be more artistically creative than Collateral ones.

[13] The hypothesis that black outlining may be indicative of a Being-in-Becoming orientation raises questions about the relationship between Being-in-Becoming and Lineal orientations. Do strongly Lineal cultures generally tend to encourage the Being-in-Becoming as the morally preferable mode of activity?

idealized stereotyping rather than individualized (i.e., necessarily "subjective") representation. On the basis of such data, Collateral orientations may be tentatively associated with relatively "objective" art forms suggestive of the shared equality of mutually accessible "small men" and of tendencies toward incomplete control of the action sphere. In this case, my interpretation differs somewhat from Fischer's (1961), for whom empty space is suggestive of avoidance of contact with strangers and of sociogeographic isolation.

Fischer's (1961) findings on enclosures can be related to Woelfflin's (n. d., p. 19) art-historical observation that in the paintings of the High Renaissance "the masses appear with stressed . . . edges," whereas in the Baroque they tend to have "unstressed edges." Since this distinction is crucial for his concept of the linear-painterly polarity,[14] I hypothesize that the linear style, with its clearly drawn dividing lines, will tend to go with Lineal orientations, and the painterly style (vague, merging contours) will be linked with non-Lineal orientations (cf. Hauser, 1957, II, p. 200).[15] Thus, European Neolithic art would imply more Lineal values than those of Paleolithic hunters may have been (Hauser, 1957, I, p. 17). And if the painterly style is inherently "subjectively in attitude" (Woelfflin, n. d., p. 20), we should, assuming the linkage between subjective and Individualistic, expect it to be associated with Individualistic values. This tends to be the case in postclassical Greece. In the Chinese culture, in which a linear style derived from calligraphy generally dominated, more painterly styles were adopted by the "individualists" and the "eccentrics" (Cahill, 1960, pp. 169–94), and by the—presumably more individualistic—Ch'an Buddhist and Taoist rather than Confucian painters. The popularity of strongly linear woodcuts in Germany, particularly during the sixteenth and early twentieth centuries, and in Japan,

14 ". . . linear style sees in lines, painterly in masses. . . . In the one case, uniformly clear lines which separate; in the other, unstressed boundaries which favor combination" (Woelfflin, n. d., pp. 18–19).

15 While the rigid stratification in the social system of India would suggest dominance of Lineal values, the religious cave paintings of India, e.g., at Ajanta, are made in a painterly style. In this characteristic, the nonauthoritarian (i.e., non-Lineal) quality of Indian religions may be projected. Indian miniature painting, less influenced by religious feelings, is predominantly linear.

perhaps especially during the early part of the Tokugawa regime (Hillier, 1954), may be related to authoritarian tendencies in these cultures. Arab paintings (Ettinghausen, 1962) and the art of the ancient American civilizations (Kubler, 1962) also tend to be linear.

Cardinet's experimental finding that "the sociable personality rejected pictures with rigid form and order" (Frumkin, 1960, p. 108) implies that the rigidity preference is linked only with Lineal, but not with Collateral, values. Thus, painterly styles may be associated with a combination of strongly Collateral with weak Lineal values (as possibly in the Paleolithic), as well as with Individualistic orientations.

The data assembled and the interpretations advanced in this section are summarized in Table 2.

Table 2. Relational Orientations and Art Forms

Value Orientation	Quality Suggested	Form Characteristic
Individualistic	Autonomy of the personality	Subjectivity
	High degree of social differentiation	Complexity
	Indistinct social barriers	Painterly style
Lineal	Immovable monumentality of power	Rigidity, colossalism
	High degree of social differentiation	Complexity
	Tendencies toward total control	Little irrelevant space
	Clearly defined social barriers	Enclosed figures, linear style
Collateral	Shared equality of "small men"	Repetitive simplicity
	Tendencies toward incomplete control	Much irrelevant space
	Indistinct social barriers	Figures without enclosures

III. TIME ORIENTATION

Each of the three conventional divisions of the time con-
tinuum—Past, Present, Future—can receive preferential emphasis
in a cultural tradition.

In the absence of experimental or cross-culturally tested data,
I hypothesize that the time orientation will be projected in the
management of space in painting. (This would constitute a spon-
taneous artistic equivalent of the "time-space continuum" of mod-
ern physics.) It is assumed that the location of subject matter in
clearly depicted depth is evocative of a Past orientation—of events
that may have happened in the distant past but are still quite
relevant. This characteristic is common in the Chinese landscape,
where the human figure may come close to disappearing in the
distance.[16] In contrast, the Greeks, who were relatively uncon-
cerned with the past, "had no horizon or perspective, no sense of
space or depth" (Muller, 1960, p. 118). Similarly in the cave
painting of India. In ancient America, there is no depth in Aztec
art, but "suggestion of deep space" can be discerned in Maya
painting (Kubler, 1962, pp. 61, 166); it is the latter who have
been greatly concerned with keeping track of the passage of time.
In cultures in which the discovery of the depth dimension has not
been made, its absence cannot, of course, be used as unambiguous
evidence to infer a non-Past orientation.

The Present orientation may be considered to be psychologi-
cally congruent with the representation of events either (a) in
front of vaguely recognizable space, or (b) in a space without
perspective, as in Persian miniatures, where "the picture . . . is
organized in strips that indicate different areas of space" (Newton,
1960, p. 287), or in folk art with its "horizontal and vertical
arrangement of figures and flat perspective" (EWA, V, p. 464). In
(a), the magnitude of the event, in combination with the relative
insignificance of the background, suggests the superior importance
of the contemporary over what has gone on before. This is charac-

16 Lineal cultures should exaggerate the magnitude of the ruler's figure,
as in Assyrian art. The Past orientation of Chinese culture makes it fre-
quently disappear in the distance (cf. Cahill, 1960, p. 28).

teristic of the art of the High Renaissance and of most modern styles from Rococo to Impressionism. In (b), everything that is important is felt to have occurred in an extended present; there is no distinguishable past.

Finally, it may be assumed that the Future orientation is psychologically congruent with the abandonment of specifically recognizable space (either because the future is unknown, or time irrelevant). The abandonment of depiction of concrete space distinguished the Christian catacomb painting from its background of late Roman art (Dvorák, 1928). This characteristic was largely retained in the Romanesque frescoes.[17] It reappears in modern abstract painting, which is felt to be groping for future values (Sorokin, 1937). "Lack of background" is psychologically interpreted as indicative of "little need for relating self to objects" (Wallace, 1950, p. 18), which may be a prerequisite of a ruthless Future orientation. The absence of background, however, can be of clear diagnostic significance only when the representation of space had been previously known and abandoned.

The management of space may not be the only artistic correlate of the time orientation. McClelland (1961) summarizes evidence from Greek literature indicating a continual decline of the Future orientation from 900 to 100 B.C. The "archaic" roughness of early Greek sculpture is contemporaneous with the strongest Future orientation. Hauser (1957, 2, p. 96) finds "angular, hasty movements" to be indicative of a Future emphasis. One of the most radical innovators in Chinese painting, Kao Ch'i-p'ei, exhibits a "rough, imprecise lineament" (Cahill, 1960, p. 187), as well as abandoning clear background. "The deliberate 'rudeness' of Larionov's work of 1907–13 . . . was a general characteristic of the so-called Futurist movement in Russia . . . they blunted, coarsened, simplified, and made emphatic the vocabulary of their predecessors" (Gray, 1962, pp. 93, 99). "Primitivization" occurs with the breakdown of tradition (Gehlen, 1960, p. 146). The Future orientation appears to be linked with intentional formal

[17] "But about the year 1420, some change in the action of the human mind demanded . . . enclosed space" (Clark, 1961, p. 14). This may reflect the increasing importance, with the waning of the Middle Ages, of Present time orientation.

roughness, suggestive of an unfinished state, of seeking (as in twentieth-century expressionism).

In Greece, the elegance of the Hellenistic style may be associated with the Present orientation prevalent in this period (Tomars, 1940). The Persian artists' "animals are . . . more elegant than their Chinese prototypes" (Newton, 1960, p. 290). "Elegant roundness" is evocative of ritualistic enjoyment of the moment, as in the Rococo age (Hauser, 1957). In French Impressionism, "the predilection for the fugitive, the evanescent" (Serullaz, 1960, p. 7)— i.e., for the Present, coexists with a generally elegant treatment.

In search of the correlates of the Past orientation, I shall again turn to Chinese painting and offer the hypothesis that it may be associated with highly detailed precision in the pursuit of traditional goals. The strong emphasis on traditional patterns in Maori art is also associated with rigid precision (Chipp, 1960, pp. 64–65). In Arab cultures, art characterized by "minuteness and perfection of detail" is linked with a Past orientation (Hamady, 1960, pp. 210, 217).

The hypotheses of this section are summarized in Table 3.

Table 3. Time Orientations and Art Forms

Value Orientation	Quality Suggested	Form Characteristic
Past	Distant events still relevant	Location in clearly depicted depth
	Perfection in the pursuit of traditional goals	Detailed precision
Present	Superior importance of present over past	Location in front of vaguely recognizable space
	Only extended present real	Perspectiveless space
	Enjoyment of the moment	Rounded elegance
Future	Time irrelevant or future unknown	Abandonment of recognizable space
	Unfinished state	Formal roughness

IV. SOME THEORETICAL IMPLICATIONS

While for several of the form-value linkages hypothesized, there is as yet no adequate cross-cultural verification, certain theoretical implications of the approach here suggested already seem evident. If art forms and value orientations are linked by psychological congruence, the former may be construed as *subconscious images* of the latter; value orientations may constitute one of the main reference systems of art. This suggests that one of the crucial social functions of art may be the subconscious assertion of value orientations, by filling the visible world with shapes emotionally suggestive of the value orientations held. Whether this is merely pleasurable, when value orientations are internalized, or also useful, in transmitting and enforcing them, is at present speculative. In any case, the concept of psychological congruity would seem to provide a strategic tool for empirical investigation of the intracultural linkages that hold total cultural systems together.

Even though there may well be a considerable range of stylistic characteristics that are psychologically congruent with a given value orientation, it cannot be assumed a priori that the value orientations and the art styles of a sociohistorical unit will, at any given time, be mutually articulated. The failure of value-style articulation appears to be most likely in times of rapid change (or under conditions of institutionalized traditionalism in some, but not all, parts of a cultural whole).

A culture that does not evolve or borrow styles of art that are psychologically congruent with its major value orientations seems likely to produce an inferior artistic tradition. Like the nineteenth-century American society, it will not feel spontaneously at home with its art, and will probably be inhibited by this feeling in its artistic expression. However, art styles may also function as means of inducing a change in the established value orientations, and they may be successful or fail in this—intentional or unintentional—dynamic application. It is tempting to speculate that greatest art may be produced when art style is both a *reflection* of the value orientations institutionalized in a culture and a successful *means* of inducing a change within this pattern.

If the present theory is supported, in its general approach, by further research, the implications for art theory and practice could be considerable. It presents the goal of artistic creativity not as perpetuation of traditional patterns or formal innovation, but as the (not necessarily conscious) seeking of forms congruent with the changing value orientations of the individual and of his society (or of some subgroup within it). This orientation might eventually provide a natural check on the cultivated irrationality of certain tendencies in contemporary art. In focusing on the relationship between values and style, regardless of content, the present theory constitutes a justification of nonobjective (no less than representational) art as a potentially significant expression of the value orientations around which society must be organized.

V. METHODOLOGICAL COMMENTS

One of the basic assumptions of the value-orientations theory is that all possible orientations are present, but to varying degrees, in all societies at all times. Hence, any complex artistic tradition or personality is potentially capable of using all distinguishable elements of artistic style. Value orientations merely create tendencies to *favor* particular stylistic characteristics, which are combined with other tendencies—some of them apparently caused by sociological factors—to form a style. Since similar tendencies may appear in different sociocultural contexts, they will emerge in diverse stylistic configurations, so that no specific historical style can be considered as a "pure" and "complete" expression of a value orientation (or of any other sociocultural variable, such as social class).

Though the interpretations suggested have been supported to a large degree by strategic illustrations from the art history of several of the major civilizations, the generalizations advanced are phrased in terms sufficiently general to generate hypotheses for cross-cultural research on varying levels of socioeconomic development. In such testing, assumptions of the present theory should be adjusted to the limiting condition that certain characteristics of styles (e.g., the depth dimension or a particular color) do not exist as technically realizable alternatives in some cultural traditions. In

such cases, it is not possible, without independent sources of information, to infer with any degree of certainty that the value orientations presumably linked with the "missing" traits are also absent. Conversely, "the reliance on certain universal materials . . . induces certain universal or widespread solutions; a human figure executed within a basket design is inevitably composed by using triangles, rectangles, straight or diagonal lines" (EWA, 5, p. 476). In this type of case, analytical inferences have to be made holding techniques as constant as possible (though the preference for a particular technique may in itself be significant as a clue to value orientations).[18]

The spontaneous expression of value orientations in artistic style is likely to be circumscribed (i.e., forced into some conventional idiom) by the artistic traditions institutionalized in a culture, which may reflect a historically prior value-orientations profile. It seems possible that, for this or other reasons, different cultures may prefer alternative ways of expressing similar value orientations in artistic style (cf. Aronson, 1958).

Bibliography

Aronson, Elliot. "The Need for Achievement as Measured by Graphic Expression," *Motives in Fantasy, Action, and Society*, John W. Atkinson, ed. Princeton, N.J.: Van Nostrand Co., 1958.

Cahill, James. *Chinese Painting*. Geneva: Skira, 1960.

Chipp, Herschel B. "Formal and Symbolic Factors in the Art Styles of Primitive Cultures," *The Journal of Aesthetics and Art Criticism*, 19 (1960), pp. 153–66.

Clark, Kenneth. *Landscape into Art*. Boston: Beacon Press, 1961.

Diehl, Gaston, and Colombo, Alfredo. *Treasures of World Painting*. Tudor Publishing Company, n. d.

Dvořák, Max. *Kunstgeschichte als Geistesgeschichte: Studien zur abendländischen Kunstentwicklung*. München: R. Piper & Co., 1928.

EWA, *Encyclopedia of World Art*. Vol. V. New York: McGraw-Hill Book Company, 1961.

Ettinghausen, Richard. *Arab Painting*. Geneva: Skira, 1962.

[18] Thus, "woodcut cultures" might be expected to have more Lineal, and "watercolor cultures" more Individualistic values. In certain historical periods, Germany may profitably be compared with England in these terms.

Fischer, J. L. "Art Styles as Cultural Cognitive Maps," *American Anthropologist,* 63 (1961), pp. 79–93.

Frumkin, R. M. "Some Factors in Painting Preferences Among College Students: An Empirical Study in the Sociology of Art," *Journal of Human Relations,* Autumn issue (1960), pp. 107–20.

Gehlen, Arnold. *Zeit-bilder: Zur Soziologie und Aesthetik der modernen Malerei.* Frankfurt am Main: Athenaeum Verlag, 1960.

Gray Camilla. *The Great Experiment: Russian Art 1863–1922.* New York: Harry N. Abrams, 1962.

Grousset, Rene. *The Rise and Splendour of the Chinese Empire.* Berkeley and Los Angeles: University of California Press, 1953.

Hamady, Sania. *Temperament and Character of the Arabs.* New York: Twayne Publishers, 1960.

Hauser, Arnold. *The Social History of Art.* New York: Vintage Books, 1957.

——. *The Philosophy of Art History.* New York: Knopf, 1959.

Hillier, J. *Japanese Masters of the Colour Print: A Great Heritage of Oriental Art.* London: Phaidon, 1954.

Kluckhohn, Florence Rockwood and Strodtbeck, Fred L. *Variations in Value Orientations.* Evanston: Row, Peterson, and Company, 1961.

Knapp, Robert H. "*n* Achievement and Aesthetic Preference," *Motives in Fantasy, Action, and Society.* ed. John W. Atkinson. Princeton, N.J.: Van Nostrand Co., 1958.

——. "Attitudes Toward Time and Aesthetic Choice," *The Journal of Social Psychology,* 56 (1962), pp. 79–87.

Kolaja, Jiri and Wilson, Robert N. "The Theme of Social Isolation in American Painting and Poetry," *The Journal of Aesthetics and Art Criticism,* 13 (1954), pp. 37–45.

Kubler, George. *The Art and Architecture of Ancient America: The Mexican/ Maya/ and Andean Peoples.* Baltimore, Md.: Penguin Books, 1962.

Lee, Sherman E. "Contrasts in Chinese and Japanese Art," *The Journal of Aesthetics and Art Criticism,* 21 (1962), pp. 3–12.

McClelland, David C. *The Achieving Society.* Princeton, N.J.: D. Van Nostrand Co., Inc., 1961.

Mills, George. "Art: The Introduction to Qualitative Anthropology," *The Journal of Aesthetics and Art Criticism,* 16 (1957), pp. 1–17.

Mukerjee, Radhakamal. *The Social Functions of Art.* Bombay: Hind Kittabs Ltd., 1951.

Muller, Herbert J. *The Uses of the Past: Profiles of Former Societies.* New York: The New American Library of World Literature, 1960.

Newton, Eric. *The Arts of Man: An Anthology and Interpretation of Great Works of Art.* Greenwich, Conn.: New York Graphic Society, 1960.

Serullaz, Maurice. *French Painting, the Impressionist Painters.* New York: Universe Books, Inc., 1960.

Sorokin, Pitirim A. *Social and Cultural Dynamics.* New York: American Book Company, 1937.

Stone, Irving and Jean (eds.). *Dear Theo: The Autobiography of Vincent Van Gogh*. New York: Grove Press, 1960.

Tillich, Paul. *Theology of Culture*. New York: Oxford University Press, 1959.

Tomars, Adolph Siegfried. *Introduction to the Sociology of Art*. Mexico City, 1940.

Wallace, Anthony F. C. "A Possible Technique for Recognizing Psychological Characteristics of the Ancient Maya from an Analysis of Their Art," *The American Imago*, 7, 3 (1950), pp. 239–58.

Winick, Charles. "Taboo and Disapproved Colors and Symbols in Various Foreign Countries," *The Journal of Social Psychology*, 59 (1963), pp. 361–68.

Woelfflin, Heinrich. *Principles of Art History. The Problem of the Development of Style in Later Art*. Dover Publications, n.d.

Worringer, Wilhelm. *Abstraction and Empathy: A Contribution to the Psychology of Style*. New York: International Universities Press, 1953.

BaKwele and
American Aesthetic Evaluations Compared*

IRVIN L. CHILD and LEON SIROTO

Very few transcultural empirical studies of aesthetics have been made to see if "there are univeral standards of aesthetic quality." In the test discussed in this article, photographs of BaKwele masks were judged by art experts in New Haven and subsequently by BaKwele carvers, and the aesthetic evaluations of both groups were recorded and compared. The amount of agreement between the two groups is surprising but consistent with the idea of universal standards of aesthetic quality. The concurrence of opinion in this sample recommends that the method be used for other similar cross-cultural studies of art.

Dr. Irvin L. Child is Professor of Psychology at Yale University. His special interests are personality and aesthetic judgment and preference. He is the coauthor of "A Cross-cultural Study of Drinking" (*Quarterly Journal Studies Alcohol,* 1965) and of "Some Trans-cultural Comparisons of Esthetic Judgment *(Journal of Social Psychology,* 1968), and the author of "Personality Correlates of Esthetic Judgment in College Students" (*Journal of Personality,* 1933).

Leon Siroto is a curator of African art at the Field Museum of Natural History in Chicago. A recent article by him entitled "The Face of the Bwiti" appeared in *African Arts* (Spring, 1968).

In matters of value, the hard-won knowledge of cultural relativity contributed by anthropologists to mankind has helped shatter the ethnocentric absolutism of Western thought. But what should replace the earlier belief in absolute universals of value? One possibility is a complete cultural and personal relativity of

* Reprinted from *Ethnology,* Vol. 4, No. 4 (October, 1965), pp. 349–60. The field study on which this article is based was made under a Ford Foundation Foreign Area Training Fellowship. However, the conclusions, opinions, and other statements in this article are those of the authors and not those of the Ford Foundation. The analysis of the data was done under Cooperative Contract No. 1748, U.S. Office of Education.

values, and many people today probably believe they are in tune with the wisdom of anthropologists in taking that position. But clearly this opinion does not prevail among anthropologists. In a discussion of ethical relativity, for example, Kluckhohn (1955) regards both extreme relativism and extreme absolutism as untenable.

The reasons with which Kluckhohn supports his rejection of complete ethical relativism seem in part to be applicable, with appropriate modifications, to aesthetic relativism as well. Some anthropologists have made quite explicit their doubt or rejection of complete aesthetic relativism. Firth (1951, p. 161), for example, in an extended discussion, which takes account of the facts of cultural variation as seen by the field worker, rejects the extreme position outright in saying, "I believe that there are universal standards of aesthetic quality, just as there are universal standards of technical efficiency." Linton (1954, p. 166), while taking no explicit position, implies at least a hunch that aesthetic relativity is likely to be found untenable:

> Whether there is some denominator common to all the expressions of a single type is one of the most important problems confronting the student of aesthetics. It is obvious that appreciation of any particular art form is to some degree a result of learning and habituation. Thus, to a European, most African art is repulsive at first contact. It is only after he has become accustomed to the medium that he can appreciate its qualities and derive esthetic satisfaction from it. The real problem is whether behind such diverse objects as a Poro mask, the Venus de Milo, and a Peruvian jar there are common factors of form, dynamic interrelation of parts, harmony of color, and so forth, which may appear in different combinations but are responsible for the esthetic effect. It seems that we have here an area in which modern psychological techniques could be brought to bear on a problem which philosophers have discussed for centuries without coming to agreement.

The appeal for empirical evidence on the question of aesthetic relativity has been answered by actual research to an astonish-

ingly small degree. One of the first to use quantitative methods in transcultural investigation of aesthetic values was an anthropologist, Robert Lowie (1921). Aware of psychological research demonstrating some tendency in Western subjects to make and to prefer rectangles shaped approximately in accordance with the golden proportion, Lowie studied the distribution of rectangle shapes in the decorative art of a particular North American Indian tribe, and reported with interest their failure to conform to this proportion. His report is an extremely valuable beginning, for which Lowie claimed no more. That it was not followed up may be traced to the defects of its background in experimental psychology, where the variables then selected for study were probably too simple to get near the heart of aesthetic value. More recently, psychological aesthetics has shifted attention to more complex variables and to actual works of art as well as to elements used in the arts. In line with this shift, actual works of art (or reproductions of them) have been used in the other two quantitative investigations known to us. Both were concerned with the question of transcultural agreement in the order of preference for a set of works of visual art. In one of these studies, Lawlor (1955) compared the preferential ratings of a few West African decorative designs by West Africans and by Europeans. In another, McElroy (1952) compared preference ratings of a variety of visual materials by Australian Aborigines and by students at the University of Sydney. In neither of these studies was any evidence found of transcultural agreement.

Each of these studies has a serious defect: the people whose judgments were used were not selected for interest in art but rather were representative in this respect of the community as a whole. There seems no reason to believe that aesthetic values would be shared by all members of the average community; in a study of college students, Child (1962) learned that preferences according with traditional aesthetic values are clearly not those of the average student. In this respect aesthetic values may well differ from moral values. Moral values have to do with the evaluation of alternative resolutions of conflicts experienced by everyone, and thus have a necessary relevance to everyone's life. Aesthetic values have to do with the evaluation of stimuli with respect to

their adequacy for satisfying a kind of interest that most individuals seem to have the option of pursuing or not pursuing; in this sense, they seem to lack any compelling relevance to every individual's life. It is possible that aesthetic evaluations may be made by or known to only some people in each society, and yet that agreement will be found between such people in various societies.

Accordingly, we need to ask whether people interested in art within one cultural tradition will have any tendency to make preferential judgments that will agree with those made by people interested in art within another cultural tradition. In the attempt to do this it seems important to use kinds of work that can readily be regarded appreciatively in both societies. Experts in our society are now so used to looking at art from a variety of cultures that they can so regard any visual art. To people in a simpler society who are interested in art, however, art from outside their own cultural tradition might be so novel that they would be unable to consider it appreciatively. One possible approach, therefore, is to obtain preferential reactions to artworks of another society from people in that society interested in those works and then compare their reactions with those given to the same works by art experts in our society. We report here what is, so far as we know, the first study of this sort ever done. It was made possible by a field trip one of us (Siroto) made, devoted primarily to studying the function of masks in BaKwele culture.

The BaKwele are a Bantu-speaking people living in the heavily forested basins of the Dja and Ivindo Rivers in the Republic of the Congo (Brazzaville) and the Gabon in western equatorial Africa. At the time when masks were used, the BaKwele were swidden cultivators who moved their settlements about often and erratically. Numerous patriclans formed large villages which were partly fortified. BaKwele religion was expressed primarily in witchcraft beliefs and in several more or less communal rites of intensification which, incidentally, decided or validated the social status of the patriclans. Numerous masks were used in a major ritual complex performed on irregular occasions, on the average perhaps every other year; a few masks were occasionally used in other ways. European contact with the BaKwele began only at the very end of the last century and eventually, probably during the

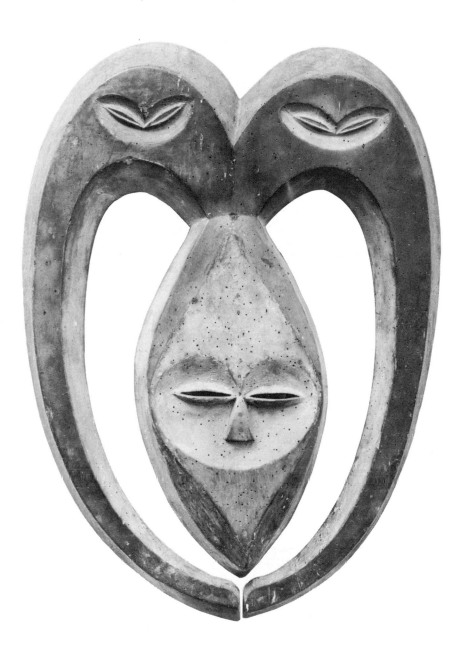

BaKwele mask from the upper Sangha area of the Congo (Brazzaville). Wood with white, rust, and umber paint. 20 3/4″ high.

1920's, led to abandonment of the rituals in which the masks were used. Some carvers have continued to make masks, however, at the request of administrators and for local use on public occasions— for entertainment rather than ritual. The younger generation have French as a second language and are commonly literate in it. Acculturation has been rapid and apparently welcomed, at least during the last few decades, but there is little sign of interest in European art. There seems no reason to believe BaKwele evaluations of their own masks would have been influenced by contact with European traditions.

The field worker took with him photographs of all the masks known to him, from publications and from museum and private collections, which might be presumed to have been made by the BaKwele or by neighboring peoples. The photographs were thirty-nine in number and were of uniform size—5 inches by 7 inches— but unfortunately not of uniform quality; some were made from published illustrations of good quality or photographs made under good conditions, but some were from poor published illustrations or from snapshots made under unfavorable conditions, and one was a photograph of a drawing.

The thirty-nine masks, as represented in the photographs, were judged for their aesthetic value—i.e., for how good they were as works of art—by thirteen experts (advanced art students and others able to make such judgments) in New Haven, Connecticut. As nearly as BaKwele language and general culture permitted, the field worker tried to obtain judgments by similar criteria from individual BaKwele; there was a difference, as will be seen.

FIELD PROCEDURE

The photographs were used as a point of entry into the ethnological study of masks. For this reason as well as for the present purposes, elders were sought as subjects. The making of masks had been confined to men, and their traditional use had been practiced only by men now well over fifty; consequently women were not interviewed, and emphasis was placed on interviewing older men.

At strategic times the thirty-nine photographs were set out in

random order on a large table or a mat on the ground. The field worker used an interpreter with whom he spoke in French. The interpreter was requested to ask the subject to choose the masks that he found "les plus beaux" or "qu'il aime plus que les autres." The terms used by the interpreter in carrying out this instruction referred to goodness in general or to beauty as it applies to persons. The BaKwele constructions for "well-made" or "well-carved" were not used in posing questions but were sometimes used by the interviewees in their comments on the masks.

The subject was asked to choose from the thirty-nine the four masks he considered to be the best. After they had been chosen, he was asked to choose four more, and then to continue choosing in this manner until the last photograph had been judged. Four of the subjects were not willing to continue all the way through, and the photographs they left at the end were all given an identical score based on the average of all the categories not used. One of these four had also selected in groups of eight rather than four, and a similar procedure of giving tied scores was followed.

The conditions under which data were gathered were in several respects unfavorable for the purposes of the study. For one thing, the circumstances were often hectic. The subject was often surrounded by all members, human and animal, of his hamlet. Children would seize photos from the table and attempt to carry them off. Women would pick up the photos they preferred and hand them to the subject for his approval. Such attempts to influence the subject were inevitable and sometimes intensive, but the field worker's position as guest of the settlement precluded any remonstrances which might have been effective. Attempts to conduct the test in seclusion seemed to make for awkwardness, as it forced upon the men the disagreeable task of having to keep their women and children out of the house in which the test was given; such attempts were therefore abandoned. In any event, the sixteen different subjects were from different hamlets, and in only two instances was one of them present when another was making his judgments; in each of these the former had made his judgments previously.

The physical arrangements themselves were less than satisfactory. Presenting so many photographs at one time made for

dubious care in inspecting the entire field and also made the prints more likely to be blown by the wind or to appear in widely varying illumination.

Because photographs rather than actual masks were used, the judgments cannot be confidently asserted to be equivalent to those that would have been made of the masks themselves. To be sure, this is true of the New Haven experts as well. But the New Haveners are at least used to seeing both an object and a photographic representation of it, so their imagination may generally carry them fairly well from the latter to the former. This is much less true for the BaKwele subjects, particularly since they were mostly older men who had been less exposed to the printed page and accompanying illustrations than had younger members of the group. In particular, some photographs in which strong shadows were apparent were subject to misinterpretation, for the shadows might be thought to be a part of the mask by a person not used to interpreting photographs as representations of three-dimensional objects.

RESULTS

The ratings made of each photograph by each of the sixteen BaKwele are presented in Table 1, each judge being identified by a number, age, and one of three categories of relation to masks. First come four judges who were carvers. (Two of these, Nos. 3 and 4, were old-time mask carvers. No. 2 was a carpenter who carved masks in the traditional style for the field worker. No. 1 has produced ivory carvings—not masks—for sale to administrators, missionaries, and businessmen.) Then come four judges who as cult leaders had used masks in the traditional manner. Finally appear eight other BaKwele interested in or knowledgeable about masks. An entry of 9 means that the judge placed a photograph in the topmost of ten possible groups of four as being one of the four best in his estimation. An entry of 0 means that he placed a photograph among the four poorest. In this table the thirty-nine photographs have been arranged in descending order of their evaluation by the New Haven experts. It is immediately apparent that there is some tendency for the BaKwele judges to agree with the New Haven

judges, as high ratings are more frequent in the upper part of the table. But we need to measure the degree to which agreement is present and the confidence that may be placed in the evidence of agreement. For these purposes certain standard statistical procedures have been followed.

First, to measure the evaluation of the photographs by the consensus of any particular group of subjects, factor analysis has been employed. For example, correlation coefficients were obtained to express the degree of similarity between the ratings of each possible pair out of the thirteen New Haven judges. A factor analysis was performed to determine the extent to which each of the New Haven judges expressed a tendency shared by their group as a whole, retaining only the single first factor which would represent this consensus, and then factor scores were calculated for each of the thirty-nine photographs to express their standing in relation to this factor. These factor scores represent the average rating given to a photograph by the thirteen New Haven judges when each one's ratings are weighted in proportion to the extent to which his judgments correlate with the general consensus of the thirteen. Identical procedures were followed for the four BaKwele who were themselves carvers, for the four BaKwele who were cult leaders, and for the eight other BaKwele considered together as a single group. The evaluations that result for each photograph are also presented in Table 1.

The factor scores representing evaluations by the thirteen New Haven experts are the point of reference for the calculations which then followed. To determine how closely the consensus of the BaKwele carvers agreed with the New Haven consensus, for example, the factor scores for the consensus of the four carvers were correlated with the factor scores for the New Haven experts. The same procedure was followed for each of the other groupings of BaKwele judges. Also, the evaluations by each individual BaKwele judge were similarly correlated with the consensus of New Haven evaluations. Results for all thirty-nine photographs together are presented in the first three columns of Table 2. For each of the groupings of BaKwele judges, the evidence of tendency to agree with the New Haven judges is significant at the one percent level (that is, so great an appearance of agreement, in the

Table 1. Thirty-nine Mask Photograph

Source[*]	Id. No.	Ambig.	Foreign	Play	Fierce	Carvers 1	2	3	4	5
Plass, 1956, No. 24–A	11			×		7	8	5	7	6
Fagg, 1953, No. 104, Pl. xxxiv	3	×		×		8	5	6	1	7
Plass, 1956, No. 24–D	29			×		4	6	1	4	1
Kamer & Kamer, 1957, No. 193	32			×		9	7	9	3	8
Segy, 1952, Fig. 184	14			×		9	9	8	8	9
Clouzot & Level, 1925–26, Pl. vii	38				×	3	6	1	4	4
Mus. Prim. Art (N.Y.), 1961, No. 70	13					7	9	7	9	8
	20			×		7	8	9	9	9
Pepper, 1958, p. 36	35				×	5	2	1	7	5
Eth. Mus. (Gothenburg), p. 5, upper R	28	×		×		6	2	8	5	6
Sweeney, 1935, No. 414	2			×		5	2	9	9	6
Olbrechts & Claerhout, 1956, No. 183	34				×	5	2	4	4	7
Mus. Prim. Art (N.Y.) 1961, No. 71A	33				×	5	2	1	0	2
Eth. Mus. (Gothenburg), p. 7	25	×	×	×		1	7	1	2	4
	31	×		×		4	2	3	5	1
Eth. Mus. (Gothenburg), p. 5, upper L	27	×		×		6	8	8	9	9
	7			×		9	9	7	8	8
Eth. Mus. (Gothenburg), p. 8, L	24			×		7	6	5	6	5
	26				×	2	2	1	1	3
	8			×		3	5	3	5	5
	5					6	7	5	6	6
Kjellberg, 1957, p. 164	19			×		9	8	9	8	9
Mus. Prim. Art (N.Y.), 1961, No. 71	36			×		8	2	6	3	0
	18	×			×	3	2	1	0	0
Ass. Pop. Amis. Mus., 1948, Fig. 32, p. 59	17					0	2	1	3	0
Clouzot & Level, 1925–26, Pl. xxi	4					3	2	1	3	2
	1			×		8	7	5	8	8
	21			×		1	5	4	2	3
	15	×				4	5	7	2	4
Eth. Mus. (Gothenburg), p. 5, lower L	10			×		6	9	8	7	7
Eth. Mus. (Gothenburg), p. 4	9	×	×			4	2	1	0	4
Cunard, 1934, p. 713	22				×	1	2	4	0	1
Eth. Mus. (Gothenburg), p. 5, lower R	6	×	×			2	2	7	5	2
Eth. Mus. (Gothenburg), p. 8, R	23				×	2	2	1	2	3
	39	×				1	2	6	7	7
Burssens, 1960, Fig. 7	37	×				2	2	1	4	1
O'Reilly's (N.Y.), 1953, No. 129	16				×	0	2	1	1	2
Cottes, 1911, Pl. xxxiii	12	×	×			0	2	1	1	3
	30			×		8	2	1	6	5

[*] Masks for which no source is given are in public or private collections and have not, to our knowledge, been pictured in publications.

entification, Ratings, and Factor Scores

Ratings by BaKwele											Factor scores representing evaluation by consensus of				
Cult leaders				Others							Carvers	Cult leaders	Other BaKwele	All 16 BaKwele	N.H. experts
6	7	8	9	10	11	12	13	14	15	16					
8	9	8	5	6	9	3.5	7	5	6	2.5	1.0	1.7	.4	.9	1.7
3.5	3.5	2	7	6	7	3.5	3	4	7	2.5	.2	− .3	.2	.1	1.7
3.5	3.5	6	3	4	3	3.5	6	2	5	2.5	− .3	− .6	− .4	− .5	1.6
8	3.5	7	8	9	8	3.5	7	4	5	6.5	1.1	1.0	.8	1.0	1.4
9	8	8	9	9	9	9	9	9	9	6.5	1.7	2.1	2.0	2.0	1.3
3.5	7	4	4	2	4	3.5	0	2	4	2.5	− .4	.1	− .9	− .6	1.3
8	9	8	9	8	8	8	9	8	8	8.5	1.5	2.0	1.8	1.8	1.2
9	9	9	9	9	9	9	9	8	9	6.5	1.6	2.3	2.0	2.0	1.1
3.5	3.5	0	4	2	1	3.5	0	3	1	8.5	− .3	− .8	− .9	− .7	.9
3.5	3.5	1	7	7	4	3.5	4	6	7	2.5	.3	− .6	.2	.1	.9
3.5	8	9	5	3	7	9	8	9	6	8.5	.7	1.0	1.2	1.0	.7
3.5	3.5	3	4	2	2	3.5	1	1	4	8.5	− .3	− .2	− .7	− .5	.7
3.5	3.5	2	4	1	6	3.5	4	1	4	2.5	−1.0	− .9	− .6	− .9	.4
3.5	3.5	4	1	3	0	3.5	1	8	1	2.5	− .7	− .5	−1.0	− .8	.3
3.5	3.5	4	5	4	5	3.5	4	3	1	6.5	− .4	− .8	− .3	.5	.2
9	3.5	7	9	7	9	8	8	6	9	8.5	1.4	1.3	1.7	1.6	.2
3.5	9	8	8	8	8	3.5	8	9	8	8.5	1.6	1.3	1.4	1.5	.2
3.5	3.5	9	3	6	6	3.5	7	5	8	6.5	.7	.2	.5	.5	.1
3.5	3.5	2	3	1	0	3.5	1	1	1	2.5	−1.2	− .8	−1.4	−1.3	.1
3.5	3.5	5	2	4	1	3.5	6	7	1	2.5	− .2	− .2	− .6	− .4	.1
3.5	3.5	5	8	7	8	3.5	5	2	6	2.5	.7	− .1	.3	.3	− .1
8	3.5	2	8	9	7	8	7	6	7	2.5	1.7	.6	1.1	1.2	− .1
3.5	3.5	1	6	5	7	3.5	3	5	5	6.5	.1	−1.3	.2	− .2	− .2
3.5	3.5	1	0	0	3	3.5	0	0	4	2.5	−1.2	−1.3	−1.4	−1.4	− .2
0.5	2.5	7	0	3	6	3.5	5	6	1	6.5	− .9	− .6	− .4	− .7	− .4
3.5	3.5	6	5	5	0	2.5	3	1	3	2.5	− .9	− .5	− .8	− .8	− .5
3.5	8	9	6	8	5	7	9	9	8	8.5	1.1	1.3	1.4	1.3	− .7
3.5	3.5	5	2	4	1	3.5	5	7	3	2.5	− .6	− .5	− .5	− .6	− .7
3.5	3.5	3	6	5	5	3.5	2	3	1	2.5	.0	− .6	− .6	− .4	− .8
3.5	8	7	0	8	3	9	8	7	6	8.5	1.3	.9	.9	1.1	− .8
3.5	3.5	0	6	6	6	3.5	5	0	1	2.5	−1.1	− .9	− .4	− .8	− .9
3.5	3.5	0	7	2	2	3.5	2	2	3	2.5	−1.2	−1.3	− .8	−1.1	−1.0
3.5	3.5	6	1	5	4	3.5	6	7	5	6.5	− .2	− .5	.1	− .1	−1.0
3.5	3.5	5	3	1	4	3.5	2	4	1	2.5	−1.1	− .5	−1.0	− .9	−1.0
9	3.5	6	1	3	5	8	3	8	9	2.5	− .2	.9	.3	.3	−1.0
3.5	3.5	4	2	1	2	3.5	4	4	7	2.5	− .9	− .8	− .6	− .8	−1.2
3.5	3.5	3	1	0	2	3.5	1	5	1	2.5	−1.5	− .8	−1.3	−1.3	−1.7
3.5	3.5	3	2	0	−1	3.5	2	0	1	2.5	−1.5	− .7	−1.6	−1.4	−1.8
3.5	3.5	1	7	7	3	3.5	6	3	3	2.5	− .1	− .7	− .1	− .2	−2.1

Table 2. BaKwele Evaluations of Mask Photographs:
Resemblance to Evaluations by Art Experts in New Haven, Connecticut
(Each entry is a correlation coefficient expressing the degree to which a
given set of BaKwele evaluations resembles the New Haven evaluations.)

Photographs remaining after 8 poor ones removed

BaKwele Judges	All 39 Photographs	All 31 Remaining Photographs	All 27 Remaining Photographs	16 Play Masks	8 Fierce Masks
			Photographs remaining after 4 more of doubtful origin were removed		
Consensus of					
a) 4 Carvers	.48**	.50**	.43*	.48*	.85**
b) 4 Cult leaders	.44**	.51**	.51**	.55*	.54
c) 8 Others	.38**	.42**	.34*	.45*	.37
d) All 16 judges	.44**	.48**	.42*	.50*	.76*
Individual judges with ages					
Carvers					
1. 35–38	.49**	.46**	.34*	.31	.80**
2. 40	.46**	.50**	.44*	.48*	.52
3. 65	.33*	.34*	.33*	.44*	−.05
4. 65	.30*	.39*	.36*	.29	.62
Cult leaders					
5. 55–60	.39**	.37*	.35*	.23	.64*
6. 55	.36*	.43**	.53**	.60*	—
7. 65	.38**	.45**	.40*	.34	.52
8. 55–60	.28*	.39*	.37*	.57*	−.08
Others					
9. 17–18	.40**	.39*	.31	.34	.25
10. 42	.32*	.33*	.21	.28	.68*
11. 23	.47**	.52**	.46**	.68**	.09
12. 65	.15	.18	.19	.15	—
13. 50	.22	.31*	.23	.45*	.30
14. 65–70	.14	.13	.06	.25	−.64
15. 45–50	.36*	.35*	.42*	.48*	.51
16. 50	.25	.36*	.26	.14	.48

° Probability of so large a positive correlation with true correlation zero, < .05
°° Probability of so large a positive correlation with true correlation zero, < .01

absence of true agreement, could arise by chance less than one percent of the time). The evidence of tendency to agree with the New Haven judges is significant at least at the five percent level for each individual carver and each individual cult leader, and also for four of the eight other BaKwele.

When eight photographs which posed ambiguities for inexperienced viewers (mostly because of shadows that might be confused with the masks) are removed, the results for the thirty-one remaining are more striking still, as may be seen in the second column of Table 2. The correlations with the New Haven judgments are somewhat larger, and there are now only two of the sixteen BaKwele judges for whom the evidence of agreement with New Haven judges fails to be significant at least at the five percent level.

Of these thirty-one remaining photographs, four are among those stated by BaKwele judges to be foreign (in addition to those foreign masks which were among the eight offering photographic difficulty). The evidence of agreement with the New Haven judges, for the twenty-seven photographs that remain after removal of those four, is less decisive although still strong, as shown in the third column of Table 2. Among these twenty-seven BaKwele masks there are sixteen "play" or "entertainer" masks. These were used in dancing which heightened and sustained ceremonial occasions, and to them the BaKwele would apply words that might be translated by "beautiful" or "good" but that would denote power, protection, and opposition to evil. Another eight of the masks were of a type considered to be fierce and fearsome, used occasionally to terrorize the village. Results calculated separately for masks of each of these two types are presented in the last two columns of Table 2. Although the results are again less decisive than for the entire thirty-nine photographs, there is still very convincing evidence of a tendency toward agreement with the New Haven judges despite the small number of masks that now remain.

In the statements of statistical significance mentioned thus far and noted in Table 2, the particular group of judges is taken as a given, and the question is what generalization can be made about how these judges would theoretically have responded to an infinitely large population of masks. But suppose we instead take a set

of masks as given and ask with what confidence one can general-
ize to the population of people of whom our judges are representa-
tive. In this event a very decisive answer is given by the nearly
uniform positive direction of the correlations presented in Table 2.
Only when the number of masks is reduced to eight—the fierce
masks dealt with in the last column of the table—is there ever a
negative correlation. In every other instance the direction of corre-
lation indicates some tendency for agreement rather than dis-
agreement with the New Haven consensus. The probability that
this unanimity of direction could have arisen by chance is, for the
four carvers or four cult leaders separately, $1/16$; for the carvers
and cult leaders together, $1/256$. Finally, for all sixteen judges
together the probability of their independently yeilding positive
rather than negative correlations by chance is something less than
one in 32,000.

We have thus far stressed the overwhelming evidence of a
tendency toward transcultural agreement because we think this is
the aspect of the results that will be surprising to many people.
Careful inspection of the data in Table 1, however, will indicate
that an equally striking result is confirmation of the fact that the
BaKwele also have evaluative standards not shared with New
Haven experts. Photographs fourteen and twenty, for example,
stand out as instances of remarkably close agreement among the
sixteen BaKwele judges in placing the photographs at or near the
top of the list, a position higher than they reach in the consensus
of the New Haven judges. The photographs that are second and
third in the New Haven consensus, on the other hand, are not
given the maximum rating of 9 by a single one of the sixteen
BaKwele judges. Very clearly there are determiners of agreement
among the BaKwele that have nothing to do with the criteria
underlying the consensus of the New Haven experts.

This fact may be represented in summary by asking how well
the consensus of one subgroup of the BaKwele judges agrees with
the consensus of another in comparison with the extent to which it
agrees with the consensus of New Haven judges. If there were no
special tendency for the BaKwele to agree with each other, one
would expect the correlations among subgroups to be lower than

the correlations between each subgroup and the New Haveners, since the consensus of the New Haveners is based on a larger number of subjects and is therefore a more stable ordering. The facts are quite the other way. For all thirty-nine masks considered together the consensus of the four carvers has a correlation of .84 with the consensus of cult leaders and of .93 with the consensus of eight other BaKwele, while the latter two have a correlation of .86 with each other; all these are much higher than the correlation between any one of these consensi and that of the New Haven experts, presented in Table 2.

The same kind of result is obtained with each of the smaller groupings of masks reported in Table 2 with the sole exception of the fierce masks; in that instance the consensus of the carvers has a correlation of .59 with that of the cult leaders and .52 with that of the other BaKwele, and the latter two groups have a correlation with each other of only .10, whereas the correlations of subgroups with the New Haven consensus reach as high as .85. Since there were only eight masks of this kind, it is impossible to be sure whether we have here an instance where there is no special cultural consensus, or whether sampling error is responsible. The customary use of this type of mask is such, however, as to favor the supposition that there may be a genuine lack of agreement because of the intrusion of other sources of evaluation. An attitude of fear and therefore dislike might well characterize those people whose experience had been that of being inconvenienced or harmed by the use of such masks, whereas those who controlled the masks or were their primary users might well have a positive feeling because of the power associated for them with such masks.

DISCUSSION

Why do the New Haven experts and the BaKwele judges show some agreement in their evaluations of BaKwele masks? Perhaps because the masks do really vary one from another in general suitability for arousing and sustaining interest in anyone who enjoys visual art, and both sets of judges are sensitive to this variation. We find this interpretation plausible in the light of our

own view of the masks: the ones rated high by both New Haveners and BaKwele do indeed seem unusually beautiful, and more interesting with repeated looking; we feel the same way about some of the masks with lower ratings, but not about all of them. To say what it is in the masks that leads us to react this way would not be easy. The history of aesthetic theory suggests that the relevant characteristics of the masks are many and complex.

But is such an interpretation necessarily called for? Perhaps the agreement between New Haveners and BaKwele has a much more superficial origin. Perhaps it is based entirely on some fairly simple and obvious characteristics of the masks. We have looked at the photographs with this question in mind and can see simple characteristics that may play some part. Two of the masks (Nos. 12 and 16) rated very low by both groups appear in very poor reproductions, enlargements from half-tone illustrations with conspicuous grain; this inadequacy of reproduction is shared by only one of all the other photographs (No. 17). This poor quality as photograph may well have rendered more extreme an evaluation which would in any event have been low for Nos. 12 and 16 in view of the nature of the masks themselves. Another characteristic which may have influenced both sets of judges is the quality of workmanship; careful smoothing is apparent more frequently, for example, in masks rated high. Here, too, this is not likely to have been the sole basis of judgment. Carefully finished pieces that rank high seem to have other more complex aesthetic attributes as well. And there are exceptions; for example, No. 37, ranked very low by both groups, seems to have been carefully finished (although subsequently damaged). Our inclination is to feel that simple featues such as these are not the sole basis for agreement, but the information provided by this one study is not sufficient to settle the question.

Another possibility, of course, is that European influence is after all a probable explanation for the agreement, despite our judgment to the contrary. This explanation might be supported by the fact that the few younger BaKwele judges, as may be seen in Table 2, on the average have closer agreement with the New Haven experts than do the older BaKwele judges. Such a relation to age, if it may be inferred from so few cases, may, however, have

quite a different meaning; younger men who seemed interested enough in masks to be chosen as judges may be more likely to have an aesthetic interest, since so many of the earlier reasons for interest in masks have disappeared. Here, too, the information provided by this one study cannot be decisive.

Inspection of the masks may also provide clues about how the standards of the two sets of judges differ from one another. Of the four masks which show the greatest tendency to be rated higher by New Haven experts than by BaKwele, two are perhaps in poor condition (No. 29 with kaolin adhering only in patches and No. 26 with tusks missing where the BaKwele would expect them), and two are of the fierce type (Nos. 26 and 38). One (No. 3) is an ambiguous photograph both because of shadows and because the mask is in a slanting position. These characteristics of mask or photograph are all somewhat more frequent here than among the rest. A reasonable explanation is that the New Haven judges are more used to admiring damaged works of art, less repelled by (partly because not knowing about) fearsome qualities or associations, and better able to interpret correctly ambiguous photographs. On the other hand, all four masks which show the greatest tendency to be rated higher by the BaKwele than by the New Haveners (Nos. 1, 10, 27, and 30) are somewhat deviant from, while still within, BaKwele tradition. This is true of only a few of the other masks, and it may be that BaKwele are attracted by such deviance, whereas the New Haveners could probably in no case have been aware of it. These four masks also share the characteristic of having some very salient feature—either horns, wings, or pronounced light-dark contrasts. This is true of more than half of the other masks, too, but it seems possible that the attention of the BaKwele judges, in view of their lack of experience in dealing with photographs, was especially readily caught by such salient features.

Consistencies of preference, more or less distinctive to a society, are obviously to be expected. The method used here could be of value to field workers who wish to identify clearly the preferences characteristic of the community they are studying, in order to relate those preferences to other aspects of the culture. Preference judgments on the same materials need to be obtained

in two or more different groups, however, before one can even begin to have a satisfactory basis for judging in what respects the preferences are distinctive to one group and in what respects they are shared by different groups.

SUMMARY

Photographs of BaKwele masks were judged for aesthetic merit by art experts in New Haven, Connecticut. During a field trip to the Republic of the Congo (Brazzaville), judgments of these same photographs were obtained from sixteen BaKwele men interested in or knowledgeable about their masks. The consensus of the sixteen BaKwele and of subgroups of them, and most of the sixteen individuals, showed significant agreement with the consensus of New Haven experts. The finding of some transcultural agreement cannot be interpreted confidently from this one study alone; it is consistent, however, with the notion that the aesthetic appeal of a work of art to an art-involved viewer is partly a function of universals of human nature, and it should encourage further transcultural comparison of evaluative responses to art. The BaKwele also showed agreement among themselves on other bases than those shared with the New Haveners.

Bibliography

Association Populaire des Amis des Musées (Paris). *Le Musée Vivant,* Numéro Spécial, 1948.

Burssens, H. "Enkele Zanda-Masker uit Uele," *Congo Tervuren,* 6, No. 4 (1960).

Child, I. L. "Personal Preferences as an Expression of Aesthetic Sensitivity," *Journal of Personality,* 30 (1962), pp. 496–512.

Clouzot, H., and Level, A. *Sculptures africaines et océaniennes.* Paris, 1925–26.

Cottes, A. *La Mission Cottes au Sud-Cameroun.* Paris, 1911.

Cunard, N. *Negro Anthology 1931–1933.* London, 1934.

Ethnographic Museum (Gothenburg). Årstryck, 1955–56.

Fagg, W. B. *The Webster Plass Collection of African Art.* London, 1953.

Firth, R. *Elements of Social Organization.* New York, 1951.

Kamer, H., and Kamer, H. *Arts d'Afrique et d'Océanie.* Cannes, 1957.

Kjellberg, S. T. *Masker ur Benkt-Åke Benktssons Samling.* Kulturens Årsbok, 1957. Pp. 157–84.

Kluckhohn, C. "Ethical Relativity: *Sic et Non,*" *Journal of Philosophy,* 52 (1955), pp. 663–77.

Lawlor, M. "Cultural Influences on Preferences for Designs," *Journal of Abnormal and Social Psychology,* 61 (1955), pp. 690–92.

Linton, R. "The Problem of Universal Values. Method and Perspective," *Anthropology.* ed. R. F. Spencer. Minneapolis, 1954. Pp. 145–68.

Lowie, R. "A Note on Aesthetics," *American Anthropologist,* 33 (1921), pp. 170–74.

McElroy, W. A. "Aesthetic Appreciation in Aborigines of Arnhem Land: A Comparative Experimental Study," *Oceania,* 23 (1952), pp. 81–94.

Museum of Primitive Art (New York). *Traditional Art of the African Nations,* 1961.

Olbrechts, F. M., and Claerhout, A. G. *Het Masker.* Antwerp, 1956. (Catalogue of an exhibition at the Royal Museum of Fine Arts, Antwerp, Sept. 16–Nov. 15, 1956.)

O'Reilly's Plaza Art Galleries (New York). 1953. Catalogue 3432, sec. 3.

Pepper, H. *Anthologie de la vie africaine* (booklet accompanying record album of same name). Paris, 1958.

Plass, M. *African Tribal Sculpture.* Philadelphia, 1956.

Segy, L. *African Sculpture Speaks.* New York, 1952.

Sweeney, J. J. *African Negro Art.* New York, 1935.

Art and Environment in the Sepik*

ANTHONY FORGE

The art of the Iatmül and the Abelam, two tribes from the Sepik River area of New Guinea, is analyzed as expression of these cultures and as direct visual communication independent of myth. The statements made by the art objects, architecture, painting, and sculpture, are relevant and essential to the social structure, although their creators or viewers may not be entirely conscious of them. Dr. Forge also advances the thesis that "apparently disparate objects may serve similar symbolic functions," and that the differences can be attributed to different environments and economics.

Anthony Forge is a Lecturer in Social Anthropology at the London School of Economics, University of London. He has done field work in New Guinea and Indonesia and his special interests are art, symbolism, social structure, and their relationship. He wrote *Three Regions of Melanesian Art; New Guinea and the New Hebrides* (1960) and is the coeditor of *Primitive Art and Society* (not yet published).

The Sepik River basin has long been recognized as an area producing some of the finest art in the primitive world.[1] Since the big German collections formed before World War I, it has been realized that the various tribes in the area, although differing in the

* The Curl Lecture, 1965. Reprinted from *Proceedings of the Royal Anthropological Institute of Great Britain and Ireland*, 1965, pp. 23–31.

[1] The material discussed here was gathered in two trips 1958–59 and 1962–63. The author gratefully acknowledges the scholarship from the Emslic Horniman Anthropological Scholarship Fund of the Royal Anthropological Institute, and the Fellowship from the Bollingen Foundation, New York, which enabled him to make these trips. He is also greatly indebted to Professor Alfred Bühler whose generosity in 1959 enabled him to visit many Sepik cultures he would otherwise have missed, and to the Wenner-Gren Foundation for Anthropological Research for assistance between the two trips.

individual styles of their art, had many stylistic features in common. In short, the Sepik as a whole is a genuine stylistic area and pieces from it are easily recognizable as such.[2] These common features have been the focus of much speculation about the derivations of the styles and their possible connection with other cultures outside New Guinea.

The interest aroused by these similarities has not been limited to ethnologists. For instance, one of the features of Sepik art, very commonly discussed, is the frequency of long noses; noses with extensions ending in animal heads, or human faces with noses like bird beaks. A favored suggestion is that these derive from representations of Ganesa, the elephant-headed son of Siva and Parvati and the Hindu god of wisdom. An alternative theory was advanced to me by a group of Iatmül in Kararau, who had found a picture of Thoth the ibis-headed Egyptian god of wisdom—used as a trade mark by an Australian book distributing firm—on the back of a mission school book. This, and the accompanying advertisement, they had copied out and showed to me as conclusive proof that the whites had also sprung from totemic ancestors. My translation of the text, which was irrelevant to the origin of man and the nature of the cosmos, convinced them that I, like the other whites, was determined to deceive them, to deny our common origins, and continue the pretense that whites were a different sort of being from blacks.

In this lecture, however, I shall not be concerned with any possible stylistic links outside the Sepik area, nor shall I be concerned with any questions about the aesthetic merits of particular pieces or styles within the area. My interest will be: How far is the art of the Sepik a means of communication, and if it is what sort of communication does it make? By what means can we find out what it communicates? Underlying these questions is the bigger one: How far does the art form a system *sui generis* or, in other words, to what extent can we take carvings and paintings as things in their own right relating to each other and the beholder, and not as mere manifestations of some other order of cultural fact such as mythology or religion? Does the plastic art of a group have its own

[2] See Wirz (1959). Bühler discusses the Sepik stylistic area and its subdivisions in Bühler (1960) and in Bühler, Barrow, and Mountford (1962).

rules, not just of style, but also of meaning and interpretation, or is its apparent unity illusory being based only on style, while "meaning" can only be discovered by relating each individual piece to a rite in which it has a function, a myth that it illustrates, or a decorative purpose it fulfils?

I shall consider these questions with material from two closely related Sepik tribes, living in strongly contrasted environment, the Iatmül and the Abelam, drawing most of my detailed material from the latter with whom I have had much more field experience.

But before proceeding it is necessary to delimit briefly the aspects of the cultures I shall be considering, as well as the groups from which the material is drawn.

If we are to consider a system of visual communication, it obviously cannot be restricted to carvings and paintings but must include all visual symbols; architecture, gesture, and dance are obvious examples.

For instance, in the course of an Abelam debate, a man jumps to his feet and, holding his arms out from his sides, turns slowly around to face all the participants in turn, glaring ferociously at them, and then sits down. There is no difficulty about this gesture, he is being his totemic bird defending its young from an aggressor, that is, he is expressing unqualified support for his sister's children in the debate. Such a gesture is a message immediately understood by all, and easily accessible to the ethnographer. When, however, it is the significance of the form of the ceremonial house, or the reasons for including certain animals or birds in the carvings of the clan spirits, then the answers to questions are always in the form: "It is the way to do it," or "This is the way our ancestors did it," or "This is the powerful (supernatural) way to do it." Similar questions among the Iatmül elicit similar answers but often with the addition of a myth, one of whose characters is said to be represented in the object in question. Both the gesture and the ceremonial house can be regarded as visual communication. But it is in the ceremonial house, the carvings of the important clan spirits, and the decorations and face painting of rituals and displays that communication, reinforced by aesthetic appreciation appears to be most intense: while it is in these areas that the

"meaning" is most obscure, and I shall be concentrating on these phenomena in this lecture.

The relation of art to myth is a much discussed question. In Arnhem Land, for example, art, myth, and ritual appear to be completely interlocked and interdependent; but it seems unlikely that one is justified in taking myth to be primary and the art to be just an expression of it. It seems rather as if they were all three different ways of expressing aspects of the same thing in words, in action, and visually, none of them being complete without the other, and none of them being the entire expression on its own. There is nothing like this integration among the Iatmül. Although there are specific pieces illustrating specific myths—a mask at Timbunke village of a grotesque face eating a child refers to a myth about cannibalism—such pieces are not, on the whole, the important ones. The main *sacra* of an Iatmül clan, carved figures, large hooks, flute heads, and masks, rarely incorporate references to a specific myth, and although they frequently do have animal totems of their clan, these totems are not personages from myths but attributes of the clan. Furthermore, Iatmül totems are not necessarily specific; for instance, all clans have a crocodile totem, all have a fish eagle totem, and most a pig totem, all commonly represented in the art. There is no visual distinction between the crocodile of clan A and the crocodile of clan B except their names; in this case it is the names that are specific to the clan rather than the natural species itself. In fact, important Iatmül figures and masks tend to be very similar, and such diacritical features as they show are usually connected with clan totems, which do not figure in the myth that is associated with the name given the figure by the owning clan.

With the Abelam the case is much simpler since there is hardly any mythology at all, and none connected in any way with the most important figures, those of the clan spirits *ŋgwalndu*. Such myths as are known seem mainly to be borrowed from the Arapesh to the north and are regarded merely as amusing tales. Of the three myths that can be found (with variations) throughout most of the Abelam area, two are concerned with the origins of long yams and the *wapinyan* (long yam spirits), and the third is about a primal female who created fire. None of these are ever

referred to in connection with the art. Although carvings of *wapinyan* are important in long yam cultivation, there is no myth explaining how each clan acquired its particular named *wapinyan* or indeed how the original single *wapinyan* of the myth came to produce so many present *wapinyan*.

This great shortage of myth and lack of regard for, and knowledge of, such myths as they have is so unusual that it is particularly useful that Phyllis Kaberry, who lived among the Abelam about two years after government control was established, similarly found almost no mythology.

I shall, then, be considering Iatmül and Abelam art, not as illustrations of myths or as myths expressed visually, but as expressions of the culture that produced them, and as expressions related directly to the culture, not through the intermediate stage of myth.

I have chosen these two groups because they seem to me to present an excellent opportunity to compare two cultures that are extremely similar in language, social structure, the importance they attach to art and ceremonial, and yet have totally different economies and modes of livelihood based on their respective environments: the Iatmül, the huge Sepik river with its floods, fens, and swamps; the Abelam, the steep ridges and fertile earth of the foothills of the P. Alexander Mountains. The outward forms of their art and architecture are very different, and yet it seems possible that the processes by which their systems of visual symbols have been formed are similar. The selections made from nature—their environment—to be visual symbols in their culture—their art—are made on the same principles and for the same purposes, the obvious disparity between the results is primarily due to the differences in their environments, that is, the raw material available for symbolism.

The Iatmül live on the banks of the middle Sepik and in lagoons connected to it; they are primarily dependent on fish and sago for their livelihood. At present they number about 8,000. Immediately to the north lives a closely related group known as the Tshuosh, living from five to fifteen miles from the river but not subject to its flooding; they also rely mainly on fish and sago. Their culture and art are generally similar to that of their nearest Iatmül

neighbors, while their language is really a dialect of Iatmül. Although the Iatmül speak of them as a group, they vary in culture and social structure, any Tshuosh village having more in common with its Iatmül neighbors than with Tshuosh villages further away. To the north of the Tshuosh lie about thirty miles of grass plains, flat, virtually sterile land covered by high, tough grass (mainly *imperator*), intersected by small watercourses on whose banks the sparse population make their small gardens. As the plains give way to the foothills of the P. Alexander Mountains the grass is replaced by bush, mainly secondary growth, with a few stands of virgin tropical rain forest. The Abelam who live on the ridges of these foothills number over 30,000 and the population density is high, averaging over 100 per square mile overall, but rising to 400 per square mile in some parts of the Wosera.

There can be little doubt about the relationship between the Iatmül and the Abelam. The whole *Ndu* linguistic family[3] to which they belong would seem to be intrusive, viewed in the context of all the Sepik cultures. It seems certain that the Abelam have moved up from the river into the P. Alexander Mountains pushing the Arapesh and other groups back, some of them right over the mountains and down to the coast.[4] The grass plains themselves that separate the Iatmül and Abelam are apparently man-made rather than natural. Robbins (1961) suggests that groups practicing slash and burn garden culture would quickly exhaust soils of the type found on the plains and move on until, in the more fertile foothills, they achieved something approaching a balance with their physical environment. This hypothesis, based entirely on botanical and ecological studies, fits perfectly with the ethnological and linguistic data.

The picture of the Abelam moving gradually north from the river, consuming the original vegetation on the plains and displac-

3 Laycock (1961, 1965) using glottochronology suggests 1880 ± 180 years ago for the split between north Abelam and Iatmül. However, the relationships suggested by his techniques within the Ndu family do not completely agree with the similarities in culture and social structure. These suggest a closer connection of the Abelam with the Iatmül than with the Boikin, whereas Laycock suggests the reverse.

4 Mead (1938) makes it clear that the Beach Arapesh in 1931 had by no means adjusted to their coastal environment.

ing the previous inhabitants, is made more likely by the fact that up till imposition of government control this process was still going on, especially in the west of the Abelam area, where the Abelam of the Wosera were pushing back the Arapesh to the north and the Gawanga to the west. As recently as the late twenties or early thirties the village of Nuŋgwaia, under pressure from its neighbors, surprised and massacred most of the inhabitants of a Gowanga-speaking village and took over their village site and land. There is a good deal more of such evidence of similar recent expansion, particularly in the Wosera, where dense population seems to have meant almost continual, gradual change of village sites. This expansion was not, of course, a planned invasion by a centralized state, but the result of the jostling together of large, fairly densely packed Abelam villages, fighting each other and gradually moving as a whole in a northerly and later westerly direction.

Further evidence in support of this conjectural history comes not only from the similarities and identities between Iatmül and Abelam but also from dissimilarities. One of the important Abelam spirits is the *walə*, and this is the only one which has no parallel, known to me, among the Iatmül. The *walə* are spirits, usually living in streams or springs but always attached to a definite tract of land; they often appear as large pythons and are believed to be responsible for conception. These are the only supernatural beings of the Abelam who have a firm, absolute territorial base; small patches of virgin tropical rain forest or water holes are sacred to them. They are also the only part of the Abelam cosmology where there is any correspondence with the Arapesh. The Arapesh also have *walə* and their specification is almost identical as well as their name. Since I know of only half a dozen words that mean the same in Arapesh and Abelam, this coincidence seems most unlikely to be accidental.

I propose to consider the content and functions of art among the Abelam and the Iatmül, on the assumption that both groups had a common origin and that their art stems from common impulses originating in a one-time common culture. It seems to me that most of the differences and divergences between them can be attributed to contrasted environments and economies and that in

the field of symbolic systems apparently disparate objects may serve very similar symbolic functions in the two societies. I cannot here undertake any systematic large-scale comparison between the two societies. My theme will be drawn from the Abelam material, with selected Iatmül examples brought in where they help the analysis. I am not interested in attempting to reconstruct any past common culture or society. But it seems to me that if any system of symbols is to be found in the art, it does not lie at the level of overt symbolism. For example, one finds that a certain face design is called butterfly by the Abelam, and further inquiries meet only with the statement that the ancestors had always painted the face that way and that it means butterfly. Any systematic symbolism must be at the level of the relation between symbols, and at this level may not be consciously perceived by either the artist or the beholder. For this sort of analysis the overt meaning of any symbol is not of great importance. What matters is the arrangement of symbols and the significance of that arrangement. I suggest that at this level similarity or identity between Iatmül and Abelam occurs, and that by comparison between the two one is protected from being blinded by the first level details to the underlying structures that are the object of the analysis.

The Iatmül live in large villages either on the banks of the Sepik River or on ox-bow lagoons just off the present course. Their villages are subject to floods for about six months of every year, and their large houses have floors ten to fifteen feet from the ground. These floods make such houses on massive posts essential, but they also make the construction of the houses easy, since posts and other main timbers can be floated into position during the flood instead of being laboriously dragged from the bush to the site. The houses themselves are usually decorated with a face under each gable and with decorative bands worked in white and dark gray leaf thatch on the end walls. The village is organized around a long, ceremonial dancing ground running like an axis through the village; the sides of the ground are formed by earth ridges on which are planted coconut palms. In the ceremonial ground are the ceremonial houses. Usually one great house is used by all the clans, with high gabled peaks surmounted by carvings of a man (or woman) with a fish eagle perching on their shoulders.

On the facade of each gable is a huge face that is the face of the house itself. The houses are all female. The dancing ground with its ceremonial houses forms the main axis of the village and the focus of its interests. It is here that ceremonies are performed and the great displays and parades take place. Captives were formerly slaughtered on the mound in front of the ceremonial house on which were planted magical plants.

If we compare this house with an Abelam ceremonial house, the differences are striking—the Abelam has one facade not two, and it is set on the ground, not raised on posts, and so on. However, if we look more closely the similarities start to emerge. Firstly, both types of ceremonial house are basically larger and exaggerated forms of the ordinary dwelling house with certain added features. The ordinary dwelling houses themselves are very obviously a product of their environment. The floods make it necessary for the Iatmül to build substantial houses with floors raised ten feet or so on posts, as well as making the assembling of the large and heavy timber easy. The houses also have to be large since during the flood all members of the family spend their only time on "dry land" there, and many household and other tasks are done there; cooking space has also to be provided for each wife. The Abelam live on the top of ridges, where flooding never occurs, and where all timber must be laboriously dragged or carried from the bush where it is cut. Most household activities take place in the open air or under the porch of the house if it is raining, and a polygamist can easily build one house for each wife; in fact, most Abelam households have two or three houses used for various purposes. An Abelam house is made for storage and for sleeping in, while a Iatmül house is made for living in. A similar distinction applies to the ceremonial house. For the Iatmül the house itself is the focus of male interests; both debates and less formal male gatherings take place on the lower level, while the upper floor is reserved for the storage of ceremonial paraphernalia and for preparations for rituals and displays. With the Abelam the house itself is used for the storage of figures and the preparations of ceremony, while the debating, informal gatherings, and displays take place on the ceremonial ground (amei) in front. Like the Iatmül, the Abelam ceremonial house is also female and, as

among the Iatmül, the interior may be referred to as the belly of
the house. The entrance is low and one has to crawl to enter or
leave; the inside is completely dark and unless an initiation
display has been prepared, it contains only the large figures of the
spirits of the clans who use it. These large figures sometimes have
a bird included in the carving which will be identified as the totem
of the owning clan, but it is not unusual for the figures to be
indistinguishable one from the other in style, or attributes; identifi-
cation is simply a matter of knowing the name. The ceremonial
house is regarded as female, and inquiries about its meaning and
symbolism elicit no response beyond that it is the house in which
the *ŋgwalndu*—that is, the major clan figures—sleep, and where
the *maira*—a general term for sacred objects, including all carv-
ings—are displayed.

If, however, one follows the actual construction of a cere-
monial house, a rather different picture emerges. The house itself
is, as has been said, structurally the same as an ordinary dwelling
house; a ridge pole resting on several pairs of crucks supports a
large number of rafters whose ends rest on the ground. There are
no central posts. For the ceremonial house the ridge pole is very
long and rises very steeply to the height of fifty or sixty feet,
whereas in a normal dwelling or storage house the ridge pole only
rises to ten feet or even less and is nearly parallel with the ground.
The ridge pole is the first permanent part of the house to be
erected, and its length and position determine the rise and shape
of the house that is built around it. Its cutting, dragging to the
amei, and placing in position are surrounded by a whole series of
taboos and invocations. All these operations have to be carried out
by members of every clan in the village. In this the ridge pole is
unique, since every other part of the house structure and its later
decoration is distributed among the clans and carried out by each
in a spirit of rivalry with the others.

I propose to consider the ridge pole and its appendages in
some detail because, although rarely referred to by the Abelam
once the house has been completed, the symbolism revealed during
the construction and the associated ceremonies shows a rather
different aspect of the house from the conventional female con-
tainer for the *ŋgwalndu* and other sacred objects. The ridge pole is

always of the same species of tree known as *maŋgə* and is personified as *maŋgəndu* (*ndu* meaning man). The species is a hard wood that grows long and straight, and is also used by the Iatmül for the ridge pole of their ceremonial houses; the Iatmül too personify it with the same name and much of what follows about the Abelam also applies to the Iatmül.

Maŋgə also appears as a sacred object in one of the Abelam initiation ceremonies, when each clan sets up a trunk to which are fastened dried yam vines; the initiates are then told that these are the *ŋgwalndu*. The Abelam initiation cycle is a series of displays of various objects each of which is said to be the *ŋgwalndu*, and culminates when the real figures are displayed.

The *maŋgəndu*, after being dragged to the *amei* without being seen by the women or children, has a projecting boss pierced with a hole carved out of the base. The boss is then wrapped up in bespelled herbs and leaves. This boss is called the *dama*—nose— of the *maŋgəndu*, and almost invariably is placed at the top forming the peak of the house. The *maŋgəndu* is raised on a scaffold running down the center of the future house and lashed to the top of it. After it is in position the crucks are placed underneath it and the rafters on top. When the structure is complete the central scaffold is cut away and removed, leaving the interior of the house entirely clear.

The *maŋgəndu* is raised just before dawn by men who have purified themselves from sexual contact with women, by bleeding their penes and observing certain other taboos. It is an extraordinary sight to see the men in the misty gray half-light struggling inch by inch up the swaying scaffolding carrying the *maŋgəndu* mainly on their shoulders, all the more impressive since in contrast to almost any other Abelam activity quiet is essential, and instead of the usual shouts and arguments that typify Abelam collective endeavor, there are only hoarse whispers and the strained panting of the men. The operation is tricky, especially as the *maŋgəndu* has to be in place before the women wake; they and the children are told that the *maŋgəndu* came and placed himself on the scaffolding although no one seems to expect them to believe it.

Once the *maŋgəndu* is securely lashed in place it receives

(*Above left*) Figure 1. Ceremonial house at Yentschanmangua village, Nyaure group, western Iatmül. The dancing ground is lined with banks on which coconuts and trees grow. (*Above right*) Figure 2. The *maŋgəndu* in place at the top of the scaffold, the crucks that will eventually support it are being put into place. The *dama* at the peak is completely concealed by its wrappings of bespelled leaves. Kwimbu *amoi*, Wingei village. (*Below left*) Figure 3. *Maŋgəndu* as tambaran. Each trunk with its body of dried yam vines and creeper fronds is said to be *ŋgwalndu*. The screen with its paintings conceals an area where the preparations for the parade take place; the performers emerge down the ramp on the left. (*Below right*) Figure 4. The completion of the house structure, Kwimbu/Wingei. The tassel has a cord attached running to the screen; by pulling this cord a concealed man makes the tassel swing back and forth in time to the music during the all-night dances that follow the ceremonies of completion. On the right of the house is a post decorated with the skulls of twelve pigs that have been ceremonially exchanged and eaten during the various phases of construction so far.

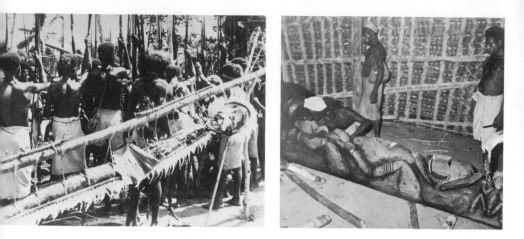

(*Above left*) Figure 5. A long yam ceremonially displayed, decorated with a basketry mask. Visitors from an enemy village, having filed in, are indicating their peaceful intentions by drawing their hands down their spears. (*Above right*) Figure 6. A new *ŋgwalndu* at Djiginambu village. After being carved in the bush, it has been carried into the ceremonial house. At this stage only the eyes, facial and pubic hair, shell breast ornament, and drop of semen are painted. The bird between the legs is a cassowary, principal totem of the owning clan. (*Below left*) Figure 7. Top of the facade of the ceremonial house at Bugiaura *amei,* Yanuko village. From the top: single face of a flying witch; seven black faces of flying foxes; immediately below a row of lozenges showing their "single breasts" as central white strokes; then a row of faces with diamond-pattern round eyes, identified as butterflies. (*Below right*) Figure 8. Hornbill carvings at the base of the facade of the ceremonial house at Kundagwa *amei,* Waigagum village. The slightly different styles of the two birds, particularly the eyes, are typical of the order of variation between villages. The upper bird comes from Kalabu village about three miles to the north, and a traditional enemy of Waigagum.

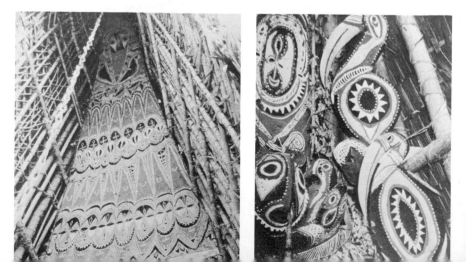

further decorative and magical treatments while the rest of the structure is built and the thatching completed. The most important of these is the passing through the hole in the nose of the *maŋgǝndu* of a length of rattan of the species called *mbal*. *Mbal* is frequently identified with pythons and hence *walǝ*. The *mbal* follows the wall on each side of the house and is buried an inch or so in the ground at the bottom. It is said to anchor the *maŋgǝndu* to the ground and prevent it moving in high winds, although it cannot do this in any utilitarian fashion. At the same time a small basket of split rattan containing a few stones is fastened just underneath the nose of the *maŋgǝndu*—these stones are called eggs and the basket a nest. I have not been able to get any further information as to their meaning or purpose.

Various constructional stages, each with minor ceremonial follow, the last being the thatching. When the thatching has been finished there follows a ceremony to mark the completion of the structure of the house, as opposed to the carving and painting of its facade and decorations, and reveals clearly the symbolism of the *maŋgǝndu*. Every Abelam ceremonial house has a peak, very occasionally this is formed out of the end of the *maŋgǝndu* allowed to project beyond the thatch. Usually, however, another piece of wood is securely fastened at a more upwardly tilted angle to the end of the *maŋgǝndu* and this forms the armature for the subsequent addition of a series of graded pots, the largest at the bottom, placed one on top of the other to form a boss with a smoothly rounded top. The placing of the last of these pots is an affair of great ceremony, again performed in silence at dawn. The head of the house is hardly visible in the mist, and the waiting men who crouch just off the edge of the ceremonial ground are silent and shivering in the cold, no fires or smoking being allowed. The man who places the final pot is alone on the thatch, only dimly seen as he rises from behind the head to place it in position. As soon as it is secure he shouts out the spearing cry of his clan, used in spearing men or pigs, *Mitserambun ndǝ ti yu* (literally *Mitserambun*, the *walǝ* bites or stings) and hurls a coconut down into the middle of the ceremonial ground; the waiting men converge on it howling and smash it to pieces with slit-gong beaters, which are specified for this occasion. At the same moment another man who has climbed up the inside of the structure to the head, where he is

completely invisible, lets fall the tassel and chain of split rattan loops by which it hangs from the nose of the *maŋgəndu*. The tassel should contain two skulls of killed enemies, but nowadays wild pig skulls, that is, pigs killed by the spear, are substituted since skulls previously used for the same purpose would not be acceptable. Even when one knows what is going to happen the effect is startling and rather horrifying, leaving an impression of a real killing rather than a symbolic one.

This ceremony is closely paralleled by the symbolic transfer of the credit for a kill in war from one village to another. This occasionally occurred when a village had asked for help from a distant ally who had no feud with the enemy concerned, and was rewarded for its aid by the purchasing with the highly valued shell rings of the credit for any kills they achieved. The testicles of the victim were hung up over the *amei* on thin cords, and after a satisfactory payment had been made, the purchasers threw sticks at the cords until they broke and the testicles were pounded to pulp, again with slit-gong beaters.

The tassel is decorated for the ensuing dance with spear points from which may hang a tally in orange seeds of kills claimed by the village, or small manikins made of burrs secretly named after kills, or a helmet basketry mask of the type associated with the *walə;* all very definitely references to the village's success in war. The tassel itself has a name, but is often referred to by the older men as the testicles of the *maŋgəndu*.[5] This symbolic identity between heads, coconuts, and testicles can be seen in other Abelam ceremonial, but I shall not produce further evidence here.

After the throwing down of the coconut, the empty shell of the house is sealed off and the *amei* decorated for an all night dance to which all neighboring villages, both friend and enemy, are invited. The decorations for this dance consist mainly of the

[5] On the rare occasions when a ceremonial house is built with the *maŋgəndu* reversed—that is with the butt end with its carved projection downwards, ending at the back of the house—it is jammed into a recess cut in a short thick hard-wood post, absent in the normal house. This recess is called the vulva of the house, and the *maŋgəndu* is said to be copulating with it.

orange seeds which are a symbol of dead enemies and of a device made from portions of white palm efflorescence and red leaf, a symbol of the successful sexual conquest of women of other villages. The decorations therefore not only refer to the unity of the village and its distinctness from and enmity toward other villages, but also concentrates on the phallic aggressive aspects we have been considering in connection with the *maŋgəndu*.

The *maŋgəndu* itself would seem to be not only masculine but also phallic. The spear-phallus identification is very common in Abelam, and spears are usually fastened beside the head of the house as decorations, while real spears and sharpened stakes with their ends smeared with red ochre are an integral part of the sides of the house, their points being angled down toward the ceremonial ground.

We have then a female house, the most important part of which is masculine and phallic, and is closely associated with warfare and the success of the village in killing its enemies. The head of the house with its peak is the focus of the masculine aggressive aspect of the house, and its construction is the job of the whole village as a unit, while the dark interior is feminine and is created by the amalgamation of the separate work of each clan.

The dual nature of the house is exactly similar among the Iatmül. Whereas the interior of the feminine house is its belly,[6] the two gables crowned by eagles are concerned essentially with warfare. Bateson records that the eagles are spoken of as "our warfare, our anger," and gives a song in which the eagles look out and see the fish and birds that they will shortly swoop down on; fish and birds being men and women of enemy villages.[7]

I have discussed the symbolism of the structure of the Abelam ceremonial house at some length as an example of what I mean by visual communication. Nothing I have said about it is particularly obscure, indeed it may well be considered painfully obvious, and yet hardly any of it was told me directly by the Abelam. To them the methods of construction and the ceremonies and taboos associated with it were the only way to do the work. They were done

6 The symbolism of the Iatmül ceremonial house is discussed in Bateson (1946).

7 Bateson (1936, p. 140; 1932, caption to Plate VIII).

because they were correct and ancestral; no one seemed to know, or care, why they were done this way, yet the *maŋgǝndu* and the house itself inspire considerable respect and even awe. To have a large and fine house is necessary for the self-respect of the men of the village: they feel their welfare and prestige to be bound up with their house.

It seems to me that the Abelam house is not just a decorated structure that serves as a setting for ceremonies and displays, but a statement about Abelam culture and society made in architectural terms; a statement that could not be just as well said in words or told in a myth. I once suggested to a group, building a ceremonial house, that the carved end of the *maŋgǝndu* might be a penis. This was rejected on the grounds that it was called *dama* (nose), and as was suggested, one would hardly bore a hole in one's penis, although one did in one's nose. My objections that the tassels were testicles, and therefore there should also be a penis, were countered by the assertion that that was just a name (*tʃimalei*). This attitude is very typical of the Abelam, especially with regard to their art. Designs and patterns and their respective parts have names, but this is the only level of meaning about which they can or will verbalize. This, of course, is hardly any meaning at all, since it leaves so many questions unanswered. Why should a painted band of flying-foxes be a virtually universal feature of Abelam ceremonial house facades? True, it frequently occurs as a clan totem, but none of the other major totems occurs on facades. If we are to regard the art and "visual communication" as a whole as something more than a decorative icing on the heavy cake of social, economic, and linguistic structures—and the time, energy, and enthusiasm that the Abelam put into such work and the strict rules and taboos under which it is carried out suggest that such a hypothesis is extremely unlikely to be correct—then we must try to discover what sort of communication is taking place. In the example of the Abelam ceremonial house, it is not my purpose to try to relate Abelam symbols to sex. I do not regard any statement about the ridge pole being in some sense a phallus as anything more than the first step in an analysis. Certainly it is hardly a more meaningful statement than the Abelam naming of designs. Much of the imagery and symbolism of the Abelam, as of many societies,

is concerned with sex, but this cannot be helped. As I hope to show, the phallus among the Abelam is not a simple unitary aggressive symbol, although this aspect predominates in the ceremonial house. What I am really trying to establish is what the Abelam are saying about themselves and their culture and society in their art. Sex may well be all-pervasive in many societies, if not all, but this is all the more reason for not being content with identifying something as a phallic symbol and leaving it at that. The most obvious question to ask next is what does the phallus mean to the Abelam. Here, again, most of the evidence comes from the art, and some of it can only be found in the art or from "visual communication."

For the Abelam, long yam growing is the essential way of obtaining prestige. These yams, single, straight, cylindrical tubers, sometimes reaching fantastic lengths—twelve feet have been recorded, and eight or nine feet are usual for the good specimens in an average year—are grown in sacred gardens only to be entered by men who have purified themselves by bleeding their penes and abstaining from all sexual contact since then. They also observe a taboo on meat and on a whole list of leaves and other edibles. The rituals and taboos of long yam cultivation are all of male strength and avoidance of contamination, abstinence from sex, and avoidance of any danger of contact with anything that might be contaminated; men light their cigarettes only from their own fires, take food only from their own wives who also have to observe a taboo on sex during this period—the Abelam definition of a good wife is one who does not commit adultery while her husband is growing yams. Men no longer eat together, except for the individual gardening groups who sometimes cook in the garden itself. The rituals are performed in a cycle based on the lunar month, and consist mainly of spells and the use of magical paints which are considered to irritate the yam and drive it deeper and deeper into the ground, and herbs whose smell excites and encourages the yam. It would be true to say that long yams are the dominant things in the male Abelam's life; to be a successful yam grower is the prerequisite of a big man or of any, indeed, who is not to be despised as a worthless, unimportant fellow. The length of yams, presented to ceremonial exchange partners at the competitive

displays that follow harvest, are the measures of the prestige and influence of the individuals of the hamlets and ritual groups into which the villages are divided. The main species of long yams are obviously phallic symbols.[8] When displayed they are profusely decorated with many of the attributes of the carvings in the ceremonial houses, principally with carved wood or basketry masks that are identical in form to those of the carved figures or the basketry masks that are the focuses of the major ceremonies. The largest yams are named, usually after the *ŋgwalndu* of the clan of the grower. They are believed to be alive, having the faculty of hearing and smell but not speech or movement, at least in the waking world; yams in more or less human form occur frequently in dreams. As to whether they have sight there is some doubt since, although they cannot see actions going on around them, they appreciate the decorations they are given at the display and a very long yam that was not suitably adorned would certainly produce badly next year. As Kaberry (1941, p. 356) has remarked, there is a great deal of identification between a man and his yam, but there is also a great deal of identification between yam and the supernatural. This indeed is one of the two areas in which man and spirit come close to uniting, a union very clearly expressed in the painting and decorating of yams, of the carvings and of the human performers in ceremonial displays. There exists a class of spirits called *wapinyan* (literally—long yam child) who are primarily responsible for the long yams; they seem to be manifestations of the *ŋgwalndu* rather than supernatural beings in their own right. Among the central Abelam minor figures are carved and sometimes named with clan-owned *wapinyan* names, but in other areas figures set up in the yam shrines, although in other respects similar, are called by *ŋgwalndu* names or "child of the *ŋgwalndu*"; in all parts of the area yam cult spells are full of *ŋgwalndu* and ancestral names, and Abelam frequently say that *ŋgwalndu* are ultimately responsible for the long yams. *ŋgwalndu's* other special responsibility is for the health and size of pigs, and in general for

[8] Long yams are believed to produce invisible secretions while in their gardens; these are often compared to semen, but are harmful, producing painful although not dangerous swellings, particularly of the joints, in men who come into contact with them.

human welfare and fertility. Pigs are virtually the only other form of production of any importance in Abelam life.

The *ŋgwalndu* themselves are represented by long, ten to fifteen feet carved figures, basically of male human beings, the proportions approximating to nature except for much larger and more impressive heads. The figures have straight legs with their arms to their sides and slightly flexed, with the hands resting on the groin. They have very obvious penes, large but pointing down toward their feet with the glans exposed—although the Abelam do not practice circumcision—with a drop of semen painted on the end. The penis is not in the erect position but neither is it detumescent.[9] (This position may well be due to aesthetic preference since, seen in profile, the penis echoes the curve of the belly.) Whatever the reasons on technical and aesthetic grounds for the position, its function in this position becomes obvious from a study of carvings of copulating couples, which are quite common among minor figures throughout the Abelam area. In these figures no attempt has been made to solve the difficulties of a naturalistic representation—however, there can be no doubt as to what is being portrayed, and the penis is represented in the same way as it is on the big *ŋgwalndu* figures. Many *ŋgwalndu*, especially in the east of the Abelam area, depart only from the normal Abelam representation of the spirit/human being, in having perched on the legs and facing up toward the trunk either a bird (in which case it will be identified as the totem bird of the clan owning the *ŋgwalndu*) or a pig. The animal's head is an inch or so from the end of the penis; the invariable reply to questions as to what it was doing there, is that it is smelling or sniffing the semen. Texts collected in various villages leave no doubt that this sniffing is considered beneficial to the clan, particularly to its pigs, for whom *ŋgwalndu* are especially responsible. This association of semen with nourishment, particularly of pigs, fits with magical practice in which white is especially suitable for pigs. All Abelam magical substances are classed as paint, various colors being suitable for

9 Fully erect penes are rare in Sepik art as a whole. There are considerable difficulties in carving them; where they do occur, they tend to be "over erect," that is, they are represented as an integral part of the belly, carved in relief on the lower portions of the belly itself.

various purposes; red and a sort of purple, the colors of the substances used for sorcery and long yams, are regarded as the most powerful. White, however, is almost completely restricted to pigs, and certain white muds when dried and pressed into balls are traded throughout the area at high prices for use as magical pig fatteners.

The phallus as an organ of nourishment occurs elsewhere in the art. As already mentioned, almost all Abelam ceremonial house facades have a band of flying-fox faces. These are represented by a black diamond-shaped face with eyes, nose, and mouth of the human type; the nose showing a one-sided feather ornament that is specifically female. Below this there is usually a row of roughly triangular decoration containing a central white stroke; this central stroke is identified as the single breast of the flying-fox. Discussion leaves no doubt that what is represented as and called the single breast is, in fact, the penis of the male flying-fox. This rather extraordinary statement needs to be set in its context of Abelam cosmology and social structure, and I hope to show that it fits in with various other features of Abelam life. Abelam clans all have a bird totem as their principal totem. They also have a whole list of other clan specific natural species—birds, insects, trees, and leaves—which may be loosely classed as totems, but I shall be concentrating on the principal bird totems. These have attached to them specific log-gong calls, special names referring to the totems that may only be used by members of the appropriate clans and other linked plant species. It is these totems that are constantly being referred to in speech and gesture, especially on ceremonial occasions or during debates, when it is literally impossible to follow what is being said without a knowledge of the principal totems of the participants. As I have said, these totems are all birds, and flying-foxes are included in this category: they are all female, not just in gender, but in fact. As the totems are women they are also thought of as mothers, and when they are referred to in oratory it is usually support for the sisters' children of the clan that is being expressed. The Abelam general word for totem is djambu; a person's djambu include the whole list of totems belonging to his clan or subclan. His maternal totem is, however, called his mbambu na apwi—Mother's Father's Bird or, often, simply

mbambu—by this is meant only the principal bird totem of his mother's natal clan. This bird is completely taboo. An Abelam may not touch his mother's totem, let alone wear its feathers or eat it. There are no similar restrictions on his own totems. This essentially maternal aspect of totems supports, in the case of the flying-fox, the identification of the very large and obvious flying-fox penis with a single female breast.

The obvious question, do the Abelam really believe this? is one that can only be answered Yes and No. Such a question raises another problem closely linked with the totemic belief, that of physiological paternity. Abelam constantly say, and particularly in debates and ceremonial contexts, that children are not conceived by men but by the *walə*. A woman is believed to be entered by the *walə* of her husband's clan when passing near his water hole or patch of bush; she is unaware of the intrusion but conception takes place; copulation has nothing to do with it. Copulation is, however, necessary to promote the growth of the child in the womb; once a woman has conceived husband and wife should copulate vigorously and frequently for some months to insure a healthy, strong child and an easy birth. However, despite this emphatic denial of any connection between copulation and conception, men returning from years working at the coast and finding their wives with babies, tend to beat them and in some cases repudiate the baby and are regarded as justified in doing so. It would seem then that Abelam do not always believe that copulation and conception are unrelated. A similar duality is to be found in the beliefs about birds. Domestic fowls, which are admitted to be birds of a sort, are recognized as having two sexes, and it might be that this is part of the explanation why fowls are the only commonly occurring bird species that is never found as even a minor totem. Bird species in which the male and female have different plumage are classified by the Abelam as different species, but it is known that they tend to associate with each other. In general, although in ceremonial contexts Abelam will insist that all birds are female and that conception is not connected with copulation, in more everyday contexts they are not always so rigorous. It would seem, therefore, that such statements are not merely the result of faulty classification but are socially essential.

Eastern Abelam informants have occasionally told me that some hornbills are male, while one said that hornbills were sometimes one and sometimes the other. Kaberry found that in Kalabu village in the north central Abelam area, hornbills alone among the birds were classified as male. The case of the hornbill is a special one, however, because although like the flying-fox it is fairly common as a totem, it is virtually omnipresent in the art where its occurrence, as is that of the flying-fox, is totally without totemic significance. In carving, the hornbill's head and neck are an integral part of the ornamentation of all major and many of the minor figures. Its huge beak makes it easy to carve and identify. This characteristic shape has been completely integrated into Abelam carving. It may be so important because of the phallic shape of its bill, which is sometimes equated with the cassowary bone dagger, *yina,* that plays a vital part in ceremony, where it is very definitely a symbol of male aggression. This identification may be relevant to the classification of the hornbill as masculine in some parts of the area. Where the hornbill is represented alone and as the complete bird and not just as the head and neck, it is always in the same form—as a flat carving with a round body on which is painted the symbol of the moon which is most unequivocally feminine. This form of carving has a specific place and purpose, being used as an essential decoration at the base of the facade of the ceremonial house, where its combination of male and female symbols echoes that of the house itself.

In this necessarily selective account of some aspects of Abelam art and architecture, I have tried to follow through the symbolism related to the phallus. It has three main forms: first, as the ridge pole of the ceremonial house which stands for violence and warfare and is associated with the spear; second, as a nutritive organ, in paintings on the facade of the house and in carvings of the vital clan spirits; and thirdly, combining both aspects in the cult of the long yams, whose display and presentation are the occasions for the hostility and rivalry by which prestige is obtained; but which is also the cult of nourishment and fertility.

It seems to me that ceremonial houses, carvings, paintings, and decorated and displayed long yams are making implicit nonverbal statements about such matters as well as others, such as the

ultimate identity of man, long yam, and spirit. These statements are only made through the art and not otherwise except, possibly, in dream interpretations.

I should like to suggest that such statements are relevant to the social structure. For instance, the flying-foxes on the facades of the ceremonial houses seem to be statements about two different things: firstly, the phallus as nourisher rather than conceiver, and secondly, the essentially feminine nature of totems. Both these statements might well be relevant to the invariant nature of matrilateral kinship ties compared to the weakness of patrilateral ties characteristic of nominally patrilineal Abelam society.

It may also well be that the cult of the long yam, which provides such a perfect symbol of male prestige and expression of male values, is linked with the norm of female sexual aggression among the Abelam. Bateson (1935) has argued along these lines for the Iatmül with regard to the male cult of flutes which are also phallic symbols and expressions of male pride and prestige. These flutes, although not of course cultivated, are otherwise surrounded by much the same taboos and attitudes as the Abelam long yams. They are also called by the same name. *Wapi*, the Abelam name for long yams, is also the name for the long male flutes, at least among the Eastern Iatmül. This identity of name can hardly be a coincidence, especially as many other words used to refer to sacred things are also the same in the two languages. One appears to be left with the supposition that *wapi* means, in some fundamental sense, a symbol of male prestige in phallic form, and that the Abelam, finding the long yam in the P. Alexander foothills, developed its cultivation (they produce far longer yams than any of their neighbors from whom they must originally have learnt the art), and elaborated a cult around it. While the Iatmül gave similar prominence to their often equally long sacred flutes.

In the comparison between Iatmül and Abelam, I have tried to show that, in the small sector of the art I have been considering, outward differences in the forms of houses and the choices made from the environment, as symbols, conceal great similarities in the "messages" that these objects are transmitting. These "messages" I believe to be statements about the nature of man and his culture, statements that may not be totally conscious in either the creators

or the beholders of the art—who do these things because they are correct—but which are relevant to and essential for the existing social structure. I also hope I have shown that at least in Abelam society these statements are not usually made, and possibly even cannot be made, by other means of communication.

Bibliography

Bateson, G. "Social Structure of the Iatmül People of the Sepik River," *Oceania,* 2 (1932), pp. 3, 4.

———. "Music in New Guinea," *The Eagle: St. John's College Magazine,* 48 (1935).

———. *Naven.* London: Cambridge University Press, 1936.

———. "Arts of the South Seas," *Art Bulletin,* 28 (1946), pp. 119–23.

Bühler, A. *Kunststile am Sepik.* Basel: Museum für Völkerkunde, 1960.

———, Barrow, T., and Mountford, C. P. *Oceania and Australia: The Art of the South Seas.* London: Methuen, 1962.

Kaberry, P. M. "The Abelam Tribe, Sepik District, New Guinea," *Oceania,* 11 (1941), pp. 3, 4.

Laycock, D. C. "The Sepik and Its Languages," *Australian Territories,* 1 (1961), p. 4.

———. *The Ndu Language Family (Sepik District, New Guinea).* Canberra: Linguistic Circle of Canberra, 1965.

Mead, M. *The Mountain Arapesh.* 1. *An Importing Culture.* Anthropology Papers. American Museum of Natural History, 36 (1938), p. 3.

Robbins, R. G. "Vegetation," *Lands of the Wewak-Lower Sepik Area, New Guinea.* Canberra: C.S.I.R.O., 1961.

Wirz, P. *Kunst und Kult des Sepik-Gebieten.* Amsterdam: Koninklijk Instituut voor de Tropen, 1959.

An African Aesthetic*

DANIEL J. CROWLEY

Professor Crowley presents a clear and complete descriptive assessment of Chokwe art and its importance and meaning to the Chokwe people. The wide variety of Chokwe art objects are created by both professional and nonprofessional artists. Artists and observers among the Chokwe have opinions on standards of aesthetic excellence and are able to express them. The responses and activities observed in this study of the art of a specific society refute many general theories long held about African art.

Daniel J. Crowley is Chairman of the Department of Anthropology, University of California, Davis. His many interests include art, folklore, and music of Africa and African-derived cultures; and multicultural community, carnival, integration of arts, and postcolonial societies in the Caribbean, West and Central Africa. Two recent publications are "I Could Talk Any Old-Story Good," in *Creativity in Bahamian Folklore* (1966) and "Toward a Definition of Calypso," in *Ethnomusicology* (1959).

A tremendous amount of ethnographic data on the functions of the arts in nonliterate societies has been collected, but much less comparative data exists on the nature of creativity in these societies, on the recruitment and training of artists, and on their hierarchies of aesthetic value. This paper will attempt to describe the graphic and plastic arts of one African people in their cultural context, and to indicate some of the attitudes and values of the artists and their audience.

The Chokwe (Batshioko, Badjokwe, Watschiwokwe, Quicos) are a Niger-Congo speaking matrilineal people numbering over

* Reprinted from *The Journal of Aesthetics and Art Criticism*, Vol. XXIV, No. 4 (Summer, 1966), pp. 519–24. An earlier version of this paper was read at a meeting of the California Division, American Society for Aesthetics, at Berkeley, California, May 11, 1962.

600,000 and classed by Murdock[1] in the Lunda cluster of the Central Bantu. They were evidently a hunting people who came under the hegemony of the Lunda Empire of the Mwata Yamvo in the seventeenth century, and have spread from their original home in northeastern Angola into the former Kasai and Katanga Provinces of the Congo (Leopoldville) and the Northwestern and Balovale Districts of Northern Rhodesia (now Zambia). The field research on which this paper is based was carried on in all three countries between January and August, 1960, from headquarters at Dilolo Gare, Katanga, and was supported by a fellowship from the Ford Foundation.

The Chokwe are a relatively adaptable people who have found no great difficulty in integrating alien objects and institutions into their own traditional culture. Although at least half have become Christians, traditional magic practices seem not to have diminished even among the most devout converts. In Dilolo at least sixty percent of the young men and boys are literate in Chichokwe, and an estimated ten percent in French, but the authority of the traditional chiefs has not yet been seriously undermined. The Chokwe readily adapt to urban living in Elisabethville and Lobito at the two ends of the Benguella railroad which crosses their territory, and numbers of them have become successful as rail and mine foremen, Christian clergy, teachers, and recently as politicians and administrators.

Their sanguine approach to life is evidenced by their attitudes toward the arts, which traditionally were incorporated into every major aspect of Chokwe culture. When apprised of our project, an American missionary warned that ". . . it's like trying to study art in Little Rock. There isn't any art here, and even if there were, this wouldn't be the time to study it." Although the Chokwe of the Dilolo Territory are relatively acculturated to the Western world, and the growing tensions of the Independence period were hardly conducive to the production or study of art, the volume of artistic production proved to be surprisingly high. Every home possessed a few objects decorated beyond function, and nearly every village had two or three pieces of impressive quality. Since it was Chokwe

[1] George Peter Murdock, *Africa, Its People and Their Culture History* (New York, 1959), p. 293.

evaluation, rather than our own, that was the object of the study, great care was taken to collect all types of objects said to possess merit, even though they might not be art in our culture. Actually, Chokwe categories of art (as against nonart) are not too different from our own, and range from purely decorative objects to religious paraphernalia, secular dance equipment for professional dancers, symbols of the power of chiefs, musical instruments, toys, and well-formed household objects. Media were also familiar, including wood, clay, iron, colored earths, grasses and reeds, seeds, calabashes, trade cloth and paper, and a unique combination of bark cloth stretched over a bent wooden frame and coated with shiny black tarlike resin, then decorated in red and white clay, cloth, or paper.

Most Chokwe are able to make some of these objects for themselves, while others are almost always purchased from a professional. Men make masks, figures, stools, bellows, metal tools, knives, charms, bark cloth, and musical instruments, while women make household baskets, and decorate house walls with colored clays, and both sexes make large plaited baskets, engrave calabashes, and make toys. Most men make their own *jinga* (small charms worn around the neck) and *mahamba* (votive figures used in fertility, curing, and hunting magic), and many make an occasional mask or stool for their own use, but most purchase their knives, spearheads, adzes, hatchets, and other tools from a professional blacksmith. Professional carvers are commissioned to make a stool or chair for a chief, or a fine mask for a professional dancer, but work only occasionally and produce only a few objects each year. Women who are expert basketmakers produce baskets for their families and as gifts to less skilled friends, but only occasionally for sale. A few men and women make a type of large square plaited basket and burden carriers for sale in village markets. Pottery is made by men, and is a fairly rare skill commanding high prices. The only artist who made his living exclusively by the sale of his products was the potter Kalandjisa. Otherwise all the artists with whom we worked carried on farming, and tended sheep and goats as the major source of their livelihood. Although commissioned objects are priced and paid for in goats, Congo currency in small denominations was also accepted. Carvers

sometimes demanded a down payment, and others were willing to accept weekly payments on account.

Great artists have wide reputations and individual styles unique enough so that they can be identified by large numbers of people. Such men attract boys who want to learn their skills, and are willing to pay in goats and to work as apprentices for the privilege. In this way, regional and village styles develop into what might be called *schools* and these too are widely identifiable. As a result, *the* Chokwe style has no single element that occurs universally, but only very generalized characteristics and subjects interpreted in styles of striking diversity. To complicate the situation even further, the *mukanda* initiation rite with its masked personages is shared in whole or in part with a number of neighboring tribes, so that the classification of styles is infinitely more complex than is indicated in the photographic anthologies of African art with their simplistic implications of "one tribe-one style."

The most important aesthetic institution of the Chokwe is the *mukanda,* a *rite de passage* that prepares a boy for manhood. Sometime between the ages of seven and fifteen, groups of boys spend a few months in isolation living in a small grass hut, during which time they are circumcised, hazed by masked figures, and taught tribal secrets, magic practices, and sexual lore. They also learn how to sing, dance, and to make and play musical instruments. Since they wear short grass skirts similar to the *tutu* of classical ballet, the *mukanda* dancing class resembles a similar subject by Dégas. The boys also learn how to make wooden and bark cloth masks and the knitted fiber costumes that complete the paraphernalia of the masked personages who run the *mukanda* lodge. There are evidently about thirty stock characters represented by distinctive masks, the number and types varying widely by area and subgroup. These characters are the subject of almost all of Chokwe aesthetic expression, and are called *mikishi* (sing. *mukishi*), meaning spirits and/or masked dancers. The most important are *Chihongo* (*Chirongo* in Angola), a fiercely aristocratic personage with a bark cloth mask, projecting horizontal beard, and elaborate off-the-face headdress; *Chikuza,* a tall conical bark cloth mask representing the father of the lodge; *Kalelua,* a bark cloth mask surmounted by a large sombrero-like hat; *Chizaluke,* an old

(*Top*) A Chizluke resin mask being displayed so we would know how to dance it, hence no knit costume. The workshop is in the rear, and the artist, Sanjolombo, is at the left. (*Above*) Chihongo and Katoyo masks (resin) being danced by court dancers of the Mwa Tshisenge at his village eighteen miles north of Dilolo Gare, Katanga.

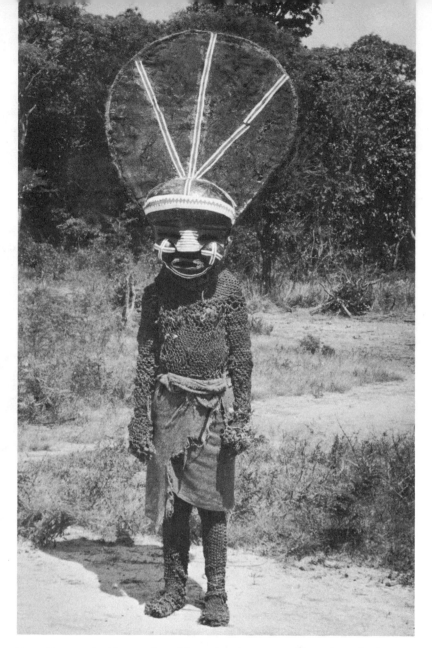

Linya Pwa, a giant Luena (Lovale) mask being worn with costume in the village of Katende Tshipoye, Congo.

chief with "existentialist" chin beard; *Chiheu,* impotent man with bald head and sometimes with enormous wooden phallus; and *Mwano Pwo,* young girl, represented by a carefully carved wooden mask, skintight knitted costume with false breasts, a sand-filled, tufted bustle, and its male wearers dance with a peculiar vibrating step.[2] Although these masks are obviously connected with traditional Chokwe religious concepts, they are not now considered to be representations of ancestors, and they sometimes appear on secular occasions, as for instance at rallies of the Chokwe political party, ATCAR. Important secular masks include *Katoyo,* an idiotlike clown with peaked cap and yellow strip across the eyes, and *Ngulu,* a realistic pig mask used in casual humorous village dances.

Figures (plural, *tuponya,* sing., *kaponya*) representing the same beings are made for votive shrines as children's dolls, and are used to decorate stools, chairs, hair combs, flywhisks, boxes, large and small drums, and wooden objects of everyday use. Blacksmiths *(fuli)* are distinguished from carvers (*songi*) and produce knives of many sizes, daggers, swords, hatchets, adzes, hoes, many types of arrowheads, spearpoints, and an elaborate kind of functionless ax used by chiefs and dancers. *Fuli* usually make the wooden appurtenances for their metal objects, such as ax handles, and also leather quivers and sheaths. Potters make bowls, vases, pitchers, wide- and narrow-necked jars, and other functional items in many sizes and shapes, most of them decorated with incised or impressed linear designs. A large carafe or ewer is a popular object around Dilolo, often surmounted by a lid with a human head or figure in traditional woodcarving style. These carafes, in black or pale gray clay, are virtually unreported in the literature, and may be influenced by European forms, but in any case are among the *chefs-d'oeuvre* of the Chokwe and their neighbors to the south, the Luena (Luvale). The Dilolo potter Kalandjisa makes pottery guinea hens, turtles, portrait busts, and even ash trays for sale to wealthy Africans and occasional Europeans. Even though the train is held up by frontier customs inspections

[2] Cf. Jose Redinha, *Mascaras de madeira da Lunda e Alto Zambeze,* Museu do Dundo—Subsidios para a historia, arquelogia e etnografia dos povos da Lunda (Lisboa, 1956).

for several hours three times a week in the Dilolo station, no airport art has developed, and no objects are for sale to travelers.

Women are forbidden to make representations of the *mikishi*, except in line drawings in colored earths on the walls of their homes.[3] Women make a number of basketry items in a coil technique quite similar to that of American Indians. Large plaited baskets, burden carriers, and mats (used as beds) are made for sale by both men and women, but baskets are more often given as gifts or exchanged for produce. Women also engrave calabashes with genre scenes and *mikishi* representations, rubbing lampblack into the incisions for greater contrast with the pale tan surface of the calabashes, which are then used as bowls and liquid containers.

Musical instruments include very large slit gongs (*chikuvu*), drums of many types, the most spectacular being the double-headed, hourglass-shaped *mukupiela* with integral handles and friezes of masks and linear patterns, many types of thumb pianos (*chisaji, kakelondondo, likembe*) with and without sound chambers, flutes, rattles, and whistles carved in the round or incised with masks, figures, or abstract patterns. The *chisaji* keys are sometimes forged locally, but more often are made of disused umbrella spokes or strips of dry bamboo.[4]

To gather verbalizations on aesthetic values, a permanent exhibit of Chokwe objects was arranged in the field headquarters, and individuals and groups were encouraged to view it and to give their opinions of each piece, putting objects of similar type into a rank order. A smaller traveling show was carried in the car for use in bush villages. Since women are supposed to believe that *mikishi* are actual spirits rather than their husbands and brothers wearing masks, they could be allowed to see the exhibits only when no men were present to object. Women of course know of the masks, and sometimes even knit the costumes for them, and the men know of

[3] Cf. Jose Redinha, *Paredes Pintadas da Lunda*, Museu do Dundo— Subsidios para a historia, arquelogia e etnografia dos povos da Lunda (Lisboa, 1953).

[4] Cf. Marie-Louise Bastin, *Art Decoratif Tshokwe*, Museu do Dundo— Subsidios para a historia, arquelogia e etnografia dos povos da Lunda (Lisboa, 1961), pp. 354–61, Pls. 205–14.

the women's knowledge but still do not want to be embarrassed by being confronted with it.

As a nation of practicing artists deeply concerned with the dramatic effects of masked dancers, the Chokwe were able to verbalize their aesthetic concepts in a remarkably precise manner. Their language (*Chichokwe*) has an extremely complex nomenclature for indicating degrees and kinds of kinship, and for classifying, for instance, types of musical instruments, but as far as one could discover, no way of differentiating the concepts of *good* and *beautiful*, both of which were *chibema*. Thus a physically ugly woman who was a good wife and mother was *chibema*, but so was a physically beautiful woman who was unfaithful and a poor mother. This problem became a popular subject of discussion among French-speaking informants, many of whom also spoke two or more local languages and *Kiswahili*, the railroad *lingua franca*.

Fortunately, degrees of aesthetic excellence were easily indicated, and new masks were preferred to old because they have the stronger power that comes with youth. Hence old and worn masks are thrown away or allowed to be eaten by termites. Similarly, bright colors are preferred to dull, so that red trade cloth and cutouts (sometimes with pinking shears) of white paper, or commercial red and white paints were replacing red (*ngula*) and white (*pemba*) clays as decorations on the black resin-covered bark cloth masks. Purple dye made from boiling our disused typewriter ribbons and carbon paper replaced black river silt for coloring the grasses used in the designs on baskets. Since the function of masks is in dancing, lightweight woods are preferred to heavy, even though they wear less well, and burlap or brown wrapping paper make lighter and more maneuverable giant masks that the traditional bark cloth.

Skillful technique was necessary if a piece was to be seriously considered, so that unsteady baskets or asymmetrical figures were greeted with derisive laughter, and carvers were loudly criticized by their fellow-villagers for offering for sale crudely finished pieces. Each artist considers (or says he considers) his own work superior to all others except that of his own teacher, or in one case, of the teacher's brother. The local style was always preferred to any other, and usually described as *proper* or *correct*. When

superbly-crafted antique Chokwe pieces collected in the Angolan fatherland were shown to the Katanga Chokwe, they expressed great admiration of the technical skill, but described the pieces as "old-fashioned," "like the old people used to make," and hence worthy but not as fine as the finest contemporary local products. *Mwana pwo* masks, of which nearly fifty were collected, were usually the favorite subject. In the wide range of types from old Angola masks with clay-encrusted fiber wigs, to dramatically painted masks for the court dancers of the Mwa Tshisenge, the leading local chief, to boldly conceived dark wooden masks made by the school of Sanjolomba, a famous Luenaized Chokwe carver, to small tourist-export masks made by Angolans in lieu of road work under Portuguese government sponsorship, *mwana pwo* was regarded as the greatest expression of Chokwe art, although a few older men considered the *tuponya* stools decorated with figures to be greater. Thus the Chokwe join the many other cultures and epochs which have found their greatest inspiration in the face of woman.

Opinion differed from village to village, but generally the neatest and smoothest new masks with the most carefully applied colors were most frequently preferred. In the representation of scarification, young men and boys were outspoken in their dislike of heavy raised welts or broad pyrography made with heated nails, even though these were in our eyes perfectly balanced with the style and mass of the mask. They liked only carefully incised narrow lines that had not been picked out with color or burning, possibly reflecting the growing dislike of cicatrization, tattooing, and teeth filing as marks of the bush. Even so, girls whose abdomens had not been cicatrized were considered infinitely less desirable sexually than those who had beautified themselves by this ordeal.

Metalsmiths, particularly those who are able to smelt metal from local ores, are considered to rank with the greatest of wood carvers. Much of their production is richly finished with cold chisel work, carved wooden handles, tooled leather sheaths, and bead-work, suggesting its importance as an aesthetic expression. Metalsmiths make the adzes which are, with finishing knives, the only tools of the carvers.

Women were found to have attitudes similar to men, liking dexterity, neatness, evenness, and ostentatious control of technique in basketry, as well as small, precisely-spaced designs rather than the bolder all-over patterns associated with the recent past. Basket design seems to go through fads, the then-current one, called *tulumbalumba* (decoration) or *tanganyika* (stars), consisted of small square dots or checkers arranged in treelike patterns over only a small part of the basket's sides, the rest remaining plain.

Virtually every village had at least one practicing artist of more than routine skill, and most had several in different media, while every home had at least one object of merit by Western standards. Favorite objects for interior decoration, besides semifunctional baskets, pots, stools, and mats, were carvings of snakes and birds, sometimes skillfully wrought but more often crudely conceived and executed. Although in other areas such sculptures are symbolic of fertility, no such significance was ever admitted by the Katanga Chokwe, so that one is inclined to accept their most frequent answer, "This is what we make for ourselves. What do you like (in your homes)?" After all, one cannot expect them to decorate their homes with masks and figures which have ritual meaning, or which are thought suitable only for hunting-magic shrines. The walls of Chokwe homes are often decorated with crude linear designs or outline drawings of *mikishi* and animals executed in colored clays by women and uncircumcised boys, and town dwellings are sometimes painted in patches with commercial paints in a manner that would have delighted Gauguin. Yards are kept neat, flowers are grown, and the village plaza is consciously laid out in even the dustiest Angola bush, complete with chief's house with terrace and flagpole, *chikuvu* slit gong, dancing place, sacred *muyombo* tree, men's clubhouse (*chota*), and open courtroom.

Sweeney[5] has remarked that the ". . . standards of judgment guiding both the creation and the evaluation of native arts in Africa . . . are quite foreign to ours," but the stress on technical skill rather than on personal expression parallels the value systems

[5] James Johnson Sweeney, "Introduction," *African Folktales and Sculpture*, Bollingen Series XXXII (New York, 1952), p. 326.

of Western craftsmen such as carpenters and joiners, artisans such as Swiss woodcarvers, and perhaps even contemporary "hard line" painters, or the Bay Area sculptors who cast their own work. It also accords well with other studies of non-Western aesthetic values by Bunzel among Pueblo potters, O'Neale among Yurok-Karok basketmakers, and Adair among Navaho silversmiths.[6] But the known nonliterate societies seem to differ sharply from ours in their greater proportion of practicing artists, higher integration of art into everyday life, and perhaps greater concern on the part of artists with the social and sociological implications of their work. Art is discussed more frequently and perhaps more clearly by larger numbers of people because art is of more immediate importance to them than to most of us, who hire specialists to produce our creativity and criticism, and even our religion. The distinction between fine and applied art appears unreal in other cultures, and suggests that we might understand our own patterns of creativity more completely if we knew more about these processes in such traditional forms as parade floats, homecoming decorations, greeting cards, and poster design—none of which has been adequately studied as art or as sociology.

It may be useful to point out a few oft-repeated theories about African art denied by the field data. The Chokwe have no fetishes or idols, since they do not believe their figures to be the actual or the symbolical embodiments of spiritual power. Although most books on the subject are written in the past tense, and suggest that African art, as a religious art, must die with the paganism that supported it, Chokwe art and religion are actually both doing very well, and give no evidence of attrition, although both are changing to use new opportunities to gain new goals. And for that matter, religious art among the Chokwe is crude, since it need function only magically, and not aesthetically. But the secular objects used on religiosecular occasions are carefully executed because the prestige of a chief, a village, a dancer, and a carver is determined by them. The idea that individual creativity is narrowly limited by

[6] Ruth Bunzel, *The Pueblo Potter* (New York, 1929); Lila M. O'Neale, *Yurok-Karok Basket Weavers,* University of California Publications in *American Archaeology and Ethnology,* Vol. XXXII, No. 1 (Berkeley, 1932); John Adair, *The Navajo and Pueblo Silversmiths* (Norman, Okla., 1944).

the restraints of tradition proved invalid among the Chokwe, who work in a number of regional and individual styles with a maximum of variation at least as great as that of Western sculptors. William Fagg's[7] hypothesis that there is greater stylistic variation between two carvers in one village than between the composite styles is borne out in this area. Only further research can test his second hypothesis that, if all art objects in Africa were adequately collected and documented, it would be possible to identify all known African museum specimens not only as to tribe and region but also, in many cases, to artist.

Generalizations about Africa, including this one, are almost inevitably wrong, yet there is evidence that traditional art activity is still widespread. Fagg has estimated 70,000 carvings extant among the contemporary Yoruba, and at least twenty other anthropologists have made important collections in the last few years, though these would not always appeal to the current antiquarian taste that prefers worm destruction, local restoration, a sacrificial patina, and masks shorn of their raffia fringes and hung in ways that distort the intention of the carver. As one of mankind's strongest sculpture traditions, African art will surmount the misunderstandings created by philistines who "may not know much about Africa, but know what they like," and contribute not only to our personal enjoyment but also to our curiosity about the nature of the creative processes through comparative studies of art in culture.

7 William Fagg, "The Study of African Art," *Cultures and Societies of Africa*, eds. S. and P. Ottenberg (New York, 1960), pp. 468–69.

Material Culture and Cognition*

MICHAEL C. ROBBINS

A theory that the form of house structure might influence cognitive prefer-
ences prompted this research. The assumption was that art style would be
related to house structure, that in a society with round houses, preference
would be shown for curvilinear forms and conversely, in one with rectangular
houses, straight lines would predominate. Using earlier research by Barry
and Fischer, comparisons were made that, however, confirmed the opposite
association. Berlyne's motivation theory appears to explain the reasons for
this and also to support the idea that "perceptual habits and cognitive pref-
erences are related to the culturally modified environment."

Michael C. Robbins is an Assistant Professor of Anthropology at Penn-
sylvania State University. His interests are psychological anthropology and
cultural ecology, and his areas of research are Africa and North America. His
article, "House Types and Settlement Patterns" (*Minnesota Archeology*,
1966), is somewhat related to the one below. He has also edited *Readings in
Cultural Anthropology* (1967).

Recent studies (Allport and Pettigrew, 1957; Segall, Campbell, and
Herskovits, 1963; etc.) have indicated that the culturally modified
environment (e.g., domiciles) may influence certain perceptual
habits and cognitive preferences. For example, Segall and his
colleagues (1963, p. 770) interpret particular visual inference
habits of Europeans as the result of residence in highly "car-
pentered" (or rectangular) urban, European environments. More-
over, Doob (quoted in Allport and Pettigrew, 1957, p. 106) has
suggested that among the Zulu—whose material cultural environ-

* Reprinted from *American Anthropologist*, Vol. 68, No. 3 (June, 1966),
pp. 745-48. The author gratefully wishes to acknowledge the assistance of
Pertti J. Pelto and Patricia M. Robbins in the preparation of the manuscript
and to thank Daniel E. Berlyne for reading it and providing additional
materials.

ment is predominantly circular—less acculturated persons prefer circles to squares in designs, as opposed to more acculturated persons, who presumably have been more exposed to rectangular European environments.

In an effort to explore these ideas further, I hypothesized that, in general, the shape of a society's cultural art style would be related to the shape of its primary house type. Specifically, it was predicted that in a society where the primary house shape was circular, there would be a preference for or predominance of curved lines in the art style. Conversely, in those societies in which the primary house shape is rectangular, there would be a preference for or predominance of straight lines in the cultural art style. The rationale for this prediction was that an art object would be cognitively preferred if it contained formal characteristics similar to those normally experienced.

METHOD

The two variables used in the investigation were: (1) the judgments by Barry (1957) of straight to curved lines in the graphic art styles of thirty societies (these are presented and discussed in another context by Fischer [1961]); and (2) the judgments on primary house shape indicated by the ratings of house ground plans in the "Ethnographic Atlas" (*Ethnology*, 2, pp. 109–33).[1] The results are contained in Tables 1 and 2 below. All sets of judgments were made by persons unaware of the hypotheses of this study, and it is fair to claim that the results cannot be explained by a judgmental bias of this type.

The results in Table 1 indicate that the general hypothesis is supported, but that the specific prediction is disconfirmed and the opposite association supported. In societies where the primary house type is circular, there appears to be a preference for or predominance of *straight* lines in art style; and in those societies in which the house type is rectangular, there is a preference for or predominance of *curved* lines in the cultural art style.

[1] Column 80 of the "Ethnographic Atlas" (*Ethnology*, 2, pp. 109–33 and subsequent installments). Circular and elliptical were combined, as were quadrangular and rectangular.

Table 1. Relation of Primary House Shape to
Linearity-Curvilinearity of Art Style*

Societies with circular house shape	Most linear to most curvilinear (ranking)	Societies with rectangular house shape	Most linear to most curvilinear (ranking)
Navaho (most linear)	1	Ashanti	2
Teton	3	Marshalls	7
Thonga	4	Hopi	8
Yagua	5	Ifugao	9
Piaute	6	Maori	11
Chenchu	10	Zuni	12
Omaha	13	Andamans	14
Samoa	15	Ainu	16
Western Apache	18	Marquesas	17
Masai	19	Murngin	21
Comanche	20	Yakut	23
Papago	22	Alor	25
Chiricahua	24	Arapesh	26
	$R^1 = 160$	Kwakiutl	27
		Bali	28
		Dahomey	29
		Trobriands (most curved)	30
			$R^2 = 305$

* Using the Mann-Whitney U Test: $U = 69$, $p < .05$ (one-tailed) (Siegel 1956).

As a further check on the art style ratings, an assistant, unaware of the hypotheses, was asked to rerate the linearity-curvilinearity dimension of the art styles of these societies. The results, presented in Table 2 on page 332 are even more striking in their disconfirmation of the specific prediction, and offer strong statistical support for an inverse relationship between the variables.

In attempting to interpret this, I recalled an interesting article entitled "New Directions in Motivation Theory" by Daniel E. Berlyne (1962), which discusses the importance of "human exploratory behavior" or "behavior whose principal function is to change

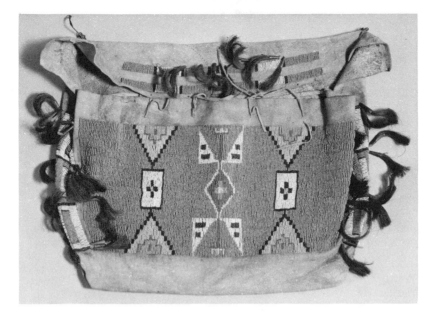

Hide saddle bag decorated with beadwork in the lazy-stitch technique. On a light-blue background appear geometric figures including terraced figures, forks, crosses, etc., in white, red, blue, yellow, and green beads. At the side and top there are red horsehair tassels held up by metal tops. Sioux Indians. The Brooklyn Museum, New York.

the stimulus field and introduce stimulus elements that were not previously accessible" (p. 152). Exploratory behavior, he explains, may be either organized or unorganized and consists of everything we consider as "recreation" or "entertainment" in contrast to "work." In the investigation of exploratory behavior, it is necessary to identify the properties of external stimuli that determine what is explored in preference to what is not. This investigation directs our attention to such properties of stimuli as "surprisingness," "complexity," and "novelty." Concerning "novelty," Berlyne writes:

> something can be "new" because it has never been encountered before . . . or . . . [has] not been encountered during the last few minutes. It may consist of an entirely unprece-

Table 2. Relation of Primary House Shape to Modified Ratings of the
Linearity-Curvilinearity of Art Style*

Societies with circular house shape	Most linear to most curvilinear (ranking)	Societies with rectangular house shape	Most linear to most curvilinear (ranking)
Thonga (most linear)	1	Andamans	10
Yagua	2	Murngin	11
Chiricahua	3	Dahomey	13
Western Apache	4	Ashanti	14
Comanche	5	Zuni	15
Samoa	6	Hopi	17
Papago	7	Arapesh	20
Teton	8	Kwakiutl	21
Paiute	9	Marshalls	22
Omaha	12	Alor	23
Navaho	16	Ifugao	24
Masai	18	Yakut	25
Chenchu	19	Bali	26
	$\overline{R1 = 110}$	Marquesas	27
		Ainu	28
		Trobriands	29
		Maori (most curved)	30
			$\overline{R2 = 355}$

* Using the Mann-Whitney U Test: $U = 19$, $p < .001$ (one-tailed) (Siegel 1956).

dented sensory quality . . . or it may consist of familiar
items in an unprecedented combination or arrangement
(1962, p. 155).

These stimulus properties are said to have a motivational effect on
certain areas of exploratory behavior, including aesthetic activities.
As Berlyne states:

The human organism . . . is . . . motivated to keep the
influx of novelty, complexity, and information within an
optimal range and thus escape the extremes of confusion and
boredom.

. . . When a person has some choice with respect to the environment he enters, he may seek out one that is likely to have the right properties. He may manufacture such an environment by surrounding himself with aesthetically satisfying artifacts (1962, pp. 168–69).

Berlyne's ideas may help to explain my results: one way in which people living in a particular material cultural environment (e.g., rectangular houses) "keep the influx of novelty within an optimal range" is by manufacturing aesthetic artifacts of a different shape (e.g., curved designs). In other words, for an art object to be cognitively preferred and aesthetically satisfying, it should contain certain "properties" *different* from those normally experienced.

This study offers support for the idea that perceptual habits and cognitive preferences are related to the culturally modified environment. Berlyne's ideas in particular appear true. While this pilot investigation does not claim to be conclusive, it does indicate the relevance of new directions in motivation theory for anthropology. In the words of Berlyne:

. . . there is a need to examine the means that societies use to maintain their preferred level of arousal. This means looking with particular attention at the artificial sources of stimulation with which they provide themselves to make up for the shortcomings of the natural environment. It means taking a new look at aesthetic activities, ceremonies, and play. Anthropologists have learned under the influence of psychoanalysis to look deeply into the content of these institutions but perhaps more attention should now be paid to their formal properties (1962, p. 170).

Bibliography

Allport, G. W., and Pettigrew, T. F. "Cultural Influence on the Perception of Movement: The Trapezoidal Illusion Among Zulu," *Journal of Abnormal and Social Psychology*, 55 (1957), pp. 104–13.
Barry, Herbert, III. "Relationships Between Child Training and the Pictorial

Arts," *Journal of Abnormal and Social Psychology*, 54 (1957), pp. 380–83.

Berlyne, Daniel E. "New Directions in Motivation Theory," *Anthropology and Human Behavior*. eds. T. Gladwin and W. C. Sturtevant. Washington, D.C.: Anthropological Society of Washington, 1962, pp. 150–73.

Fischer, J. L. "Art Styles as Cultural Cognitive Maps," *American Anthropologist*, 63 (1961), pp. 79–93.

Murdock, G. P., and associates. "Ethnographic Atlas," *Ethnology*, 2 (1963), pp. 109–33 and installments in subsequent numbers and volumes.

Segall, Marshall H., Campbell, Donald T., and Herskovits, Melville H. "Cultural Difference in the Perception of Geometric Illusions," *Science*, 1939 (1963), pp. 769–71.

Siegel, Sidney. *Non-Parametric Statistics for the Behavioral Sciences*. New York: McGraw-Hill, 1956.

Visual Categories:
An Approach to the Study of
Representational Systems*

NANCY D. MUNN

The visual arts of a society are like other cultural codes, a way of ordering and categorizing experience. The categorical analysis of the Australian Walbiri representational system and its meaning is contrasted with graphic data from other societies. The pattern of organization found in the Walbiri pictorial system also orders their totemic designs. These designs can function to classify totemic species by reassembling them in a different order in a way similar to those described by Lévi-Strauss.

Nancy D. Munn is an Assistant Professor of Anthropology in the Department of Anthropology of the University of Massachusetts, Amherst. Her particular interests are symbol theory, ritual and religion, art and iconography, and idea systems. She has done field work in Australia and New Guinea. Two other articles related to this one are "Australian Aborigines; Problems in Comparative Art; Symbol Theory," and "Totemic Designs and Group Continuity in Walbiri Cosmology," both published in *Aborigines Now* (1964).

The graphic representations of the central Australian Walbiri and supplementary comparative data are used to explore the general thesis that categorical analysis can be applied to representational systems. Certain features of the meaning ranges of typical Walbiri elements are examined and compared with those of pictorial elements from other systems. It is suggested that Walbiri totemic designs, consisting of combinations of these elements, can func-

* Reprinted from *American Anthropologist*, Vol. 68, No. 4 (August, 1966), pp. 936–50. This paper is a revised version of one given at the 1964 meetings of the Australian–New Zealand Association for the Advancement of Science in Canberra. At the time, the author was in Australia under the auspices of the Australian Institute of Aboriginal Studies. The author is grateful to Robert J. Smith and Victor W. Turner for reading and commenting upon an earlier draft of the present paper.

tion to classify totemic species by dissecting and reassembling them in a manner similar to that described by Lévi-Strauss for other cultural systems.

I

Culturally standardized systems of visual representation, like other sorts of cultural codes, function as mechanisms for ordering experience and segmenting it into manageable categories. While this orientation toward the examination of pictorial art has recently been emphasized by the art historian E. H. Gombrich (1960), it has not to date been taken up by anthropologists, who might well extend current studies of cultural categories and schemes of classification to include it.

In this paper, intended to be exploratory, I use the notions of "element" and "category" to discuss some classificatory aspects of pictorial systems. While my illustrations are drawn primarily from the graphic art of the central Australian Walbiri[1] and from bark paintings made at Yirrkalla[2] in northern Australia, supplemented by examples from other societies, it is my contention that an approach based on the definition of contrastive units and meaning ranges is relevant to any system of culturally standardized representations (two- or three-dimensional) where one can identify discrete, recurrent units through which visual contrasts are made.[3]

[1] Research among the Walbiri was supported by a Fulbright grant and carried out under the auspices of the Australian National University between 1956 and 1958 at Yuendumu settlement, Northern Territory (central Australia), where primarily southern Walbiri were in residence. The social organization of the Walbiri is described by Meggitt (1962). Further details of the graphic system, the social processes in which it is embedded, and the cosmological significance Walbiri attach to their totemic designs (see part II of this paper) are given in Munn (1962, 1963, 1964).

[2] The Yirrkalla elements are after illustrations of bark paintings in Mountford (1956, Plates 112A, 96B, 106B, 108B, 119A, 119C, 115A). Other major sources illustrating Yirrkalla paintings are Berndt (1964) and Elkin, Berndt, and Berndt (1950).

[3] A few examples of well-developed representational systems are the paintings and carvings of the northwest coast Indians, Navaho sand paintings, ancient Mayan sculpture and painting, certain African figurine systems like the Ashanti goldweights, Yoruba religious carvings, and masking systems like those of the Dogon or the Pueblos. The religious sculpture and

In Figure 1, I have assembled some visual schemata from Walbiri sand drawings and designs on sacra and from Yirrkalla bark paintings of northeast Arnhem Land that exemplify two familiar sorts of schemata occurring in Australian art. Each schema shown here is an irreducible unit, used to stand for certain meaning items, examples of which are listed under it.[4] All the schemata are iconic in the sense that some feature of likeness characterizes the relation between the visual form and its meanings, and this feature is intrinsic to the functioning of the graphic system. Put another way, each schema provides a "structural equivalent" for its object within a particular system of such equivalents (cf. Arnheim, 1954, p. 132). I therefore use the term "representation" in its broad sense to cover all these visual elements regardless of the character of the visual similarity between the element and its referents.[5]

painting of medieval Europe and Byzantium and of Indian Buddhism and Hinduism furnish additional examples of highly elaborate iconographics. All of these arts, although varying in complexity, are built upon the principle of discrete, recurrent contrasts.

[4] The published examples of Yirrkalla schemata for lizards, turtles, and human beings appear in some instances to consist of a separable schema for "arms" (or "arms" and "legs") combined with a "body" schema. The typical Yirrkalla element, however, is a contour of the whole figure, and it is not clear whether internal segmentation may also occur. For present purposes, I regard these representations as unbreakable units exemplifying the schematic type discussed in the text.

[5] A narrower use of the term "representation" is sometimes made. Thus Beardsley (1958, pp. 270 ff.) treats circles and similar visual forms as nonrepresentational and merely "suggestive" because of their relatively generalized visual properties. According to his definition, "design x" can be said to depict or represent "object y" when "x contains some area this is more similar to the visual appearance of y's than to objects of any other class" (1958, p. 270). The circle, he suggests, has a shape sufficiently general for it to stand for various classes of species of phenomena such as plates, moons, etc. "But it is no *more* like a moon than it is like a plate, and so it cannot really be said by our definition to *depict* (i.e., represent) any of these things" (p. 270). In effect, Beardsley's argument arbitrarily restricts representation to object classes of a certain level and kind of generality, as he himself makes clear in his subsequent argument. Yet, as I discuss later, a visually simple form like the circle can certainly provide a pictorial equivalent for a class of objects—in the case of the Walbiri circle, a class of "closed," nonelongate, or roundish objects—and one must grant that a

All the items that can be represented by one schema constitute what I shall call a *visual category*. By this term I mean any range of meaning items represented either by a single, irreducible visual schema (as in Figure 1) or by a unitary combination of more than one such schema (as in Figure 2). Categories defined by schemata of the first sort—the fundamental elements of a graphic system—I call *elementary categories*. Those defined by unitary constructions of more than one element I call *composite categories*.

As an example of an elementary category, consider the tree from Yirrkalla paintings depicted in Figure 1a. In the literature on the paintings, a meaning provided by the informant in a particular instance—for example, "mangrove tree" or "casuarina"—is generally noted. However, the published data do not give enough information to determine with any certainty whether this particular "tree" schema can be used to depict any variety of tree distinguished by informants (so that all varieties would in effect belong to the one visual category), or whether the conventions restrict it to some varieties and not others. Moreover, a cursory examination of Yirrkalla paintings indicates that the painters use a number of slightly different schemata for trees. A tree can be drawn, for instance, with the branches extending upward rather than down, or with curved branches rather than straight ones. The problem is whether these and other variations in form are simply free variants—either standardized alternatives or idiosyncratic variations subject to the invention and whim of the painter—or rather indicators of some regular change in the meaning of the element. And, if the latter, do these changes refer to class inclusion (for exam-

circle used in this way would then meet Beardsley's definition of "representation." A more far-reaching criticism, however, is that the pictorial value of the circle or of any other visual form can only be determined by examining the particular system of visual-semantic contrasts of which it is a part. One can, in fact, conceive of a pictorial system in which the circle is used to stand for (let us say) waterholes only, with constrasting elements serving to represent classes such as moons or plates. In such a system, the circle would function as a pictorial likeness for waterholes and no other class of objects. On this view, the iconic value of a visual element is relative to its position in a particular system of conventions and cannot be defined outside of a system.

ple, are only certain kinds of trees drawn with curved branches)?

Only by more precisely determining the range of inclusion of each visual term can one come to predict the usage of the visual elements and to recognize and interpret innovations that may occur. Ideally, one should be able to define the semantic limits, or rules of use, for a particular schema; the specific meanings or referents will vary within these limits. If a standard schema comprehends a relatively general category such as "tree," an informant might use it to specify a casuarina tree in one instance, a mangrove in another; or he might say that it is just "a tree." The specific meaning depends upon the informant's selection from a range of possible meanings.

The degree of generality of the visual terms in a single system will vary, of course, as the examples from Yirrkalla art in Figure 1a suggest. Thus, the outline of a snake can probably be used for all varieties distinguished by the aborigines, but what appear to be more specific distinctions are illustrated by the occurrence of contrasting schemata for stingrays and devilrays and for fresh-water turtles (tortoises) on the one hand and green and hawksbill turtles on the other.[7] For the Walbiri elements, the meaning ranges of examples in Figure 1a and 1b also reflect different degrees of generality, as will become clear later.

The proper functioning of some representational systems depends quite directly upon a rather wide variability in the specific meanings possible for each schema, i.e., upon a relatively high degree of category generality. For instance, in a discussion of objects used in divination among the Ndembu of Northern Rhodesia, Turner (1961, pp. 8 ff.) describes a figurine that represents

[6] The English labels used here are the ones that serve to translate native terms as given in Mountford (1956): "green turtle," *gariwa;* "hawksbill turtle," *kouwaradji;* "fresh-water turtle" or "tortoise," *mimala.* Native terms also distinguish the two kinds of rays. I have no information, however, that would indicate whether Yirrkalla aborigines distinguish more general groupings, roughly comparable to our "turtles" or "rays," either by inclusion in a single verbal category or by other grouping techniques. It is of some interest that in the Yirrkalla string figures collected by McCarthy (1960, Figs. 176, 178), the distinctive feature of the tortoise is again the long neck, and the whole figure is constructed quite differently from that shown for the green turtle.

A. Continuous Meaning Ranges

Yirrkalla

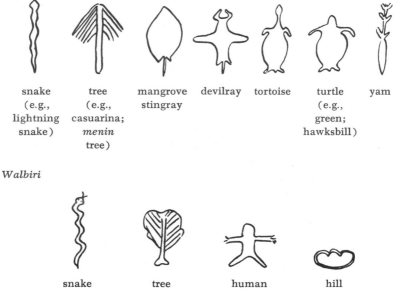

snake
(e.g.,
lightning
snake)

tree
(e.g.,
casuarina;
menin
tree)

mangrove
stingray

devilray

tortoise

turtle
(e.g.,
green;
hawksbill)

yam

Walbiri

snake

tree

human

hill

Figure 1a. Elementary Visual Categories

in simple outline the forms of a man, a woman, and a child. Turner points out that the diviner may interpret this figure in various ways. In one instance he may say that it represents a chief and his kin (man = chief; woman, child = kin); in another, a headman and his kin; in still, a third, witches. The man, woman, and child can be an elementary family, but more commonly they are interpreted as "comembers of a matrilineage"; further, the particular relationships within the matrilineage, and thus the specific kin represented, will vary with the diviner's interpretation. As Turner remarks, "all kinds of groups, relationships and differences of status can be expressed by this symbol" (1961, p. 9). Turner emphasizes that this sort of "multireference," as he calls it, characterizes all the divinatory objects.

B. Discontinuous Meaning Ranges—*Walbiri*

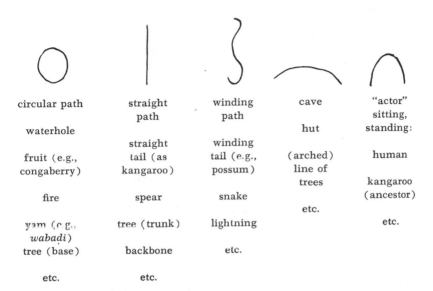

circular path	straight path	winding path	cave	"actor" sitting, standing:
waterhole			hut	
	straight tail (as kangaroo)	winding tail (e.g., possum)	(arched) line of trees	human
fruit (e.g., congaberry)				
fire	spear	snake		kangaroo (ancestor)
			etc.	
yam (e.g., *wabadi*)	tree (trunk)	lightning		etc.
tree (base)	backbone	etc.		
etc.	etc.			

Figure 1b. Elementary Visual Categories

The use of relatively general visual categories is well known to Western art historians; many examples can be cited from medieval European and Byzantine art. Thus Weitzmann (1947, p. 156), writing of certain early Christian book illuminations, comments that the "formula" for a Byzantine emperor was used "wherever a ruler or high dignitary was to be represented": ". . . Joseph in Egypt, or Pharaoh himself, King Saul, King David, or King Solomon all look alike, because the same convention was used for each of them." Similarly, Gombrich (1960, pp. 68–69) says of the "Nuremberg Chronicle": ". . . we find the same woodcut of a medieval city recurring with different captions as Damascus, Ferrara, Milan and Mantua. . . . we must conclude that neither the publisher nor the public minded whether the captions told the truth. All they were expected to do was to bring home to the reader that these names stood for cities." For each such fairly

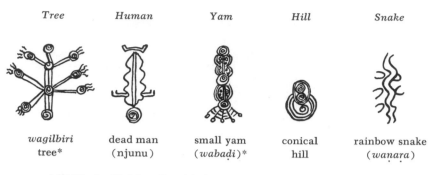

Tree	Human	Yam	Hill	Snake
wagilbiri tree*	dead man (njunu)	small yam (*wabaḍi*)*	conical hill	rainbow snake (*waṇara*)

* Slightly simplified from the original.

Figure 2.
Composite Visual Categories—*Walbiri*

general visual term, the specific meaning relevant to a particular usage can be communicated in different ways. The oral identifications of the Ndembu diviner have been mentioned; in literate societies the parallel device is the use of written inscriptions. The Carolingian scholar Alcuin (quoted in De Bruyn, 1946, 1, p. 283) states this function succinctly: "Represent a woman holding an infant on her knee. If there is no inscription how does one know if she represents the Virgin with Christ or Venus with Aeneas, Alcmene with Hercules, Andromica with Astyanax?"

To turn to the schemata in Figure 1b, the problem of category generality is presented here in a special form. These schemata cover highly general categories, each of which includes a variety of different classes of phenomena. The circle, for instance, can be used to specify a waterhole (or, when required by context, a particular waterhole at a named place), fire, fruits of various kinds, and other items. In ordinary usage, as in a sand drawing accompanying conversation, only one of these meaning classes is relevant at a time. For example, a circle between two facing arcs might in one instance specify two (particular) persons sitting at a waterhole and, in another, two persons sitting at a fire; these individuals might be human beings or ancestral persons such as kangaroo men or any other class of mobile being recognized by the

Walbiri. The point is that the persons using the system select in each instance a specific meaning from the range of possible meanings.

The visual category comprehended by the circle consists of all "roundish" or "closed," nonelongate phenomena. Items of a straight, elongate form like spears and straight paths are represented by a straight line. Elongate, winding forms like snakes and lightning are represented by a meander line. These categories are so broad that an indefinite variety of phenomena can be pictured by each element; the Walbiri schemata characterize an object by a basic defining feature of shape. Pictures of this kind reduce objects to their limiting features rather than elaborate their visual particularities (hence they have often been confusingly labeled "abstract" or "geometric").

Thus, the meaning ranges of the Walbiri elements shown in Figure 1b are not restricted to species of things, such as "trees," "yams," or "turtles"; rather, they intersect class or species distinctions of this kind. The circle, which conveys the "roundness" or "closedness" of an object, can portray equally well a yam, say, or the base of a tree (standing for the tree as a whole in some Walbiri usages). In the Yirrkalla idiom a yam is represented by a more specialized form, which cannot also depict a tree. Rather, the pictures for "yam" and "tree" contrast as separate elements in the system.

Borrowing a label from linguistics, I have called meaning ranges of the type exemplified in Figure 1b *discontinuous* since they include heterogeneous classes of meaning items, only one of which is relevant at a time. As we shall see, however, Walbiri also make use of metaphoric linkages in some segments of the graphic system, so that more than one of these classes of items can be applicable in a single instance.

Meaning ranges of the 1a elements, on the other hand, I have called *continuous* since they do not cover heterogeneous classes of meaning items. A "tree" schema might be used for different varieties of trees, but cannot also represent waterholes, fires, and other such classes of phenomena.

As Figure 1a indicates, elements with continuous meaning ranges do occur in Walbiri art; this system also uses "footprints,"

most of which (for example, kangaroo or dog prints) have continuous ranges. Conversely, what appear to be discontinuous categories occur also in the Yirrkalla system. The emphasis upon highly general elementary categories with discontinuous ranges is, however, an outstanding characteristic of central Australian art; as we shall see, Walbiri art is elaborated on principles that "play" upon this feature.

One may infer that an art like the Walbiri, functioning primarily with discontinuous elementary categories, could operate with a smaller number of elements than one relying largely on continuous categories. Where the meaning ranges are discontinuous, it is theoretically possible to increase the number of classes of phenomena represented without expanding the repertory of visual elements. Walbiri women, for instance, represent the Australian billy-can in their sand drawings by a circle rather than by creating a specific schema to picture it, for the billy is readily fitted into the category of "roundish," "closed" forms represented by the circle. Or let us suppose that, using the elements of this system, we wanted to portray a car. We might decide to represent the whole car as a circle; or, alternatively, we might treat the wheels as circles and the axle and body of the car as a line. We would then have to combine the circles and the line in an appropriate arrangement, but we still would not have increased the number of basic elements or elementary visual categories. On the other hand, if we were using elements of the continuous type, we would have to create a separate schema to picture a car, and so we would add to the number of visual elements in the system.

Ethnographic examples of pictorial systems relying primarily upon discontinuous categories, other than the central Australian, can only be identified tentatively from the descriptive literature. It seems probable, for example, that the parfleche decoration of the Arapaho Indians described by Kroeber (1902), and examined by Boas (1927, pp. 88 ff.) along with other similar systems, is of this kind. The elements in this art are lines, triangles, rectangles, and other basic forms, which are combined into a limited number of standardized arrangements. A single element can stand for a variety of different meaning items: a triangle, for instance, can stand for items such as "mountain," "tent," and "body-part of a

person"; elongate items like paths, however, are represented by lines.

Kroeber was impressed by the variety of meanings for each element. Thus, in describing a particular bag, he says:

> It will be noticed that identical white spots mean on different sides of the bag respectively snow-patches and turtle-eggs. What signification they have depends in each case on the symbolic context. Similarly a three pronged figure . . . often signifies the bear's foot, but here, when adjacent to a turtle-symbol, a turtle's foot. Such representation of different objects by the same symbol—or such different interpretation of the same figure . . . is constantly found . . . (1902, p. 83).

There is an interesting similarity between Kroeber's description of the Arapaho design meanings and the semantic descriptions of central Australian designs by early observers. In both cases, meanings were thought to be highly variable without any discoverable intrinsic patterning; extrinsic "context" and the informant's personal whim were the only limiting factors. Davidson (1937, pp. 91 ff.), for instance, stressing the "inconstant character" of design meanings in central Australian art, pointed out:

> For the geometrical designs . . . we find great differences in meaning. A group of concentric circles or a spiral . . . are often interpreted as representing a totem center, the totemic animal or plant, a waterhole or some other natural feature of the terrain, the imprint in the earth left by a person's buttocks, the intestines of an animal or bird, an egg, or other things or places . . . (1937, p. 95).

In my opinion, it is very likely that the Arapaho system, like the central Australian, makes wide use of elements with discontinuous meaning ranges and that it has, therefore, a discoverable semantic structure.[7] If this is the case, then it would be useful to

7 The element arrangements in Arapaho designs provide additional evidence for this hypothesis. Although the same or similar types of constructions can in different instances refer to very different objects or object-complexes, the construction *resembles* the specified objects in each instance. One common construction, for example, consists of two "mirror-image"

reconsider Boas' classic treatment of the semantic variability of such designs in the light of the present discussion.

II

I now turn to composite categories in Walbiri art. I mean to illustrate both the pictorial possibilities of a system using discontinuous elementary categories and one of the ways in which it can provide an organizing pattern or structure through which separate classes of phenomena—in this case totemic phenomena—can be ordered.

My examples are drawn from men's totemic designs, since it is within this genre of Walbiri art that the potentialities of the graphic system are most fully realized. Each design is connected with one of the totemic ancestors whose travels created the country, and it pictures various features of the species to which the ancestor belongs. A single ancestor is generally represented by more than one design. A few designs are connected with "mythical" beings not directly associated with the creative ancestors, but like them classified in terms of the subsection and descent systems.[8] One example in Figure 2, the "dead man," is of this sort.

Figures 1a and 2 illustrate two different ways of representing similar phenomena, both of which occur in Walbiri art. In Figure 1a are elements comprehending continuous categories; except for the figure of a human being, each was identified by an informant as a totemic design or part of a design. In Figure 2 are examples of the more typical Walbiri designs: composite constructions of circles, lines, and additional constituents. These constructions

segments with a connecting element or "juncture." This can specify various items: examples are "two frogs with heads in scum" (scum = juncture from either side of which the legs and bodies of the frogs extend); a turtle (carapace = juncture from which the claws extend). See Kroeber (1902, Fig. 28; Plate XII, Fig. 4). The systematic iconicity of a construction over a range of very different phenomena is one index of internal semantic order in the designs. Walbiri constructions operate very similarly (see above, part II).

8 Rights over ancestral totems and their associated designs are held by patrilineal groups; the totems are classified in the same father-son subsection couple as the groups that have rights over them.

actually yield continuous categories on the order of "snake," "tree," "yam," etc.

For present purposes it is sufficient to note the general order or class of phenomena and the particular variety represented by the designs in Figure 2 (*wagilbiri* tree, small yam, etc.), but a more detailed consideration of meaning ranges and of the degree of exclusiveness of visual distinctiveness of the constructions would be necessary for an accurate assessment of the categories. For example, the meander line combined with a particular arrangement of arcs appears to be restricted to representations of rainbow snakes, while similar but not identical configurations occur for other snakes. Although the meander line is also used in the closely related designs for rain—where it may specify lightning, say, or rain falling—the snake arrangement of arcs and meanders does not occur in rain designs, and two informants in fact distinguished rain and rainbow snake on this basis.[9]

Thus, through the combination of different selections of elements into various arrangements, a system that works with highly general elementary categories of the discontinuous type can yield composite categories with continuous meaning ranges. This mode of representation can provide pictorial detail as easily as one using elementary continuous categories. The depictions of trees in Figures 1a and 2 are structurally different—the former is a single, unbreakable unit; the latter has hierarchical structure since it is made by combining more than one element into a unified pattern—but the latter also pictures the roots, trunk, branches, and leaves in an appropriate arrangement.

In the representations of Figure 1a, the different pictures cannot be broken down into any shared constituent parts, and the Walbiri representations of a snake, tree, human, and hill do not bear any significant similarity to each other. Nothing in the

9 Not all categorical contrasts can be determined as clearly from my data as those for rain and rainbow snake and related species; nevertheless, the typical designs for certain well-known totem species contain clear-cut visual contrasts. In the case of less well-known totems the problem of analysis is more complex. In addition, not all designs available for a totem contain features distinguishing the species. Some designs, for instance, are part of a highly generalized graphic idiom that can be used for any totem. Thus, designs of differing degrees of generality or distinctiveness occur.

observable form of the pictures would convey to us that these phenomena might have anything in common. But in the typical totemic designs of Figure 2 it is precisely the similarity between representations of different phenomena that strikes us. These similarities are of two kinds: shared terms or elements and shared types of arrangements. The relatively distinctive constructions can be resolved into constituent elements, of which the circle and the straight or meander line occur either singly or together in all the pictures. Other elements, such as the arc, also occur in more than one design. Thus the composite categories covering classes such as "tree" or "yam" can be broken down into elementary categories partially shared with other designs.

The constructions also share common arrangements. We may distinguish one sort in which a central unit consisting of a circle (or series of circles) and line sequence is accompanied by various elements ranged around or adjoined to the sequence. The pictures of the tree, man, and yam are of this kind. In another sort of arrangement the central unit consists of a circle or line (in the example, a meander line) with surrounding or adjoined elements; "conical hill" and "rainbow snake" are the examples. I call the central parts of these designs the *core* and the surrounding elements *adjuncts*. Walbiri themselves, when making these designs, generally draw the core elements first and then add the surrounding elements, but the core-adjunct analysis and description derives from my examination of semantic and structural features of the designs rather than from any explicit Walbiri analysis.[10] While other types of constructions occur in the totemic designs, this core-adjunct type is basic to the system as a whole and has the widest distribution among the different totems.

The designs in Figure 2 can all be broken down into core and adjunctive parts. Elements functioning as the core are always

[10] The criteria used for designating parts of designs as core or adjunct, and occasional ambiguities giving rise to problems in the analysis of particular designs, are not discussed here. Compositional features from other parts of the system suggest, for instance, that the branches in Table 1 could perhaps be analyzed as core rather than adjunctive elements. Difficulties of this sort, however, are outside the scope of this paper, which aims only to call attention to an organizing structure implicit in the representational system.

circles or lines or both. Elements that may fill the adjunctive slot are widely variable; they include the circle and straight line as well as, more commonly, other elements in the system. In Table 1 the vertical columns show both the core and adjunctive positions and the visual elements from the designs in Figure 2 that occur in each position. The elements and positions illustrate a kind of vocabulary and grammar, in terms of which a design can be constructed.

The horizontal columns show the assemblages of parts (from Figure 2) that are relevant to a particular totem species. For example, the dead man consists of backbone, buttocks, ribs, arms, and legs. The backbone and buttocks are treated as the core, while ribs, arms, and legs function as adjuncts. The arrangement of parts is handled in terms of a general pattern common to designs for other phenomena. Moreover, the backbone, buttocks, and ribs belong to larger categories: the backbone to a category of elongate items that can all be represented by the line; the buttocks to a contrasting category of "roundish" items represented by the circle; and the ribs to still another broad category of plural, semicircular items represented by arcs. Only the arms and legs are pictured by elements with a very limited distribution in the designs as a whole. Different parts of the dead man are thus reclassified into broad visual categories (roughly: roundish, elongate, and semicircular segments) common to other species as well.

In effect, to picture an object in this system one dissects it into two parts: on the one hand, a central stem or torso-like part such as the tree trunk and its roots, the snake's body, the main portion of the hill; on the other, its appendage-like parts such as tree branches and leaves, the pearl shells associated with the rainbow snake (which he is said to send out with the rain), and the conical tip of the hill.

Since the body or torso-like parts are of two kinds—elongate items (meandering or straight) such as the snake and yam stem, and closed, roundish items such as the hill and yam tubers—there is an additional dual classification into elongate and roundish segments of the torso implicit in the structure of the system. This classification is reinforced by an explicit Walbiri metaphor. Walbiri equate the elongate parts with the paths of these totemic beings (tree trunks and yam stems, for instance, are also ancestral paths), and all the roundish parts with their camp sites (for

example, the yam tuber is the camp of the yam). This metaphor functions to reinforce the unity of each visual category since varied items in the same category are metaphorically identified as "the same thing" (see also Munn, 1962).

Table 1 can now be read as the outline of an analysis and classification of phenomena. This classification, implicit in the structure of the totemic designs, suggests the sort of dissection and reordering of different totemic species in terms of a common structure discussed by Lévi-Strauss (1962). One of his examples is the description of totemic animals in the ritual chants of the Osage Indians. Lévi-Strauss points out that the different animals connected with the Osage clans are described in the texts in a way that effectively analyzes these species into a "system of invariant characters supposedly common to all the species" (1962, p. 193).

Thus, in the Osage chants the puma asserts that he has black feet, a black muzzle, and a black tail. According to Lévi-Strauss, all the other totemic animals and birds are similarly described, and items such as beaks and noses are equated. The different totems are in effect broken down into a set of corresponding parts: the muzzle or noselike parts, including the bear's muzzle, the eagle's beak, and other such items; the feetlike parts, including the bear's feet, the eagle's claws, and so on. In addition, all these items are said to be black, a feature that (because of certain symbolic associations important to the Osage) is stressed as being common to all the animals.

On the one hand, each of these totemic species is distinctive and functions as the symbol of a particular clan; on the other hand, each can be analyzed into a set of parts shared with the other totemic animals and intersecting these species differences. As Lévi-Strauss points out, there is "a sort of ideal dismemberment of each species that re-establishes . . . the totality on another plan" (1962, p. 195).

Much the same may be said of the Walbiri designs. On the one hand, totems of different species can be represented by contrastive designs.[11] On the other hand, a common structure and

[11] Walbiri designs do not constitute a "heraldry" in the strict sense of this word. A single patrilineal group has rights over a number of totemic species, and designs for these species do not necessarily share common visual features marking them off from designs representing totems con-

Table 1. Core-Adjunct Construction

	CORE		ADJUNCT					
	○	\|	○	\|	}}}))	⊐	oo oo
Tree (*wagilbiri*)	tree roots (and branch junctures)	trunk	branch tops (camps)	branches (paths adjoining main track)	leaves			
Human (dead man)	buttocks	backbone				ribs	legs, arms	
Yam (small yam)	yam tubers (=hills)	underground stem				roots (also: lines— roots)		small tubers
Hill (conical)	hill		conical tip (small camps)					
Snake (rainbow snake)		snake's body				pearl shells		
	Camp	*Path*						

shared visual categories intersecting these differences reorder the different species in terms of a common pattern. This reordering provides a kind of visual comparison and analysis. A construction of the core-adjunct type can in theory be used to represent any totemic species, which could thus be analyzed and reassembled in the terms I have described.

The reliance upon graphic elements comprehending highly

trolled by other groups. Segmentation in the social structure cannot be "read off" from critical visual contrasts between designs or relevant sets of designs.

general visual categories with discontinuous meaning ranges together with the use of a limited number of construction types (of which I have discussed the most widely used one) makes it possible to represent an indefinite variety of totemic species without necessarily increasing the visual complexity of the system. Since the number of Walbiri totem species is exceedingly large (Meggitt [1962, p. 205] counted over 150 totems for the Walbiri as a whole, some of them belonging to the same species), this graphic economy is of some functional significance.

The design structure that I have described also meshes with Walbiri cosmology. Walbiri regard each major totemic ancestor as an individual with a particular set of locale associations; the individual belongs to a species, and a cluster of attributes (including characteristic behavioral as well as formal attributes) stereotypes each species, marking it off from others. But all species of ancestors also share certain important attributes: for example, all made camps and left track-marks in the country (Munn, 1962, 1964). These shared attributes are criteria of the class of totemic ancestors.

This interplay between similarity and difference, unity and plurality, is also plotted in the design system, as I have briefly suggested, although a more precise examination of the links between design structure and these principles in the cosmology is outside the scope of my paper. To the extent that the design structure conveys an organization inherent in the cosmology, the designs function as visual models that present these principles, as it were, directly for inspection. Bober (1956–57, p. 84) comments on this kind of function when he describes certain circular schemata or *rotae* in a medieval school book as "visual instruments" because of "their peculiar capacity to give visual expression to broad syntheses of a given subject; to show correlation between its parts." In this sense, Walbiri designs can also be called "visual instruments."

III

In his recent review of ethnoscientific studies, Sturtevant (1964, p. 107) has pointed out that since "non-linguistic communication systems are also structured . . . it seems wise not to

restrict the meaning of ethnoscience to the study of terminological systems." Although he suggests that "complex aesthetic phenomena" may be one of the possible candidates for structural analysis, Sturtevant does not mention visual representations as such. In the present paper I have attempted to show that the concepts of elementary unit and category can be illuminating in the analysis of representational systems. I have distinguished a type of visual category that includes radically different, "discontinuous" classes of meaning items from one in which the included items are relatively homogeneous or "continuous." In the Walbiri case I have shown how the use of discontinuous elementary categories as a basic organizing principle affects certain features of the larger representational structure.

One implication of this paper is that representational systems, or aspects of them, could be compared cross-culturally along structural rather than simply stylistic dimensions. It is interesting to consider, for example, how an art handles the problem of contrasting a series of related individuals or classes of phenomena such as totemic ancestors, a pantheon of gods, or saints. I have described one solution to this problem, that characteristic of Walbiri totemic designs.

Some additional notes may be helpful in suggesting a comparative context. Where the elementary categories are continuous (rather than primarily discontinuous, as in the Walbiri case), schemata for members of the series may be systematically differentiated by sets of contrastive features, such as clothing, position, etc., elaborated across the series. Thus, in medieval European art the portrait "type" of each saint is differentiated by a cluster of traits involving clothing, beard, and hair style; these traits are components of the elementary schema (the human figure), unlike emblems, which are *added to* the unit. A less systematic, but similar mode of specification is suggested by Ray for Alaskan Eskimo carvings: "selected diagnostic characteristics of animals are of primary concern to the contemporary carvers. . . . The carvers differentiate the white fox from the red fox, for example, by making the legs of the former shorter, and they indicate the differences between polar bear and brown bear by the smaller size of the brown bear's palms and the greater amount of fur on the polar bear's front legs" (1961, p. 144).

Another device, that of adding diacritical emblems to a representation, is familiar from diverse arts. Emblems, such as the corn or arrows often held by the personae of Navaho sand paintings, are the distinctive attributes of certain individuals or social categories, for instance, the category "warrior." Emblems may also occur along with featural contrasts, as in later medieval depictions of saints or in Indian images of the Divine Buddhas. In all these examples the problem is one of showing the distinctive features of a number of individuals or separate categories of beings who also share common characteristics. The particular solution chosen will, of course, be framed, as in the Walbiri case, in terms of the wider representational structure.

The questions I have raised lead to more general issues in the study of pictorial codes. What structural devices are widespread in such codes, and how does iconicity itself limit the possible ordering techniques employed cross-culturally? To answer these and related questions we must refine the current ethnographic tools used in describing the representational arts. Indeed, the ideal that Conklin has voiced with respect to language could well be applied to the study of visual representations: "accurate and productive ethnography . . . [must go] beyond the identification and mere cataloguing of linguistic forms to the point where crucial structural semantic relations can be described systematically" (1962, p. 86). The substitution of "representational" for "linguistic" in this statement would aptly sum up the viewpoint of the present paper.

Bibliography

Arnheim, R. *Art and Visual Perception*. Berkeley: University of California Press, 1954.

Beardsley, M. C. *Aesthetics: Problems in the Philosophy of Criticism*. New York: Harcourt Brace, 1958.

Berndt, R. M. (ed.). *Australian Aboriginal Art*. Sydney: Ure Smith, 1964.

Boas, F. *Primitive Art*. Oslo: H. Aschehoug, 1927. Reprinted 1955, New York, Dover; page references to this edition.

Bober, H. "An Illustrated Medieval School-Book of Bede's 'De Natura Rerum,'" *Journal of the Walters Art Gallery*, 19–20 (1956–57), pp. 65–97.

Conklin, H. Comment on C. Frake, "The Ethnographic Study of Cognitive

Systems," in *Anthropology and Human Behavior*. Washington, D.C.: Anthropological Society of Washington, 1962.

Davidson, D. S. "A Preliminary Consideration of Aboriginal Decorative Art," *Memoirs of the American Philosophical Society*, vol. 9. Philadelphia, 1937.

De Bruyn, E. *Études d'esthétique médiévale*. 3 vols. Bruges: de Tempel, 1946.

Elkin, A. P., Berndt, R. M., and Berndt, C. M. *Art in Arnhem Land*. Melbourne: Cheshire, 1950.

Gombrich, E. H. *Art and Illusion: A Study in the Psychology of Visual Representation*. (Bollingen Series XXXV.5.) New York: Pantheon, 1960.

Kroeber, A. L. "The Arapaho," *Bulletin of the American Museum of Natural History*, No. 18. New York (1902).

Lévi-Strauss, C. *La pensée sauvage*. Paris: Plon, 1962.

McCarthy, F. "The String Figures of Yirrkalla," *Records of the American-Australian Scientific Expedition to Arnhem Land*, Vol. 2: *Anthropology and Nutrition*. ed. C. P. Mountford. Melbourne: Melbourne University Press, 1960.

Meggitt, M. *Desert People*. Sydney: Angus and Robertson, 1962.

Mountford, C. P. *Records of the American-Australian Scientific Expedition to Arnhem Land*, Vol. 1: *Art, Myth and Symbolism*. Melbourne: Melbourne University Press, 1956.

Munn, N. D. "Walbiri Graphic Signs: An Analysis," *American Anthropologist*, 64 (1962), pp. 972–84.

———. "The Walbiri Sand Story," *Australian Territories*, 3 (1963), pp. 37–44.

———. "Totemic Designs and Group Continuity in Walbiri Cosmology," *Aborigines Now*. ed. M. Reay. Sydney: Angus and Robertson, 1964.

Ray, D. J. *Artists of the Tundra and the Sea*. Seattle: University of Washington Press, 1961.

Sturtevant, W. C. "Studies in Ethnoscience," *American Anthropologist*, 66, No. 3, pt. 2 (1964), pp. 99–131.

Turner, V. W. "Ndembu Divination, Its Symbolism and Techniques," *Rhodes Livingston Papers*, No. 31. Manchester: Manchester University Press, 1961.

Weitzmann, K. "Illustrations in Roll and Codex: A Study of the Origin and Method of Text Illustration," *Studies in Manuscript Illumination*, Vol. 2. Princeton: Princeton University Press, 1947.

Principles of Opposition and Vitality
in Fang Aesthetics*

JAMES W. FERNANDEZ

Using Durkheim's theories relating social organization to spatial organization and the dominance of the idea of contradiction in primitive society, Dr. Fernandez analyzes Fang aesthetics from his field data.

Central to the aesthetic ideas of the Fang is the notion of obtaining vitality through a balance of opposites—not only of forms, but also of qualities. This is demonstrated in their *bieri* statues, in the spatial organizations of the villages, their social organization, and other elements.

James W. Fernandez is Associate Professor of Anthropology in the Department of Anthropology, Dartmouth College. Religious cosmology and symbolic interactionism, cognition, and behavior are his subjects of interest, and Africa the area of his field research. Among other articles he has written "African Religious Movements—Types and Dynamics" (*Journal of Modern African Studies,* December, 1964); "Symbolic Consensus in a Fang Reformative Cult" (*American Anthropologist,* August, 1965); "Unbelievably Subtle Words—Representation and Integration in the Sermons of an African Syncretist Cult" (*Journal of the History of Religion,* August, 1966).

I

As part of his introductory argument to *The Elementary Forms of the Religious Life,* Durkheim raises a seminal point that has rarely since been adequately followed up in the literature or tested in the field. It is a point that he had raised previously, with Mauss, in an article, "On Some Forms of Primitive Classification,"

* Reprinted from *The Journal of Aesthetics and Art Criticism,* Vol. XXV, No. 1 (Fall, 1966), pp. 53–64. This paper was read at the Seminar in the African Humanities, Indiana University, March 20, 1963. This research, undertaken in Equatorial Africa, was supported by the Ford Foundation and the Program of African Studies, Northwestern University. For the invitation to address the seminar and for helpful comments the author is grateful to Alan Merriam and Roy Sieber.

which appeared in his *Journal de l'Annee Sociologique* in 1904.[1] If we examine some excerpts from Durkheim's argument we will see its relevance to the topic we have before us—Principles of Opposition and Vitality in Fang Aesthetics. He is speaking about the way in which Australian and North American Indian tribes lay out space.

> Among the Zuni, for example, the pueblo contains seven quarters. Each of these is a group of clans which has had a unity. Now their space also contains seven quarters and each of these seven quarters of the world is in intimate connection with a quarter of the pueblo that is to say with a group of clans. One division is thought to be in relation with the north, another represents the west, etc. [Moreover] each quarter of the pueblo has its characteristic color which symbolizes it.[2]

Since Durkheim's perspective is a sociological one, this material leads him directly to affirm that "the social organization has been the model for the spatial organization and a reproduction of it," an affirmation that he easily translates later into the book's major point—that social life has been the source of the religious life.

The relevance of these facts of social and spatial organization to aesthetic problems should be clear, for aesthetics, after all, has as one of its primary concerns the manner in which values, whether colors or tones or even words for the poet, are formally arranged in space. Presumably if one is able to tie up spatial organization with social organization he shall have said either one of two things. Either aesthetic preference responds more than we realize to social structure or social structure is itself to some extent the expression of an aesthetic preference.

More directly relevant for the body of our discussion, however, is Durkheim's further discussion in which, talking about the distinction between right and left in the primitive's organization of space, he suggests that in primitive societies the idea of contradiction is dominant. We have not clearly recognized this, he says,

1 Now translated with an introduction by Rodney Needham, *Primitive Classification* (Chicago, 1963).

2 Emile Durkheim, *The Elementary Forms of the Religious Life,* trans. from the French by Joseph Ward Swain (London, n.d.), p. 12.

because in our own societies the principle of identity dominates scientific thought. But our present logical bias notwithstanding, our doctrine of the excluded middle and our inability to contemplate unresolved contradictions, the idea of contradiction has been historically of the greatest importance. In primitive thought and in the mythologies that linger on in our own day Durkheim argues:

> We are continually coming upon things which have the most contradictory attributes simultaneously, who are at the same time one and many, material and spiritual, who can divide themselves up indefinitely without losing anything of their constitution. In mythology it is an axiom that the part is worth the whole.[3]

In the contradiction between the sacred and the profane Durkheim is of course to give us full explication of not only the importance of contradiction in primitive societies but indeed the necessity of it. Unfortunately, these two categories have never been fully understood and the overtones of the terms have tended to mystify the reader.

Rather than pursuing Durkheim in the direction of the sacred and the profane I shall take up this notion of contradiction as it manifests itself in Fang culture. I shall be interested in the idea in a number of areas of Fang life, but it must be kept in mind that my basic interest in it is as it is central to their aesthetic—their notions, that is, of preferred form in object and action. For what is aesthetically pleasing to the Fang has, as I shall attempt to show, a vitality that arises out of a certain relationship of contradictory elements. The Fang not only live easily with contradictions; they cannot live without them.

It is well known to Africanists that a good many peoples of that continent possess uncentralized political systems in which order and stability, however, are achieved through lineage structure and a principle called segmentary opposition. Of these people one might truly say that they cannot live without contradictions. The Fang, though highly uncentralized, do not have fully functioning lineages and by the period of field work, 1958–1960, had only the relics of segmentary opposition. In this they are like the rest of

3 Durkheim, p. 13.

the Bantu of northwestern equatorial Africa. For these people other kinds of evidence such as that introduced here are relevant.

Fang discourse in the area of aesthetics provides a direct translation for the word *vitality* (*eniñ*, or, more exactly, the capacity to survive). It is more difficult to find a substantive to translate the word *contradiction*. They speak of things that are in the general sense contradictory, adverbially in circumlocution as not being close to one another (*ka bi*—not approximate—not congenial and by extension not possible) or as standing opposite from each other (*mam me ne mfa ayat*). It is immediately apparent that they have a spatial analogy in mind when they speak of what we would call contradictions and, therefore, I have taken as the most satisfactory translation for Durkheim's term the word *opposition*, since the spatial analogy is in this word as well. There are difficulties in this translation for quite obviously what is contradictory may include more than what is simply in opposition. Contradiction may imply inconsistency which is not necessarily opposition. I shall ignore this difficulty, however, and limit myself to the principle of opposition as a portion of the idea of contradiction.

II

These notions of opposition and vitality first stood out for me in my data when I was querying the Fang as regards their famed ancestor figures. I had a collection of some twelve of these figures of various qualities, individual styles, and dates of manufacture (most of them recent unfortunately), and I simply asked each informant to select those he especially preferred and those he especially disliked, explaining why.[4] I accepted the thesis, incidentally, that there is such a thing as art criticism in nonliterate society and that art lies not so much in the act of creation but comes into being in the relationship between creation and criti-

4 The photographs are of a male figure, ht. 13 inches, and a female figure, ht. 17 inches. The male figure was carved in the 1930's, the female figure in the late 1950's. Both were carved by old men solidly within the tradition of Fang carving. The male statue was carved for a reliquary. Both statues are among the twelve figures mentioned.

cism—the artist and his critics. As events turned out among the Fang, there is indeed a lively spirit of art criticism. It flows around the carver as he is in the process of turning out his statue in the men's council house, and it influences his work. If I can take one of our focal concepts here in vain, it becomes possible to speak of an opposition between the carver and his village critics. Very often the villagers consider themselves the final cause of the statue and apply what social pressures they can to the efficient cause, the carver, to see that the work turns out to their expectations. The carver in his turn must reach some sort of accommodation with his critics and what this is depends upon the personalities involved. In some Fang villages the carver retreats from the council house to the solitude of the banana plantation behind the village and in these villages respect for the carver is sometimes even institutionalized though he cannot expect to escape his critics when the statue is completed. Carvers do not have much status or power in Fang society, though they are esteemed; therefore, they cannot expect to impose aesthetic acquiescence upon their clients. Nevertheless, it is a curious fact that I never found a case in which a statue was refused. The view seems to prevail that any statue can serve its function atop the reliquary whether it is aesthetically satisfying or not.

Given this custom of criticism, what, then, was the response of these eight informants, two of them carvers themselves, to the twelve figures? In explaining that response one must remember that it is the product of the evolution of Fang attitudes toward their ancestral figures as well as the evolution of the figures themselves. The Fang ancestor figure of the last thirty or forty years is a different object from the aboriginal one, and the thesis that the full figure was a stimulus response to European religious statuary is not to be rejected out of hand—probably by indirect acculturation from the coastal peoples of the southern Gabon, more particularly the Loango Vili and Balumbo who traded far up the coast and inland in the last half of the last century. In any case, as Tessmann has affirmed,[5] the aboriginal ancestral statue was simply a head carved on a stem thrust down into the top of the round bark

[5] Gunter Tessmann, *Die Pangwe*. Volkerkundliche Monographie eines Westafrikanischen Negerstammes (Berlin, 1913), pp. II, 117.

barrel containing the ancestral skulls. Tessmann does not point out what informants make clear that the bark barrel (*nsuk*) was taken as the belly or torso belonging to the head. The stomach, thorax, and sometimes viscera, it might be mentioned, are the centers of power and thought while the head is simply the organ of apprehension and direction enabling what fundamentally belongs to the torso willfully to be put to use. The Fang entertain a lively sense of opposition between the head and the torso that might be summed up appropriately in our aphorism "your eyes are bigger than your stomach." The hope for the Fang is that the head and the stomach should work together in complementary fashion though they do not always succeed in doing so. In any case the original reliquary (*bieri*) was conceived as a head (the carving) and a stomach (the bark barrel). These two elements had a relationship of complementary opposition. They worked together to accomplish the vital purposes of the cult though they were really in some sense opposing entities.

As Tessmann has further shown, the Fang ancestor carving changed from simply a head to a half figure, and finally to a full figure that perched on top of the bark (*nsuk*).[6] What took place, as I intend to show from the remarks of my informants, was a shift from the opposition between bark (*nsuk*) and carving to an opposition or oppositions within the carving itself, a tension which, as in the aboriginal situation, was a source of the carving's vitality. Accompanying this change in form of Fang statuary was a change in function. This change is signaled by Tessmann's remark that in his day the *eyima bieri* statues were very easy to purchase.[7] The Fang were eager to sell them—in strong contrast to the reliquary which was impossible to obtain. By the 1940's and '50's, however, and this was the ethnographer's personal experience, it became difficult indeed to buy or even view these statuettes which were practically all secreted away from the zealous eye of administration and missionary. It is clear that the Fang had come to attach considerable importance to the figure itself. Here again there is, conceivably, another example of stimulus diffusion, for the Fang were bound to have remarked the importance laid upon religious

6 Tessmann, p. 118.
7 Tessmann, p. 117.

statuary and graphic representations of the deity in Christianity, and were bound to reflect more respectfully upon their own figurations of the supernatural. It is of equal interest that only in recent years have pieces of cranial bone been actually worked into small concavities in the statuettes themselves. This custom, as well, is probably to be traced to the long-standing custom among the Loango, but what is of greater interest is that it represents to some degree a transfer of the function of the reliquary to the statue itself. In sum, the statue, the latter-day Fang ancestor statue, is a much more awesome and much different object from its predecessors. It is a much more autonomous object. Something of this awe was reflected in the approach of those informants called upon for an aesthetic critique of those statues which had already been in use. Insofar as it is always difficult to render an adequate aesthetic judgment of that which is at the same time sacred, so the informants' response to these figures seemed truncated by comparison to their response to the others. Apparently having rested on top of the craniums, they were somehow thenceforth removed from everyday aesthetic judgment.

In setting my informants before the statues arranged in a row, I tried to limit myself to the question, Which figures do you like the most and why? (*wa dan nyugue beyime beze Amu dze?*) In some cases I had to prompt an explanation for the informants, especially the carvers who hesitated apparently to criticize the work of another and tended to limit themselves to indicating their preference. But at no time was any aesthetic criteria suggested to the informant as a means of eliciting a response. I cannot enter here into a complete analysis of their responses, but I shall suggest the pertinent features. Their statements were full of words, of course, suggesting the finished or unfinished quality of the particular object, was it smooth, and had it been completely cut out from the wood from which it was made or were there still traces of its rougher origins? They talked about the balance (*bibwe*) of the object and whether its various quadrants balanced with the rest. If one leg or one arm or one shoulder was proportionately differently carved from its opposite, this was practically always a cause for comment and criticism. (Criticism was advanced against the two figures pictured here on this basis.) There should be balance in the

figure, and the proportions of opposite members whether legs or arms or eyes or breasts should display that. Without this balance of opposite members, it was said—and this is the important comment—the figure would not be a real one (*a se fwo mwan bian*), it would have no life or vitality within it (*eniñ e se ete*). I must confess that those features that seemed to have what *we* would call movement or vitality were not those selected by my informants. They generally picked those whose presentation and posture were stolid, formal, even—and perhaps this is the best word—suppressed.

This whole idea that vitality is obtained through the balance of opposite members in the statue was a clue of some importance in my understanding of Fang culture. This idea is, of course, crucial to our discussion and it deserves further examination. The Fang generally, and not only these informants, argue, when speaking of their statuettes, that they are "our traditional photographs." "They are our way of representing living persons as the European represents them in photographs." Now it is rarely argued that these statues represent particular living persons, just living persons in general. They are not portraits. But despite their quite obvious stylization the Fang insist that they are in some sense accurate portrayals of living persons. Now I have come to believe after lengthy discussions on this matter—for example, the Fang recognize well enough that the proportions of these statues are not the proportions of living men—that what the statue represents is not necessarily the truth, physically speaking, of a human body but a vital truth about human beings, that they keep opposites in balance. Both the statues and men have this in common and therefore the statues in this sense are accurate portrayals—accurate representations of living beings. They express, if they are well done, a fundamental principle of vitality. I am obliged to say, however, that this is an inference developed from my informants' remarks.

Though I think it unnecessary here to reconcile Fang statements with what has been disclosed above, it is often said that the *eyima bieri* gathers its power from its association with the craniums in the bark barrel and is nothing without it. This is, of course, primarily true of the *eyima bieri* before pieces of bone were actually placed within it and it became a *mwan biañ* (literally,

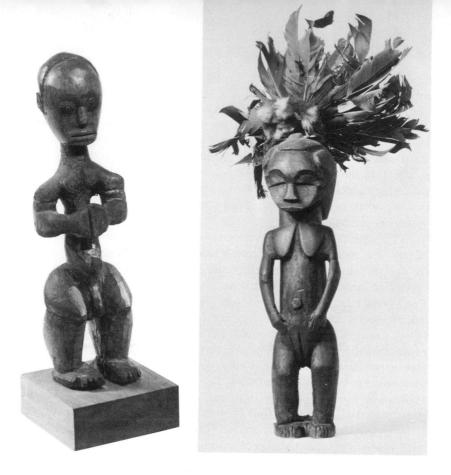

medicine child). It also should be noted that once a year during the initiation cycle of the ancestral cult the statues were taken off their reliquaries and danced as puppets above a palm thatch partition. Here, too, the object was to animate them, vitalize them, give them life. Whatever implications may be drawn from these further facts in respect to the vitality of the statuettes, it may, in any case, be concluded that it was important that they possessed this quality and that the aesthetic reaction to the figures was conditioned by that requirement.

Before considering the princples of opposition and vitality in other areas of Fang life, I should mention one further opposition—

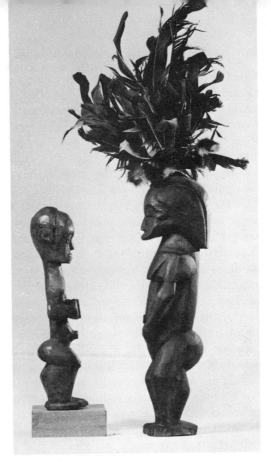

(*Far left*) Figure 1.
Male figure, 13″ high.
Mwan biañ. *Demaniacion
Akurnam*. Spanish Crimea.
(*Left*) Figure 2.
Female figure. *Eyima bieri*.
District d'Oyem, Gabon.
(*Right*) Figure 3.
Male and female figures.

though not a spatial opposition—which the Fang feel add quality
to these statues. If one looks closely at these statues, one finds that
the great majority of them have infantile or childlike features. The
obvious feature is the protruding stomach and umbilical rupture
which figures so largely in many statues. The umbilical rupture is
primarily characteristic of infants and children, less characteristic
of the strengthened stomach wall of adults. Another infantile fea-
ture lies in the stylization of the eyes obtained by nailing round
disks of tin into the orbital cavities. This feature was first called to
my attention by my clerk, who remarked the wide open glare of an
infant as being like that of an *eyima*. Research bore out the rele-

vancy of that association for many Fang. Finally the proportions of
the statue—the large torso, the big head, and the flexed, dispropor-
tionately small legs are definitely infantile in character. Now the
opposition contained here lies in the fact that the statue presents
both an infantile and an ancestral aspect. While the Fang argue
that the statues represent age, the ancestors, and their august
powers in their descendants' affairs, they also recognize the infan-
tile qualities of the figures themselves.

There are, of course, cosmological and theological explana-
tions for this juxtaposition of contradictory qualities in the statues.
Among these is the fact that the newborn are felt to be especially
close to the ancestors and are only gradually weaned away by
ritual and time to human status. Another explanation for the
infantile quality lies in the primary concern of the ancestral cult in
fertility and increase. An infantile representation is an apt expres-
sion of the desire for children. More important than that, I would
argue, however, is the fact that these contradictory qualities in the
ancestor figure give it a vitality for the Fang that it would not
possess if the *eyima* simply figures an aged person or an infant.

There is one other important and familiar opposition in Afri-
can traditional sculpture, that between male and female elements
as found in androgynous sculpture, particularly from the western
Sudan. Unfortunately, because the presence of Fang statues em-
bodying a male-female opposition would greatly enhance my argu-
ment as to the achievement of vitality through opposition, there
are to my knowledge no clear-cut examples of such sculpture
among the Fang. Where such statues are found in Africa the
argument we are developing here may apply.

III

I turn now to a discussion of opposition and vitality in other
areas of Fang life with the object of suggesting that these principles
at work in their aesthetic reaction to their ancestor figures are
found more broadly in their culture. First impressions support me
here. The Fang village, when approached from the equatorial rain
forest, with its two long rows of huts facing each other across a
narrow barren court, provokes in the observer the immediate

impression of oppositon. And it would seem that the existence of oppositions in their society is recognized in the way the Fang lay out their villages. In fact, the minor segment of the clan (the *mvogabot*) is often defined as those brothers who build opposite each other because, it is said, it is better to shout insults across the court of the village to your distant brother than whisper them in his ears as your neighbor. This spatial opposition prevails even within the family (*ndebot*, house of people), and the Fang say *nda mbo, binoñ bibañ* (one house, two beds) to imply that opposition and resultant division lie even in this smallest social unit, the domestic household of the extended family. Equally it may be noted that the arrangement and mechanics of dispute in the men's council house follow this plan of opposition. In the *aba* there are two rows of benches upon which the disputants sit facing each other and between which the witnesses or judges rise, one at a time, to make their statements.

The opposition which exists within the minor segment (*mvogabot*) is that of lineage relatives whose relationship is distant enough, usually more than four generations deep, so that it no longer imposes a strong allegiance. Their tenuous relationship is signified by spatial opposition in building arrangement. *Ndebot,* houses of people, extended families within the *mvogabot,* build side by side in the lengthening double row of houses with which we are familiar, so long as they feel strong allegiance. But they build opposite when they no longer feel the close bonds. A feeling of separation and instability within the lineage is expressed by spatial opposition. It is necessary to point out, however, that the spatial opposition of village structure is not conceived as an undesirable end in itself but is regarded as necessary. One row of houses without its opposite does not constitute a village; such a village cannot be good, pleasing, or functional. Two opposite rows of houses, it is said, stand off the forest and in the old days of internecine strife provided a closed, fortified rectangle against surprise attack. Moreover, the social antagonisms of lineage members living on opposite sides of the court are one important source, it is admitted, of the animation (*elulua*) and vitality (*eniñ*—the word is actually used) that is one of the desired features of village life. Here, then, as well, opposition is associated with vitality.

What is aesthetically appropriate is socially necessary. The oppositions we have noted are part of a larger scheme guaranteeing social viability.

Now the achievement of viability in the social structure through complementary opposition of equivalent segments has been, as mentioned above, fully demonstrated by anthropologists in respect to segmentary kinship systems. Though the Fang recognize segments within their lineages and though these seem to be vestiges of corporate kinship groups, those segments do not now have full corporate character. Hence they do not provide complete data in respect to the notion of complementary opposition. It is possible, however, to examine the same principle in full-blown operation among the Fang in the kinship mechanism known as complementary filiation—the tendency to trace relationship of ascending generations alternately to male and female progenitor and progenitrix. Thus the *ndebot* is traced to a woman founder, the *mvogabot* to a male, the next segment beyond that to a female, and eventually to the clan which is traced to a male. Now the point here is that male and female qualities are to the Fang opposing ones. The principal connotation of male origin is divisiveness and conflict; the principal connotation of female origin is unity and common purpose. Moreover, these connotations accord with the nature of the various segmentary groups as they are traced to either male or female. The *ndebot* seen as founded by a female is cohesive and fairly stable. The *mvogabot* traced to a male founder is divisive and volatile and so on up to the clan level whose male origin accords with its characteristic potential for dispersion and division.

The Fang argue when questioned about this custom that no clan, lineage, or segment can be created by men alone; hence they must trace their kin groups to both male and female. They argue in effect, if I may be permitted to summarize the drift of a good bit of field material on this point, that the viability of the kin group lies in the fact that it is anchored in opposing qualities male and female which, however, due to their distribution at different levels of the lineage, achieve complementary opposition. The lineage structure systematically distributes maleness and femaleness so that these two opposing qualities do not clash at the same level. In

the same way the village layout distributes opposition in space so that these oppositions are complementary and not conflictive.

It may be argued, I think, that this manipulation of male and female elements in the lineage genealogy gives evidence of a "kind of experimentation or play of fashion," as Kroeber called it,[8] in which the Fang are using and distributing the different valences of maleness and femaleness in the social structure in order to provide for themselves an aesthetically satisfying fiction. The distribution of these opposites, maleness and femaleness, in other words, satisfies aesthetic criteria and in doing so provides for viability. The opposition between maleness and femaleness not only is found in the social structure, incidentally, but is carried throughout the Fang world view and is evident in dualistic sets such as hot (male) and cold (female), night and moon (female) and day and sun (male), earth (female) and sky (male). These sets of oppositions suggest an elemental opposition—a dualism in fact—in Fang culture itself which though it has clear manifestation in social structure does not exhaust its importance there but lies behind all cultural manifestations.

I shall return to this problem of dualism in the conclusion. I want first, in a final attempt to link the principles of opposition and vitality, however, to consider what the Fang mean by maturity and what for them are the sources of maturity. For I think it may be argued that a truly mature man is an object of aesthetic appreciation.

The mature man (*nyamoro*, real man) is a man between thirty-five and fifty-five, at the height of his powers. The idea of his maturity and of his power stems, in good part, from the Fang theory of physiology. This is not an easily clarified subject. What is clear is that man receives his essential forces and powers from the blood of his mother and the sperm of his father. The maternal element goes to make the flesh, blood, and bloody organs of the body cavity, particularly the heart. The paternal element goes to make up his bones, sinews, and brains. Just as the creation of the child is dependent upon the harmonious working together of these

8 A. L. Kroeber, "Basic and Secondary Patterns of Social Structure," *The Nature of Culture* (Chicago, 1952), p. 217.

ordinarily incompatible elements, blood and sperm, so the full power of the adult is dependent upon the working together of the two sets of body members that the two essential substances of coitus have brought into being. A man with strong brain, bones, and sinew but with weak blood, organs, and heart, will confront life as inadequately as he who has strong blood but weak sinews. The brain, the bones, and the sinews, are the center of the will, the driving force, the determination of a man, while the blood and the heart are the sources of reflection, deliberation, and thought (*asiman*, thought, that which gives direction to determination). Taking direction without determination is as useless to the Fang as determination expressed without direction. In a complete man, as in a vital ancestral figure, these opposing sets of attributes are held in balance so as to work together in complementary fashion. Out of the complementary relationship between opposites, life—vitality— is most fully achieved by the *nyamoro*. He, the mature man, most successfully combines the biological heritage of female blood and male seminal fluid—willful determination and thoughtful direction. Youth tends to be too active, too willful; age, too deliberative, too tranquil. Here appears again vitality arising out of the appropriate relationship between opposites.

There is not space to examine the principles of opposition and vitality in Fang aesthetic reactions to other manifestations of their culture. These principles at work might best be shown in Fang comment upon traditional dances where their gustatory appreciation in the vitality of the dance rises out of the presence of oppositions: the male drummers, the female dancers; the low sound of the drum, the high pitched and falsetto voices of the women; and, of course, the customary scheme by which the dancers face each other in two opposed lines. These principles of opposition and vitality might also be followed into the new syncretist cult of Bwiti as they express themselves in the ritual under elaboration in that cult. Even without these further examples, I hope it is sufficiently clear that when Fang assume a posture of aesthetic scrutiny the presence of skillfully related oppositions constitutes an important part of their delight and appreciation. This is so because vitality arises out of complementary opposition and for them what is aesthetically satisfying is the same as what is vitally alive.

IV

The data derived from the Fang, the extent to which the principle of opposition arises in many different areas of Fang life, indicate that there is an underlying duality in Fang culture. This duality is manifestly institutionalized in the latter-day syncretist cult of Bwiti—a religious movement designed to restore integrity, harmony, and regularity to lives greatly disturbed by acculturation. The Fang members of Bwiti oppose the left hand to the right hand in ways that Hertz[9] long ago argued, they oppose the earth to the sky, male to female, northeast to southwest, night to day, hot to cold. In fact, it is easy to construct for the Fang Bwitist a table of symbolic classification—sets of opposed values such as we have given above—in which the pairs of opposite terms are analogically related by what Needham[10] calls the "principle of complementary dualism." This principle has been explored recently by Needham for the Purum and Meru, by Beidelman for the Kaguru, and by Faron for the Mapuche.[11] While such systematic analysis of the coherence of symbolic values and the relation of the dualistic symbol system to the social structure are important extensions of the original Durkheimian insight, I have limited myself here, using terms from the Fang's own aesthetic vocabulary, to show how aesthetic appreciation rests upon the presence of vitality in the object or action and that this in turn rests upon the appropriate relationship—whether this be a balanced relationship or a complementary relationship—between opposites.

Two larger questions remain to be considered. Anthropologists sometimes employ the term *logico-aesthetic integration* to refer to the manner in which the disparate elements of culture were brought into some systematic relationship. The first question then is how does logico-aesthetic integration obtain in a dualistic culture where oppositions play such an important role? Second,

9 Robert Hertz, *Death and the Right Hand* (London, 1960).

10 Rodney Needham, "The Left Hand of the Mugwe: An Analytical Note on the Structure of Meru Symbolism," *Africa*, XXX, 1 (Jan., 1960), pp. 20–33.

11 T. O. Beidelman, "Right and Left Hand Among the Kaguru: A Note on Symbolic Classification" *Africa*, XXXL, 3 (July, 1961), pp. 250–57. Louis Faron, "Symbolic Values and the Integration of Society Among the Mapuche of Chile," *American Anthropologist*, LXIV, 6 (Dec., 1962), pp. 1151–164.

what about this overarching question—the impact of social structure upon aesthetic principles? Is it because opposition is a fact of social life that it becomes such an important component of aesthetic appreciation?

In respect to logico-aesthetic integration—if we mean by that the extent to which patterns of behavior conform coherently to a given logic and a given set of aesthetic principles—two things are to be said. First, if one admits that analogy is a kind of logic, then there is no reason why integration should not prevail in a system of analogic oppositions; and in fact we have argued that this is the only kind of integration that makes sense to the Fang. Second, in respect to the aesthetic component of this integration, it must be pointed out that true aesthetic integration of a total culture, if not an impossibility, can only, in any case, be the consequence of "relentless concentration on the whole life process as an art." Thompson has argued that this exists among the Hopi.[12] I do not find it among the Fang. They are too materialistic and opportunistic to be constantly preoccupied with living out all of life in an aesthetically satisfying manner. For most Fang passable inter-relationships—relationships which are functional, goal-reaching, and gratifying—can be established without benefit of much aesthetic elaboration. But it should also be said, and this is a measure perhaps of acculturative disintegration, that there is, except among the members of Bwiti, less concern with the aesthetic satisfactions offered by objects and actions than formerly. One can see this in an increased tendency toward shabby and unbalanced construction in village layout and upkeep. Formerly the Fang proceeded on the road to gratification with more emphasis on aesthetic means and with more realization that aesthetic experience itself was an important kind of gratification.

Despite this negative data, there are still many actions and objects in Fang life that provoke a posture of aesthetic criticism. I have examined some of them, notably the ancestor figures and the behavior of a mature man. And of course aesthetic principles may be in operation in Fang culture even though no deliberate and overt attempt is made on the part of the culture carriers to apply or make out these principles. In fact, instead of asking: To what

[12] Laura Thompson, "Logico-Aesthetic Integration in Hopi Culture," *American Anthropologist*, Vol. XLVII (1945), pp. 540–53.

extent do aesthetic principles reflect the necessities of social structure? it might rather be stated inversely: To what extent does social structure reflect aesthetic principles? Is society aesthetic preference drawn large?

CONCLUSION

To such large questions only large answers can be given. The data suggests that what are given in Fang life, what are basic, are two sets of oppositions. One is spatial, right and left, northeast and southwest; the other is qualitative, male and female. Both the social structure and the aesthetic life elaborate on these basic oppositions and create vitality in so doing. This elaboration, however, in both areas is creative, a fashioning in some sense according to what is pleasing. To this extent the social structure is no different from the ancestral figure; it is the expression of aesthetic principles at work. And the fundamental principle at work among the Fang is that in doubleness, duality, and opposition lies vitality, in oneness and coincidence, death.

In both aesthetics and the social structure the aim of the Fang is not to resolve opposition and create identity but to preserve a balanced opposition. This is accomplished either through alternation as in the case with complementary filiation or in the behavior of a full man; or it is done by skillful aesthetic composition in the same time and space as is the case with the ancestor statues or cult ritual. This objective is reflected in interclan relations. The Fang, like many nonliterate people, lived in a state of constant enmity with other clans. However, their object was not that of exterminating each other or otherwise terminating the hostility in favor of one clan or another. The hostility was regarded as a natural condition of social life, and their concern was to keep this enmity in permanent and balanced opposition.[13] So in their aesthetic life, they aimed at a permanent and balanced opposition. In this permanent tension between opposites lay the source of vitality in Fang life. When this balanced arrangement is upset, as it has been by acculturation, then one can only expect that some of the vitality will go out of that life.

[13] This point has been made by Joan Rayfield, "Duality Run Wild," *Explorations,* No. 5 (1955), pp. 54–67.

Aesthetics in Traditional Africa*

ROBERT FARRIS THOMPSON

Recent research has proved false the beliefs of earlier ethnologists and art critics that Africans were incapable of aesthetic evaluation. In his field work among the Yoruba of Western Nigeria, Dr. Thompson found common standards of taste and judgment. Yoruba aesthetic criteria are used to evaluate positive or canonical art and set limits for ugly or noncanonical forms of art. Specific examples of Yoruba art are analyzed in terms of these criteria.

Robert Farris Thompson is an assistant professor in the Department of Art History at Yale University. He teaches a course on the arts of Africa relating stylistic elements and meaning in the sculpture, dance, and architecture of West Africa. He is also interested in the relations of African and Afro-American art and music, and has written "New Voice from the Barrios" (*Saturday Review,* October, 1967), and *African and Afro-American Art: The Transatlantic Tradition* (1968).

African aesthetics is the application of consensual notions of quality to particular problems of form. Traditionally, artistic criticism is carried out south of the Sahara in spoken rather than written words. It is an aspect of the civilizations of this vast region that remains invisible to those who correlate artistic criticism with literacy. Roger Fry, writing about 1920, profoundly respected the order of intensity and imagination in the sculpture of tropical Africa but he did not suspect that sharpened qualitative expectations informed these achievements. On the contrary, he wrote: "If we imagined such an apparatus of critical appreciation as the Chinese have possessed from the earliest times applied to this Negro art, we should have no difficulty in recognizing its singular beauty. It is for want of a conscious critical sense and the intellec-

* Reprinted from *Art News,* Vol. 66, No. 9 (January, 1968), pp. 44–45, 63–66.

tual power of comparison and classification that the Negro has failed to create one of the great cultures of the world."

Today we know that nonliterate art flows not only from religious necessity but also from critical pleasure in formal quality. "What is important here," recently writes the psychologist Irvin Child, "is that the occurrence of what we would call aesthetic responses is a possibility for all societies, a definite reality for many." Artistic judgments may be made by virtually every member of a society favoring art, and these, Child reports, show some consistency wherever made. If this is so, and it is also true that Africa probably has no society that does not produce some form of art, then the same land mass conceals an extremely rich source of aesthetic criticism. An absurdly conservative estimate of five critics per African language already predicts the presence of five thousand connoisseurs. The real number of African critics may be astounding. Had we tape recorders enough and time, we might explore a world cultural asset.

The exploration is rendered problematic by those field investi gators who continue to report, uncritically, the failure of African artists and African patrons to rank their possessions, as if the finding confirmed the absence of aesthetic criticism at the ethnographic level. An American photographer was once asked to select his best works for a retrospective exhibition. He replied bitterly that the task ressembled a request to rank his own children. Is it reasonable to expect artists and patrons in *any* culture to rank their own works or possessions before strangers with pleasure? I think it is significant that those sculptors in Yoruba territory in West Africa who shared their critical insights with me did so apropos of the work of their rivals. The substance of their arguments might well have evaporated had they been asked to criticize their own works. Some Africans, in short, more readily evaluate art when it belongs to someone else. When Yoruba criticize art—and I have met a few patrons who were willing to assess the merits of sculpture on altars to the gods—they often speak fluently and convincingly of the delicacy of a line or the roundness of a mass, attesting, again and again, a refined ability to identify swiftly the aesthetic components of form.

Old-fashioned ethnologists would have considered such a

level of evaluation impossible for people living face-to-face with nature. And they never suspected that "primitive man," himself highly conversant with art and artists and noting extremely few men of like aesthetic bent among the missionaries and traders from the nineteenth-century Western world, might have addressed the same reproach to people living face-to-face with science and technology. The alleged lack of aesthetic response among ethnographic peoples may well have derived from a kind of intellectual pidgin arising from the meeting of "civilized" and "primitive" man, neither believing the other capable of sustained aesthetic analysis. There is reason to believe like assumptions sometimes influence transactions involving African art *in situ* to this day. Paul Bohannan reports that a Tiv weaver in Northern Nigeria keeps his best piece for his mother-in-law and sells his worst piece to foreigners (who presumably never knew the difference!), and Melville J. and Frances S. Herskovits discovered in the 1930's that the great brass casters of Abomey, in what is now the Republic of Dahomey, sold excellent pieces to indigenous patrons and coarser works to Westerners. In the process, Western and African prejudices are reconfirmed.

The most important factor of identification, when discovering African critics, is the reasoned standard of judgment. Judgments of quality imply an aesthetic when they are reasoned and fairly systematic. I found in the course of my own researches in Western Nigeria, for example, that the comments of some two hundred Yoruba (a majority of them nonliterate and devotees of the traditional gods), when compared, proved to be founded upon common denominators of taste, in sum, the Yoruba aesthetic. Each criterion, a named abstraction, defined a category of elegance or finish by which Yoruba recognize, greet, and explain the presence of art. No Yoruba recited the entirety of these ideas; criticisms were fragments of a total design.

Perhaps the most important of these categories is *jíjora,* broadly translated as "mimesis at the mid-point"—i.e., the siting of art at a point somewhere between absolute abstraction and absolute likeness. The canon swiftly emerged in the vocabulary of a number of critics who applied to their arguments, when figural sculpture was under discussion, the identical expression—*ó jo*

enia "it resembles somebody." They did not say that carvings resembled specific personalities. Portraiture in the Western manner is considered virtually sinister by traditional Yoruba. It is believed that if an Efon Yoruba sculptor carved a given man as he actually appeared, warts and all, that these very traits might be transmitted to the face of his next-born child. To one Yoruba critic on a farm near Igbessa, Nigeria, a slight hint of identifiable facial expression sufficed to provoke criticism; the lips, he said, were curved on a statuette as if in laughter. The lips of ideal statuary are pursed, reflecting impersonal calm and dignity. It is interesting that Hans Himmelheber was told by a Guro artist on the Ivory Coast: "I am afraid to carve the face of a particular man or girl, for if that person should die soon after, people might attribute the death to this portrait." But if sculpture ought not to be too real, neither must it be excessively abstract. One Ekiti Yoruba sculptor derisively compared a colleague's work to a box, hence impugning his ability to enliven the medium with human presence.

The frequency of "visibility" (*ìfarahòn*) as a stressed quality of sculptural beauty among traditional Yoruba is striking. A master sculptor, the Alaga of Odo-Owa, told me: "One knows from the visibility of the face and other parts of the image whether the work is beautiful." Visibility as criterion may embody a knowledge of the process of carving, thus as criterion it is an informed assessment of the initial stages of adzework (are the major masses visible?) and the final stages involving knifework (are the incised embellishments and linear designs visible?). The Alaga continues: a sculptor, for example, must not only "block out a schematic eye" (*yo ojú*), providing a gross relief, he must also "open the eye" (*là ojú*) with sensitive lining. Visibility, therefore, refers to clarity of form and line. The latter quality is a matter of special concern. The phrase, "this country has become civilized," literally means in Yoruba "this portion of the earth has lines upon its face." In fact, the basic verb, to cicatrize (*là*), incarnates multiple connotations of imposing human pattern upon brute natural phenomena.

Equally paramount in the mind of the Yoruba critic is the notion of luminosity. Again, the Alaga of Odo-Owa tells us that when he finishes a commission for indigenous patrons (his works for Europeans are sometimes indifferent) he stands back to exam-

ine the luminosity (*dídón*) of the work, the polished surface and the play of shadowed incisions upon these surfaces. I shall never forget the criticism of a cultivator from Odo-Nopa in Ijebu-Yoruba country; he praised one statuette and damned another on the score of luminosity: "One image is not beautiful and can quickly spoil. Its maker did not smooth the wood. Another image was carved so smoothly that one hundred years from now it will still be shining—if they take proper care of it—while the unpleasing image will rot regardless."

The taste for luminosity is a kind of conservation. Because the reflection of the light is devoutly desired, Yoruba artists do not portray actually soft textures. When a Yoruba carves a representation of a head-tie, turban, cap, or gown he discovers luminosity by thickening widths and bringing surfaces to a relatively luminous finish. Hence equivalents of Hellenistic "wet drapery" are unknown.

Other criteria are: symmetry, positioning (. . . "here the ears are good, well-fixed, not too far down, not too far up" . . .), delicacy, relative straightness and upright posture, and skill. A master sculptor of the Egbado Yoruba, as an example of the prizing of the last quality, was widely known by the beautiful attributive name of *Onipasonobe* ("Possessed-of-a-knife-like-a-whip"). It is a miniature poem in praise of skill. Such was the talent of the late Egbado sculptor that his knife summoned shapes, as with a whip, from the brute wood and made the shapes do as they were told. Finally, a canon of fundamental importance is ephebism (*òdó*), the depiction of mankind at the optimum of physicality between the extremes of infancy and old age. Even where a beard indicates maturity or old age, the whole of the sculpture glows with the freshness of early manhood. Close study of Yoruba aesthetics makes clear the importance of the following issue: does the image make its subject look young? To imitate the masters of Yoruba life in their actual elderly state would deny the Yoruba idea of sculpture its realization.

Seen as a unit, Yoruba aesthetic criteria form an exciting mean, vividness cast into equilibrium. Mimesis, as Yoruba understand it, strikes a balance between abstraction and literal likeness; artistic representations are neither faint nor conspicuous, lack-

luster nor blatant, too young nor too old. Compare the Yoruba folk novelist, Tutuola, describing a beautiful woman: "She was not too tall and not too short, she was not too black and not yellow." And when a young Yoruba told Justine Cordwell that his favorite color was blue—"It is midway between red and black. It is not too conspicuous as red and it is not so dark as black. It is cool and bright to see"—he spoke with the full authority of his ancestors.

The visitor from art circles in the Western world, conditioned by a visual culture of abstract expression and optical shock (the Pop-Op continuum), would hardly suspect that the very elements which he found laudable in African sculpture might be those considered hideous by traditional Yoruba. Nor would he realize that the notion of ugliness in Yoruba art is one way of proving the positive aesthetic, such as it has been outlined above. A broken rule implies the rule intact.

It is permissible to defy the norms in at least the following contexts: satire, collective moral inquisition, and psychological warfare. As an example of the first, consider an image associated with a cult of ancestral power and entertainment, the Egungun. The particular image is named "The Big Nose" and comes from the Aiyebade District of the Western Region of Nigeria and was collected for the Nigerian Museum, Lagos, in 1950. The eyes acquire in direct sunlight the murky power of a skull and the canon of visibility is memorably violated. The mouth is lipless, a virtual gash framing warty teeth. There are so many things "wrong" with this image that it is said that when it appeared many people would laugh helplessly. Westerners might misread this mask as an expression of cosmic anguish or terror. In point of fact, obliteration of organic detail to the point of bone structure does not denote horror so much as derision—the mask is said to poke fun at the pompous and the vain, mirroring a lack of propriety with a considered indecorousness of expression. Daumier-like, the social comment is handled with a degree of control far more intimidating than raw protest.

Sanctioned expression of artistic ugliness finds a second context in the field of psychological warfare where sculpture was used, before the colonial period, to terrorize enemy ranks. To the citizens of the ancient city of Oyo-Ile, the imperial capital, it was

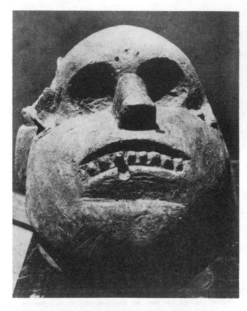

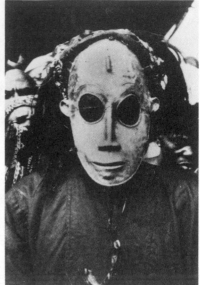

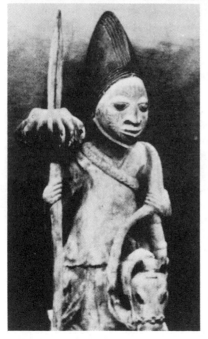

(*Top left*) Aesthetic standards are deliberately violated for a satirical sculpture that provokes laughter (not as Westerners might assume, horror). *Egun Tokele Bomu,* "The Big Nose." 15″ long. Nigerian Museum, Lagos. (*Top right*) Aesthetic standards deliberately violated in sculpture used for psychological warfare. *Alakoro,* a brass face mask probably cast before 1837 and used to astonish enemies. 12″ high. It survives in the Gbogi compound of Oyo, Nigeria. (*Left*) Masterpiece of Yoruba sculpture. *The Image of the Thundergod as Crowned Lord of the Yoruba* fulfills the aesthetic criteria by shaping animal vitality into measured roles. Carved before 1837. 36″ high. Nigerian Museum, Lagos.

the brass mask known as *Alakoro* that formed the spectacular instance. The mask survives today in the Gbogi compound of Oyo, Nigeria. It is a long oval face of brass, protruding of forehead and concave of nose and cheeks. The regard is awesome: deep-set eyes lend dramatic power to the image and have inspired the famous local curse—"you with the eyes like Alakoro." Informants tell a traditional tale that explains these stylistic anomalies: "In the old days, if war against our capital city, Oyo-Ile, became serious, Alakoro would be dispatched to the front where he would start to dance, astonishing the enemy with his glaring face and sunken eyes and causing them to stand in their tracks."

It should be clear from these two examples that the tension between canonical and noncanonical forms of art does not permit a simple definition of Yoruba sculpture and that a priori generalizations about African formal values without reference to tribal aesthetics may lead to academic disaster.

Let us take as a final example of Yoruba sculpture *The Image of the Thundergod as Crowned Lord of the Yoruba*. It is a masterpiece of Oyo Yoruba carving and is now in the Nigerian Museum, Lagos. The piece is carved in *funtumia elastica* and is a fitting resemblance of the Yoruba thundergod, "swift king who appears like the evening moon." This is the Yoruba thundergod in an extremely rare sculptural appearance, honored with a full-dress expression of aesthetic quality. The effortless beauty of this piece of sculpture fulfills in the coolness of its expression the conditions that make Yoruba sculpture spiritual. It teaches us that we owe the decisive things of life to collectedness of mind. It shapes animal vitality into measured roles. And having told us these things, it stands at the closing point of an investigation of the artistic criticism of an impressive province of sculpture in the history of world art.

Sculpture of the Eastern Solomons*
WILLIAM H. DAVENPORT

This article is a description and analysis of the creative process and the various art styles of the Solomon Islands in their cultural context. The role and function of art in society, and its close association with social activities on the one hand and supernatural beliefs on the other, is important in determining its forms and patterns. Its quality comes from the aesthetic sense and technical skill of the individual professional artists.

William H. Davenport is a Professor of Anthropology at the University of Pennsylvania. His subjects are comparative social structure and economics of primitive societies, theory in culture and personality, and primitive and peasant cultures of Oceania and the Caribbean. He has written "Nonunilinear Descent and Descent Groups" (*American Anthropologist,* August, 1959), "The Family System of Jamaica" (*Social and Economic Studies,* December, 1961), and "Jamaican Fishing: A Game Theory Analysis" in *Papers in Caribbean Anthropology* (1960).

With the special exhibition from the Eastern Solomon Islands (December 8–May 31) the University Museum presents a new collection of primitive art that was obtained from the field. Also, the relevant background and contextual information for the collection was recorded. This is a happy, but all too rare, situation, for most collections of primitive art have been assembled from objects that were originally obtained either as curios or for their visual impact alone; their functions, meanings, and the circumstances of their manufacture were not recorded or at best were recorded incompletely. Moreover, in most cases it is now too late to retrieve this related information, for in the processes of culture change and accommodation stimulated by the overpowering influence from

* Reprinted from *Expedition,* Vol. 10, No. 2 (Winter, 1968), pp. 4–25.

industrial sections of the world, most primitive societies have allowed their traditions of aesthetic expression to die.

The tradition of art in the Solomons lives, literally, on borrowed time. Although it continues in some communities it no longer flourishes throughout the archipelago as it did fifty years ago. The time is close when it will be preserved only in museums, private collections, libraries, and archives located far from the South Seas. Today, most Pacific Island peoples have either already cast aside much of their traditional culture, or they are in the process of doing so. The Pacific has become a part of the modern world.

For two centuries Europeans have regarded the South Seas with contrasts of imagery. In the last century the uninhibited, gentle, yet unrepentant Polynesians of the central Pacific were contrasted with the savage, contentious Melanesians of the southwest Pacific. In this century the lure of the tranquil life amid reefs, lagoons, and tropical vegetation on islands with catchy names like Borabora and Pukapuka has been set against the horror of modern war on inhospitable islands with incongruous names such as Guadalcanal and Bougainville. Even at this moment the islands present to us simultaneously the pictures of luxurious modernity in tourist Hawaii and the last remnants of true Stone Age peoples in interior New Guinea—the two, moreover, connected by scheduled air service. The South Seas, as always, offer an exotic geographic and social setting upon which Europeans can project their fantasies of withdrawal.

In recent years still another interest in South Seas cultures has developed, and this is even influencing our tastes in small ways. This interest is in the plastic arts, and particularly in the many traditions of sculpture that come from Oceania. The novelty of forms and the strangeness of the compositions have both attracted and repulsed persons who are interested in modern and contemporary art. Moreover, because of the remoteness of South Seas cultures, the wide gap of incomprehension that separates our culture from those in which the sculptures are produced, and the total anonymity of the artists who created them, we are able to inject our own ideas of art into these objects. As a result most people regard the arts of the South Seas as a kind of expression-

ism, and by implication, an expressionism in which unknown primitive artists are manipulating forms and ideas largely according to their personal aesthetic tastes just as artists do in our society. The many regional styles that are clearly present in South Seas art are often thought to be analogous to periods or schools in our own art tradition. But this is not the case, and in this article we shall attempt to look at *one* of these regional styles—the Eastern Solomons—from another point of view. As best we can we shall try to convey it as the people of that culture see it.

For many years a Solomon Islands art style has been recognized, and because many examples of it are in museum collections two sorts of objects have come to represent this style. One of these consists of humanoid figures, sometimes full-figure, sometimes head and arms only, with a canine-like snout. The other is a composition of naturalistic birds or fish, separately and together, carved as the ends or supports of oval bowls. The former are religious icons that were fastened to large canoes, the latter are ritual offering bowls used in the worship of tutelary deities. Both kinds of objects are of wood, usually stained black, and often liberally enhanced with inlays of mother-of-pearl or etched details through the dark surface, which reveal the light shade of the underlying wood. Small details are often carved in low relief to enrich the surfaces.

To Solomon Islanders these two objects are as different in style significance as are Delft and Chinese Blue-and-White porcelain to us—the two are historically related, but each represents the product of a different culture. The humanoid sculptures come from the Western Islands of the British Solomons, the bowls come from the Eastern Islands of that group. The peoples of the two areas speak different languages, are racially quite different, and have different cultures and institutions.

Actually, there is a third lesser-known areal style of sculpture in the Solomons that comes from the Central Islands. It, too, consists of human and animal figures with black (or white) surfaces, sometimes inlaid or etched, but the figures are usually simpler and are rarely built into complex compositions. Rarely, too, are the surfaces of these figures embellished by bas-relief. In brief, it is a

much simpler and reduced style, and to European eyes it has little interest when compared with the Eastern and Western styles. Also, this Central sculpture is related to its culture and embedded in social institutions in quite distinctive ways that are different from these relationships in adjacent areas. Knowing this, the style differences communicate to Solomon Islanders differences in ethnicity.

The visual communication of cultural and social differences can be brought about by still more subtle distinctions. For example, even within one of these three cultural provinces sculpture from the extreme East—from Santa Ana, Santa Catalina, and the Star Harbour area at the tip of San Cristobal Island, where the objects in the University Museum show were obtained—can be readily differentiated from that of the remainder of San Cristobal and from that of Ulawa Island. Furthermore, on a still more localized level, carvers of Santa Catalina Island treat certain motifs in a way that is different from the way neighboring Santa Ana carvers handle the same motifs on the same kind of objects. An example of this is in the decorative scrolls that both islands use on their ritual bowls. Santa Ana carvers prefer to separate the scrolls from the body of the bowl, while Santa Catalina carvers prefer to keep the scrolls tightly articulated and integrated with the form of the body of the bowl.

Personal styles within areal and subareal styles are just as readily recognized and evaluated. In recent years, for example, the carver in the Eastern Solomons who had the greatest reputation was a man from the Star Harbour area named Tigoana. He died in 1964 and his cousin Karopungi is now regarded by some as his successor. The differences between the two men's work are striking. Most people think Tigoana much superior, but Karopungi has a flair for detail that Tigoana spurned. His low relief panel, carved about twenty-five years ago for a commemorative feast, is a unique and distinguished work. The two cousins each learned from his father who were brothers, and their fathers both learned from their father.

Differences of this sort are just as notable on Santa Ana Island. Reresimae, Sao, Faruara, and Nimanima are all sculptors of note there. The works of the last two are similar in that they are

more formal, more precise, and their compositions are more tightly integrated than the first two. Reresimae and Sao, however, are close friends and admirers of each other's work. As a result of this, they influence each other. Reresimae carved a massive housepost for the University Museum which was not a copy, but which was greatly influenced by a similar post carved by his friend which stands in one of the Santa Ana sacred houses. In carving another post for the Museum collection, Sao returned the compliment of his friend by using a theme that was suggested to him by Reresimae. Some of the local criticism of the works of the two men is that they have both been influenced by carvers from Ulawa, an island eighty-five miles to the north, thus their styles are not so "pure" as are works of their competitors, Faruara and Nimanima.

Personal styles of carvers are also revealed in preferences for the kinds of objects carved. Reresimae likes to carve both ritual bowls, which he considers to be a minor sculptural form, and posts, which are considered to be major works. Sao, his friend, has done bowls, but does not like to do them so well as posts. Nimanima will not be bothered with bowls at all.

Personal preferences and evaluations of this order are, for unaccountable historical reasons, also repeated as local style differences. Santa Catalina carvers have always regarded their bowls as some of their best art. On that island, however, there is not a carver of posts to be found, and elaborately carved posts are not an architectural feature of their sacred commemorative structures as they are on neighboring Santa Ana Island. The same is true for carved caskets in which the disinterred bones of illustrious men are encased, and which are a feature of Santa Ana funereal commemorations. These are not a part of the same rites as they are observed on Santa Catalina. On the other hand, very large (up to ten feet long) bowl-shaped vessels, from which servings of special food are made at certain feasts, are rarely carved on Santa Ana. They are a specialty of Santa Catalina carvers and are, in fact, the major sculpture of that island. Both Santa Ana and Santa Catalina peoples utilize the large vessels, but it is usually a Santa Catalina carver who receives the commission to carve a new one for celebrations on either island.

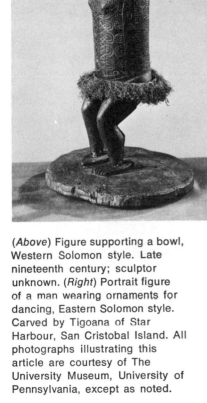

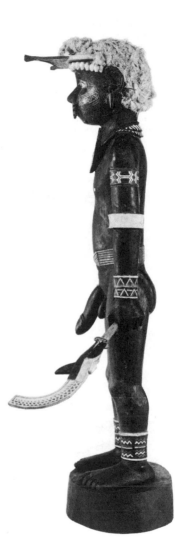

(*Above*) Figure supporting a bowl, Western Solomon style. Late nineteenth century; sculptor unknown. (*Right*) Portrait figure of a man wearing ornaments for dancing, Eastern Solomon style. Carved by Tigoana of Star Harbour, San Cristobal Island. All photographs illustrating this article are courtesy of The University Museum, University of Pennsylvania, except as noted.

Figures 1–14. Ritual communion bowls. The separated treatment of supporting scrolls that is preferred by Santa Ana carvers occurs on figures 2 and 5; the articulated treatment used by Santa Catalina carvers occurs on figure 12. The same scroll motif is enlarged and elevated at the ends of figure 4, reduced and repeated under the rims of 6 and 13. The shark of figure 13 represents a real species; the shark heads of figures 2, 5, 9, 10, and 12 depict a vicious but imaginary shark species. The bent fish of figures 1 and 11 is a garfish; the side fish figures of 10 are porpoise; the fatter fish of 3, 6, 9, 10, and 11 are bonito; the birds are species that appear with bonito schools. Anthropomorphic figures represent deities; the double bowl in figure 14 is dedicated to a twin tutelary deity. These bowls range from one to two feet in overall length.

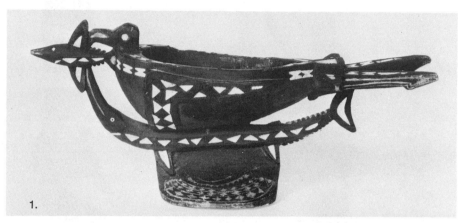

1.

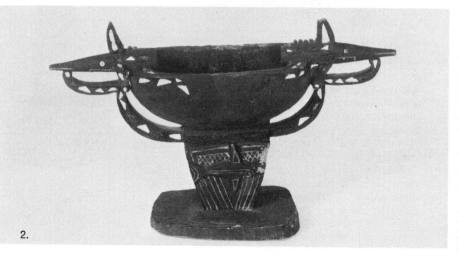

2.

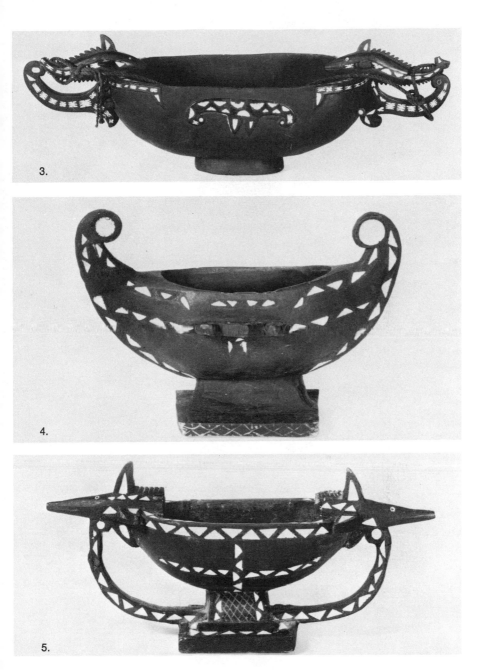

3.

4.

5.

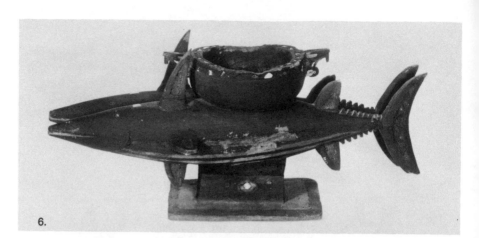

6.

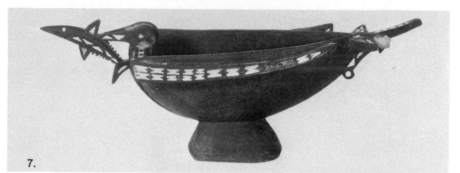

7.

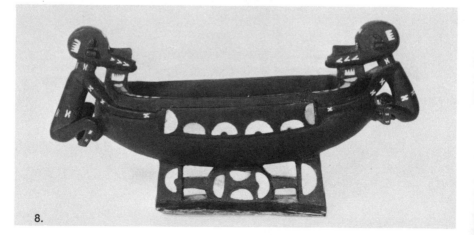

8.

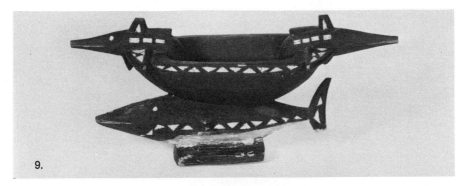

9.

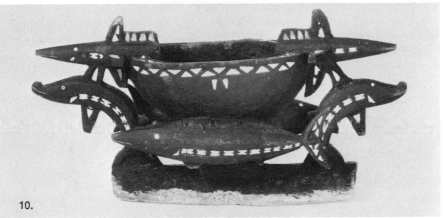

10.

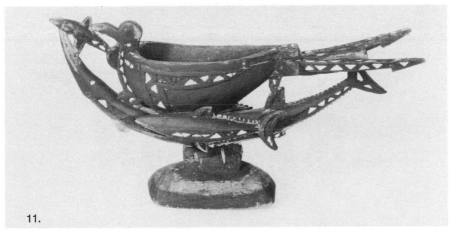

11.

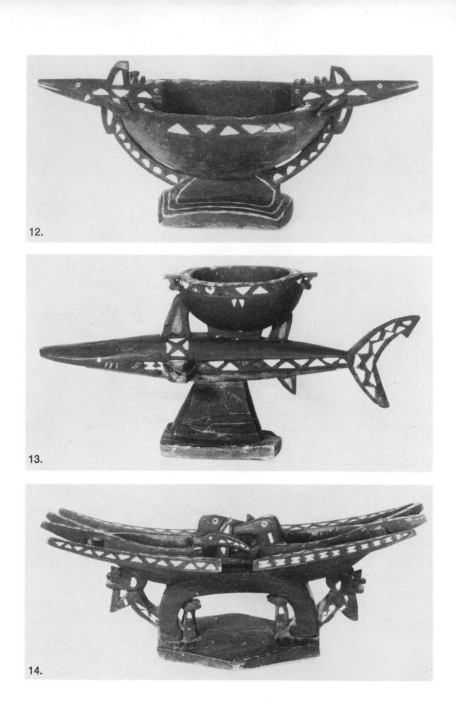

12.

13.

14.

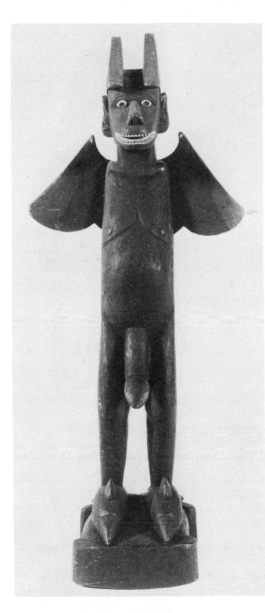

(*Above*) Figure of a deity by Tigoana.
(*Right*) Figure of a legendary
hero by Karopungi.

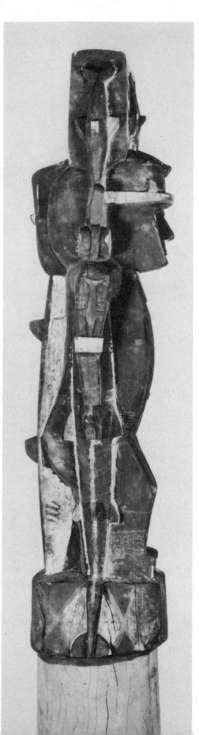

(*Above*) Commemorative house post. Two prostitutes by Karopungi of Star Harbour, San Cristobal. Prostitutes are sometimes brought in from other villages on festive occasions. (*Right*) Canoe house post. Deity Pa-na-waiau, "Bonito School," by Reresimae of Natagera Village, Santa Ana. (*Right*) Canoe house post. Deity Mara-Kirio, "Porpoise Changeling," by Sao of Natagera Village, Santa Ana. (*Far right*) Canoe house post. Wakewakemanu by Murisigaie of Gupuna Village, Santa Ana. All of the deities depicted in these posts control the appearance of schools of bonito and tuna as well as the birds and sharks that follow these schools.

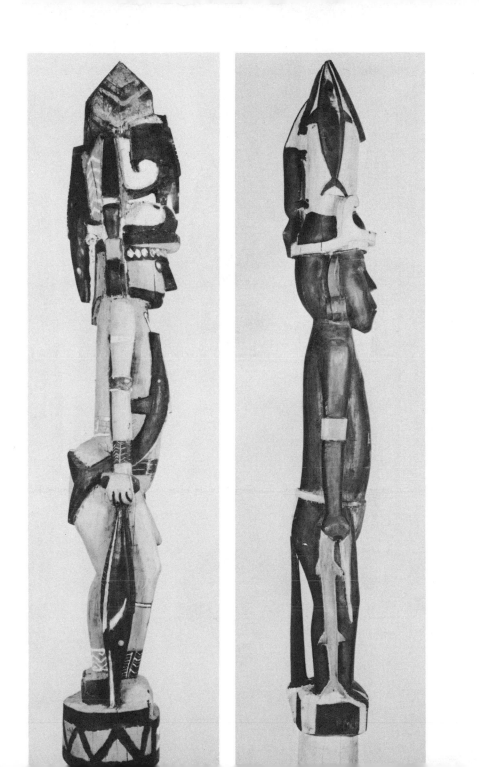

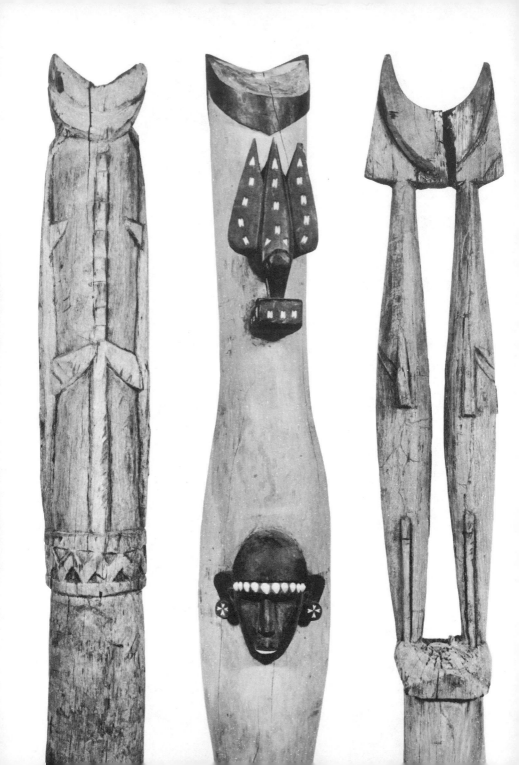

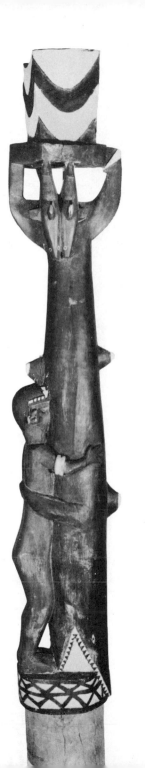

(*Far left*) Commemorative house post. Two bonito carved in low relief. Carved by Waifura of Gupuna Village, Santa Ana. (*Center left*) Offering post. The carving is called Qanga, "Swelling," which represents the deity Siqaru, who has powers to make staple crops grow large and to cause and cure diseases whose symptoms include swelling. (*Left*) Commemorative house post. The same dual bonito theme as on the post at left, but here carved in the full round. Carved by Murisigaie of Gupuna Village, Santa Ana. (*Right*) Canoe house post. The mythical hero Mauri Asi, "Saved at Sea," by Faruara of Natagera Village, Santa Ana.

(*Far left*) Canoe house post. The deity Wakewakemanu by Reresimae of Natagera Village, Santa Ana. This conception of the deity has him in fighting stance behind a shield; the conception of the same deity illustrated on page 395 has him holding two garfish that he uses as arrows to shoot death and sickness. (*Left*) Commemorative house post. The deity Karema-nua, who is half man and half shark, killing his human brother. Carved by Nimanima of Gupuna Village, Santa Ana.

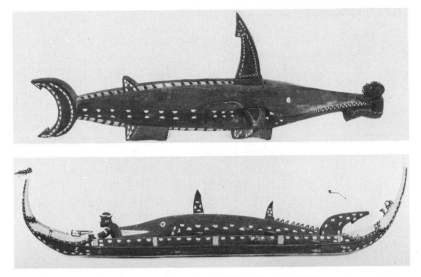

Caskets for the bones of honored dead. (*Top*) A shark killing a man, which signifies the violent death of the man Okuo a few years back. Carved by Tarofimana of Natagera Village, Santa Ana. (*Above*) A shark holding a man, signifying the legend of the deity Waumauma, superimposed on a model of bonito fishing canoe. Carved by Nimanima of Gupuna Village, Santa Ana. (*Below*) Serving vessels for commemorative feasts. Although they look very much like communion bowls in these photographs, the top vessel, carved by Rasia and Farunga of Santa Catalina Island, is over nine feet long; the bottom vessel, carved by Farunga of Santa Catalina Island, is about six feet long. These large containers are used to present and serve food at commemorative feasts.

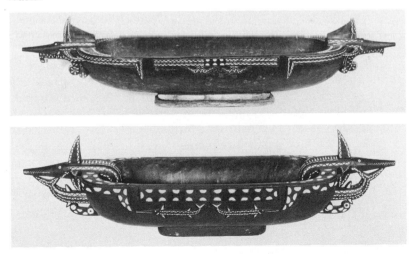

Who becomes a carver in the Eastern Solomons is determined mostly by interest and aptitude. There are neither hereditary positions for artists nor hereditary groups of artisans. Anyone who has the interest and ability may become a sculptor. It helps, of course, if either one's father or maternal uncle is a skilled carver, for in that case the two senior men who are closest to a boy in this matrilineal society are immediately available to give guidance and instruction. But this family interest is not necessary, for it is possible to receive specialized instruction from any expert if it is desired. All men in this society are skilled woodworkers, and carvers are not necessarily better than ordinary craftsmen in the use of their tools. All men, too, are familiar with the traditional motifs and designs used in carving. High interest, then, is the first prerequisite for becoming a carver.

Beyond this, the necessary talents are the same indefinable aesthetic characteristics that seem to distinguish the artist from the nonartist in our society. Whatever these characteristics are, they appear to be cognitive and in them seem to be located the factors that also produce individual variations among artists. Nowhere are these variations more noticeable than in the manner in which a carver approaches the problem of his sculpture. Farunga of Santa Catalina, who is regarded as one of the best carvers of large vessels, thinks out every detail of his design and tries to anticipate every technical problem of execution before his axe is even lifted to fell a tree for the material. With his design fixed in mind he works compulsively for long uninterrupted periods as if he were racing against time, Farunga will not tolerate anyone to help him or anyone but his wife to watch him while he carves.

Reresimae also conceives his design completely before he starts to carve, but he works at a more leisurely pace than Farunga, and he likes to have an assistant to keep him company and to do most of the rough carving after he has delineated the critical outlines of the constituent forms. He also lets the assistant do most of the final surface refinement with a small adze, pumice stone, and a scraper of broken glass. His assistant for the two posts he carved for the University Museum was Maemae, a man in his late fifties who was born in Ulawa Island and who is a carver of fine ritual bowls. Maemae was eager to work with Reresimae on

these posts, for he had never worked on posts before and wanted to learn the technique which he considered to be more difficult.

Nimanima and Faruara work in another way. They start carving when they have only a rough idea of what they want to achieve. Details of form and composition are evolved as they carve. Both men work much more slowly than Farunga and Reresimae and both frequently become blocked by their inability to decide between alternative conceptions.

Karopungi's technique is in some ways an enigma. One of the characteristics of his personal style is the roughness and irregularities of the surfaces and edges of the integral forms. Indeed, on this account his work is often criticized for being careless and sloppy. But whether or not special surface treatment is done for a studied effect or is just poor technique I could not determine, for he refused to discuss it. Nevertheless, he works quickly and surely up to a point, then he is apt to lose interest for a time and turn to another piece until the right mood strikes him to return to the piece he left.

Despite these idiosyncrasies, when the work of any one or all of these carvers is compared with the attempts of men who are not fully recognized carvers, the differences are immediately apparent. Occasions to make such comparisons arose several times, for many men who are not fully competent sculptors did try to produce work that they hoped would be purchased for the Museum collection. The difference was never in technique alone, but in the conception of the sculpture. By local standards their forms were not appropriate, their compositions were not balanced correctly, and their iconography was thought to be deviant or inappropriate. In one instance, a would-be carver, although a fine craftsman, was unable to make an acceptable reproduction of a very fine post that stands in one of the Santa Ana canoe houses, because he could not master the composition of the original.

It has been seventy-five years or more since blades of stone and shell have been used, but the tools that carvers use today are the simplest possible. Adzes, the blades for which are made from any kind of scrap iron, ground down to the correct shape on a volcanic stone, or from a steel plane blade, are the all-purpose tool. With a kit of adzes of several shapes and sizes a good craftsman

can do most anything. Aside from the adze a nail or a bit of stiff wire serves as a drill point or punch; a salvaged screwdriver, usually obtained off the American military dumps over twenty years ago, or a flattened spike serves as a chisel or gouge. Few men even have a good pocket knife, and many have only a sharpened table knife or some kind of small iron blade for whittling. To smooth out the adze marks, surfaces are finished by scraping them with broken glass and rubbing them with pumice stone. Both float in from the sea; the glass as Japanese fishing net floats, the pumice from an active volcano located 150 miles to the east. Paint is nearly always applied to sculpture. Black is achieved by mixing powdered charcoal with the sap of a certain tree and applying the mixture at least once, followed by one or more applications of the sap alone. The other traditional colors are white and terra cotta. The white is from lime obtained by burning coral, the terra cotta is from a red earth. The black is permanent, the white and terra cotta not.

On some of the Museum's carvings orange (red lead) and pale blue oil paints have been used in place of the lime white and earth terra cotta. This oil paint was salvaged from a ship that was wrecked on the reef of Santa Ana Island a few years back. There is no question that if carvers could obtain oil paints easily, they would use them all the time and in as many colors as possible.

Shell inlay, which against black surfaces is almost the hall-mark of sculpture from the British Solomons, comes from two kinds of shell. The small, angular mother-of-pearl is cut from the paper-thin shell of the nautiluses that drift ashore. The larger, round and half-round shell inlays come from a relatively large species of conus shell. The inlay disks must be ground out of the flat ends of the conus, but these are no longer made because of the enormous labor involved. Whereas the nautilus mother-of-pearl is relatively valueless, the conus disks are extremely valuable. Conus disks are always saved after the decorated object has deteriorated and used again. All conus disks are now heirlooms.

To accommodate shell inlay the wood is cut out to only the approximate shape of and a bit larger than the inlay. The pocket is filled with a natural putty, obtained by scraping out the oily fruit pulp of a common tree, and the shell is pressed into the putty. The

putty hardens with the texture of plastic wood. When it is smoothed and the entire surface of the sculpture is stained black, the putty and wood are indistinguishable. For linear patterns of inlay a channel, rather than individual cuts, is made. After filling the channel with putty the shell bits are pressed in as close or as far apart as taste dictates.

One thing all carvers have in common is a distinctive mode of attack to a piece of sculpture. This approach, in fact, is used for all forms of woodworking, whether it be sculpture or making a canoe paddle. The first step is to remove all unwanted wood from around rough volumes, which are left in irregular cubic form. The second step is to reduce each of these cubes to the desired sculptural form. Thus, the first step is to rough out the relationships of the major sculptural elements, and in this most carvers draw guidelines with charcoal and make sketches on the ground in order to see how the relationships will look.

In the Eastern Solomons there are alternative ways of presenting the basic sculptural forms. In one, all forms are basically rounded, ovate, or spherical. In another the forms are as angular or cubelike as possible. Still another is to mix these two in various ways so that some surfaces are curved and some flat with the two joined by an angular articulation. These two modes, spherical and cubist, are used interchangeably and selecting one or the other or mixing them is a matter of taste that determines personal style.

Since the rough volumes that are hewed out first are basically cubist, if the carver desires a cubist form the angularity of the rough form is more or less preserved as he refines the preliminary into the final shape. If the carver desires a spherical form, he first makes a cubelike form of the scale ultimately desired, then he works the angles and the corners of the cubic form down into rounded surfaces. As one carver explained, "One can always convert an angular form into a rounded one, but the reverse is not possible."

Sculpture is clearly recognized as a special talent, but it does not command the highest respect among all the woodworking skills. Greatest value is attached to the combined skills that are required to construct and finish the special canoes that are used for ritual bonito fishing and the large canoes used for interisland

travel and trade. These canoes are the most elegant products of this culture, and there is a high degree of sacredness attached to both types. They are not only exceedingly fine from a utilitarian point of view, they are also lavishly ornamented with carving, shell inlay, incised design, and painting. All the valued male skills must be combined for producing the finest of these canoes. While most men can construct a good utility canoe it is the rare man who can by himself construct and decorate a fine bonito canoe or a large trading canoe. Rarely, however, does one man try to make one of these by himself. Most often it is a group project in which gifted men in all the required skills combine their talents to produce the best craft they can. Despite the pooling of talent the construction is always placed under the direction of one gifted man who, if not in possession of all the actual skills, at least has an intimate understanding of all of them.

If a man can build a good house, construct a sound utility canoe, cut efficient and aesthetically pleasing canoe paddles, carve minor and major sculpture well, and also perform the tedious operation by means of which delicate geometric patterns are cut into all children's faces (see below) then he may be spoken of as a "talented man." To excel in one or two only of these masculine skills is not enough. The "talented man," or artist must be gifted in all. This requirement of mastery over a combination of skills is in keeping with the minimum specialization of labor in all sectors of Melanesian societies. Of a total population of about 1,500 people in the Star Harbour–Santa Ana–Santa Catalina area not more than about ten persons could be rated as "talented men."

Excellence in several skills must also be achieved by a woman before she is rated a "talented woman." The feminine skills required are mastery of the forms of plaiting appropriate for fans, baskets, and fine mats, as well as the delicate art of tattooing. This complicated tattooing is applied to women only, but in recent years it has been abandoned.

Even though most carving is done on commission by an individual patron or a group of patrons and the carver must usually be paid for his work, the amount of remuneration is not great and men are therefore not drawn to sculpture for economic reasons. Men carve because they like to and because they receive social

recognition for their work. Usually, the patron organizes and purchases everything that the carver needs. He arranges for the tree, organizes the labor to fell it and carry the log to where the carver wants to work, and calls extra labor whenever the carver needs it. During the carving the patron feeds the carver and his helpers with special dishes. When the carving is finished there is usually some kind of celebration in the form of a feast, although this varies according to the use to which the carving will be put. In any case, the carver is paid something for his work over and above the food which he has received. Traditionally, this payment was in the form of shell beads, which are negotiable currencies in this area, but nowadays it may be in Australian cash. In the case of the ritual bowls, however, the patron can never pay the carver in currency, for the bowl is actually for the tutelary supernatural of the patron and for the carver to receive outright payment for something that is so intimately associated with a supernatural would be offensive to that deity.

Abilities in the plastic arts are clearly recognized as distinct from merely good craftsmanship, but no art object is produced for aesthetic considerations alone. All Eastern Solomons art is made with the intention of enhancing some object or activity that is imbued with high cultural value. In other words, the contexts for which art is deemed appropriate are limited, and they are mostly limited to those situations, objects, or activities that are very social and highly religious.

If we think of two independent dimensions in this culture, one extending from the personal to the social, the other extending from the secular to the supernatural, then we will find that the more social the context on the one hand or the more closely associated with the supernatural on the other hand, the more likely the plastic arts are to be deemed appropriate. Let us consider a few examples that illustrate this. Traditionally, the only art of a truly personal and secular sort is the tattooing of women. For cosmetic reasons only, most women were tattooed some, but few women were tattooed extensively. The extent was purely a matter of personal choice. Men's tattooing was never extensive or considered to be a fine art. In contrast to tattooing, all children of both sexes are subjected to the ordeal of having distinctive patterns deeply

scratched into their faces so that every adult will carry what are considered to be pleasing facial scars. The significance of facial scarification, though, is not entirely cosmetic as is tattooing. The facial scars are visible marks of a particular social and cultural identity. No one but the peoples of this area have them. In summary, women's tattooing was a personal matter, and not universally applied even to all women; facial scarification is a social matter and is universal to all.

People wear virtually no personal ornaments except at large important social occasions. The most artistic of these ornaments are the men's nose pendants and ear ornaments which are ground out of shell. The higher the social status of the wearer, the more delicately carved are his ornaments. Women's ornaments for the same occasions consist mainly of arrays of shell currency worn on arms and legs, over the shoulders, and around the waist. The same relationships exist between social status of the women and the value represented in the ornament. Thus, personal ormanents were social expressions of rank.

Houses and their furnishings are generally bare of any ornamentation. There is no interest at all in applying artistic talents to domestic activities and appliances. In contrast to this, objects that are used for secular public occasions when many households cooperate are often decorated or embellished in some way. Food bowls have attractively carved lugs on each end and there is a large number of abstract forms in which these lugs can be carved. The carving, however, serves as much as a means to identify one's own bowls from the dozens of others that are used at the same time as to serve personal aesthetic tastes. The large mortars in which staples and nuts are mashed together to make feast puddings and the presses in which large quantities of grated coconut meat are squeezed in order to extract the oily milk for puddings, may be decorated. These objects are used mainly in connection with public feasts, not in the private routines of everyday living.

Turning to objects used in relations with the supernatural, only a few of these receive artistic attention when the relationship is solely between an individual and a deity. One such case, however, is the carved ritual pole used only in Santa Ana Island for private ceremonies with one's supernatural tutelary. Each man has

one of these in his dwelling to which he directs his prayers and makes personal offerings. Such carved poles are not made elsewhere. Instead, a miniature ritual bowl is carved and this bowl is used in a private ceremonial by a person to honor his tutelary. When the same tutelary deity is invoked in public, the ritual object is very elaborately carved and inlaid with shell. These are the bowls for which the Eastern Solomon Islands are famous. They are used in periodic ritual meals, which each worshiper eats in communion with his deity and all worshipers have their communion together as a congregation.

All major works of art—the carved house posts, caskets, large vessels, and bonito canoes—are created as recognitions of relationship with the supernatural. One of these recognitions is the commemorative feast for a selected deceased relative. From time to time a community decides to undertake one of these expensive and arduous commemorative efforts. During its course a vast amount of foodstuffs and other forms of valuables are distributed and consumed. In one of these rites several social divisions of one community select a few of their dead male relatives to be honored, and all the divisions coordinate their efforts so that combined commemorations become a joint celebration. Surrounding communities are invited to attend and are lavishly entertained. Each of these commemorative sequences has as one of its objectives the construction of some major works of art which after the celebrations are completed will stand as testimony that the rituals were successfully undertaken. These works can be the building of a house from which the feast distributions are made and in which all the posts are carved and other architectural features are similarly embellished. Or the commemorative works may be the construction of a number of the fine canoes that are used only for bonito fishing, or (on Santa Ana Island only) the carving of caskets in which the bones of the honored dead are encased after they have been recovered from their graves. Regardless of which of these enterprises is selected, all of the participating groups will have commissioned a large food vessel from which its contributed food is distributed to its entire assemblage.

The focal place for most communal relations with a supernatural, such as the congregational communion meals with

tutelary deities and the commemorative rites for the dead, is the canoe house, and each community has one or more of these structures. It is because these structures are the houses of public worship, so to speak, as well as being places where canoes are kept, that the best aesthetic skills are lavished upon them. On Santa Ana Island and elsewhere on San Cristobal (but not on Santa Catalina Island), king posts for the canoe houses are carved in complex compositions of figures that depict mythical, religious, and ritual events. On Santa Ana Island too, the caskets with the bones of the men honored by commemorative rites are also deposited in these houses. And it is here that the most valued and revered of all objects, the sacred canoes for bonito fishing, are kept. The canoe house is a structure in which the secular domain of man intersects the sacred domain of the deities.

The fish that they class as bonito also include some of our tuna, but all share the feature of often appearing in large schools. These schools are seen irregularly only during one season of the year when the bait they feed upon also school. Not only the bonito are attracted by the schools of bait, but so are large numbers of several species of fishing birds that feed on the same bait. Around the fringes of the schools lurk hundreds of sharks that feed upon the bonito. The combination of bait, bonito, birds, and sharks produces a phenomenon that the islanders regard as an awesome manifestation of their powerful tutelary deities. In their pagan religion the bonito are believed to be under the absolute control of some of these deities. Bonito, too, are considered to be the most delectable of all fish, and the appearance of a school is a valuable gift to humans. But schools of bonito are as unpredictable in their occurrence as they are nervous when a fishing canoe is in their midst. They appear without advance notice, they disperse suddenly without warning, and with them are always the most vicious of all sea creatures, sharks. The bonito school then has three salient characteristics: it contains one of the most valued of all seafoods in vast quantities; it is unpredictable and subject to quick change; it also attracts animals that can kill or maim humans. The three characteristics, generosity, fickleness, and danger seem to be just the features of temperament ascribed to the tutelary deities. The bonito schools reflect these, because they are a manifestation of the deities.

Personal ornaments of ground tridacna shell. (*Top row*) Ear plugs with
pendants of trade beads and bats' teeth, a form of currency. (*Center row*)
Nose pendants with bird-head motif. Only men of great prestige would wear
this type of valuable heirloom jewelry. (*Above*) Nose pendant of pearl shell.
This motif is called "school of fish," and it is often etched or carved in low
relief on the large trading canoes. Pearl-shell ornaments are not as valuable
as those of tridacna shell, and they may be worn by any man regardless of
status.

(*Top*) A trough mortar about three feet long. This household utensil is used for mashing cooked staples and dried nuts or coconut cream together to make puddings. (*Above*) Food bowl. Ordinary household eating bowls are devoid of decoration except for the lugs at the ends. The form of the lugs on this bowl is called "half betel nut." Secular eating bowls have either no foot or a small one; ritual communion bowls are set on pedestals. (*Left*) Household mortar. The low-relief decoration is the frigate bird. This motif is often reduced to a *W* or *M* and even further abbreviated to a *V*, called "half frigate bird."

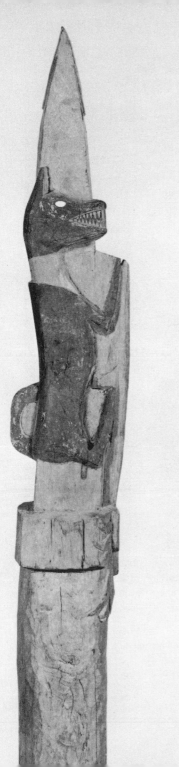

Offering posts. Smaller than the carved posts for commemorative houses and canoe houses, these images serve as altars to which prayers are spoken and first-fruit offerings of important crops can be made. The illustration on the far left represents the deity Waiwori, who appears to man as a dog or as a coconut crab. The crab is carved just below the dog. Carved by Faruara of Natagera Village, Santa Ana. The illustration on the left shows one of the many deities that appear to humans as a shark and a sea bird. The bird is carved in the tail of the shark. The human figure represents the man from whom the deity was derived. Carved by Maemae of Natagera Village, Santa Ana.

One of the canoe houses at Natagera Village, Santa Ana Island. These structures serve not only as storage places for the sacred bonito canoes, but also as men's club houses, ritual centers for the worship of tutelary deities, and as ossuaries for the storage of encased bones of honored dead. The ossuary of this house is located in the center at the rear. The large post at the left, carved by Sao, inspired Reresimae to carve the post of Pa-na-waiau (illustrated on page 394) now in The University Museum, University of Pennsylvania. Photographed by William H. Davenport.

A sacred bonito canoe about to be launched on San Cristobal Island. Bonito canoes are inlaid with shell and have carved stems both fore and aft. Ordinary fishing canoes do not have such elaborate decoration. Santa Ana Island lies in the distance. Photographed by William H. Davenport.

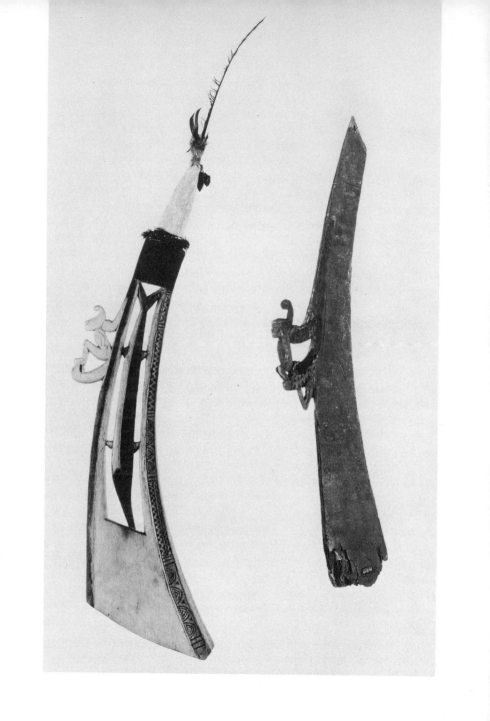

Stem pieces for bonito canoes. The anthropomorphic figures represent generalized deities. The double-disk design (*second from right*) is a variation on the scroll motif. The head of a sea bird (*far right*) is also a scroll design modified by the addition of a beak and fish.

Two men's dance batons.

(*Left*) A shield. The shaft is used to parry javelins, the feather-shaped blade is used to protect the back of the head. (*Second from left*) Canoe paddles of the type used with the great trading canoes. (*Right*) Two women's dance paddles. The shape of the men's dance batons is derived from the shields; the shape of the women's dance paddles derives from the canoe paddles.

417

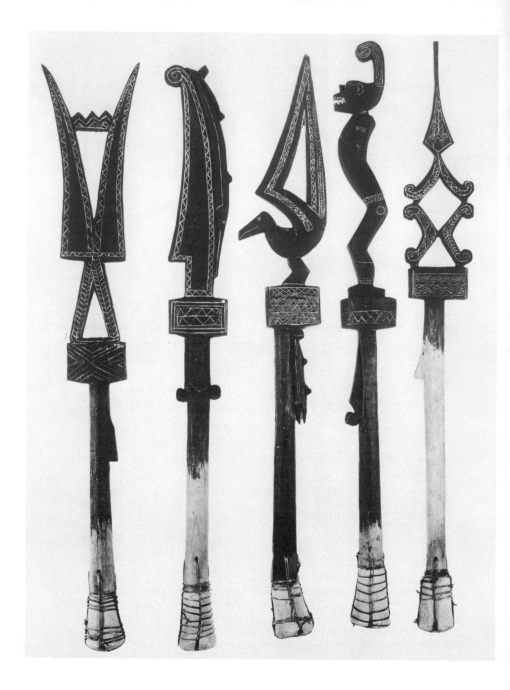

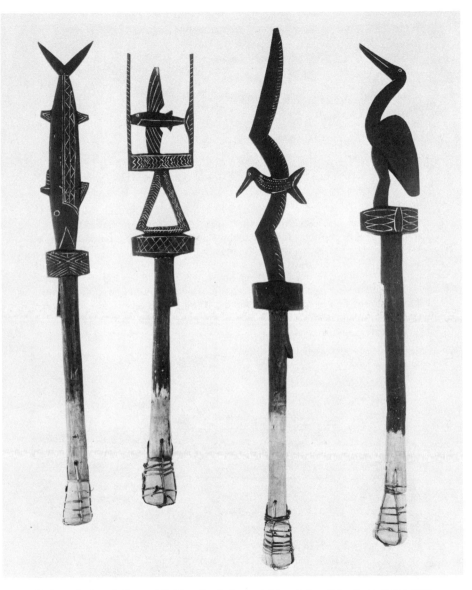

(*Left and above*) Carved fishing floats for catching flying fish. Only those sets of floats kept in the sacred canoe houses are carved with decorative flags like those illustrated here. Those made for household use are plain. Carved by Tasi of Gupuna Village, Santa Ana Island.

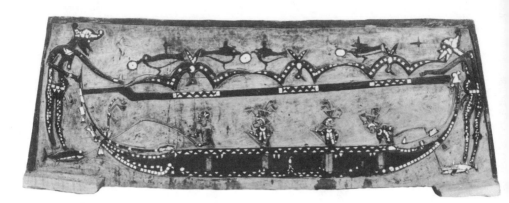

Low-relief panel with polychrome shell inlay. This panel was carved by Karopungi of Star Harbour, San Cristobal Island, to decorate a commemorative feast house. The scene represents a canoe in the midst of a school of bonito. Fishermen fore and aft have bonito on their lines, but the deities standing on them are not releasing the fish. Three species of birds following the school hover and dive overhead. The three fishermen with elaborate headpieces are initiates into the cult of ritual bonito fishing. Their headdress is the kind worn only during this initiation. The left side of the panel is shown in greater detail below.

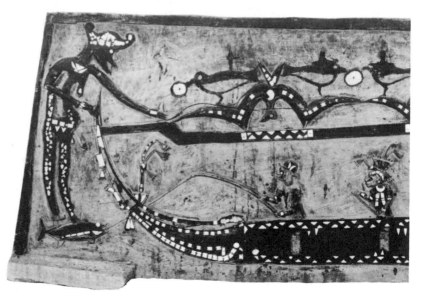

The appearance of schools of bonito have still another significance. If they appear regularly then relations between the deities who control them and mankind are amicable; if they do not appear regularly then relations between the society and its tutelary deities are strained. The bonito school is a kind of barometer that indicates the state of relationship between society and the supernatural.

With all these supernatural associations, it is not surprising that the fishing craft used to catch the bonito are regarded as sacred ritual objects and are suitably enhanced by the most valued skills the society possesses. Moreover, bonito fishing is of such singular importance that every boy must go through a long initiation which introduces him to the mystic milieu of the bonito. The initiation commences when a group of young boys meet the sacred canoes coming in from a successful catch. Each boy is taken into a canoe where he embraces one of the fish and comes ashore with that bonito as if he had caught it. The supernatural forces within the bonito are transferred to the boys by a ritual drinking of a few drops of bonito blood. Then for a period of from six months to two years the boys must live in the sacred canoe house isolated from women and the ordinary activities of community life. Their return to community life is marked by a large celebration in which the boys, decked in adult finery, are paraded up onto a platform where they are briefly shown off to the receiving villagers. The platform itself is a major artistic effort upon which many weeks of labor have been expended. Following their debut the initiates are ritually desacralized, a feast is given to celebrate their reentry into the community, and they resume their lives in a spiritually transformed state. The social significance for the ritual seems to be to separate boys from their infantile dependence upon women and to prepare them for the one activity that best symbolizes the grown man in this society.

These conceptual and ritual relationships to the supernatural and the bonito as well as the initiation into them are depicted in Karopungi's bas-relief panel. It was originally carved as a furnishing for a commemorative ceremony that was undertaken in the Star Harbour area about twenty-five years ago. The carver wanted

to depict what he considered to be the most important aspects of community life.

Many constituent forms in the sculpture, birds, fish, sharks, sea birds, and deities portrayed as humans, are intended to illustrate these conceptions of tutelary deities in their relationships to bonito. Other animals that occur, dogs, land birds, crabs, and porpoise, convey the way other deities that are not associated with the bonito reveal themselves to humans. Thus, much of the iconography of religious sculpture is derived from the beliefs that supernatural beings have concrete forms into which they transform themselves so as to become visible to men.

There are also carvings that do not depict religious mysteries and whose subjects seem to be secular; yet, they too are religious. In these all the activities depicted are rituals, bonito initiations, commemorative rites, or legendary figures who were endowed with great supernatural power.

Even the cognitive processes of creativity of the artist are interpreted in a supernatural way. Ask an artist how he conceived of a particular sculpture, and he will answer that he dreamed of it. By this he means that the creative dream was caused not by his own conscious and unconscious mental equipment alone, but by stimulation from a deity. This, however, is not exactly the situation in the case of the ritual communion bowls, for with them the tutelary deity communicates to his worshiper the kind of bowl he wishes, and these wishes are then conveyed to the carver who has been asked to carve the bowl. The carver must do his best to conform to the supernatural specifications of content. Sometimes a similar situation develops in the context of a commemorative feast. The soul of the deceased man who is to be remembered informs the organizer of the event what kind of large bowl he desires, and these wishes are conveyed to the commissioned carver.

In spite of the iconographic realism and the aesthetic literalism of Eastern Solomons sculpture there is still another, deeper, more abstract significance to their plastic arts. Most works are statements of faith in and adherence to the beliefs and social rituals in which the highest traditional cultural values are expressed. It is these traditional values that give motivation and

direction to the entire society. The art is a testament of these values and motivations.

As mentioned at the beginning of this article, the traditional plastic arts of the Eastern Solomons are disappearing in direct response to increasing contact with Europeans and their culture. This is happening in spite of the fact that Europeans are increasingly interested in the exotic arts of the South Seas. The University Museum's present exhibition is but one manifestation of the growth of this interest. But increasing involvement with European culture is causing a restructuring of traditional interests and values. To the present generation the preeminent problem of life is no longer the maintenance of an amicable relationship between man and his deities. The problem now is how man—the Solomon Islander—can maintain a rewarding relationship with the civilizations that surround him and make him feel more impotent and dependent than ever did his deities. His deities have been permanently eclipsed and with their disappearance the foundations of the art also vanish.

Bibliography

Bernatzik, Hugo A. *Owa Raha*. Wien: Bernina-Verlag, 1936.

Fox, Charles E. *The Threshold of the Pacific*. New York: Alfred A. Knopf, 1925.

Ivens, Walter G. *Melanesians of the South-east Solomon Islands*. London: Kegan Paul, 1927.

Selected Bibliography

Crowley, Daniel J. "Aesthetic Judgment and Cultural Relativism," *Journal of Aesthetics and Art Criticism,* Vol. 17, No. 2 (December, 1958), pp. 187–93.

D'Azevedo, Warren L. "A Structural Approach to Esthetics: Toward a Definition of Art in Anthropology," *American Anthropologist,* Vol. 60, No. 4 (August, 1958), pp. 702–14.

Fagg, William. "The Study of African Art," *Bulletin of the Allen Memorial Art Museum,* Vol. 12 (Winter, 1955–56), pp. 41–61.

Firth, Raymond. "The Social Framework of Primitive Art," in *Elements of Social Organization.* London: Watts, 1951, pp. 155 82.

Fraser, Douglas. *The Many Faces of Primitive Art.* Englewood Cliffs, N.J.: Prentice-Hall, 1966.

Gerbrands, Adrianus Alexander. *Art as an Element of Culture, Especially in Negro-Africa.* Leiden: Brill, 1957.

———. *Wow-Ipits. Eight Asmat Carvers of New Guinea.* The Hague: Mouton, 1967.

Cjessing, Gutorm. "Art and the Anthropological Sciences," *Current Anthropology,* Vol. 3, No. 5 (December, 1962), pp. 479–80.

Hall, Edward T. "Art as a Clue to Perception," in *The Hidden Dimension.* Garden City: Doubleday, 1966, pp. 71 83.

Haselberger, Herta. "Methods of Studying Ethnological Art," *Current Anthropology,* Vol. 2. No. 4 (October, 1961), pp. 341–84.

Kavolis, Vytautas M. *Artistic Expression; a Sociological Analysis.* Ithaca, N.Y.: Cornell University Press, 1968.

Kubler, George. *The Shape of Time; Remarks on the History of Things.* New Haven, Conn.: Yale University Press, 1962.

Leach, Edmund R. "Aesthetics," in British Broadcasting Corporation: *The Institutions of Primitive Society.* Oxford: Blackwell, 1954.

Levine, Morton H. "Prehistoric Art and Ideology," *American Anthropologist,* Vol. 59, No. 6 (December, 1957), pp. 847–64.

Lewis, Philip. "A Definition of Primitive Art," *Fieldiana: Anthropology,* Vol. 36, No. 10 (1961).

Linton, Ralph. "Primitive Art," in Elisofon, E., *The Sculpture of Africa.* London: Thames and Hudson, 1958, pp. 9–16.

Lyons, Joseph. "Paleolithic Aesthetics: the Psychology of Cave Art," *Journal of Aesthetics and Art Criticism*, Vol. 26, No. 1 (Fall, 1967), pp. 107–14.

Mead, Margaret, Bird, Junius B., and Himmelheber, Hans. *Technique and Personality in Primitive Art*. New York: The Museum of Primitive Art, 1963. (Lecture Series No. 3)

Merriam, Alan P. "The Arts and Anthropology," in Tax, Sol, *Horizons of Anthropology*. Chicago: Aldine, 1964, pp. 224–36.

———. *The Anthropology of Music*. Evanston, Ill.: Northwestern University Press, 1964.

Movius, Hallam L., Jr., Kooijman, S., and Kubler, George. *Three Regions of Primitive Art*. New York: The Musuem of Primitive Art, 1961. (Lecture Series No. 2)

Muensterberger, Warner. "Roots of Primitive Art," in Wilbur, G. B. and Muensterberger, W. *Psychoanalysis and Culture*. New York: International University Press, 1950, pp. 371–89.

Noguchi, Isamu. "The Arts Called 'Primitive,'" *Art News*, Vol. 56, No. 1 (March, 1957), pp. 24–27.

Redfield, Robert, Herskovits, Melville J., and Ekholm, Gordon F. *Aspects of Primitive Art*. New York: The Museum of Primitive Art, 1959. (Lecture Series No. 1)

Schmitz, Carl A. *Wantoat; Art and Religion of the Northeast New Guinea Papuans*. The Hague: Mouton, 1963.

Shapiro, Meyer. "Style," in *Anthropology Today: Selections by A. L. Kroeber*, ed. Sol Tax. Chicago: University of Chicago Press, 1962, pp. 278–303.

Symposium on the Artist in Tribal Society, London, 1957, ed. Marian W. Smith. London: Routledge and Kegan Paul, 1961.

Taylor, Donna. "Anthropologists on Art," in *Readings in Cultural Anthropology* by Morton H. Fried. New York: Crowell, 1959, pp. 478–90.

CAROL F. JOPLING, anthropologist, has taught primitive art at the University of Massachusetts, Amherst. A graduate of Vassar College and of Catholic University, she taught courses in primitive art and pre-Columbian art at American University and Catholic University in Washington, D.C. On a field trip to Mexico in 1969 she investigated the art and ritual of the Zapotec people of the town of Yalalag, Oaxaca. In 1970 she made another trip to Yalalag to do field work on the women weavers.